CHICAGO MAKES MODERN

EDITED BY MARY JANE JACOB AND JACQUELYNN BAAS

School of the Art Institute of Chicago

CHICAGO MAKES MODERN

How Creative Minds Changed Society

UNIVERSITY OF CHICAGO PRESS · CHICAGO AND LONDON

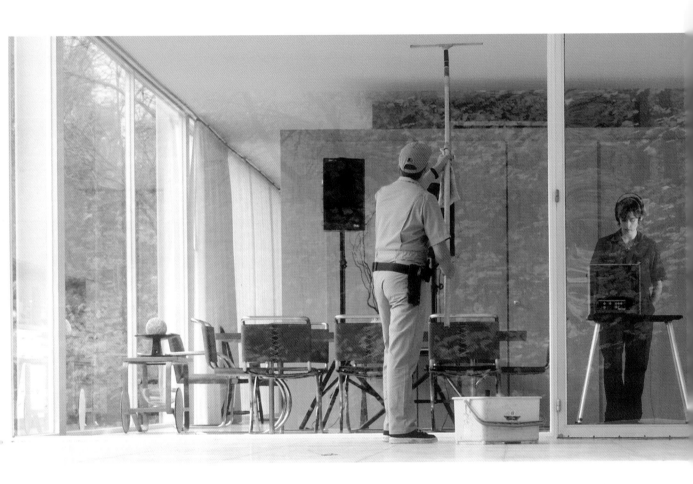

This book is a project of the Department of Exhibitions and Exhibition Studies at the School of the Art Institute of Chicago: Mary Jane Jacob, executive director; Trevor Martin, director; Todd Cashbaugh, associate director; Christina Cosio, assistant director; Kate Zeller, assistant curator and editor for this volume. ¶ The University of Chicago Press, Chicago 60637. ¶ The University of Chicago Press, Ltd., London. ¶ © 2012 by the School of the Art Institute of Chicago. ¶ All rights reserved. Published 2012. ¶ Printed in China. ¶ Individual authors retain copyright to their essays or interviews. ¶ Every effort has been made to identify and locate the rightful copyright holders of all material not specifically commissioned for use in this publication and to secure permission, where applicable, for reuse of such material. Credit, if and as available, has been provided for all borrowed material either on the page, on the copyright page, or in the acknowledgments. Any error, omission, or failure to obtain authorization with respect to material copyrighted

by other sources has been either unavoidable or unintentional. The editors and publishers welcome any information that would allow them to correct future reprints. ¶
21 20 19 18 17 16 15 14 13 12 1 2 3 4 5 ¶ ISBN-13: 978-0-226-38956-1 (paper) ¶ ISBN-10: 0-226-38956-1 (paper) ¶ Library of Congress Cataloging-in-Publication
Data ¶ Chicago makes modern : how creative minds changed society / edited by Mary Jane Jacob and Jacquelynn Baas. ¶ pages ; cm ¶ Includes bibliographical references
and index ¶ ISBN 978-0-226-38956-1 (paperback) ¶ ISBN 0-226-38956-1 (paperback) ¶ 1. Modernism (Art)—Illinois—Chicago—History—20th century. 2. Modern movement
(Architecture)—Illinois—Chicago—History—20th century. 3. Arts—Illinois—Chicago—History—20th century. 4. Artists—Interviews. I. Jacob, Mary Jane. II. Baas, Jacquelynn, 1948- ¶ N6535.
C5C475 2012 ¶ 700'.41120977311—dc23 ¶ 2011050364 ¶ ☉ This paper meets the requirements of ANSI/NISO Z39.48-1992 (Permanence of Paper).

Iñigo Manglano-Ovalle, *Le Baiser (The Kiss)*, 2000. Collections of the Museum of Contemporary Art, Chicago, and the Whitney Museum of American Art, New York. Courtesy of the artist.

CONTENTS

ARTISTS' MIND

FOREWORD

WALTER E. MASSEY

It might seem unusual for a person who has spent most of his career in the realm of science and technology to be asked to write a foreword for a book on art, architecture, and design, and particularly a book that focuses on modernism. But art and science are not as dissimilar as some might think. Both are ways of trying to understand, interpret, and communicate about the world around us. Both are disciplines peopled by individuals who, in the best instances, are strongly motivated by curiosity and passion for their work, and who either possess or cultivate a creative instinct.

There are differences, of course. Science, for the most part, is guided by a desire for orderliness and predictability, with objective assessment among its strengths. This is especially true of what one might call "ordinary science." Art often thrives on the opposite, seeking to discover and reveal truths about our world by shaking our perceptions of it, often applying a process of self-critical, subjective reflection to the task. But both good art and good science benefit from attention to the creative impulse, and both offer ways of explicating, ordering, synthesizing, revealing, and understanding the material world in which we live, the way our senses detect, filter, and organize our interactions with our surroundings. And both are concerned with how we ourselves are affected and shaped by these experiences. Beauty and elegance are prized and admired in scientific experiments and theories, just as they are in works of art, design, and architecture.

A selection of talks and writings by Richard Feynman, a prominent physicist who was also an appreciator of art, is collected in the book *The Pleasure of Finding Things Out*.[1] I think this pleasure impulse underpins both the arts and the sciences and provides the

Jan Tichy, *Lighting Crown Hall*, 2009. Project for Bauhaus Labs workshop, S. R. Crown Hall, Illinois Institute of Technology, Chicago.

drive for ongoing inquiry in each. The ways in which things are found out may differ, but the ultimate joy of discovery is experienced by artists and scientists alike.

I think of art also as a way of bringing the emotional experiences of the creative maker to an audience in a way that provokes, uplifts, and expands the spirit or provides a call to action. As this book indicates, art, like science, can be used to stimulate positive changes in the world, to help create a more just and healthy society.

The concept of modernism flows across these fields in a similar manner. My deeper experience with modernism is in the sciences, where it dates to the late nineteenth and early twentieth centuries. This was a time when classical physics was being replaced, sometimes slowly but often quite abruptly, by new ways of thinking about the world around us, primarily relativity and quantum mechanics. Although these new ways of thinking had their foundations in the past, they did not always grow in a predictable and orderly manner, making them appear quite shocking and therefore, to many, controversial. Similarly, modernist forms of expression in art, architecture, and design drew upon concepts established during the classical, Renaissance, and Enlightenment eras—although often the influence was most forcefully expressed as rejection of those ideals. The concept of the neutrino, named by Enrico Fermi, and the positing of wave-particle duality by Henri de Broglie were ideas that were just as striking and provocative in the scientific world as the deconstructed imagery of Picasso's *Les Demoiselles d'Avignon*, the pragmatism of Mies van der Rohe's skyscrapers, or Le Corbusier's modular approach were in the world of art, architecture, and design.

There are several phrases in this marvelous book that might lead a reader who did not know it was primarily about art, architecture, and design to mistakenly believe it addresses science and scientific research. In the introduction, the editors speak of the need for "constant recalibration," of "new flows of information circulating within space and time," of "creative making" and "self-realization," and of the need "to be self-critical." These are equally valid descriptors of scientific research. This book is fundamentally about creative individuals, creative acts, and the effects individuals and acts have on society. This is a theme that certainly straddles the worlds of art and science.

This book also addresses another passion of mine, and that is the city of Chicago. It speaks to the importance of place in creativity, and how a particular environment can both provide a palette, one might say, and an inspiration for exploration into new forms of self-expression and representation. One could write an amazing book about modernism in science also beginning in Chicago with the dawn of the nuclear age, wonderful discoveries regarding the properties of light, and the exploration of those curiously strange entities called quarks, all of which took place in this great city.

While I do not wish to overemphasize the parallels between art and science, or to oversimplify the substantial differences, I welcome the opportunity this book provides

to deepen my understanding of both. One of the exciting roles I am able to play at this point in my life is to be in an institution—the School of the Art Institute of Chicago—where I can witness the nexus of these two forms of human expression, which are so important in helping us to comprehend the world around us as well as to understand ourselves as human beings.

Note

1. Richard P. Feynman, *The Pleasure of Finding Things Out: The Best Short Works of Richard P. Feynman*, ed. Jeffrey Robbins (Cambridge: Perseus Books, 1999).

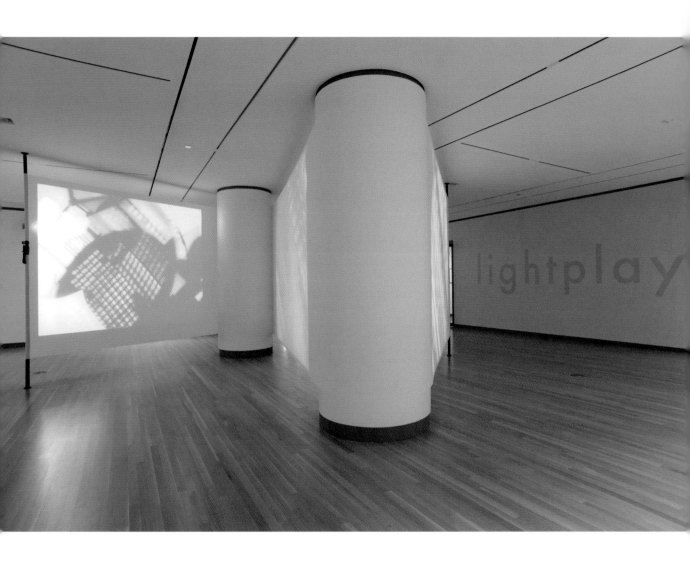

ACKNOWLEDGMENTS

MARY JANE JACOB AND **JUSTINE JENTES**

Just what *was* "modern"? The question drove a program we first discussed in spring 2007. We were motivated by the ways in which Chicago was formed by the modern spirit and by the role it played in shaping modernism throughout the world from the end of the nineteenth century through the mid-twentieth. We were thinking of the hundredth anniversary of the Burnham Plan—Daniel Burnham's modern vision of the city, laid out in 1909. We were also anticipating Renzo Piano's Modern Wing at the Art Institute of Chicago, a new landmark that would open in 2010. Meanwhile the School of the Art Institute was setting in motion the reuse of an existing one—Louis Sullivan's Carson Pirie Scott & Co.—for contemporary art.

Our investigation was spurred, too, by the exhibition commemorating the ninetieth anniversary of the founding of the Bauhaus in Weimar. The show, which originated in Germany, would be mounted at New York's Museum of Modern Art in late 2009, and we knew the story would there be told from the point of view of the host venue. Among claims of restoring a proper understanding of the modern ideas that sprang from the historic Bauhaus, we wanted to look at what it meant to artists, architects, and designers today and within the context of our educational institutions. We wanted to see what had been germinated here by two progenitors from the German school—László Moholy-Nagy and Ludwig Mies van der Rohe—who landed on the shores of Lake Michigan. Thus, the first joint venture of the School of the Art Institute of Chicago (SAIC) and the Mies van der Rohe Society at the Illinois Institute of Technology (IIT) was launched.

This program was shaped by collaboration and synchronicity, creativity and fortitude, linking opportunities that extended throughout the city and recognizing the ongoing, dedicated work of so many institutions invested in the modern. Through it all we sought to weave a strong conceptual thread. Our process was one of conceiving of exhibitions and public programs *as* research. Of course, any good exhibition or program is based on

Moholy: An Education of the Senses, 2010. Installation view, Loyola University Museum of Art, Chicago. Photo: James Prinz.

research, amassing or building knowledge and imparting it to an audience. But exhibitions *as* research are less common. Such a methodology proceeds organically; the exhibition itself is an in-progress endeavor, not a finished product but part of a wider process. Exposing its internal processes, it depends on public viewing and interaction for the development of knowledge.

To push the boundaries of the Bauhaus and recognize antecedents of the modern story in Chicago meant trying to *live* the idealist pedagogy that Walter Gropius created for art and design education in 1919. We needed to locate the new life that came with its importation to Chicago in 1937, when Moholy-Nagy founded the New Bauhaus, and the next year, when Mies van der Rohe arrived at what is now IIT, ultimately transforming architectural training and the cityscape of Chicago and then, through his work and that of his students, the world. It also meant probing what modern means today to the faculty and students of schools of art, design, and architecture. Why is modern not merely a bygone style but a living presence among us?

At the outset there were those who supported this effort. We would like first to acknowledge the leadership of Lisa Wainwright, dean of faculty and vice president of academic affairs at SAIC, and Betsy Hughes, vice president for institutional advancement at IIT. As anyone familiar with the logistics of presenting exhibitions and public programs knows, it is the staff that does the heavy lifting. Thus, our heartfelt appreciation goes to Kelly Hyman Merrion, program coordinator at the Mies van der Rohe Society at IIT. At SAIC, assistant curator Kate Zeller played a fundamental role in all aspects and served as SAIC editor for this volume. Thanks, too, to director of exhibitions Trevor Martin and associate director Todd Cashbaugh, as well as associate dean of academic administration Paul Coffey, vice president of facilities and operations Thomas Buechele, and director of design and construction Ronald Kirkpatrick.

To live the modern moment we assembled in June 2009 a temporary international school called "Bauhaus Labs." We were joined by the Bauhaus–Universität Weimar (the city of origin of the Bauhaus) and Bezalel Academy of Art and Design in Tel Aviv (the UNESCO city of the Bauhaus). Modeling the Bauhaus teaching format, five "workshops" took place in Mies's S. R. Crown Hall at IIT, a national historic landmark that remains one of the most influential and inspiring structures in the world. "Blank Page," led by designer Martin Avila and material scientist Mikael Lindstrom from Konstfack, University College of Art, Craft and Design, Stockholm, considered innovative applications for experimental paper materials; "Experiencing Modern," led by IIT Institute of Design professors Anijo Mathew and Martin Thaler, investigated the visitor's experience of Chicago as a modern city; "Looking Modern," under Jacquelynn Baas, took a critical look at collection display in the Art Institute of Chicago's new Modern Wing; "Installing Modern," with Madrid-based architect Marcos Corrales, tested propositions for the design of the planned exhibition *Learning Modern*; and "Lighting Crown Hall," led by artist Jan Tichy, turned Mies's iconic building into a spectacular site-specific art installation at night. We also benefited from the "Visual Training," modeled by Walter Pederhans under Mies and offered here by associate professor Catherine Wetzel and Homa Shomaie of IIT's College of Architecture, with the help of Donna Robertson, Rick Nelson, and Faith Kancauski.

We would like to acknowledge our academic partners: Liz Bachhuber, professor of art and head of the MFA program "Public Art and New Artistic Strategies" at the Bauhaus–Universität Weimar, along with former rector Gerd Zimmermann and current rector Karl Beucke; Nahum Tevet, head of the MFA program, and Tamar Eres, executive administrator, at Bezalel Academy of Art and Design; and Ronald Jones, professor of interdisciplinary studies, the Experience Design Group, at Konstfack. The expertise of the Chicago Architecture Foundation, which daily makes this city-as-museum available to residents and visitors in informative and insightful ways, also contributed. We would like to thank Barbara Gordon, vice president of program operations, and Whitney Moeller, manager of public programs, who aided us in the "Bauhaus Labs" program and proved to be valuable partners throughout the modern program. "Bauhaus Labs" was made possible in part by the support of the Emily Hall Tremaine Foundation.

The keystone of the overall program was the exhibition *Learning Modern*, held at SAIC's Sullivan Galleries. The galleries are housed in the steel-frame building originally designed by Sullivan for the Schlesinger and Mayer department store; constructed between 1898 and 1904, it was soon sold to Carson Pirie Scott & Company, with an addition completed by Burnham in 1906. Its cream-colored, glazed terra-cotta and the cast-iron details at street level exemplify the architect's signature decorative design, but it was the structure's geometric simplicity that came to epitomize the industrial aesthetic, and its enormous Chicago windows foreshadowed the modern curtain wall. Its open, light-filled, unadorned plan was startling: factory as department store. As Kathleen James-Chakraborty tells us in "From Chicago to Berlin and Back Again," Gropius, in part inspired by this building, would two decades later create at Dessau the factory-department store as school.[1] Now, a little more than a century later, this Chicago department store has become a school, with SAIC's move onto several floors and the use of the seventh as galleries. Sullivan's landmark is also located at the zero point in Chicago's street-numbering system, the cartographic center of the city. In the 1960s, when this space was Carson Pirie Scott, the store presented design shows in its windows, collaborating with notable designers of the era. So it seemed a prophetic starting point for thinking about the modern in the city. As Marcos Corrales said early in the process, "There is already something in the skin of the building."

J. Morgan Puett's project *Department (Store)* filled the space's larger gallery with 130 mirrored, tabletop display cases that were filled with art through a collaborative, emergent process of exchange. The following year, in *Learning Modern*, we would apply the teaching ideals of the Bauhaus—its multidisciplinary and hands-on approach, which is part of our school's inheritance—to the unfolding of an exhibition. Not only would faculty and students find their place in the show, but also the public, through a process of experiential education.

In many ways, *Learning Modern* started with Sullivan's windows: looking out on the city, at a world the gallery shared with other buildings and the people they contained, forming a continuity in midair. We wanted to include the windows that frame, from north to south, Bertrand Goldberg's Marina City, Skidmore Owings and Merrill's (SOM) new Trump Tower, Burnham's Reliance Building, Holabird & Roche's Chicago Building, the Inland Steel Building by SOM's Bruce Graham and Walter Netsch, Helmut Jahn's Xerox Building, Graham's Sears (now Willis) Tower, and more.

But how to manifest the modern? Some of our answers: speed, repetition, transparency, a layering of images and ideas; a continuous process of expanding and contracting, density and absence; forces that slow you down and are more experiential than optical; works perceived in different ways, different groupings, as you move around the space; a network of experiences that encourages participation and probing, such that you leave with more questions—more thoughtfully considered, more tangibly elaborated, more meaningful—when you walk back out into the world, which is where those questions (and maybe some answers) live.

In a planning exercise that sought to imagine this as an exhibition, one brainstorming group took as its metaphor the settings on a 1950s turntable: 33, 45, 78 RPM. "You go round the exhibition more than once, and you go at different speeds. Seeing at different speeds allows the density of the artifacts and ideas to build up experience. The fastest speed is a synthesized light-and-sound experience of projected media. The middle speed allows a didactic consideration to drift in, exploring certain key systemic connections across decades and between the current and former disciplines. The slowest speed allows favorite moments, text quotes, images, and artifacts to be lovingly considered in static silence, memorized and carried out as simply but profoundly enhanced understanding and desire. Proceed from eyesight to insight."[2]

We would like to thank the artists and designers who participated and offered their work for dialogue: Ângela Ferreira, Lisbon; Andrea Fraser, Los Angeles; Charles Harrison, Chicago; Walter Hood, Oakland; Ken Isaacs, Granger, Indiana; Narelle Jubelin, Madrid, and Carla Duarte, Chicago; Carole Frances Lung (aka Frau Fiber), Los Angeles; Iñigo Manglano-Ovalle, Chicago; the Mark-Mark-and-Matt Collaboration (Mark Anderson, Mark Beasley, and Matt Nelson), Chicago; Helen Maria Nugent and Jan Tichy, Chicago; Liisa Roberts, Helsinki; Kay Rosen, Gary, Indiana; Staffan Schmidt, Malmö, Sweden; and Catherine Yass, London. Architects and SAIC faculty members Douglas Pancoast and Tristan d'Estrée Sterk, as cochairs of the 2010 Association for Computer Aided Design in Architecture conference, contributed enormously to the discourse of the show, bringing the architectural work of Joshua Cotten, Justin Nardone, and Douglas Pancoast, Chicago; Thom Faulders Studio, Berkeley; and Arturo Vittori, Bomarzo, Italy. We also wish to thank curator-professor Mika Hannula, who was an early collaborator in the project and who later worked with many of these artists on their texts in this volume. Finally, we offer our gratitude and very special thanks to exhibition designer Marcos Corrales, who interwove these works in such an exceptional way, retaining Sullivan's sense of open space, inserting a lecture area and dark rooms for video, keeping some works centralized and spreading others out so that they intersected other works and formed itineraries of their own, encouraging a flow of experience that engendered participatory engagement.

Education as the art of conceiving a meaningful continuum of experience arose as a guiding thought in our planning sessions. We came to see the space of the exhibition as a place for students and faculty not only to view works, but also to make work and to experiment, contributing to the living dynamic of the exhibition. Manifesting the school as interdisciplinary laboratory for creating ideas and testing them—works presented as provisional and prototypical, rather than fixed and finished, as in a museum—led us to

give the *Learning Modern* show a continually evolving form. We wish to cite those faculty-student projects, "workshops" in the Bauhaus tradition, that jumped into the process and took part in the space and time of the show: Charles Harrison's class contribution *Redesigning the View-Master*; Ken Isaacs's *Living Structure* re-creation, under the direction of Andy Hall; the South Side Community Art Center project and installation under Drea Howenstein; Jaak Jurisson's "Visionary Drawings" class; Travis Saul's *taxis*; Chris Reilly and Taylor Hokanson's *Lil' CNC*; and a fusion of poetry and sound by the SAIC Sound Department's Lou Mallozzi with the Poetry Center of Chicago, presented as part of Experimental Sound Studio's tenth annual Outer Ear Festival. There were also several graduate student projects, undertaken with Sullivan Galleries staff: the performances *Messy Modern* and *Ready>Steady>Cook* and the installations *Beacon*, *project*, and *Tracing Eames*.

Finally, special thanks go to Gillion Carrara and Caroline Bellios of the SAIC Fashion Resource Center for the in-depth study and presentation of the work of modern fashion designer Claire McCardell. In addition to the holdings of the SAIC Fashion Resource Center, generous loans were provided by the FIDM Museum at the Fashion Institute of Design and Merchandising, Los Angeles, and the Texas Fashion Collection, Denton.

The excellent team responsible for the *Knowledge Box* reinterpretation included, along with architect Ken Isaacs, Barbara Isaacs, Sara Isaacs, project curator Susan Snodgrass, and Catherine Bruck, archivist at IIT. Alexander Derdelakos and Chris Strailman, IIT students, saw to its construction, with advice from IIT faculty member John Kriegshauser and, at SAIC, Matt Davis and Joe Iverson; audiovisual production was undertaken by Jeff Panall, with Kurt Frymire and Hillary Strack. Photographic images were obtained courtesy of *Life* magazine (© Time Inc./Time Life Pictures/Getty Images).

Most of all, we would like to acknowledge our special funders for the *Learning Modern* exhibition and all its corollary programming. In addition to SAIC and the Mies van der Rohe Society at IIT, these are William and Anne Hokin, Alicia Rosauer and Robert Segal, and the Illinois Arts Council, a state agency. We would especially like to thank the Graham Foundation, without which this book would not be possible.

Learning Modern came to life with "Modern Mondays," in which many of the artists, faculty members, and others entered into public conversations; the series was organized by graduate curatorial assistant Joe Iverson and graciously supported by illy caffè North America, Inc. Many other programs set the scene and led to the genesis of ideas, among them a lecture series, "Bauhaus to Greenhaus," that set out to imagine a changed way of living, revisiting the utopian modern vision as it lives on today; this series brought to Chicago leading European architects and designers whose practices draw on the Bauhaus tradition and address today's sustainability challenges. It was steered by assistant curator Kate Zeller and developed by the Mies van der Rohe Society at IIT, the SAIC Department of Exhibitions and Exhibition Studies, and the SAIC Department of Architecture, Interior Architecture, and Designed Objects. We found ready collaborators in our colleagues at the Goethe-Institut Chicago, Rüdiger van den Boom, director, and Eugene Sampson, program coordinator. Following their lead, other international cultural partners joined: Margreth Truempi, head of cultural affairs, Consulate General of Switzerland; Tina Cervone, director, Istituto Italiano di Cultura, Consulate General of Italy in Chicago; and

Peter Verheyen, deputy head of mission and consul for economic affairs, and Herbert Wennink, commercial officer, Consulate General of the Kingdom of the Netherlands. Additional funding was provided by Pro Helvetia, the Swiss Arts Council, and the Swiss Benevolent Society of Chicago. With Andrea Green, director of SAIC's Visiting Artists Program, we were able to expand this series and bring other speakers into the programming during the year.

• • •

Our year of modern programming culminated, fittingly, with the deeply resonant and evocatively beautiful exhibition *Moholy: An Education of the Senses*, curated by Carol Ehlers. Her vision: to bring back to Chicago the spirit of Moholy-Nagy. Here was an artist who had arrived on the brink of war in Europe and died nine years later of leukemia, barely past the end of World War II yet always looking forward to the day when mankind would surpass such dead-end conflicts. A number of shows in Europe around that time were dedicated to or prominently included this artist, but none in the United States, none that looked at his impassioned last years, none in Chicago. In addition to recognizing Moholy-Nagy's essential role in modernism, we were impressed by our conversations with artists and designers, so many of whom looked to this artist as a secret, personal mentor. But realizing Ehler's vision presented a challenge. How to make this show a *living* experience of the artist's work, so the visitor could sense it, experience it? How to appreciate his still relevant plea that through art and design we can become better citizens and make a better world, not in heroic fashion but as transformed individuals, sensitive and self-aware individuals in society? The challenge was admirably met by Helen Maria Nugent and Jan Tichy, working together for the first time as an exhibition design team. Their insight—imagining what Moholy-Nagy might do today, how he might use technology, how he might have wanted his work to be seen—led to an exceptionally innovative exhibition design. The show was initiated and initially organized by SAIC's Department of Exhibitions and Exhibition Studies and the Mies van der Rohe Society at IIT, and we were most fortunate to partner with the Loyola University Museum of Art (LUMA), where the show was ultimately realized. In conjunction with the exhibition, LUMA organized a comprehensive series of lectures and programs that considered the impact of Moholy-Nagy's work at its time, as well as the legacy of his vision. Our deep gratitude to Pam Ambrose, director of cultural affairs at LUMA, for her vision, great flexibility, and collaboration on this important show. Others at LUMA whose efforts made possible this exhibition and related programs were: Jonathan Canning, curator; Andrew Cunningham, exhibitions manager; Emily Grimm, manager of visitor services, design, and publications; Ann Meehan, curator of education; and Lisa Stuchly, curatorial assistant. The exhibition was generously supported by a grant from the Terra Foundation for American Art.

Finally, "Vision in Motion: Filmmaking at the Institute of Design, 1944–70" was a film series staged at SAIC's Gene Siskel Film Center, organized by Amy Beste; here Hattula Moholy-Nagy, daughter of the artist, played a key role in both making films available and enlightening audiences. This series, reflecting on Moholy-Nagy's groundbreaking experimental art-film program at the Institute of Design, was presented in collaboration with

the Chicago History Museum and the SAIC's Gene Siskel Film Center. It was inspired in part by Moholy-Nagy's "New Vision in Photography" course in summer 1946 at the Institute of Design, of which he wrote, "Students will find Chicago an interesting place to explore with the camera. Its varied industrial and cultural institutions will also contribute to the creative experiences of the serious photographer."

Chicago is still modern, still an interesting place that fosters creative experiences. And this is what we sought to do: to make a modern experience of art, design, and architecture in a city that is enduringly dedicated to the modern, and to make public the role of schools of art, design, and architecture in shaping that modern world and worlds-to-come as a way of teaching, learning, and living.

Notes

1. Elsewhere, James-Chakraborty has written, "With its equation of the studio classrooms with the gazed concrete frame of an American daylight factory, the purpose-designed structure in which the school reopened in Dessau in 1926 continues to be the most compelling manifestation of the school's intention to marry industry and art." "Introduction," in *Bauhaus Culture: From Weimar to the Cold War*, ed. James-Chakraborty (Minneapolis: University of Minnesota Press, 2006), xvi.

2. This group was chaired by Anders Nereim, professor in the Department of Architecture, Interior Architecture, and Designed Objects at SAIC, who is quoted here.

...ignored by the scientific
...s time. Recalling me cont...
...tomist, he writes. "This i...
...did not realise howeve...
...ing and see... that the...
...to work at constant...
...ience with the bodily eye...
...faced with the danger...
...of seeing nothing." Go...

...metamorphose des plantes...
...iades, 1975), 171 (My translat...

The best interpreter of g...
...osophy and epistemology...
...ntieth century was Rudo...
...1 - 1924). The pedagogic...
...developed for his Waldor...

...rological era Althou...
...visited the Bauh...

...haus pedagogies. Steiner's...
...k on the other hand, usu...
...expressionist, is more ex...
...the Wrightian designation...
...ich bears the same meaning...
...cent essay. Most of the...
...holy-Nagy's personal libr...
...n lost or given to the In...
...y few remained in his...
...g them Goethe's Farbenlehr...
...otated.

Introduction

MARY JANE JACOB AND JACQUELYNN BAAS

Modernism is a pervasive current that remains alive in thought and action. The modern mind does not have a fixed point of view. Modernity is an ongoing, ever-morphing process that questions existing forms of authority, methods of making and doing, and perhaps most importantly, the ethics that underpin these activities. Modernism enables and demands constant recalibration, with new flows of information circulating within space and time. Its dynamic impulse pulled us into its vortex to ask: Why is there a growing interest in twentieth-century modern art, architecture, and design today? What has been left undone that draws us back to the modern to reexamine and take it up again?

What we have found is that, while modern style can be codified and displayed, modern mind remains open to new forms and applications. It is driven to discover a better way that is beneficial, not just to a few, but to our planet and everything it encompasses. While humanistic in its focus, within the wider frame of this holistic way of thinking, humankind is but a part. We set out to explore the modern mind today, how it manifests itself in the arts, and where it seeks to take us.

The modern mind project was a research undertaking. The notion of modernity as process encourages a multidimensional and multidisciplinary approach; ours became a joint task of scholarly, artistic, and curatorial research. While the pursuit of the scholar is well-established territory, artistic research—making art *as* artistic research—is a more recent professional direction.[1] Art has always told us about the world and given insight into the deeper realms of humanity. But to identify and validate art as research has been suspect, due in part to an age-old bias that privileges thought over action, mind over hand. Yet the mind is always present, and the modern mind in particular vigorously pursues a path that straddles reason and intuition, fact and imagination, the conscious and the unconscious. Moreover, for artists, research happens before, during, and after the making of a work, and this process is shared by other creative individuals in fields

Narelle Jubelin and Carla Duarte, *Key Notes* (detail), 2009. Installation view, in *Learning Modern*, Sullivan Galleries, School of the Art Institute of Chicago. Photo: Carla Duarte.

seemingly remote from the realm of art. This is what makes the creative act so important: creative making is not just the execution of a plan set out ahead of time, but the constant reexamination of intent and outcome.

The modern mind project aimed to become just this kind of creative research. It began with brainstorming in open-ended think tanks among invested arts professionals.[2] The core research took the form of commissioned artists' investigations, which were presented in the form of two exhibitions: *Department (Store): A Collaboration with J. Morgan Puett* and *Learning Modern*. A concurrent historical, monographic study—*Moholy: An Education of the Senses*—occasioned an interpretative installation design that reflected and enhanced meanings that historical works can hold for artists and museum visitors today.[3] Results of scholarly research were also presented via lectures, films, and a host of public programs. In all these ways, we examined how Chicago in the first half of the twentieth century came to be a hotbed of modernism in thought and practice, while also examining modernism's persistence and necessity today. Chicago's role in the past, present, and potential future of modernism was thus foregrounded, both in particular and within the larger international network that has promulgated the social and cultural precepts of modernism.

In the curatorial process of organizing these events, we modeled our practice on the modalities of both scholarly and artistic research. Thus, the many forms in which the modern mind project was realized were not seen as products or endpoints. Rather, they served as platforms for ongoing engagement with modern ideas as they live in us today. We aimed to be responsive to the collective process that we instigated among a group of practitioners—scholars, curators, artists, architects, and designers—who worked together over three years. This emergent methodology, although not unlike that of the Bauhaus, ran counter to dominant curatorial practice, in which an exhibition and its corollary research are designed to present an authoritative, definitive view. For us, these moments of sharing thinking, presenting research for further scrutiny and reflection, became a method of working through experience. Likewise, most exhibitions have catalogs that presume to give closure and provide documentation. Only now, with this volume, can we attempt to capture what the modern mind project revealed and inspired. The research process has led us to a book in two sections: the opening historical chapters elucidate the modern movement through an array of Chicago stories, largely overlooked; the second half presents contemporary voices and images from artists, designers, and architects.[4]

This anthology begins with Mary Jane Jacob's historical essay "Like Minded," which assesses the progressive ideas of three creative individuals in Chicago—Jane Addams, John Dewey, and László Moholy-Nagy—as they imagined the modern individual who could find self-realization and, in doing so, help create a more just and healthy world in the twentieth century. Dewey reappears as a motivating force throughout the book, as does the great designer and pedagogue Moholy-Nagy. Perhaps due to his early death soon after World War II in his new home of Chicago, his work on this side of the Atlantic has been overshadowed by his early Bauhaus years. Yet we have found that the legacy of his progressive vision endures in artists, architects, and designers around the world.

Historian Maggie Taft shares new perspectives on Moholy-Nagy with her essay "Better Than Before: László Moholy-Nagy and the New Bauhaus in Chicago." She takes up the

coming of the Bauhaus to Chicago as represented through a series of early exhibitions here and in New York at the Museum of Modern Art. Troubled political times made the moral challenge of design all the more urgent to Moholy-Nagy, who chose to pursue this challenge "not as a translation of the German curriculum—nor as a capitalist-minded transgression of it . . . —but instead as a bid for modernism's survival, as well as a kind of connective tissue between the prewar European avant-garde and the postwar American strand of modernism." With the survival of his school at stake, Moholy-Nagy struggled to root his idealistic vision within the realm of capitalist enterprise of the Institute of Design (as the New Bauhaus was later renamed).

Ronald Jones, an artist-critic and professor, also looks at Moholy-Nagy and the ethical role of the designer today in his essay "Moholy's Upward Fall." According to Jones, Moholy-Nagy was one of the few who understood that "historically the creative disciplines have been handed few occasions to make moral decisions based on the effects their work would *definitively* have on other people," and who tried both to meet this challenge and bring it to future generations through his teaching and his books. Jones provides a pragmatic view of Moholy-Nagy's wartime "upward fall" and argues that his attitude is even more important today, when "it seems urgent that we too strive for persuasive solutions to menacing problems." Moholy-Nagy's mission is ours as well, Jones suggests, and the need to engineer "both methods and means for producing results across disciplines" may be even more pressing now.

The energy of the modern medium of film for Moholy-Nagy as well as his significance for the field are presented in the essay "Designers in Film: Goldsholl Associates, the Avant-Garde, and Midcentury Advertising Films" by film historian Amy Beste. As she tells it, the artist's curriculum for the New Bauhaus placed a unique emphasis on the camera, and the motion picture camera in particular. By the time he arrived in Chicago in 1937 to open the school, Moholy-Nagy was convinced of film's potency as a creative and mass medium and "saw the founding of the School of Design as an opportunity to establish the experimental film laboratory he had envisioned throughout the decade."

A constant drive to experiment and innovate led Moholy-Nagy to assemble around him other creative minds. Fellow Hungarian György Kepes was one of them. In "Modern Mind and Typographic Modernity in György Kepes's *Language of Vision*," Michael J. Golec, a design historian, looks at the import of this seminal 1944 book. An original member of the New Bauhaus, Kepes headed the Light and Color Department. According to Golec, Kepes capitalized on the school's lablike environment and advanced Moholy-Nagy's conception of a laboratory curriculum in *Language of Vision*. In the end, he "exceeded his mentor's formulations by producing . . . the most important book of the 1940s and 1950s that dealt with the problems of sense perception and expression in contemporary art and design."

Any book on modernism must address the field of architecture. We asked architectural historian Kathleen James-Chakraborty to follow a stream of developments in architectural modernism, which she traces in "From Chicago to Berlin and Back Again." James-Chakraborty begins with the familiar story of the development of the steel-framed office building by Chicago architects in the 1880s. Simultaneously embracing and distancing

itself from modernism, the Chicago narrative evolved through the migration of ideas and personalities between Chicago and Berlin. Louis Sullivan and Frank Lloyd Wright, she explains, influenced "the interwar European avant-garde, and especially Germans like Walter Gropius, Erich Mendelsohn, and Ludwig Mies van der Rohe, to invent what we know as modern architecture or the international style." Mies's move to Chicago brought things full circle, resulting in "another golden age in Chicago architecture." James-Chakraborty also contextualizes the work of Moholy-Nagy and Kepes, and traces the Cold War period's embrace of modernist architecture for "its effectiveness as propaganda for the United States, and by extension both capitalism and democracy." She concludes with another cycle: the design for a commercial forum on the edge of Potsdamer Platz by Helmut Jahn, a Chicagoan of German birth and a student of Mies.

While the work of visionary architect Buckminster Fuller has been the focus of recent attention, his work in Chicago has not. In "Buckminster Fuller in Chicago: A Modern Individual Experiment," curator Tricia Van Eck examines the influence of Chicago and its surroundings on Fuller's modernist enterprise, starting in 1926 and spanning the years to 1972. Fuller returned to Chicago in 1948, two years after Moholy-Nagy's death, to the Institute of Design. The essay, filled with poignant biographical insight and keen understanding of Fuller's prophetic mission, is based on the author's research as she expanded the Whitney Museum of American Art's Fuller retrospective when it traveled to Chicago's Museum of Contemporary Art in 2009.

Architects Andreas Vogler and Arturo Vittori's essay "Keck and Keck: The Chicago Modern Continuum" reexamines these forward-thinking Chicago architects, whose innovative designs have slipped from popular memory. The two provide an historical and personal view of two prototype projects by Keck and Keck: the House of Tomorrow and the Crystal House at the 1933 Century of Progress exposition in Chicago. (It was at the Crystal House that Fuller presented his first prototype of his Dymaxion car.) Both were conceived as "laboratory houses," a concept mined by Vogler and Vittori for their own futuristic series of MercuryHouses, in "the tradition of reinventing the world based on scientific and creative processes and on respect for nature.... This is what drives the modern world in all fields: in science, engineering, architecture, and art."

For many, Mies is the quintessential modern architect, and his legacy looms large in Chicago. Architect and professor Ben Nicholson honors the master, albeit probingly, in his autobiographical essay "Mies Is in Pieces." He centers on his sixteen-year experience teaching in Mies's Crown Hall at the Illinois Institute of Technology, a "space that lies outside of conventional perception through the five senses." After what he calculates to be about eight thousand visits to this building, Nicholson is in a position to look at it with exceptional acuity.

Mies has also been the inspiration for Chicago artist Iñigo Manglano-Ovalle. The curator Elizabeth A. T. Smith traces Manglano-Ovalle's extensive engagement with the architect's iconic buildings "as a means of interrogating the reformist and purist intentions of modernism." Smith follows Manglano-Ovalle as he moves in and out of private and public buildings in the Chicago area, Berlin, and Barcelona, finally making a sculpture of Mies's unbuilt 1951–1952 design for a House with Four Columns. In all of these works,

Mies's buildings "play dual roles as protagonist and as supporting actor," Smith says, as she illuminates for the first time the interrelationships between art and architecture in the projects that form this lyrically analytical body of work.

In its focus on the ideas of a single contemporary artist, Smith's essay serves as a bridge to the second section, "Artists' Mind," which opens with Kate Zeller's "My Modern: Experiencing Exhibitions." Zeller leads the reader through the exhibitions that were part of this project: *Department (Store): A Collaboration with J. Morgan Puett*, *Learning Modern*, and *Moholy: An Education of the Senses*. Many of the artists featured in these shows, and for whom the exhibitions served as artistic research, have contributed their reflections to this section, edited by Mika Hannula.

"Artists' Mind" continues with texts by the designers of two of the exhibitions. In "Incomplete Final Checklist (Unconfirmed)," architect Marcos Corrales provides an insightful key to the process that led up to the installation of *Learning Modern*, discussing his role in negotiating conversations and multiple artists' minds, balancing their desires and contextual requirements. Helen Maria Nugent and Jan Tichy, who designed *Moholy: An Education of the Senses* and contributed their own installation artwork, *Delineations*, to *Learning Modern*, seeking in both to embody Moholy-Nagy's ideas and bring them forward for audiences today. In their text, "Lightplaying," they speak of their generative dialogue: "Including Moholy-Nagy in our conversation, instead of discussing him, we were able to create a contemporary experience rather than a historical archive."

Ângela Ferreira takes up the powerfully present personality of modernist architect Mies van der Rohe. As she tells it, she "had already spent some time dwelling on the modernist phenomenon, particularly on modernist architecture in Africa. . . . So the possibility of studying the origins of the modernist movement [in Chicago] was too tempting to ignore." She chose to collapse and combine Mies's Crown Hall with the contemporaneous Dragon House of Mozambican modernist Pancho Guedes, and "set to work with the spirit of a learner." Meanwhile, evoking the visionary functionalism of Buckminster Fuller, and inspired by the space of Louis Sullivan's Carson Pirie Scott Building—the site of the *Learning Modern* exhibition—Walter Hood created *Bioline*, a project along a four-meter-wide, galvanized-metal air duct that was installed overhead when the space was turned into a gallery. Recognizing that "the hermetic characteristic of modern architecture in relation to site miniaturizes our experience of the natural environment," Hood sought to reorder this relationship, to "objectify material things that embody and express abstract ideas and principles about space and technology, but have become ordinary and commonplace objects in the environment around us."

Sullivan's landmark building, a keystone of modern architecture, was also the jumping-off point for the first contemporary art intervention into this commercial space-turned-gallery, J. Morgan Puett's collaborative installation project, *Department (Store)*. She locates this work within her practice and an ongoing concern: what does this future actually look like? Finding "new arrangements of sociality" through experimental processes that "are constantly being kneaded together," Puett adds that her modality is "seeking a collaborative, coevolving, and ultimately *shared* experience with learning 'as you go' as a constant, generating collective research experience." Narelle Jubelin and Carla Duarte swept around

Sullivan's space in another way in creating the sumptuous, fourteen-panel work *Key Notes*, interweaving many sources of modernist abstraction, theory, and history. This work both enveloped the galleries in dialogue with Sullivan's State Street and Madison Avenue windows and served as an inspirational foundation for the exhibition overall.

Staffan Schmidt gives voice to those who made modern architecture in his five-screen video work, *Modernity Retired*, a study of the modern as it is remembered. Speaking with architects Alfonso Carrara, Natalie de Blois, Ken Isaacs, Gertrude Kerbis, and Peter Roesch in their Chicago homes, Schmidt asks open-endedly—"What *was* modernity?" Curator Zoë Ryan also probes this question in an interview with industrial designer Charles Harrison, a midcentury student of design at the Institute of Design at IIT and the creator of nearly seven hundred designs for production, including the commercially viable redesign of the View-Master and the plastic garbage can on wheels that revolutionized waste management.

Dance legend Anna Halprin performed as a child at the 1933 Century of Progress exposition in Chicago, where Keck and Keck's and Fuller's works were on display. She profited, too, from a progressive, experience-based public school curriculum and from the teaching of an innovative college instructor, both informed by the theories of John Dewey. Starting her career in New York, then relocating to California in 1945—and finding there a new beginning—Halprin went on to be one of the greatest driving forces in modern dance as she came to understand that "the creative process would lead us to find our own style." Contemporaneously, Italian artist Michelangelo Pistoletto also sought to find a style of his own. Like Halprin's, his path became social, taking him out of the hermetic isolation of the artist's studio to undertake an experiment in cooperative working and global thinking. His life's project, Cittadellarte, is a place where "art, as a primary expression of creativity, assumes a social responsibility, playing an active part in the construction of a new civilization on a worldwide scale. We aim to inspire and produce a responsible change in society through ideas and creative projects."

The section concludes with three newer voices: Indian artist Jitish Kallat, Chinese artist Ai Weiwei, and the Venetian collective artway of thinking. Kallat takes up the subject of modernization and religious tolerance in his interview with curator Madhuvanti Ghose, considering a historical event of supreme influence within Indian culture that took place in Chicago: the speech of Swami Vivekananda at the First World Parliament of Religions held on September 11, 1893. *Public Notice 3*, Kallat's site-specific 2010 installation at the Art Institute of Chicago, joins this earlier moment with the terrorist attacks at the World Trade Center and the Pentagon on the very same date 108 years later.

Ai Weiwei aims to play an active role in the modernizing of his nation, where human rights are so perilously at risk. He finds that "art is a continuous attitude toward our life, in every aspect." Asked whether he considers himself a modernist, he replies in the affirmative: "In our times, we need to be ready to face changes. Being in a continuous process of change is a way to admit to your own conditions, to renew yourself, and to be self-critical." Change is constant, and so too may modernism be.

Finally, the artists Federica Thiene and Stefania Mantovani, who are the driving forces behind the collective artway of thinking, work through a collective creative process to

enable others to realize social change. "Making art for us is, in principle, the way in which we create relationships in the world and through which we build life experiences. Being an artist is an expression of the soul that takes form in work and in daily life. We firmly believe that the responsibility of the artist is to act with awareness in order to produce and inspire responsible changes in oneself, in personal relationships, and in society." Moholy couldn't have said it better.

Notes

1. See Satu Kiljunen and Mika Hannula, eds., *Artistic Research* (Helsinki: Academy of Fine Arts, 2002).

2. Our research process began by going to a glass box to think outside the box. We convened in September 2007 at Mies van der Rohe's classically modern Farnsworth House in Plano, Illinois, where we discussed the importance of process over product in modernism, pedagogy as process, how we might use the intellectual and physical resources of Chicago to explore the subject of the modern, and what might be learned from reassessing modernism from the perspective of the twenty-first century. Six months later, artists and other arts professionals representing forty Chicago cultural institutions gathered at the historic Cliff Dwellers arts club, founded in 1907 and now located atop the 1958 Borg-Warner building, to consider the potential of "the modern" as a defining concept for public programs in Chicago. The final large-scale exploratory meeting took place in Sweden, at Göteborg University in fall 2008, where we focused on how the modern might be manifested in an exhibition that would serve both as a culmination of our artistic research and as a starting point for others' learning. As we shifted toward exhibition planning, the following year of research became more project-focused.

3. The exhibitions that took place at the School of the Art Institute of Chicago's Sullivan Galleries were *Department (Store): A Collaboration with J. Morgan Puett*, August 23–December 13, 2008, and *Learning Modern*, September 26, 2009–January 9, 2010. *Moholy: An Education of the Senses* was presented at the Loyola University Museum of Art, February 11–May 9, 2010.

4. Our previous anthologies, *Buddha Mind in Contemporary Art* (2004) and *Learning Mind: Experience into Art* (2009), similarly encompassed a range of perspectives, including the first-person voice of artists.

Modern Minds

Buckminster Fuller, projected Old Man River project in East Saint Louis, Illinois, 1971. Courtesy of the Missouri History Museum, Saint Louis.

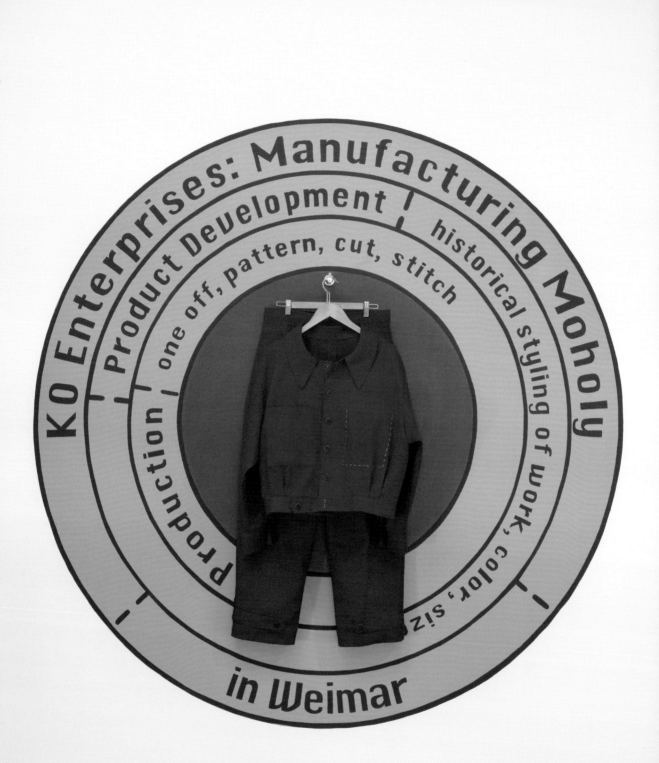

KO Enterprises: Manufacturing Moholy

Product Development

one off, pattern, cut, stitch

historical styling of work, color, size

Production

in Weimar

Like Minded: Jane Addams, John Dewey, and László Moholy-Nagy

MARY JANE JACOB

Making the modern world required a modern mind, with not only new ideas but a big view of things. That was the mind possessed by three creative individuals, coming to Chicago from near and far, whose work at the end of the nineteenth century and into the twentieth helped shape the modern world: Jane Addams, John Dewey, and László Moholy-Nagy. We are still catching up to them and all they imagined; our world is still wanting for lack of a fuller realization of their positive and wide vision.

Addams and Dewey developed a close intellectual and personal relationship beginning with his first visit to Hull-House to lecture in 1892, but most important was their exchange of ideas and sympathies: practice into philosophy, philosophy fortifying practice.[1] Moholy-Nagy only met Dewey once (Addams had died two years prior), but the philosopher's ideas entered into the artist's American reinvention of the Bauhaus. While Dewey is clearly the link, the hinge through which ideas formed early in the century evolved to midcentury and beyond, all three shared essential values and belief systems in social justice, the optimism of the twentieth century, and the conviction that the individual in modern times had the power to make change for the great benefit of mankind. Each grew to take positions on education, museums, and society, which have come down to us over the years, but maybe less appreciated is the trust each placed in art and in its role in a democratic way of life.

This essay will look at how Addams's, Dewey's, and Moholy-Nagy's views intertwined, not according to a strict analysis of influence, for they were independent practioners in different fields; they did not constitute a school of thought or collectively galvanize a movement. Rather, they shared times of change and in need of changing. They developed a self-awareness and moral resolve and, becoming more aware of the world, drew on this inner resource and were propelled to touch others. They embodied the American promise

Frau Fiber, a.k.a. Carole Frances Lung, *Manufacturing Moholy in Weimar* (detail), 2009. Installation view, in *Learning Modern*, Sullivan Galleries, School of the Art Institute of Chicago. Photo: Jill Frank.

of a better life and aimed to make it so. With ideas and practices in common, and with Dewey serving as a through line—in his philosophy and person—they also shared this path with others they influenced. This is a story of three like-minded visionaries who changed their minds early in life and spent the rest of their days dedicated to opening the minds of others.

Changing Course

What change feels like depends on where you sit. Jane Addams grew up in a comfortable household in southern Illinois but, being unmarried, had the uncommon task of staking out her own direction. Like so many others of means, she traveled to Europe. There, in 1887, she encountered the other side of life on a less-than-grand detour to London's Toynbee Hall settlement house. It became the inspiration for Hull-House, which she founded two years later. Her philosophy of direct engagement departed from the usual practice of hands-off charity. Hard work followed; a spinal affliction persisted throughout her life; but she built a place in the community that set an example for the world and defined modern social work and sociological methods.

It was the desperate conditions of life for the immigrant populations around Hull-House that Ann Arbor university professor John Dewey first encountered in Chicago of 1892 and that opened his eyes to a life unknown to him in Michigan, his native Vermont, and points between. It was an awakening and an experience that resonated throughout his life as he advanced ideas and sustained family losses. He went on to become America's greatest intellectual leader of educational and social reform, with a philosophy of democratic life that put the self—each one of us—at the center of change.

László Moholy-Nagy left law studies to enter the Austro-Hungarian army and, coming face-to-face with war and injury, emerged an artist. From his years at the Bauhaus he formed a vision of innovative art and design in the machine age, informed by values of social responsibility. He made revolutionary works, explored new materials, and advanced the genres of photography and film. Invited to bring Bauhaus ideas to Chicago, he arrived in 1937, with war again on his heels. Aware that organized xenophobia threatened enlightened European life, he found in this city a haven. Generations of hopeful immigrants had been coming here, yet Moholy-Nagy knew well that the problems that lay beyond these shores were our problems too. He established a school where others could learn to reset the course of the world. His philosophy of ethical design in the service of mankind, tempered by a wariness of the misuse of modern technology, made him ready to invent a new and positive method and mindset.

A world in change, a world in turmoil and in need, was also a world of opportunity for Addams, Dewey, and Moholy-Nagy. In the introduction to the 1945 edition of Addams's *Peace and Bread in Time of War*, originally published in 1922 after the war to end all wars, Dewey writes as another world war comes to a close, "One of the ironies of the present situation is that a war caused in large measure by deliberate Nazi provocation of racial and class animosity has had the effect in this country of stimulating the growth of racial fear and dislike, instead of leading to intelligent repudiation of Nazi doctrines of hate. The

heart of the democratic movement, as Miss Addams saw and felt it, is 'to replace coercion by the full consent of the governed, to educate and strengthen the free will of the people through the use of democratic institutions' in which 'the cosmopolitan inhabitants of this great nation might at last become united in a vast common endeavor for social ends.'"[2]

Diagramming a New World

What could a new world look like? Personal experience provoked these individuals to formulate a worldview grounded in this world. Whatever they dreamed would be meaningless if it could not be put into effect—if it could not have an effect! So each created a laboratory, an experimental institution, to test their ideas.

Hull-House was at once a social service organization and a group of women living in a home of the same name, fully participating and sharing in the community's issues. It became, as Dewey called it, "an institution—without becoming institutionalized," "a way of living—a companionship that had extended from the neighborhood to the world."[3] Hull-House brought in other minds too, creating a civic think tank. The residents of Hull-House, nurturing and invested in a process that also became a model feminist alliance, understood how sustainable change can be made: to fix one problem meant to look at the interrelation of many. They drew the first demographic maps of the city—*Hull-House Maps and Papers* (1895)—to scientifically analyze, and at the same time humanize, the social situation. They organized for social causes and into social clubs, and they took on elected city positions because to be effective demanded changing the system. So while Addams evolved a plan for Hull-House's services and programs to aid immigrant populations, it was the image of the city in the future that she promoted among her cohort. "Miss Addams has reminded us that democracy is not a form but a way of living together and working together," Dewey said.[4]

The incubator of democracy for Dewey was the school, and so in founding the Chicago Laboratory School in 1896, he drew "a diagrammatic representation of the idea which we want embodied in the school building."[5] This setting needed to be conducive to learning, a place where personal experiences could grow out of the world and feed back into it. It needed to be open, experimental in its processes of problem solving—"learning by doing" would become the mantra of the Progressive Education movement he sparked. If we learn from experience, then our everyday is a ready laboratory, but Dewey had first to establish the value of our own experience in the world.[6] This was the philosophical path of Pragmatism, rooted in the foundational belief that by actively working toward the ends of mutual benefit we have the power to change our lives and those of others. Fellow Pragmatists Charles Sanders Peirce and William James sought to validate this engagement of the individual, but it was Dewey who linked Pragmatism's sense of agency to that of responsibility for a democratic society. Thus, he suggested that people need to be educated in regard to values, "not to get themselves personally 'right' in relation to [an] antecedent author and guarantor of these values, but to form their judgments and carry on their activity on the basis of public, objective and shared consequences. Imagine these things and then imagine what the present situation might be."[7] Going on to diagram society,

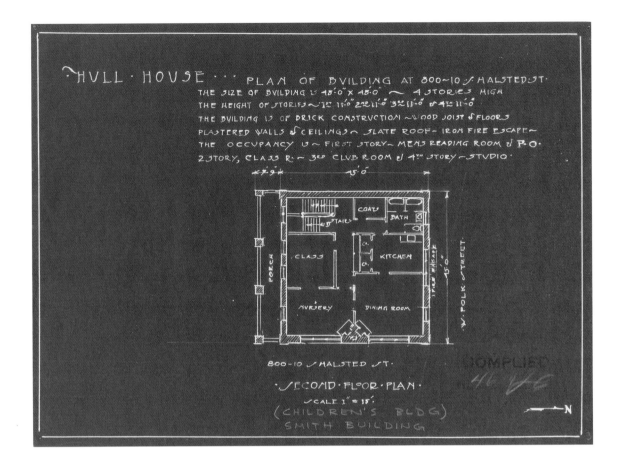

THVLL·HOUSE··· PLAN OF BVILDING AT 800~10 J HALSTED JT·
THE JIZE OF BVILDING IJ 48'-0"X 48'-0" ~ 4 JTORIEJ HIGH
THE HEIGHT OF JTORIEJ ~ 1JT 11'-0" 2NE 11'-0" 3RE 11'-0" & 4TH 11'-0"
THE BVILDING IJ OF BRICK CONSTRUCTION ~ WOOD JOIJT & FLOORJ
PLAJTERED WALLJ & CEILINGJ ~ JLATE ROOF- IRON FIRE EJCAPE ~
THE OCCVPANCY IJ ~ FIRJT JTORY~ MENJ READING ROOM & P·O·
2 JTORY, CLAJJ R·~ 3RE CLVB ROOM & 4TH JTORY ~ JTVDIO·

800~10 J HALJTED JT·
·JECOND·FLOOR·PLAN·
JCALE 1" = 15'·
(CHILDREN'S BLDG)
JMITH BUILDING

Dewey placed human experience within a systematic, all-encompassing philosophy that was not theory as much as a way of living, bringing this philosophy into everyday practice as he used it to make educational and social policy, and promoted its presence throughout American culture.

"A human being is developed only by crystallization of the sum total of his own experiences," Moholy-Nagy said.[8] If we learn from experiences in the world, then developing our capacity for perceptual awareness is an essential skill. That was the mission Moholy-Nagy took up with his "education of the senses."[9] To educate the whole student meant to maximize his or her multiple intelligences—intellectual, emotional, spiritual. "A specialized education becomes meaningful only if a man of integration is developed along the lines of his biological functions, so he will achieve a natural balance of his intellectual and emotional power instead of on those of an outmoded educational aim of learning unrelated details."[10] Like Dewey's learning method, Moholy-Nagy's was experiential and experimental. When Moholy-Nagy founded the New Bauhaus in 1937, he drew first from the German Bauhaus, where he had earlier developed the foundation course. But the curriculum needed to go further. So he redrew the educational scheme to include photography, film, and kinetic and light sculpture, added music and poetry, and merged this with Dewey's Pragmatism by joining forces with Charles E. Morris of the University of Chi-

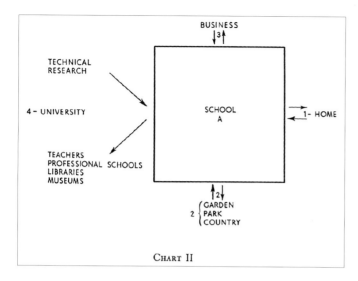

CHART II

John Dewey's conception of the unity of school and life. From Dewey, *The School and Society* (1900).

cago Philosophy Department, who fortified the school's intellectual base with social and natural sciences.[11] With this more humanistic approach, he developed a philosophy of design education that reached beyond vocational intent to the realm of society: "Only if it is clear to man that he has to crystallize his place as a productive unit in the community of mankind," Moholy-Nagy wrote, "will he come closer to a true understanding of the meaning of technical progress. For not the form, not the amazing technical processes of production should engage our real interest, but the sound planning of man's life."[12] Later he would state, "To be a designer means not only to sensibly manipulate techniques and analyze production processes, but also to accept the concomitant social obligations.... Thus quality of design is dependent not alone on function, science, and technological processes, but also upon social consciousness."[13]

For Addams, Dewey, and Moholy-Nagy, education played a critical role in the scheme of things, and each seized upon the chance to make an educational institution, conceiving of it in the widest terms.[14] As they saw it, education is formative: one develops knowledge of the world but, as importantly, of oneself in the world. It is continuous: with practice, the open and curious mind is renewed, serving the individual over a lifetime and incorporating others in a caring way. It is generative: when skillfully employed, education expands from its positive impact on us to work through us on the world, with the potential to generate capability in others. "Our time is one of transition striving toward a synthesis of all knowledge. A person with imagination can function now as an integrator," Moholy-Nagy said. But coming on the scene later, he feared that the spirit of education was lost: "Today neither education nor production springs from an inner urge, nor from an urge to make products which satisfy the requirements of one's self and those of society in a mutually complementary way."[15] This problem seemed to be linked to American capitalism—the economic counterpart to American democracy—and while he acknowledged that industry was indispensable to raise the standard of living, he also saw how self realization can become confused with self gain.[16]

Capitalism remained a vexing concern for Moholy-Nagy as he struggled with the competing interests of the school's industrialist backers, who, at odds with his philosophy of a whole education, preferred an education directed toward a single mode of application. He strove to assert the need for a more sympathetic workplace, believing that the goal of technology is to free man to achieve "a balanced life through free use of his liberated creative energies."[17] He pointed to the efficiency that drives factories but creates inhumane conditions, such as Addams fought to change, expressing his desire to cease turning "man into a machine, without taking into account his biological requirements for work,

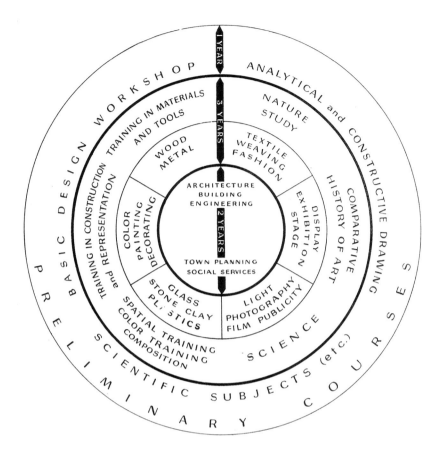

recreation and leisure." Addams and Dewey would have concurred with Moholy-Nagy's assertion that "the creative human being knows (and suffers from it) that the deep values of life are being destroyed under pressure of moneymaking, competition, trade mentality. He suffers from the purely material evaluation of his vitality, from the flattening out of his instincts, for the impairing of his biological balance."[18]

Museums as Part of the Social Scheme

Museums can be institutions of renewal, affording an escape from the day-to-day. At the same time, the everyday is reflected in its images and objects in expected and unexpected ways, so that, if viewers are attuned, meanings emerge, and these experiences can be renewed as they return to them in their minds over time. Dewey believed all this and yet spoke with scorn of American museums as showpieces of a moneyed class: "The growth of capitalism has had a powerful influence in the development of the museum as the proper home for works of art, and in the promotion of the idea that they are apart from common life."[19] He disdained museums for subscribing to a hierarchy that placed the fine arts over the everyday manual arts, and for removing art from the life experience from

which it sprung and to which it could contribute. Unfortunately, this division drives the public away from museums, as Dewey observed: "Many a person who protests against the museum conception of art, still shares the fallacy from which that conception springs. For the popular notion comes from a separation of art from the objects and scenes of ordinary experience that many theorists and critics pride themselves upon holding and even elaborating."[20] He did, however, believe in the broader educational potential of museums to offer exceptional experiences that we can take into living. So he placed a museum in the center of the 1900 plan of his ideal school. It was to be a place to sift through and reflect on experience, making sense of it and multiplying the effects of learning, not a storehouse of masterpieces or even casts or reproductions of them. It would draw on examples collected in the field and look at the life of the community in which the school was situated. It could enhance and enliven any subject or make connections between them, creating a synthesis of knowledge and, hence, understanding.

The same year saw the founding of the Hull-House Labor Museum, a brainchild of Addams. Like all she undertook, it was born of her own experience. This time the spark was the sight of an elderly Italian woman spinning yarn on Polk Street. Addams reflected on older people detached from what they knew and did in their country of origin, now cast into menial, at times cruel, factory jobs and divorced from the products of their labors. She thought too of the youth, more Americanized but still caught between the old and new world, youth who saw no connection to their families' cultural and vocational past and felt a general sense of shame that their parents and grandparents didn't fit in. She posited:

> It seemed to me that Hull-House ought to be able to devise some educational enterprise, which should build a bridge between European and American experiences in such wise as to give them both more meaning and a sense of relation. I meditated that perhaps the power to see life as a whole, is more needed in the immigrant quarter of a large city than anywhere else, and that the lack of this power is the most fruitful source of misunderstanding between European immigrants and their children, as it is between them and their American neighbors.... If these young people could actually see that the complicated machinery of the factory had been evolved from simple tools, they might at least make a beginning toward that education which Dr. Dewey defines as "a continuing reconstruction of experience." They might also lay a foundation for the reverence of the past which Goethe declares to be the basis for all sound progress.[21]

Talking with Dewey moved her initial thoughts to an interpretative level, transforming her experience so that it could be shared with others who could then find meaning for themselves. Within a month she opened a museum. Thus, Dewey's idea of continuity found its first museological application in the textile industry displays of the Hull-House Labor Museum, which offered a vivid, visual presentation of then and now and one's place in it. Community people were the agents and experts of their own labor; they were the object of the museum without being objectified because they were of this place, participants and contributors—a union of roles Dewey would come to value.[22]

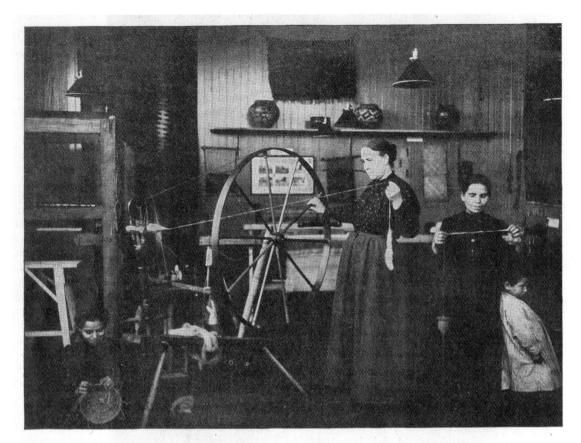

SPINNING WITH WOOL WHEEL.

In Dewey's view, museums not only needed to make their exhibitions available to working people but to come to terms with the real circumstances of their lives.[23] The desire to extend meaningful museum access to a wider demographic and, in turn, to value their experiences led Dewey to partner with Dr. Alfred C. Barnes.[24] In 1922 Barnes established a foundation based on his own art and education theories, welcoming the workers in his pharmaceutical business as well as the public.[25] As his expression of the continuity of production, Barnes displayed tools and handcrafted metalwork, the stuff of common labor and skilled craft, in animated and suggestive formal arrangements with traditional paintings, Asian art, and, most notably, late nineteenth- and early twentieth-century European paintings. Dismissive of any high-low dualism, he also exhibited his collection of African, Native American, and American folk art, encouraged workers to spend time in the adjacent garden, and offered courses in aesthetics and horticulture. At its heart, the Barnes Foundation was conceived as an educational institution for perceptual training. Its enlivened and multilayered approach has over the years been misunderstood in a museum field anxious to see the paintings solely as masterpieces, to the exclusion of the context of the viewer's experience, but to Dewey, here was a man who was turning his fortune to the

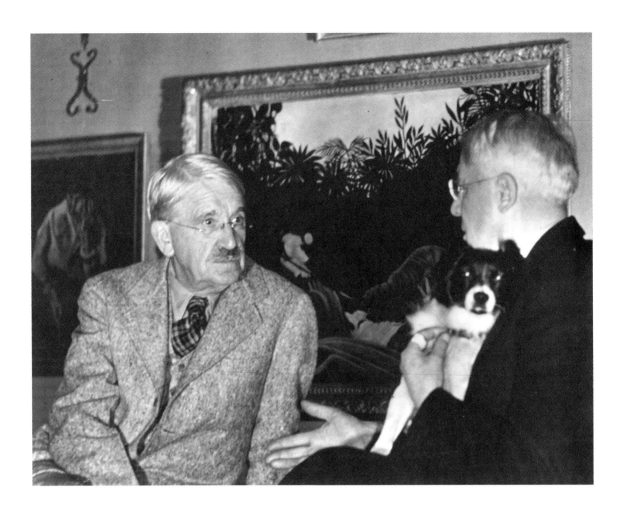

John Dewey, Albert C. Barnes, and Fidèle with Rousseau's *Eclaireurs attaqués par un tigre* (Scouts Attacked by a Tiger), 1941. Photo: Pinto Studios. Photograph Collection, Barnes Foundation Archives, BF584. © 2010. Reproduced with permission of the Barnes Foundation.

public good instead of personal tribute. Emanating from a deep understanding of how art permeates life, the foundation was "not an artistic or aesthetic educational enterprise in that narrow and exclusive sense of the word which considers Fine Art and Painting in the way Sunday is often related to week-days and work-days." Rather, it demonstrated that "art is not something apart, not something for the few, but something which should give the final touch of meaning, of consummation, to all the activities of life."[26]

Alexander Dorner was another person who shared that sense that art museums were irrelevant to most people's experience but could be made to matter if pushed into the modern world. As director of the Hanover Museum in Germany, he took up "the need for a reorganization of the wide-range museum collections in such a manner that they could become a positive force in the nexus of public life."[27] To Dorner, museums lacked continuity with the past, a break exacerbated by a hierarchical division of the arts that was out of step with the times; the most vital contemporary images, he recognized, were to be found in popular culture. He also saw the educational responsibilities of museums on a broad cultural level that could contribute to improving life, "liberating incentives and productive energies for our public life."[28]

In 1930 Dorner embarked on a project with Moholy-Nagy: the Room of Today. In a radical departure from usual museum practice, the works shown there were to be made through processes of replication (photographic, projected, filmic, or mechanical)—not unique originals laden with monetary value and all that conveyed regarding the prestige of the owner and genius of the maker but, like mass media, works of cultural power. It was to feature Moholy-Nagy's own *Light Prop for an Electrical Stage*—a hybrid sculpture/installation, a constantly changing performative project, a machine producing light and shadow that suggested lighted street advertising or theater.[29] The project was never realized due to the museum's closure by the Nazis, but Dorner continued on this path. His eventual move to the United States, in 1938, one year after Moholy-Nagy, brought him into contact with Pragmatism. This philosophy, along with other influences (especially an interest in physics, which had likewise been formative for Dewey), helped him articulate his own philosophic aims for the museum as "a positive force in the nexus of public life."[30] "To base the development of visual creation on any eternally identical human ideas or categories is therefore no longer possible," he would write. "The changing force of life is of such a depth and intensity that it explodes any such unification. To understand that means to be driven toward a new philosophy, not only of the history of art, but also of esthetics and the art museum—toward a philosophy which reaches with a heretofore unknown force into our whole conduct of life."[31] One proposition advanced by Dorner was of a museum in multiple. Composed of inexpensive facsimiles, it could exist simultaneously in different places—a democratic solution—and, for him, the only way to justify museums as *public* institutions.[32] This was his translation of Dewey's call for a museum that could benefit a broad constituency, respond to the energy of the times with an expanded definition of art, and be driven by the belief that art is a powerful communicative power.

Art as Life-Actualizing

In pursuit of his mission for museums, John Dewey believed that nothing was more useful than art, for no field had gone deeper in capturing the human soul. He greatly admired works of art, the labors and achievements of individual artists and their great capacity to speak of wider human issues and convey a continuity of human experience, and took them into his own experience. Art fed him intellectually, personally. Restoring the continuity between art and the everyday could bring about an understanding between one's psychic and social lives. In reconfiguring the art museum, Dewey's desire was not so much to teach art history or train artists, though such professional applications were also valid, but to contribute to the living of life, or the art of living.[33] Art thus held a pivotal position in his scheme of social institutions, not only for museums but also in the public school system, which he felt did "not yet touch what is most common, most fundamental, most demanding public recognition—an appreciation of the place occupied in all human activity by that intelligent method which is the essence of art and by the liberated and enjoyable methods which are the result of the presence of art."[34]

More than recreation, the viewer enters into an act of re-creation each time, for a work of art is a work of art "only when it lives in some individualized experience."[35] They

must re-create art to experience it, and the experience an artwork brings into being varies among viewers and is personal to each. For Dewey, art was this experience rather than the object or thing that catalyzed it; it was the process it ignited rather than the product of the artist's hand.[36] Inspirational in the mind of the viewer, a work of art also acts over time and can be experienced again, later, even though we are no longer in its presence. Art can take us anywhere as it moves us to new awareness, and from there new meanings arise that can play a role in the future, directly or indirectly.[37] Art, then, becomes part of a continuous series of thoughts and actions that make up our life. In this way art "liberates subsequent action and makes it more fruitful in a creation of more meanings and more perceptions."[38] The awareness that comes with looking at art leads to a sense of the whole, producing a satisfying emotional quality and giving experience an aesthetic quality. So developing our perceptual capacity in art opens up perception in all aspects of our life.

Dewey thus advocated art appreciation, a term much disparaged today for its connotation of dilettantism. Art appreciation in Dewey's time was not a specialized education but rather a training in observation to open the mind that was accessible to all. This sharpening of perception was not just intended to analyze works of art, but also to lead to an understanding of our role within humanity. It could help us lead a more satisfying and more responsible life.[39]

Dewey, in speaking of such reflective thinking, brings up the question of taste:

> The word "taste" has perhaps got too completely associated with arbitrary liking to express the nature of judgments of value. But if the word is to be used in the sense of an appreciation at once cultivated and active, one may say that the formation of taste is the chief matter wherever values enter in, whether intellectual, esthetic or moral. Relatively immediate judgments, which we call tact or to which we give the name of intuition, do not precede reflective inquiry, but are the funded products of much thoughtful experience. Expertness of taste is at once the result and the reward of constant exercise of thinking. . . . Taste, if we use the word in its best sense, is the outcome of experience brought cumulatively to bear on the intelligent appreciation of the real worth of likings and enjoyments. . . . Such judgments are the sole alternative to the domination of belief by impulse, chance, blind habit and self-interest. The formation of a cultivated and effectively operative good judgment or taste with respect to what is esthetically admirable, intellectually acceptable and morally approvable is the supreme task set to human beings by incidents of experience.[40]

A good way to cultivate taste, Dewey thought, was to look at works of art. Reflecting on those experiences, accumulated over time, one could develop the capacity to make better judgments and take more beneficial actions. To exercise taste today means to be discriminating about a thing, often associated with value in monetary terms. But for Dewey, attending to the art object shared more with the Buddhist practice of bringing focus to an object and, meditating on it, going more deeply into its meanings as well as outward to where those meanings lead. It is a self-generating dynamic: the more we cultivate an open and aware mind, the more we can see in and through art; the more we look at art,

the more open our mind. It is practiced until it becomes a habit of mind. This cultivation of perception on observational levels is a step toward a life practice of opening up one's self to oneself and to others. And for Dewey, art is an ideal means for the cultivation of consciousness.

Opening minds and hearts in the immigrant community to art's restorative power was part of the path Jane Addams took to making a better present,[41] but for Addams and Dewey to imagine a better future amid fractious ethnic conflict locally and in the world meant developing a means for understanding across cultural difference. Art could do this too. Addams felt and Dewey saw the empathetic power of art. He wrote, "Works of art are the means by which we enter, through imagination and the emotions they evoke, into other forms of relationship and participation than our own."[42] Both believed that in perceiving art we come to understand the wider story of humanity over time, to appreciate others' struggles and differences. With this understanding, Dewey found in art the possibility of realizing the American ideal of being created equal, an ongoing challenge that sits at the center of the doctrine of democracy. It was a right Addams fought for and a freedom Moholy-Nagy sought in coming here. If we democratize aesthetics, not only by making art available to more people, but by expanding our notion of where aesthetic experience comes from—and art is just one means, as Dewey points out, though a very good one—we can cultivate empathy and inclusiveness, freedom and fairness.[43] If we expand our mind to experience what art (or other aesthetic experiences) can do, breathe it in fully, make its meanings integral to our way of being, they can become a habit, part of our totality. Then we are better equipped to act as responsible members in a participatory democracy.[44] In placing art appreciation as a key learning and life exercise, Dewey argued that art was necessary both for personal well-being and for the advancement of society. Answering the backlash that persists still in American society, that is, the assessment that art is impractical, he wrote, "Why have not the arts which deal with the wider, more generous, more distinctly human values enjoyed the release and expansion which have accrued to the technical arts?"[45] If personal development is the pathway to social development—an obligation we all share—and social development is key to making a modern world, then art has a central role in society.

Practicing Progress

Practice is a way the mind learns to deal with the uncertainty of the modern world, where there are no eternal truths, no focus on an afterlife to distract us from this life. Thinking of practice in its most liberal sense, Dewey urged, "We should regard practice as the only means (other than accident) by which whatever is judged to be honorable, admirable, approvable can be kept in concrete experienceable existence."[46] Practice cultivates a habit that leads to a beneficial way of life, and from Addams's, Dewey's, and Moholy-Nagy's moral and ethical stance, partaking of greater fulfillment for oneself leads to contributing to the improvement of all. That was the ultimate goal of their reforms, their efforts to modernize. For them, that was progress.

The systems each advocated offered ways of living that viewed life as a process. Dewey

László Moholy-Nagy with students at the Institute of Design, Chicago. Photo: Ray Pearson. Courtesy of the Chicago History Museum.

wrote in his introduction to Dorner's book that "the idea of *process* is making its way into that which is known and the idea of operations into our account of how we know," and called out Dorner's idea that the individual is both "a partaker in the 'general process of life' and a 'special contributor to it.'"[47] This concept of emergence as a scientific method is paralleled in art: art as an event leading to knowing and from which new cycles of process unfold, Dewey said, "genuine art is a liberating event to and *by* its producer and *for* the one who perceives it with intelligence, not by pre-formed routine."[48] Because art is liberating and energetic, it expands our perception in a world of flux and change, and can play a role within a dynamic and generative system that aims toward improving life.

So how to find and define a path for our practice? Addams sought to remove basic life obstacles, Moholy-Nagy to instill a greater sense of our relationship to the made world. While one can follow Addams's example or be inspired by Moholy-Nagy's, neither was comprehensive enough. A philosophy for the modern age was needed, and for much of the twentieth century America saw itself as the leader of the modern world. Dewey aimed to give American democracy a philosophy of its own. It had a Pragmatist focus. It also found resonance with Asian philosophies.[49] This seems no coincidence. During his eight years at the University of Chicago, Dewey would have had occasion to be exposed to Asian

philosophy, in part due to the presence of D. T. Suzuki in LaSalle, Illinois, where he was working on the first translations of Buddhist text.[50] Later, in 1919, Suzuki met Dewey in Japan and served as his guide and translator.[51] During that same trip, Dewey went to China, where his interpreter was Hu Shih. Hu had received his doctorate at Columbia, studying under Dewey, and had taken his teacher's ideas to China in 1917; indeed, there Dewey found that his ideas were already known and having an impact.[52]

Some aspects of Buddhism might be called out for their alignment with Dewey's development of Pragmatist philosophy, which depended on the agency of the individual to take action and to embody values that can guide actions toward the betterment of self and others.[53] One's life and hence society was not predetermined by a divine plan; there was no dualism of absolute truths and the everyday, but rather a flexible system with commensurate responsibility to act according to circumstances. Thus, we are responsible for ourselves as well as for advancing society. Buddhism's concept of buddha mind—an awakened state of consciousness—which respects both everyday action and the search for enlightenment as the same path, is consistent with Dewey's dismantling of Christian theology–based philosophy, his critique of its binary structure and subjugation of mankind to eternal powers in favor of self-actualization.

But to act in a right way, it is essential to be aware. So the mind plays a central role, not just in being educated, as important as that is, but also in developing self-reflective action and insight. Buddha mind is not just a repository of knowledge—answers, in the traditional Western sense—but an agile and open mind. Continually evolving and in a state of becoming or self-development, the modern mind needs to remain flexible in order to contend with the new, and for Dewey, and others like-minded in his time, this was clearly the challenge of their age. So the individual must continually practice to maintain openness. In Buddhism this is achieved through meditation. Dewey suggested art.[54] Buddhism's focus on the present cultivates awareness, an appreciation of each action in the everyday, no matter how small, seeing this as a path to a right life, a process as important as the end product. For Dewey, "The process is art and its product, no matter at what stage it be taken, is a work of art."[55] This took pedagogical form in his call for "learning by doing"; it was evident in the value he shared with Addams and Moholy-Nagy in recognizing the honest work of people in all stations of life. His deep and pervasive meditation on the aesthetic in the everyday most importantly lead to his book *Art as Experience*, in which he would write that "any practical experience will . . . have esthetic quality."[56]

For Dewey, as for Buddhism, acquiring a keen ability to focus and cultivate awareness leads to clarity of mind. Then actions can proceed, guided by a moral rudder, conscious of the consequences. This recalls the Buddhist idea of interconnectedness, envisioned as a net in which all things are a part, each reflecting the whole, each affected by every other part. This provides a model for imagining and understanding our individual effect on the greater whole. In the responsiveness and elasticity of this vast web of consciousnesses we see a model of the Pragmatist concept of the individual's relation to society and the consequentiality of all actions of all persons. Individuals cannot separate themselves from others or from the environment; additionally, there is no division between mind and body, matter and spirit. From interconnectedness the Buddhist value of compassion follows.

For Dewey, as for Addams, empathy with less fortunate populations was a motivating force. Empathy was also a force Dewey saw as particular to art and as enabling art to have a positive influence on viewers.

Finally, there is the Buddhist understanding of impermanence: that everyone is part of an ongoing flow of energy that moves from form to dissolution or emptiness. Within this emptiness lies all potentiality, and from it all form arises again. This aligns with Dewey's view on the philosophical implications of new science for the modern mind, particularly Darwin's concept of evolutionary change and physics' theories of energy and probabilities over predetermined outcomes. By giving the individual a place in the universe, as uncertain and in flux as it may be, Dewey's worldview echoes Buddhist wisdoms.

• • •

But how does the story end, this quest for social progress that can seem mired in quicksand? Do we ever get there? As a quest, it is a passage; it is a practice along a path whose end we cannot see but that it is important to imagine and which at times we can even perceive. If we stay on course, we get a little further, but it remains a continual, unending process.

What these modern minds so skillfully and passionately brought to the equation in the twentieth century was the place of art. For Addams it was an enriching aspect of life. For Dewey it was the best means to attain consciousness, the object of a personal practice in a world of experiences, and the means by which we can practice aesthetic living and practice a democratic way of life—for that, too, needs constant attention. For Moholy-Nagy it was a benchmark for an ethical design invested with a sensibility of and for this world. He uniquely among the three possessed an artist's mind. It was "this union of partaker and contributor" that "describes the enduring work of the artist," to Dewey.[57] When asked if he was planning a utopia, Moholy-Nagy said, "No, but it is a task for tireless pioneers. To stake everything on the end in view—the supreme duty for those who have already arrived at the consciousness of an organic way of life."[58] Moholy-Nagy is not alone in that mission. It continues on today . . . as it must.

Notes

1. See http://plato.stanford.edu/entries/addams-jane/ (2006; revised 2007). Dewey assigned Addams's books in his courses, and Addams and Dewey worked together personally and politically. When Hull-House incorporated, Dewey became one of its board members. He often lectured to the Plato Club, Hull-House's philosophy group, dedicated his book *Liberalism and Social Action* to Addams, and named one of his daughters in her honor.

2. John Dewey, "Democratic versus Coercive International Organization: The Realism of Jane Addams," in Jane Addams, *Peace and Bread in Time of War* (Boston: G. K. Hall & Co., 1960; originally published by the Women's International League for Peace and Freedom, 1922–1945).

3. Paul Kellogg, "Twice Twenty Years at Hull-House," in *100 Years at Hull-House*, ed. Mary Lynn McCree Bryan and Allen F. Davis (1969; Bloomington: Indiana University Press, 1990), 191.

4. Ibid.

5. John Dewey, *The School and Society* (Chicago: University of Chicago Press, 1900), 79.

6. In *The Quest for Certainty* Dewey confronted a fundamental philosophical problem—that knowledge is valid to the degree that it is a revelation of an existence or Being beyond human action—and called for a new approach that

acknowledges human experience as it relates to our emotional and volitional life. We proceed from knowledge gained in nature, science, and technology, but, he pointed out, traditional philosophy's division of theory and action had persisted, with the result that the "moral and distinctly humane arts" had not benefited from a parallel development: "Why have not the arts which deal with the wider, more generous, more distinctly humane values enjoyed the release and expansion which have accrued to the technical arts?" He went on to show that knowledge gained from experimental inquiry, the foundation of his educational plan but more generally applicable to life, bridges theory and action. See John Dewey, *The Quest for Certainty: The Later Works, 1925–1953*, vol. 4, *1929*, ed. Jo Ann Boydston (Carbondale: Southern Illinois University Press, 2008), 35–39.

7. Dewey, *Quest for Certainty*, 38.

8. László Moholy-Nagy, *The New Vision: Fundamentals of Design, Painting, Sculpture, Architecture* (New York: W. W. Norton, 1938), 10.

9. See László Moholy-Nagy, *Vision in Motion* (Chicago: Paul Theobald, 1947), 5.

10. Moholy-Nagy, *New Vision*, 11.

11. Morris steered the humanities and science divisions at the New Bauhaus and its successors, and personally taught a course in intellectual integration. After the school's first year Morris tried to align the operation with the University of Chicago, but because university president Robert Hutchins had previously disagreed with Dewey, this suggestion was not taken up. Dewey's ideas were the basis of Morris's own semiotic theory. Morris cited the close similarities between Walter Gropius and Dewey with respect to art and art education and gave a copy of *Art as Experience* to Moholy-Nagy. In a letter dated July 7, 1938, Moholy-Nagy responded: "I looked at it [*Art as Experience*] and I found his style and thoughts remarkable. I was amazed by the congruence of his ideas with ours." Morris later said: "I think of Moholy-Nagy as one of the most vital and significant persons I have been privileged to have as a friend." Letter from Charles Morris to Lloyd Engelbrecht, dated June 3, 1968, University of Illinois at Chicago archives/library. *Art as Experience* was introduced as required reading for the product design workshop at the Institite of Design. When Moholy-Nagy traveled to New York in November 1938, Morris provided him with a letter of introduction to Dewey. At that time Dewey gave the artist his recently published volume *Experience and Education*. Alain Findeli, "Moholy-Nagy's Design Pedagogy in Chicago (1937–46)," *Design Issues* 7, no. 1 (Fall 1990): 14.

12. Ibid., 13.

13. Moholy-Nagy, *Vision in Motion*, 55.

14. Addams stated, "A settlement is a protest against a restricted view of education," taking up educational reform while it educated a community. Bryan and Davis, *100 Years at Hull-House*, 104. Observing the example of Hull-House, Dewey saw the community center as a school in that it serves the needs of persons today by bringing diverse people into contact in a setting conducive to interaction, connecting intellectual and different modes of having knowledge in life, and as a site for continuous instruction. Dewey, "The School as Social Center," in ibid., 103–8.

15. Moholy-Nagy, *New Vision*, 12.

16. "The chase after rewards in money and power influences the whole form of life today, even to the basic feelings of the individual. He thinks only of outward security, instead of concerning himself with his inner satisfaction." Ibid.

17. Ibid.,13.

18. Ibid., 13, 14. Capitalist values at work created a wave of personal despair against which Addams swam. One of the first causes she and Dewey joined forces on was the defense of workers during the 1894 Pullman strike. Dewey could well have had Hull-House constituencies in mind when he wrote, "Industrial life is correspondingly brutalized by failure to equate it as the means by which social and cultural values are realized." Dewey, *Quest for Certainty*, 225.

19. John Dewey, *Art as Experience* (1934; New York: Penguin, 2005), 7.

20. Ibid., 4.

21. Jane Addams, *Twenty Years at Hull-House* (New York: Penguin, 1981), 172.

22. Some images of the Hull-House Labor Museum, like the portraits of women in their traditonal dress, recalled the more objectified style of the official photographs of cultures on view along the Midway at Chicago's 1893 world's fair; others capture the activity of the place as a living museum in a way that none of its heirs today (historic villages and museum period rooms) can. Ultimately, it was the context of the surrounding Chicago neighborhood that breathed life and relevance into this place as a museum.

23. Offering free admission was not enough to bridge the social divide, Dewey argued, when criticizing the Metropolitan Museum of Art and Art Institute of Chicago. Museum staff also needed to be conscious of the conditions that he observed and Addams sought to confront and change: "I do not see how any very high popular artistic standard can exist where a great many of the people are living in slums. Such persons cannot get artistic culture

simply by going to free concerts or the Metropolitan Museum to look at pictures, or the public library to read books, as long as their immediate surroundings, or what they come in direct contact with, unconsciously habituates them to ugly, sordid things." See Tracie E. Constantino, "Training Aesthetic Perception: John Dewey on the Education Role of Art Museums," *Education Theory* 54, no. 4 (2004): 407.

24. For a discussion of Barnes's aesthetic method, see Constantino, "Training Aesthetic Perception." Dewey had met Barnes in 1918 when Barnes attended his classes at Columbia University. In 1923 Barnes named Dewey his foundation's first director of education. Barnes also dedicated his book *The Art in Painting* (New York: Harcourt, Brace and Company, 1925) to Dewey, "whose conceptions of experience, of method, of education inspired the work of which this book is apart." Dewey, in turn, dedicated *Art and Experience* to Barnes, "in gratitude."

25. Before establishing the foundation, Barnes had hung paintings and offered art appreciation classes to workers at his factory.

26. From Dewey's address at the dedication of the Barnes Foundation. Constantino, "Training Aesthetic Perception," 413.

27. Alexander Dorner, *The Way beyond "Art"* (New York: Wittenborn, Schultz, Inc. 1947), 17. Dewey wrote the introduction to this volume, which was dedicated to him and in which Dorner considered the history of art and sought to imagine its role in making a better world.

28. Dorner wrote, "Exhibitions should help to explain our present position in the course of historical growth. They should help to explain the meaning of our present controversies. Thus exhibitions could be turned into liberating incentives and productive energies for our public life." Joan Ockman, "'The Road Not Taken': Alexander Dorner's *Way beyond Art*," in *Autonomy and Ideology: Positioning an Avant-Grade in America* (New York: Monacelli Press, 1997), 96.

29. Dorner's label at the end of this room, and so of the museum tour, read, "We can only understand the present out of the past's urge for self-transformation, as the evolutionary urge to reorganize all inherited ideas and thus as a slow and gradually extended process of growth, in which various old currents interpenetrate and are transformed in essential ways under the pressure of new experiences." Kai-Uwe Hemken, "László Moholy-Nagy and the 'Room of Today,'" in *László Moholy-Nagy Retrospective*, ed. Ingrid Pfeiffer and Max Hollein (Munich: Prestel Verlag, 2009), 171.

30. Dorner, *Way beyond "Art,"* 17. See also Dewey, *Quest for Certainty*, 117, 160–63.

31. Dorner, *Way beyond "Art,"* 17

32. Ockman, "'Road Not Taken,'" 116–18.

33. "Instruction on the arts of life is something other than conveying information about them. It is a matter of communication and participation in values of life by means of the imagination, and works of art are the most intimate and energetic means of aiding individuals to share in the arts of living." Dewey, *Art as Experience*, 350. Richard Shusterman presses this notion further in his volumes *Pragmatist Aesthetics: Living Beauty, Rethinking Art* (1992; Latham, MD: Rowan & Littlefield, 2000) and *Practicing Philosophy: Pragmatism and the Philosophical Life* (New York: Routledge, 1997), in which he lays out his own next-step philosophy along these lines as "somaesthetics."

34. Constantino, "Training Aesthetic Perception," 413–14.

35. Dewey, *Art as Experience*, 113. Also see ibid., 348: "We understand [art] in the degree in which we make it part of our own attitudes, not just by collective information concerning conditions under which it was produced. We accomplish this result when, to borrow a term form Bergson, we install ourselves in modes of apprehending nature that at first are strange to us. To some degree we become artists ourselves as we undertake this integration, and, by bringing it to pass, our own experience is reoriented.... This insensible melting is far more efficacious than the change effected by reasoning, because it enters directly into attitude."

36. Dewey believed that we commonly think art is an object, such as a painting, but "the actual work of art is what the product does with and in experience." So "art is a quality that permeates experience; it is not, save by a figure of speech, the experience itself," and "art is a strain in experience rather than an entity itself." Dewey, *Art as Experience*, 1, 338, 344.

37. Works of art "*suggest* ends and enjoyments they do not adequately realize; that these suggestions become definite in the degree they take the form of ideas, of indications of operations to be performed in order to effect a desired eventual rearrangement." Dewey, *Quest for Certainty*, 119.

38. John Dewey, *Experience and Nature and Human Nature* (New York: W. W. Norton, 1925), 371.

39. For a discussion of the contrast of Dewey's concept of continuity to analytical aesthetics, see Shusterman, *Pragmatist Aesthetics*, 12.

40. Dewey, *Quest for Certainty*, 209.

41. In "Art Work" Addams recounts instances of art contributing to the self-worth of immigrants and of its ability to lift one's spirit in difficult conditions. She acknowledges her collaborator, Ellen Gates Starr, as being more knowledge-

able about art and more artistically gifted than herself. Starr was an advocate of the Arts and Crafts movement and made long-lasting organizational contributions in Chicago. See Bryan and Davis, *100 Years at Hull-House*, 39–42. In *Hull-House Maps and Papers*, Starr authored the chapter "Art and Labor," in which she spoke passionately of art in the community, the need for a national art of the people, and the value of any labor as an expression of thought, without hierarchy. See Residents of Hull-House, *Hull-House Maps and Papers* (Urbana: University of Illinois Press, 2007), 130–37. Mary Jo Deegan, comparing Starr's work in *Hull-House Maps and Papers* to that of male Chicago sociologists, cites her unique contribution in considering the sociology of art and linking creativity to adequate housing, health, and group respect. See Deegan, *Jane Addams and the Men of the Chicago School, 1982–1918* (New Brunswick: Transaction Publishers, 1988), 60.

42. Dewey, *Art as Experience*, 347.

43. The notion of democratizing aesthetics became conflated with democratizing art. Surely Dewey wanted art to be widely available, and his ideas were a cornerstone for the mission of the New Deal's Works Progress Administration. But as demonstrated there, his revolution lay in extending art to the crafts and other popular forms. It seems clear that Dewey would have found avant-garde trends in modernism alienating and not publicly accessible. It is interesting to imagine, however, how he might have received today's socially engaged art practice in communities and with specific constituencies, as well as late twentieth-century artists' projects as institutional critique that offered challenging models for museum curating and education, allowing new ways to open up art expereince to new audiences, making it relevant and integrated into their life experiences.

44. This integration of self counters the disjunction of matter and spirit posited by mind-body dualism, of which Dewey wrote, "The pathological segregation of facts and value, matter and spirit, or the bifurcation of nature, this integration poses the deepest problem of modern life." Martin J. Verhoeven, "Buddhism and Science: Probing the Boundaries of Faith and Reason," *Religion East and West: Journal of the Institute for World Religions* 1 (June 2001): 80.

45. Dewey, *Quest for Certainty*, 36–37. In the same book, he criticized narrow notions of practicality and usefulness: "Instead of being extended to cover all forms of action by means of which all the values of life are extended and rendered more secure, including the diffusion of the fine arts and the cultivation of taste, the processes of education and all activities which are concerned with rendering human relationships more significant and worthy, the meaning of 'practical' is limited to matters of ease, comfort, riches, bodily security and police order, possibly health, etc., things which in isolation from other goods can only lay claim to a restricted and narrow value. In consequence, these subjects are handed over to the technical sciences and arts." Ibid., 25–26.

46. Ibid., 26.

47. John Dewey, "Introduction," in Dorner, *Way beyond "Art,"* 9–10.

48. Ibid., 10.

49. Dewey found Western philosophers to whom he could adhere, but he also wrote of his frustration with the field of philosophy. See Dewey, "Philosophy's Search for the Immutable," in *Quest for Certainty*, 21–39.

50. In 1893 the World Parliament of Religions took place as part of the great World's Columbian Exposition. Asian philosophy already had its intellectual followers in the United States, but this meeting was cataclysmic. One of the event's organizers, Paul Carus, asked the Buddhist priest Soyen Shaku to recommend an English speaker knowledgeable in Zen who could translate texts for his Open Court Press; Soyen designated Suzuki, who would go on to be a leading scholar and a prime mover in bringing Buddhism to the US. Suzuki came to Illinois in 1897 and stayed in LaSalle with Carus until 1909. According to Robert H. Scharf, Suzuki was impressed with the writings of William James, and thus gave his own subsequent writings on Zen a Pragmatist cast, in order to appeal to Americans. Carus was, as well, a significant teacher for Suzuki, who promoted the religion of science along with Western philosophy while a student in Tokyo. Sharf, "The Zen of Japanese Nationalism," in *Curators of the Buddha*, ed. Donald S. Lopez Jr. (Chicago: University of Chicago Press, 1995), 107–60. In 1951 Suzuki returned to the US on a lecture tour and subsequently accepted a post at Columbia University (1952–1957), where Dewey had also taught. There Suzuki is perhaps best known as the teacher of the musician John Cage and other members of the New York avant-garde, artists who synthesized Asian and Western thought in their art and life practice.

51. Dewey does not speak openly about Zen; likewise, Suzuki does not speak of Dewey. He never read Dewey's writings, though he did read about his ideas, according to a conversation between Suzuki and Van Meter Ames. But Ames suggests that Suzuki's lack of concern with Dewey, and his close friend and colleague at the University of Chicago George Herbert Mead, points more to Zen's affinity with their thinking than not, even though they "had no more knowledge of Zen than their American predecessors." Here was another instance of like-mindedness over influence. Ames, *Zen and American Thought* (Honolulu: University of Hawaii Press, 1962), 281. This supposition is born out when

we read such statements by Dewey as, "For the uniquely distinguishing feature of esthetic experience is exactly the fact that no such distinction of self and object exists in it, since it is esthetic in the degree in which organism and environment cooperate to institute an experience in which the two are so fully integrated that each disappears." Dewey, *Art as Experience*, 259.

52. See Ames, *Zen and American Thought*, chap. 14, "China and Chicago," for a discussion of Dewey and neo-Confucianism as developed by Fung Yu-lan, who fused Confucianism, Taoism, and Zen Buddhism with American thought, especially that of Dewey and George Santayana. Fung was a student of Hu; Ames believes he probably heard Dewey during his trip to China, then went to work with him at Columbia University, where he received his PhD in 1923.

53. See Ames, *Zen and American Thought*, chap. 13, "Dewey and Zen."

54. Dewey said, "For philosophy like art moves in the medium of imaginative mind, and, since art is the most direct and complete manifestation there is of experience *as* experience, it provides a unique control for the imaginative ventures of philosophy.... The significance of art as experience is, therefore, incomparable for the adventure of philosophic thought." Dewey, *Art as Experience*, 309.

55. Dewey, *Experience and Nature*, 373.

56. Dewey, *Art as Experience*, 41.

57. Dewey, "Introduction," in Dorner, *Way beyond "Art,"* 10.

58. Moholy-Nagy, *New Vision*, 16.

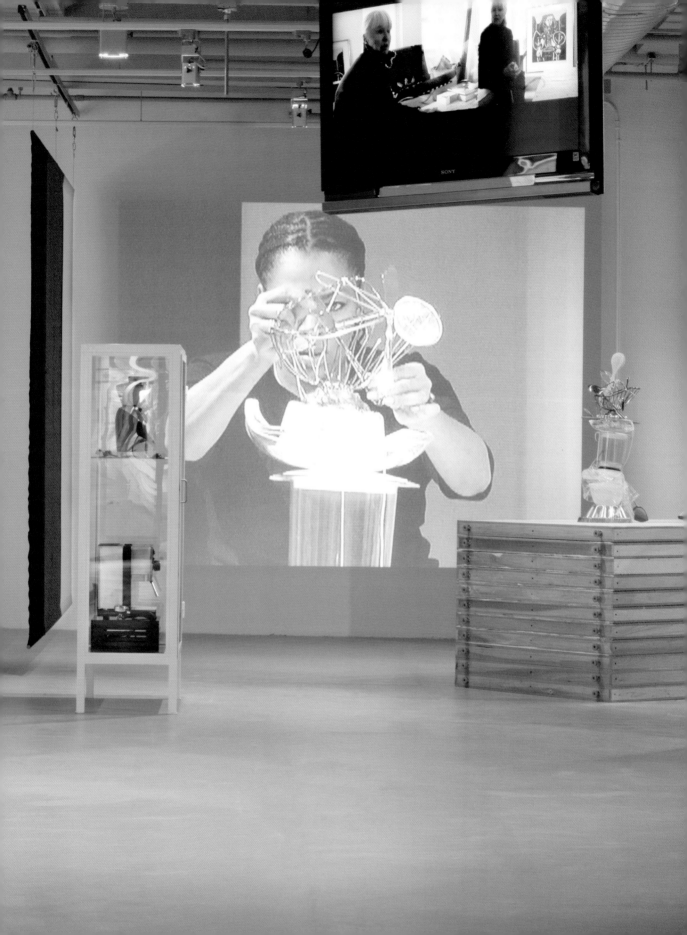

Better Than Before: László Moholy-Nagy and the New Bauhaus in Chicago

MAGGIE TAFT

In 1931 the Bauhaus came to Chicago. There had been whispers of the German school of art and design in years prior, initiated primarily by Alfonso Iannelli, a School of the Art Institute design professor, and Helmut von Erffa, a former student who lived and lectured in Chicago at the end of the 1920s.[1] Now came the first introduction to Bauhaus objects, by way of a show at the Chicago Arts Club and a small display of textiles and metalwork at the Art Institute's *3rd International Exposition of Contemporary Industrial Art*.[2] Thus was the German institution imported: not as a system of theoretical reflection or radical pedagogy but in the form of industrial goods. And it was the optimistic perception of these objects' potential for consumption that led, in turn, to yet another import: László Moholy-Nagy.

Moholy-Nagy emigrated to America in 1937 at the behest of the Association of Arts and Industries, a Chicago-based group of Midwestern industrialists organized in 1922 to advocate and facilitate the relationship between the visual arts and commerce.[3] According to Nelson Pelouze, the group's first president, one of the association's chief aims was "the early establishment in Chicago of an industrial art school where the trained designer upon graduating is ready to report for duty to any one of the many industries requiring such trained artists or designers."[4] After Walter Gropius, founding director of the German Bauhaus, turned down the group's invitation to establish such a school, they rushed the following telegram across the Atlantic to Moholy-Nagy:

> Plan design school on Bauhaus lines to open in fall. Marshall Field offers family mansion Prairie Avenue. Stables to be converted into workshops. Doctor Gropius suggests your name as director. Are you interested?[5]

He was.

It was under these very practical circumstances that the New Bauhaus opened in Chi-

cago. But the situation was also an urgent one. Moholy-Nagy had not been exiled from Germany, as many of his colleagues had been. Instead he chose to leave in 1934, going first to Amsterdam and then to London, deeming what he called "the moral anguish of emigration" the necessary and sole option within "the paralyzing finality of the European disaster."[6] Surely he was referring to Hitler's growing power and the impending threat of National Socialism. But I think he also had something else in mind—the failure of modernism. In this essay, I consider Moholy-Nagy's work at the New Bauhaus not as a translation of the German curriculum—nor as a capitalist-minded transgression of it, as some art historians would have it—but instead as a bid for modernism's survival, as well as a kind of connective tissue between the prewar European avant-garde and the postwar American strand of modernism.

Recent work on the German Bauhaus has confirmed Gropius's claim that "the purpose of the Bauhaus was not to propagate any style, system, or dogma."[7] Rather it was, as he told a group of Chicago industrialists in 1949, "to rouse the creative artist from his otherworldliness and to re-integrate him into the work-a-day world of realities."[8] And yet by the time the Bauhaus reached America, Moholy-Nagy insisted that what was needed was "not only 'industrial designers' for the daily routine."[9] This distinction crystallized in 1936 when he traveled to Berlin for the Olympics, encountering former Bauhaus colleagues and students now dressed in Nazi uniform. "Everyone I talked to in Berlin was suddenly two persons," he wrote in a letter to his wife, Sybil. "They had all split into an ethical and a political self. I could not accept one and reject the other." Thus, upon arrival in America, he implored, "not only aesthetically, but morally; we must control the application of our materials, technique, science and art in creating for human needs."[10] What he was after, and what I mean to elaborate here, was an ethical design practice.

Accordingly, Moholy-Nagy's American project for modernism can best be understood neither as an aesthetic mode nor as a style but, rather, as a method by which to approach both design work and daily living. What I propose here is that the formal solution he supplied was rooted in a return to the most elementary forms and procedures of design and founded on an orientation toward process, which tangibly prolonged, enhanced, and expanded the designer's manipulative control, thus deferring the immediate fulfillment of market needs. This is evidenced in exhibitions of work by New Bauhaus students, as well as a handful of objects made in the school's foundations course. These exhibitions and objects, along with Moholy-Nagy's wartime curriculum, implemented in the fall semester of 1941, can be understood as indexes of an experiment in a new type of modernist practice.

To understand this practice it is first necessary to consider the institution that housed it. The New Bauhaus opened in Chicago in 1937 only to close the following spring. It was resurrected in February 1939 as the School of Design in Chicago, when Walter Paepcke, president of the Container Corporation of America and one of the New Bauhaus's financiers, supplied Moholy-Nagy with the necessary funding. Then in 1944 it was renamed the Institute of Design, which is how it was known in 1949 when it became affiliated with Illinois Institute of Technology, to which it is still linked today. The school's trajectory communicates the nature of its unsteady start, the causes of which were both financial and political.[11]

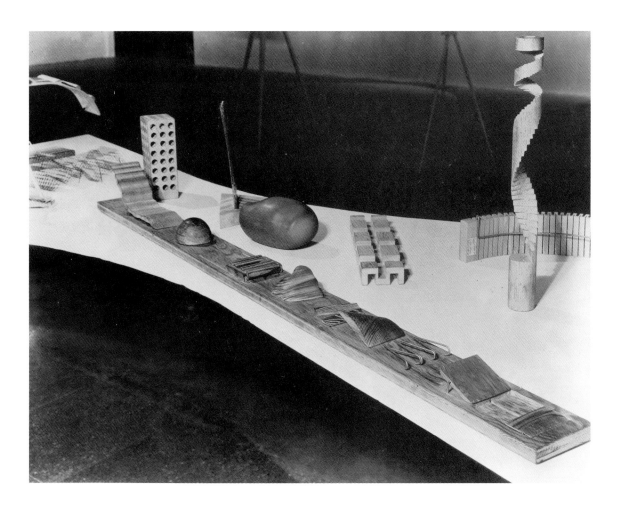

Moholy-Nagy's program did not effortlessly fit with that of his American industrialist sponsors. The New Bauhaus, housed in Marshall Field's nineteenth-century Prairie Avenue mansion, renovated with a concrete and steel addition, wore this disconnect on its façade.[12] The formal clash between Fields's regal mansion and the appended modernist cube makes clear the theoretical conflict between two disparate ideologies. While the New Bauhaus's board, comprised largely of industrialists, wanted merely to incorporate an industrial Bauhaus aesthetic into extant production practices, Moholy-Nagy was more focused on the possibility offered by the very notion of construction. "There's something incomplete about this city and its people that fascinates me," he wrote to his wife. "It seems to urge one on to completion. Everything seems still possible."[13] As Institute of Design professor John Grimes has explained, "What Moholy was selling and what Chicago was buying were two very different products."[14] But what exactly *was* Moholy-Nagy selling?

Apparently not very much. Upon visiting Moholy-Nagy in 1946, ten years after the New Bauhaus had opened, Herbert Read reported that he "gathered that many of the Institute's designs had already been taken up by manufacturers," and yet he was able to name none specifically.[15] At the time of Moholy-Nagy's death in November 1946, Sibyl

Moholy-Nagy confirmed that no immediately salable products had been turned out by any of the workshops.[16] In the absence of manufactured goods, Moholy-Nagy's program for the American school is made apparent in a handful of exhibitions of student work organized during the New Bauhaus's first and only year.

The first of these, *Bauhaus: 1919–1928,* the first major retrospective of Bauhaus work in the United States, was held at the Museum of Modern Art in New York in 1938.[17] Organized by Herbert Bayer and Ise and Walter Gropius, the show included not only objects produced in Germany during the period specified in its title, but also ones being made in America more contemporaneously. It presented samples of work from Black Mountain College in North Carolina and the Laboratory School for Industrial Design in New York, both of which had on their faculty former Bauhaus masters adapting elements from German Bauhaus curricula. The show also included student work from Moholy-Nagy's New Bauhaus in Chicago.

Toward the end of the exhibition, displayed on an elongated, biomorphic table, was an assortment of wooden sculptural pieces produced at the new school. A polished globular form sat next to more geometrically obedient blocklike pieces, one gridded and horizontally oriented, another erect and, in its height, resembling a miniaturized modernist skyscraper. The contours of carved wooden spirals rhymed the vertical curvatures of German Bauhaus paper helixes from the *Vorkurs,* the preliminary course's German counterpart, which Moholy-Nagy had also developed, on view in a different section of the exhibition.[18]

Despite this resemblance, there was something peculiar about the objects from the New Bauhaus, something that distinguished them from the rest. This had, in part, to do with the manner of their exhibition. Unlike the other objects on view—enclosed within glass cases, sitting on or against the walls, or, like the paper helixes, mounted upon pedestals—the wooden pieces from the New Bauhaus were spread out upon an open table, as though available to touch.[19] One object, a long strip of wood decorated with a variety of protruding textured shapes, was intended for precisely this kind of encounter. Indeed, it was described in the exhibition catalog as a "tactile chart," a "scenic railway" for the fingertips.[20] This metaphor astutely articulates the difference between the New Bauhaus objects and those produced by its German progenitor. The amorphous, textured shapes of the American pieces desperately assert their appeal to tactility, as though building blocks for viewers to assemble as they please. The solid forms of the German pieces, by contrast, are almost intimidating in their austerity. They are quite evidently fine objects of design. The status of the New Bauhaus sculptures appears more uncertain. In their appeal to tactility, they decline the familiar role of sculpture as something to be visually circumnavigated and avow themselves as objects of a different kind.

This was even more evident in a show of student work held in Chicago just a few months later, at the close of the inaugural academic year. Objects were strewn across long tables. Images on paper covered the walls in a condensed arrangement that more closely resembled salon-style display than the stoic, modernist, one-row hang typically employed by MoMA. Geometric sculptures, like a Tatlinesque spiral suspended around a centrifugal support, recalled constructivist designs from the 1920s. "Tactile charts" abounded. Some, resembling a Josef Albers lattice painting or a Gunta Stölzl gridded textile, rested

flat, as if to serve as a practical diagram of possible surface textures. Others took on more irregular and organic shapes, as though to subvert the possibility of systematized use; their erratic curves and textures confused the imported notion of a modernism defined by regular, clean lines and reproducible ease. Unable to place the designs, a reporter from *Time* described the show as "an exhibition of bewildering nameless objects: gadgets of wire, wood, sandpaper, linoleum, felt, rubber and ordinary paper cut in odd accordion-pleated patterns."[21]

The exhibition differed not only from Chicago's expectations but from the first public show organized by and at the German Bauhaus in Weimar in 1923. There, items from the preliminary course were largely absent, reserved for student practice rather than public scrutiny. Instead the public was presented with items for purchase. The exhibition was cleanly organized, with ceramics, for example, displayed on stacked shelving and tapestries hung neatly on the walls. The presentation suggested a kind of showroom that mimicked the manner in which such objects might be displayed in a domestic interior. Student hands had made these goods, but they appeared ready for mass production and entry onto the commercial market. And in fact, two years after this exhibition Gropius would establish a corporation for the manufacture and marketing of, as the agreement described, "the finished prototypes of the Bauhaus that [were] to be utilized in actual production."[22] As was already evident in 1923, students were encouraged to produce designs to this end. Their furniture pieces, metal appliances, textiles, and other wares were made available for purchase by way of the *Katalog der Muster*, a mail-order catalog designed by Bauhaus graphic designer and typographer Herbert Bayer.[23] According to visitor accounts, the New Bauhaus show exhibited no such aspiration.

In his review for the *Chicago Daily News*, art critic Clarence Bulliet described the student exhibition as "an 'art' show as never has been seen on land or sea in Chicago.... It's more of a craft show—but it isn't that either. For, rugs out of a 'craft' show can be laid on the floor, or book ends stood on the mantle, while the 'gadgets' exhibited at the Bauhaus have no 'useful' purpose whatsoever."[24] As images of the installation make evident, the objects appeared more like examples of experimental sculpture or painting from the European avant-garde. But due to Moholy-Nagy's exclusion of fine arts fields from the school's curriculum, they could not be comfortably identified as such. Evading any sort of familiar description, their strangeness put them just beyond comprehensive grasp. Visitors to the exhibition were shown objects that refused to comply with either utilitarian demands or aesthetic expectations.

Despite the ambiguity provoked by this nondesignation, the journalist from *Time* concluded his review by assuring that "visitors who studied ... got a good insight into the methods by which Moholy-Nagy and his associates hope to revitalize U.S. architecture and U.S. design."[25] What exactly these might be, he left unstated. But his remark does suggest that the exhibition did something other than introduce discrete products for application. These forms constituted an effort to reconceive of ways and types of functionality originating in the school's curriculum.

Training in materials began as part of the preliminary course, required of all students upon enrollment at the school. In this yearlong class, students experimented in a variety

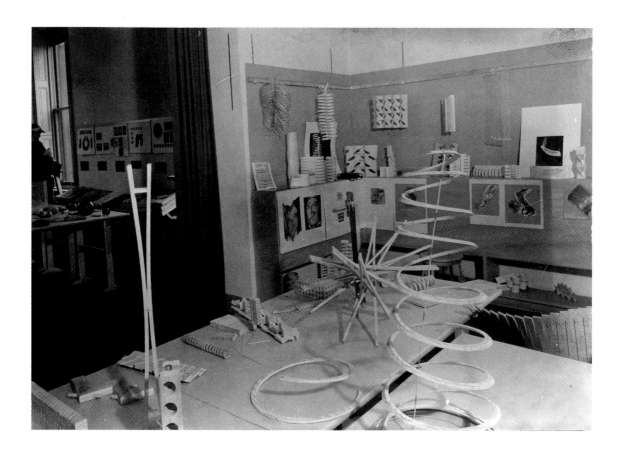

Work from the preliminary course, New Bauhaus School of Design, Chicago, 1937-1938. Photo: Hin Bredendieck. Courtesy of the Bauhaus Archiv/Museum Für Gestaltung, Berlin.

of mediums in order to familiarize themselves with an array of textures, surface qualities, and properties. Students made hand sculptures, wherein they molded materials, typically wood, to suit the curve of the hand in an appeal to both shape and texture.[26] They also constructed the aforementioned tactile charts, which Moholy-Nagy explained as physical "dictionaries of the different qualities of touch sensations, such as pain, pricking, temperature, vibrations, etc."[27]

This exercise had also been carried out at the German Bauhaus under Moholy-Nagy's direction and Josef Albers's co-instruction. There, too, students were directed to excite a full range of bodily sensation induced by touch, but to very different ends. The *Tasttafeln*, as they were known to the German students, accomplished separate yet complementary tasks for the two instructors. For Moholy-Nagy, the exercises were a way of elaborating perception, "the basic sensory experience, which, nevertheless, has been least developed with a discourse of art," while Albers described them as investigations into "inherent characteristics."[28] Herbert Bayer confirmed that such training was meant to determine "the fundamental properties of [the] materials," to discover something internal to them.[29] Integrating both positions, Leah Dickerman has recently argued that exercises like the *Tasttafeln* were investigations into human nature; according to Dickerman, the "chart-like touch panels" also served as "data-gathering tools with which to record the psychological reactions of individuals to different textures."[30]

At the New Bauhaus, Moholy-Nagy clarified his program, in which form was not to be found but instead generated from the designer's hand. The distinction, between honesty *to* form, as was the case in Germany, and responsibility *for* form, as I understand to be the case in America, is a subtle one. But it is also crucial, relocating the site of design from the natural and innate properties of materials to constructed and composed decisions by designers.[31] In America, Moholy-Nagy's rhetoric around an exercise like the tactile charts advocated that designers "control the application of our materials," using, for instance, these dictionaries of touch. Describing the exercise in his posthumously published book, *Vision in Motion*, Moholy-Nagy explained it as a combination of play and discipline. Incorporating elements of Johannes Itten's early *Vorkurs* instruction, Moholy-Nagy encouraged students first to enact emotional interpretation, composing tactile charts "solely with the power of intuition," and then to practice restrained precision, photographing their chart by "minute observation, a coordination of the eye and the hand. With this combination of approaches," he explained, "swift emotional decisions are brought into an organic relationship with the relatively slower process of the critical mind."[32] Instead of deferring to innate properties, the designer held the responsibility for making choices. It was in this that design practice became ethical. More than just aesthetic, that is, more than a matter of form and materials, design required decisions and discernment and so became a place for judgment.

The hand sculptures illustrate this well. With rare exception, they were made of wood. Their smooth sheen and gliding contours were sculpted to appeal to the particular grip of the individual maker. Carving the portable piece required careful and consistent contact with the object throughout the duration of its making. Spread across the table, their bulbous forms are made available to any hand. But their carefully belabored surfaces are, in fact, absolutely personal to the touch of each object's maker. As a reporter from *Everyday Arts Quarterly* explained, "Students make *Hand Sculptures* to develop their sense of touch."[33]

Yet this appeal to tactility and the handmade ought not to be construed as a return to a craft aesthetic. It can be better understood as a way of recalibrating the relation between man and machine, instructing students to consider precisely the complexity of the tasks that machines were being asked to perform. Later on in the *Everyday Arts Quarterly* article, the reporter asserts that students "fall back on their tactile experience when designing a new type of telephone, a glass tumbler, or tool handles."[34] Illustrating this was a metamorphosis montage in which a hand sculpture was pictured transforming into a telephone. Though the construction of the hand sculptures seems largely irrelevant to mechanized industry, we are shown how it gave students an opportunity to familiarize themselves with shapes and forms that are pleasurable to hold. But perhaps we can also speculate on how it may have instructed a kind of humility before and careful treatment of technology and machine production.

This offers insight into Moholy-Nagy's active position within a system of capitalist enterprise. While at the school, he worked closely with entrepreneurs, courting their financial support, much as Gropius had done in Germany. Both, in fact, contacted John D. Rockefeller for financial support, although to no avail. The difference is that by the

time Moholy-Nagy reached Chicago, the Bauhaus had been branded. It would have been simple for Moholy-Nagy to import it by replicating its tendencies, handing his students mass-produced materials like steel sheeting, widely available in the prewar years and relatively cheap even during the Depression, and instructing them to design a teapot or a lighting fixture, as he had done in Germany. Instead, the Americans labored over amorphous wood carvings fit only for clutching, and fumbled with fabrics and various other materials to produce tactile charts. The New Bauhaus moniker served as a sort of shield to this experimental and as yet unformed practice, and it was effective enough to secure Walter Paepcke's financial support for the school's subsequent incarnation as the School of Design. Though not indefinitely.

Resources and finances were scarce, and there was a perpetual threat that the school would be forced to close. This came to a head in 1941. With the start of US military involvement in World War II, young men began to join the armed forces and student enrollment plunged. Teachers, too, departed to fight. Maintenance personnel and office workers left for higher-paying jobs at factories supporting the war effort. Moholy-Nagy's school was left with few bodies and even fewer workshop supplies. Metals and photographic materials were carefully rationed and hard to come by. Everyday goods like paper and plywood skyrocketed in price and became nearly unaffordable. But when Paepcke told Moholy-Nagy the school was no longer viable,[35] Moholy-Nagy proclaimed the institution "invaluable for the war effort" and assembled a "Three-Point Plan" directly addressing wartime needs in order to prove it. The plan called for (1) developing wooden springs for furniture to satisfy demand in the absence of metal ones, (2) exploring and expanding industrial camouflage techniques and technologies, and (3) coordinating a rehabilitation program for veterans based on "sensory experiences and their application in creative work."[36]

The first of these three points, the spring project, took the most concrete material shape. According to Sibyl Moholy-Nagy, herself an architectural historian, the wooden springs "developed organically from woodcuts, made by hand and machine, which gave to a rigid board a rubber-like elasticity. Once cutting, laminating, and gluing had been carefully explored, it was a logical step to find a practical application for this unexploited quality of man's oldest material."[37] This experimentation resulted in some twenty-four varieties of spring, intended to replace metal ones in furniture and mattresses, for example (see photo on page 48).[38] Though none ever went into mass production, they received ample attention from local and national press and were touted as an exemplary instance of the impressive command Chicago School of Design students had over their materials. For a reporter at *Business Week*, it was in the procedures of manipulation and the possibility this offered that the project's success and, by extension, Moholy-Nagy's, his students', and the school's seemed to lie.[39]

Of the three components of Moholy-Nagy's wartime curriculum, it was the experiments in camouflage that demanded such manipulation be executed with the most delicacy. An entirely new course was developed, combining lectures delivered by local experts in the fields of optics and war and a studio component in which students developed projects not only for military camouflage but also, and more specifically, for domestic civil-

ian and urban defense. To this end, Moholy-Nagy, appointed to the mayor of Chicago's personal staff in charge of citywide camouflage activities, participated in design initiatives that proposed to "conceal the vastness of Lake Michigan with a simulated shore line and floating islands."[40] According to one magazine reporter, Moholy-Nagy's methods were so sophisticated that "his team could make even the Merchandise Mart, 'the world's largest building,' look like a forest from the air. 'Just a few dabs of paint,'" Moholy-Nagy told the reporter. "'That's all it will take to create this phenomenal optical illusion.'"[41]

This farfetched abstraction well conveys the typical nature of the projects produced by students of the camouflage course. The outline for the class professed its purpose to be "the understanding of visual fundamentals valid in every field of visual activity," and it seems from a series of exhibitions that this purpose, rather than the invention of immediately viable camouflage techniques, predominated as the experiments proceeded.[42] For example, in the exhibition *War Art*, held in the spring of 1942 at the Renaissance Society, a contemporary art space affiliated with the University of Chicago, students contributed not sophisticated technologies capable of furthering local defense and the war effort but projects that appear to be simple experiments in geometry and patterning. Despite Moholy-Nagy's professed concern with local conditions and geography, work included investigations into animal patterning (zebra print, for example) that were hardly relevant to Chicago's urban landscape. As is typical of camouflage, these natural patterns were mobilized in the service of optical volumetrics. With their tendency toward curved lines and rotoscopic movement, these patterns transformed the urban grid into visual abstractions. In fact, the installation looks much like the earlier one exhibiting work from the New Bauhaus's preliminary course. The camouflage experiments appear to have been rendered as a way for students to develop command over design, only in this case optical proficiency rather than textural. The work was conceived under the guise of practical innovation, with government authority endorsing such a claim. But as the course description explained, it "could function two ways: first for teacher education, second for the *preparation* of volunteers for civilian and military camouflage."[43]

The third part of Moholy-Nagy's curriculum, "Better Than Before," also trafficked in preparation rather than production. Officially authorized by the deputy director of the Mental Hygiene Service of the Illinois State Department of Public Welfare, it sought to educate nurses and doctors in experimental rejuvenating therapies for war veterans.[44] The school trained medical practitioners to engage patients in sensory exposure and development by breaking down basic but complex tasks into their fundamental components. In both activities and purpose, "Better Than Before" resembled the cornerstone of the school's original program: the preliminary course.[45] Each aimed to develop sensorial capacity through assignments such as tactile charts, hand sculptures, machine wood cuts, paper cuts, and metalwork, to name but a few. The aim was haptic, not material.

This is made ever clearer by that which Moholy-Nagy excluded from his program—most obviously, a print advertising campaign. There was at the school already an entire workshop dedicated to advertising arts, and offering its services to the war effort no doubt would have been the most industrious way of meeting Paepcke's demand to make the school viable. But Moholy-Nagy didn't include this very basic propagandistic solution.

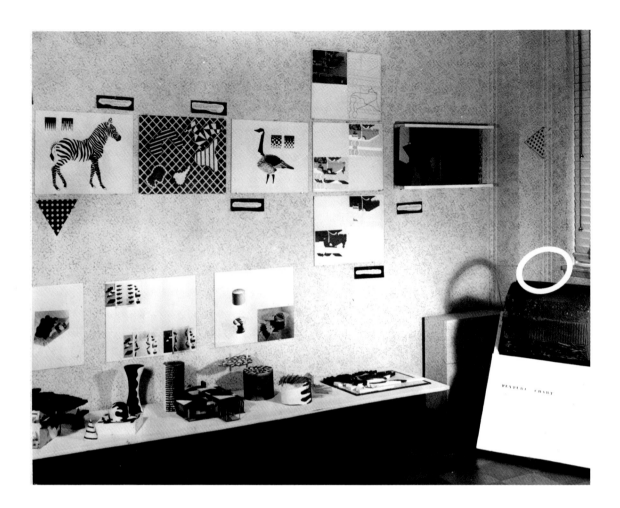

Exhibition of student work from the camouflage course, New Bauhaus School of Design, Chicago. Courtesy of the Illinois Institute of Technology Archives.

Instead, he proposed a plan whose outcome would be largely unquantifiable, the measure of its success difficult to gage. Rather than concentrating on the production of viable designs for mass circulation, Moholy-Nagy's wartime curriculum reveals a committed interest in favor of the procedural aspects of design, rejecting the industrial push toward innovative materiality characteristic of so much midcentury design.[46] At Moholy-Nagy's new Bauhaus, this was neither the mode nor the measure of a successful future for modernism. Instead of newness, it was maintenance that was needed.

Though the threat to America was less immediate than in Europe, where the fighting was taking place, the culture of objects in the United States was vulnerable and in its own way susceptible. The nation had just risen from a decade of Depression, and even with the turnaround, the consumer market was still characterized by rationing and shortages. It was within this context, an economic climate wracked by devastation and defined by instability, that Moholy-Nagy's Three-Point Plan as well as his larger American Bauhaus project must be understood. The curriculum's emphasis on the design process over designed goods was symptomatic of, though not necessarily commensurate with, a cultural economy oriented toward maintenance and preservation amid a devastated (and

devastating) global landscape. "To be a designer means not only to sensibly manipulate techniques and analyze production processes, but also to accept the concomitant social obligations," Moholy-Nagy wrote in *Vision in Motion*. "Thus quality of design is dependent not alone on function, science, and technological processes, but also upon social consciousness."[47]

Moholy-Nagy's program certainly did not reject the tools of modernity, but it did remind students to be mindful of their relation to them. And this was crucially symptomatic of the fundamental feature of education at the New Bauhaus and its successors. Students were not working out design solutions, developing prototypes, and forging active connections with local industry. They were concerned foremost with process; when their impractical products were exhibited, it was not so much the crafted objects that were to be observed as the decisions that had gone into their making. The reporter from *Time* hinted at this in his remark about the subtle display of the school's revitalizing methods, even if he couldn't say precisely what they were.

Moholy-Nagy, however, provided some explanation in his description of the preliminary program. In addition to testing students' abilities and sampling the components of the specialized workshops, the course gave the student "ample opportunity to make a careful choice of his own field of specialization later."[48] Anticipating the significance of abstract expressionism's action painting, according to critics like Harold Rosenberg, Moholy-Nagy's preliminary class supplied a field in which designers were presented with a range of material choices and taught to make decisions among them. Instead of designing discrete objects for manufacture, the New Bauhaus introduced a prototype for the practice of design itself as a mode of living. In stark opposition to the Nazi agenda, under which Moholy-Nagy found everyone divided into two selves—a masked ethical one and formed political one—Moholy-Nagy's program, with its emphasis on rigorous tactility, manual manipulation, and experimental procedures, initiated a space for the strategic maintenance and survival of an ethical and political self by reimagining her as a touching, feeling subject.

Notes

1. Lloyd C. Engelbrecht, "The Association of Arts and Industries: Background and Origins of the Bauhaus Movement in Chicago" (PhD diss., University of Chicago, 1973), 181, 151.

2. Sybil Gordon Kantor, *Alfred H. Barr Jr. and the Intellectual Origins of the Museum of Modern Art* (Cambridge, MA: MIT Press, 2003), 210.

3. Though the Great Depression slowed production, the interwar period in America was characterized by an industrial boom based upon factory production of home appliances, automobiles, furniture, and other consumer goods. Most of this burgeoning industry was rooted in the Midwest, particularly in Illinois, and Chicago specifically. Saul Bernard Cohen, *Geopolitics of the World System* (Lanham, MD: Rowman & Littlefield, 2002), 106.

4. Engelbrecht, "Association of Arts and Industries," 132.

5. Sibyl Moholy-Nagy, *Moholy-Nagy: Experiment in Totality* (New York: Harper & Brothers, 1950), 139.

6. László Moholy-Nagy, quoted in Sibyl Moholy-Nagy, *Experiment*, 132, 145.

7. Walter Gropius, "Unity in Diversity," in *Apollo in the Democracy: The Cultural Obligation of the Architect* (New York: McGraw-Hill, 1968), 29. See also Barry Bergdoll and Leah Dickerman, *Bauhaus 1919–1933: Workshops for Modernity* (New York: Museum of Modern Art, 2009).

8. Walter Gropius, "Address," 11, Institute of Design Records, Illinois Institute of Technology.

9. László Moholy-Nagy, quoted in Paul Betts, "New Bauhaus and School of Design, Chicago," in *Bauhaus*, ed. Jeannine Fiedler and Peter Feierabend (Cologne: Könemann, 2000), 67.

10. László Moholy-Nagy, quoted in Sibyl Moholy-Nagy, *Experiment*, 132; László Moholy-Nagy, quoted in Betts, "New Bauhaus," 67.

11. This has parallels to its German counterpart, which opened in Weimar in 1919, moved to Dessau in 1926, changed hands in 1927, and again in 1930, when it moved to Berlin under the directorship of Ludwig Mies van der Rohe. Here too the impetus was primarily financial and political struggle.

12. The bold sculptural massing of the original building, designed by Henry Holmes Smith, evoked the traditions of nineteenth-century monumentality. Though a domestic dwelling, the shelves of floors expressed in the spandrels and horizontals of the fenestration system carried with them a certain civic weight. Photographs taken after its conversion indicate significant renovations: a modernist cube, constructed from concrete, steel, and glass, was added to its side. In the original building, the windows receded into the façade; in this addition, they sat flush with the exterior whitewashed surface. The cubic mass formally and conceptually resembled a Le Corbusier construction, likely familiar to Chicagoans after the Chicago Architectural Society's 1935 exhibition of Le Corbusier's theory and architecture.

13. Sibyl Moholy-Nagy, *Experiment*, 145.

14. John Grimes, "The New Vision in the New World," *Aperture* 87 (1982): 18.

15. Herbert Read to David Stevens (Rockefeller Foundation), October 18, 1946, Institute of Design Collection, Daley Library Special Collections, University of Illinois at Chicago.

16. Sibyl Moholy-Nagy, *Experiment*, 217.

17. This was the only Bauhaus survey at MoMA until the seminal traveling show *Bauhaus, 1919–1933: Workshops for Modernity*, organized by the Bauhaus-Archiv Berlin, the Stiftung Bauhaus Dessau, and the Klassik Stiftung Weimar to mark the ninetieth anniversary of the founding of the Bauhaus in Weimar. It was presented at multiple venues in Weimar under the title *Das Bauhaus Kommt aus Weimar* and at Martin Gropius Bau in Berlin as *Bauhaus. A Conceptual Model* before a smaller version went on to MoMA.

18. The *Vorkurs* was begun by Johannes Itten when Gropius opened the Bauhaus in 1919, but Moholy-Nagy restructured it upon his arrival at the school in 1923. In a departure from Itten's expressionist pedagogy, in which lessons on form and color were taught through a system of oppositions to be apprehended through intuition, Moholy-Nagy's curriculum advanced the comprehensive study of material, basic construction technique, and opportunities for practical use. Referring to his paintings from the period, but in terms equally applicable to his curriculum, Moholy-Nagy explained that his purpose "was not to demonstrate only individual inventions, but rather the standards of a new vision employing 'neutral' geometric forms." László Moholy-Nagy, "Abstract of an Artist" (1944), in *The New Vision and Abstract of an Artist* (New York: Wittenborn, 1947).

19. Although there is no record of whether museum patrons were allowed to handle the objects, frequent visitors to MoMA would have been familiar with this kind of display from the design exhibition just prior. In this previous show, *Useful Objects*, domestic design goods were exhibited on tables, and museumgoers were invited to touch, lift, and hold them.

20. Museum of Modern Art *Bulletin* 5, no. 6. While the *Bulletin* does not make clear that these objects were produced in the New Bauhaus's introductory course, photographic and textual records of pieces produced there correspond precisely to those on view at MoMA.

21. *Time* (July 11, 1938), 21, Institute of Design Records, Illinois Institute of Technology.

22. "The Position of the Bauhaus in Today's Economy," reproduced in Hans M. Wingler's *The Bauhaus: Weimar, Dessau, Berlin, Chicago* (Cambridge, MA: MIT Press, 1978), 111.

23. Herbert Spencer, *Pioneers of Modern Typography* (New York: Hastings House, 1970), 146–47.

24. Clarence Bulliet, *Chicago Daily News* (July 9, 1938), 13, Institute of Design Records, Illinois Institute of Technology.

25. *Time*, 21.

26. "Exhibition: Work from the Preliminary Course, 1937–1938," Institute of Design Records, Illinois Institute of Technology.

27. László Moholy-Nagy, *Vision in Motion* (Chicago: Paul Theobald, 1947), 68.

28. Josef Albers, quoted by Frank Whitford, *Bauhaus* (London: Thames and Hudson, 1984), 135.

29. Herbert Bayer, Walter Gropius, and Ise Gropius, eds., *Bauhaus, 1919–1928* (Boston: C. T. Branford Co., 1952), 89.

30. Bergdoll and Dickerman, *Bauhaus*, 32.

31. Heidegger writes, "When we handle a thing … our hand must fit itself to the thing…. Use itself is the summons which determines that a thing be admitted to its own essence and nature, and that the use keep to it. To use something

is to let it enter into its essential nature, to keep it safe in its essence." Martin Heidegger, *What Is Called Thinking* (New York: Harper & Row, 1968), 187.

32. László Moholy-Nagy, *Vision in Motion*, 67.

33. Walker Arts Center, "A Guide to Well-Designed Products," *Everyday Arts Quarterly*, no. 3 (Winter 1946/Spring 1947), 3.

34. Ibid.

35. László Moholy-Nagy, quoted by Sibyl Moholy-Nagy, "Moholy-Nagy: The Chicago Years," in *Moholy-Nagy: An Anthology*, ed. Richard Kostelanetz (New York: Praeger, 1970), 24.

36. László Moholy-Nagy, "Better Than Before," *Technology Review* (November 1943), 7.

37. Sibyl Moholy-Nagy, *Experiment*, 186.

38. Most effective were the so-called "Victory springs," named for both their association with the war effort and their shape: a series of alternating Vs constructed of veneer, which remained widely available during the war years, hinged with wedges at either end to create zigzagging joints with an accordion-like flexibility. According to Moholy-Nagy, if properly rendered, the Victory springs could not only simulate metal springs of any compression weight but also perform more durably. The design was patented, and in a citywide furniture show in July 1942, Seng Co., a big furniture hardware outfit, displayed an experimental model chair that made use of the design. But the wooden prototype remained too expensive to enter the market—40 cents for a single wooden spring, compared to 25 for its metal counterpart.

39. "Wooden Springs," *Business Week* (October 31, 1942).

40. Sibyl Moholy-Nagy, *Experiment*, 183.

41. William Feaver, "Brave New World," Elizabeth Paepcke Papers, University of Chicago.

42. "Outline of the Camouflage Course," Institute of Design Records, Illinois Institute of Technology.

43. Ibid.

44. It was at just this time that the US government began funding and building convalescent hospitals specializing in veteran medical recovery.

45. "Courses in Rehabilitation: Orientation Course in Occupational Therapy," 2, Institute of Design Records, Illinois Institute of Technology.

46. In 1930 Frederick Kiesler, designer, curator, and friend of Moholy-Nagy, explained that "the department store ... was the true introducer of modernism to the public at large. It revealed contemporary art to the American commerce ... as the interpreter for the populace of a new spirit in art." This was, in part, employed as a marketing technique, a reaction to Depression-era production. As the economy began to emerge from its slump, American manufacturers pushed products by creating demand, appealing to the desirability of newly fashioned items rather than necessity and practical need. The design industry in turn fostered the illusion of progress rather than progression itself. This was particularly true of the popular streamlined style, the "teardrop or bullet-shaped aerodynamic design" that had been conceived to minimize air resistance and increase the efficiency of trains and automobiles but was quickly adopted to give immobile refrigerators and armchairs a façade of functionalism. A 1930 article in *House Beautiful* explained that the modernist style America had adopted was "expressive of the changed living conditions of [the] day," while keeping "enough traditional features to enable the more conservative to accept it." "Our Home Builders Service Designs a Modern House," *House Beautiful* 67 (January 1930). For more on this, see Douglas Haskell, "Utilitarian Design," *Creative Art* 9, no. 5 (November 1931): 375–79; Frederick Kiesler, *Contemporary Art Applied to the Store and Its Display* (New York: Bretano's Publishers, 1930); Rosemarie HaagBletter, "The World of Tomorrow: The Future with a Past, 1930–1945," in *High Styles: Twentieth-Century American Design* (New York: Whitney Museum of Modern Art/Summit Books, 1985); J. Stewart Johnson, *American Modern, 1925–1940: Design for a New Age* (New York: Harry N. Abrams, 2000).

47. Moholy-Nagy, *Vision in Motion*, 56.

48. László Moholy-Nagy, quoted by Alain Findeli, "Moholy-Nagy's Design Pedagogy in Chicago (1937–46)," *Design Issues* 7, no. 1 (Fall 1990): 8.

Moholy's Upward Fall

RONALD JONES

April 12, 1942, provided a fresh, summery day in Chicago for the tea party hosted by the Renaissance Society. The occasion was the opening of an exhibition titled *War Art*. Two days earlier, halfway around the world, the Bataan Death March had begun in the Philippines, and two weeks later the Nazis would force Belgian Jews to begin wearing stars; the Second World War was becoming a juggernaut. In fact, by the end of that same year the first self-sustaining nuclear chain reaction occurred just up the street from the Renaissance Society at the University of Chicago, as part of the Manhattan Project.

But *War Art* was designed to address a complex question: how might art and design contribute to winning a world war? The introduction to the exhibition positioned it as "a demonstration of new developments in art in their application to war activities" and therefore included "work done by the School of Design of Chicago and the W.P.A. Illinois Art and Craft Project, the two organizations in Chicago which have focused art activities on actual war needs." Measured by today's values, the virtues of *War Art* seem ambiguous, and yet, as you will see, that is the lesson to carry away from this story: how to inherit modernism without having to accept the ambiguity of postmodernism.

Within memory the arts and letters have had a default "antiwar" setting; the Art Workers Coalition's chilling and chiding 1970 poster framing the massacre at My Lai—"*Q: And Babies? A: And Babies*"—is emblematic. Occasionally artists and designers have rebelliously sidestepped routine pacifism to face war squarely. Of the First World War Otto Dix admitted: "The war was a horrible thing, though it was something powerful all the same. I certainly didn't want to miss it." Dix's impulse to join the fighting was an expression of his ability to personally reconcile the repulsion and attraction of bearing witness to the brutal spectacle of humankind's first mechanized war. But *War Art* was something else again, and there has never really been another undertaking like it. Organized by László Moholy-Nagy, then director of the School of Design in Chicago, or New Bauhaus,

Frau Fiber, a.k.a. Carole Frances Lung, *Manufacturing Moholy in Weimar* (detail), 2009. Installation view, in *Learning Modern*, Sullivan Galleries, School of the Art Institute of Chicago. Photo: Jill Frank.

László Moholy-Nagy in Budapest, Hungary, 1915. © The Moholy-Nagy Foundation; Artists Rights Society (ARS), New York.

the exhibition was an example of ethical exhibitionism that sits comfortably next to President Obama's Nobel Peace Prize acceptance speech, in which he said, "I understand why war is not popular. But I also know this: the belief that peace is desirable is rarely enough to achieve it." *War Art*, like Obama's message, attempted a realistic engagement with war. However attractive the prospect of peace was in April 1942, Moholy-Nagy understood that desire alone would never be enough to achieve it and so chose to seek peace by taking a posture toward war that may be fairly described as proactive, pragmatic, and relevant, and above all courageous, which we mustn't forget is a morally neutral virtue.

Historically the creative disciplines have been handed few occasions to make moral decisions based on the effects their work would *definitively* have on other people. But one such example was the conscious decisions of Walter Dejaco, the architect who largely designed, and in part oversaw the construction of, the gas chambers and crematoria at Auschwitz. Dejaco made a decision "creatives" rarely face: the decision that would carry him across the moral bridge from *contemplation* to *application*, from considering how he *could* do evil were he to build a death camp, to rationalizing how he *would* apply his talents and turn Auschwitz into a fiendish reality. Moral and ethical decisions of that magnitude are rare in the studio. In truth, Moholy-Nagy's decision was driven as much by his concerns over the uncertain future of the School of Design as by his students' potential creative contribution to the war effort. Nevertheless, as with Dejaco, his decision required crossing a moral bridge, moving from contemplating how he could turn design education toward serving the war effort to saying he would do so. A veteran of the First World War, he well understood the ethical dimensions of such a decision, having said about the Bauhaus curriculum that it would engage not only "aesthetically, but morally; we must control the application of our materials, technique, science and art in creating for human needs."[1] He explicitly understood that moving from contemplation to application required a moral decision. Of course, it was a moral decision his students would take as well.

Moholy-Nagy's inspiration for pivoting the School of Design toward "actual war needs" was born out of a "here and now" crisis directly related to the impact of war on the home front. As the fighting got under way, severe shortages of students and staff—who were leaving for war or for better-paying industry jobs related to the war effort—combined with rising costs of rationed material, made it obvious to Walter Paepcke, president

of the Container Corporation of America and generous philanthropist, that the school would need to close its doors.[2] Moholy-Nagy made a case to the contrary; the school, as he envisioned it, would become "invaluable for the war effort."[3] He launched a bold initiative known as the "Three-Point Plan," a curriculum that would make design directly relevant to the war effort. The three studios involved would address the development of wooden springs, industrial camouflage, and sensory studies for veteran rehabilitation. With an economy of means, the plan promised to create entrepreneurial and attainable solutions to real wartime problems, thus projecting sufficient power and influence to save the school. Its expediency does not imply that Moholy-Nagy's curriculum was any less courageous, relevant to the moment, or proactive. Instead, it added a second layer to his decision: he would show Paepcke and everyone else that a design school could be a factor in winning the war, and thereby insure the school's peacetime future. Let's not forget that Moholy-Nagy had already seen one Bauhaus dismantled by the very war he was now prepared and positioned to fight, *by design*.

For his strategy to work, the Three-Point Plan had to deliver products that would live up to the metrics for success set forth by the war machine Dwight Eisenhower would later christen the "military-industrial complex." And this would be Moholy-Nagy's great failure. The bedsprings, known as "Victory springs," inspired innovative production techniques using veneer strips and hinged wedges. But they cost almost twice as much as metal springs to produce and consequently never went to market. The "design" of the wooden springs was widely celebrated in the press, but it had no impact on reducing the demand for metal during the war years, its raison d'être. The outline for the second of the plan's three points—"Industrial Camouflage Course with Certificate," initiated at the School of Design under the leadership of György Kepes—had greater scope: not only did it address camouflage techniques for the military, but also techniques especially designed to protect civilians living in cities. There were lectures on "aerial warfare" and "protective concealment in nature" given by military officers and University of Chicago scientists. As with the Victory springs, the press was mesmerized, this time by the promise of camouflage spectacles. But Moholy-Nagy promoted claims that were surely over reaching: Chicago's Merchandise Mart, then the world's largest building, would be made to look like a forest to enemy bombers overhead. "Just a few dabs of paint; that's all it will take to create this phenomenal optical illusion." And the catalog for the *War Art* exhibition contained as much, if not more, exaggeration as Moholy-Nagy's press-baiting. It includes descriptions of rather scientifically advanced camouflage projects from the School of Design, but to compare these descriptions with what was actually on view is to discover a disparity so significant that one can only conclude the descriptions were intended to be misleading.[4] Moholy-Nagy was better at disguising the failures of the Industrial Camouflage Course than the students were at producing practical applications of new camouflage techniques.

The third part of the Three-Point Plan, "Better Than Before," fared even worse than the first two, although its premise—designing experiential systems to rehabilitate returning war veterans—sounds like a project a present-day design innovator like IDEO might take on.[5] The course outline describes rehabilitation modules as "sensory experiences through the medium of various materials, combined with theoretical studies,"[6] reveal-

ing how heavily Moholy-Nagy relied on the core elements of the Bauhaus curriculum for "Better Than Before," rather than adapting them to existing rehabilitation therapies. And while his instincts were prescient with the Victory springs and experiments with camouflage, which borrowed ideas across disciplines to design new hybrid systems that demonstrated measurable effects, "Better Than Before" contributed nothing, either to winning the war or recovering from it. What the Three-Point Plan did was to save the School of Design; this was no small achievement.

In his failure, Moholy-Nagy showed us our future. By now, the ambiguity of postmodernism in general and relativism in particular has become a paradoxical hindrance.[7] The sacking of relativism goes like this: the assertion that all truth is relative is itself either relative or not. If it is relative, then it can be ignored because its certainty exists only relative to someone else's point of view, which we are not obliged to share. If it is unconditional, thus not relative, then it disproves the principle that all truth is relative. Either way relativism is undone. According to relativism, inconsistent claims may have equivalent legitimacy. But to say, "Dejaco's designs for the gas chambers at Auschwitz made possible the killing of innocent people held against their will," is not to make a statement about attitudes or ways of thinking; it is a fact in the world. If you consider it a mindset, then it becomes a psychological profile of the narrator rather than the physical circumstances of the murders Dejaco facilitated *by design*. Truth, freed from relativism, steadies the strategic

language and wartime tactics of Moholy-Nagy, making them, among other things, proactive and unconditional. Dejaco succeeded but was unconditionally *wrong*. Moholy-Nagy failed but was unconditionally *right*. Taking design to war was Moholy's upward fall.

Today we stand amid many wars—ecological, political, religious, and sociological—but with few actionable and winning strategies at hand. Using Moholy-Nagy's wartime curriculum as a lens to help us focus on and assess our present circumstances, it seems urgent that we too strive for persuasive solutions to menacing problems, aligning them across disciplines, often those furthest from our own. If we lift up, for example, government policy-making, then President Obama's unvarnished reasoning—"the belief that peace is desirable is rarely enough to achieve it"—clarifies the terms of Moholy-Nagy's motivation: pragmatically, our desire for peace will sometimes be fulfilled *only* by winning it. With this example of empathic commitment, the president strategically departs from the values of relativism, the ambiguities of postmodernism, and fashionable pessimism for a new "postcritical perspective." Broadly speaking, he calls for engagement with proactive strategies triggering entrepreneurial, innovative, and attainable solutions to wicked problems.

With hindsight, Moholy-Nagy's plan to win wars by design fortuitously aligns with President Obama's postcritical policy toward war—*that peace is desirable is rarely enough to achieve it*. But no one would be surprised if a poll of practitioners of the creative disciplines revealed that a majority find Moholy-Nagy's idea of putting design at the service of war repugnant, beyond the ethical boundaries they habitually live within. That this nominal critique of Moholy-Nagy's plan is so predictably small-bore, without a trace of nuanced attention to other possibilities, is evidence of a persistent streak of naiveté that accounts for the consistent failure within the creative disciplines to offer more proactive or influential alternatives. In the long run, the absence of any imaginative alternatives beyond mere critique not only lacks credibility, but is downright incapacitating. The monodimensional critique of war from the cultural side may sometimes be provocative—"*Q: And Babies? A: And Babies*"—but it will never be *transformative*. This is the knowledge President Obama shares with Moholy-Nagy.

I am willing to predict that most members of the creative disciplines reading this sentence will learn here for the first time that Moholy-Nagy's original vision has been expanded upon, realized, and implemented by none other than the United States Army. In 2006 the army's School of Advanced Military Studies (SAMS) initiated an overhaul of its *Field Manual 5-0: Army Planning and Orders Production* (FM5-0). By March 2010 the new version had been published and was becoming operational. Titled *The Art of Design*, FM5-0 explicitly uses Design Thinking to drive the core of the army's planning and battle doctrine; indeed, the second chapter is titled "Design Thinking."[8] This 337-page manual describes design as "a methodology for applying critical and creative thinking to understand, visualize, and describe complex, ill-structured problems and develop approaches to solve them"—a definition Moholy-Nagy would have found *au fait*.[9] In the foreword to another army publication, Lieutenant General William Caldwell writes, "Design is the next step on a path to maturing our battle command model for the complexities of operations in an era of persistent conflict."[10]

In scholarly articles leading up to the publication of FM5-0, Colonel Stefan J. Banach and others helped to ground the application of Design Thinking in battle doctrine, even as wars become increasingly multidimensional, volatile, and perilous and the army faces a future of "persistent conflict." In an article published a year before FM5-0, Banach accurately contrasts the role of the scientist with that of the designer, arguing that battlefield commanders must be able to act with the agility of designers in order to succeed at the army's core business: saving lives. He writes:

> Design is focused on solving problems, and as such requires intervention, not just understanding. Whereas scientists describe how the world is, designers suggest how it might be. It follows that design is a central activity for the military profession whenever it allocates resources to solve problems, which is to say design is always a core component of operations.[11]

The integration of Design Thinking as an applied army doctrine has not been without opposition. In 2010, following the release of FM5-0, SAMS created a blog titled "Improving the Army's Design Approach" to encourage an openhanded discussion and to foster insight around design's role within the ranks. To visit the blog is to discover that the right questions are being asked, with an agility and transparency that appear beyond the reach of the creative disciplines. Major Ed Twaddell, who was enrolled in a SAMS seminar devoted to the new design doctrine, wrote:

> The Army has clearly stated what Design does: '[enhance] a commander's ability to understand and visualize complex situations, [and develop] adaptive and learning organizations, in order to facilitate planning, preparation, execution, and assessment,' but has not expressed exactly what it is, other than to say that it is a 'way of organizing conceptual work … to assist the commander in his formulation of operational concepts.' Finally, the Army must define at what levels of war Design is appropriate for use.[12]

Of course, what Major Twaddell asks today—*at what level of war is Design appropriate?*—Moholy-Nagy asked seventy years ago. Except, this time, the question, coming from the army, is more weighted with the sophisticated application of a postcritical perspective to wicked problems than the creative disciplines have been able or willing to manage. Could it be that the army has outstripped the creative disciplines when it comes to being imaginative, entrepreneurial, and innovative?

Bruno Latour believes so. In 2004, two years before the army began its revision of FM5-0, Latour published his watershed essay "Why Has Critique Run out of Steam? From Matters of Fact to Matters of Concern" in the pages of *Critical Inquiry*. Latour asked a simple but probing question: "What has become of critical spirit?" This is his answer:

> Quite simply, my worry is that it might not be aligned to the right target. To remain in the metaphorical atmosphere of the time, military experts constantly revise their strategic doctrines, their contingency plans, the size, direction, technology of their projectiles,

of their smart bombs, of their missiles: I wonder why we, we alone, would be saved from those sort of revisions. It does not seem to me that we have been as quick, in academe, to prepare ourselves for new threats, new dangers, new tasks, new targets. Are we not like those mechanical toys that endlessly continue to do the same gesture when everything else has changed around them?[13]

Latour is not asking academia to endorse war-making, nor am I, but rather to face up to the limitations of criticality and its theories, methods so rote that they have foreclosed on their own relevance. Of course things have changed dramatically since Latour wrote his article; in 2004, the military's keen ability to respond to the need for policy modification could only be described in the most general of terms—*military experts constantly revise their strategic doctrines*—but that was then. FM5-0, *The Art of Design*, is hard evidence of the army's (postcritical) revision of its own doctrine so that it now reaches across an array of disciplines, integrating them into an effective interdisciplinary practice.

Advanced research indicates that interdisciplinary innovation in which the alignment between disciplines is very low fails more often than not, but when it does succeed it is consistently of greater value than any other kind of innovation.[14] I am not yet prepared to concede that FM5-0 is simply an example of interdisciplinarity. Why? Because the alignment between design methods and military doctrine is so extremely low that the army may well have created a complex and sophisticated transdiscipline or even an early but advanced example of postdisciplinarity. It's just too soon to tell. What we do know is that army leadership had no qualms about exploiting Design Thinking. So why do designers resist adopting best practices of highly advanced forms of creativity like FM5-0, no matter where they emerge? Because this would require a moral decision of the gravity of Moholy-Nagy's: to fight a war by design. The most important lesson the creative disciplines will likely carry away from FM5-0 is knowing that it exists at all, thus opening the door to something as manifestly innovative and creative in the art or design worlds.

Moholy-Nagy's ambition for his Three-Point Plan, which committed design to war, demonstrated what we would describe today as a postcritical perspective. By comparison, critical theory, unable to actualize divergent or disruptive innovation, seems like little more than toothless compliance with prevailing attitudes about its own efficacy. Critical theory is habitually without creative alternatives to the object of its critique, that is, "to write poetry *after* Auschwitz is barbaric."[15] But we have arrived at a point where critical theory is being called upon to answer a basic question: what is the continuing relevance, value, and productive potential of criticality, or "oppositional knowledge"?

This is hardly a new question. In George Orwell's 1940 essay on Charles Dickens, he framed the same question:

The truth is that Dickens's criticism of society is almost exclusively moral. Hence the utter lack of any constructive suggestion anywhere in his work. He attacks the law, parliamentary government, the educational system and so forth, without ever clearly suggesting what he would put in their places.... And so far as social criticism goes, one can never extract much more from Dickens than this, unless one deliberately reads meanings

into him. His whole "message" is one that at first glance looks like an enormous platitude: If men would behave decently the world would be decent.[16]

What Orwell found lacking in Dickens—any actionable solutions to the misery he so accurately and artistically described—is what is lacking in oppositional knowledge today. If artists and designers want to participate in reshaping the political, social, economic, and cultural agendas, they will have to begin to think beyond the exhausted forms of radicalism, beyond the stylistic tradition that limits their practice to a form of critical belligerence. Consciousness raising or mere criticality may allow them to claim the moral high ground, but they lack the means or methods to achieve anything more. This means that their practitioners can't meaningfully *hold* the high ground.

Critical Design provides an example of what I mean. The term, first used by Anthony Dunne in his 1999 book *Hertzian Tales: Electronic Products, Aesthetic Experience, and Critical Design*, means to distinguish designed artifacts, which embody critique or commentary on a variety of subjects but most often consumer culture. In a discussion with Rolf Hughes around the continued usefulness of criticality, I wondered about the efficacy of so-called Critical Design, "which we typically associate with the work of Dunne and Raby, Troika, Martí Guixé, Jurgen Bey, and others":

> A routine example of Critical Design would be the t-shirt by Martin Margiela that reads: "THERE IS MORE ACTION TO BE DONE TO FIGHT AIDS THAN TO WEAR THIS T-SHIRT BUT IT'S A GOOD START." Really? Is this "good for me" self-indulgence, dressed up as a first thrust against a disease that has killed twenty five million people since 1981, really a good start? ... While the roses are being passed around in Critical Design circles, we must admit that on the whole, these designers condemn themselves to manufacturing transgression against authority by consistently escalating old-school radicalism, rather than by inventing new pragmatic and entrepreneurial systems that would directly intervene and empower change. If we look at truly wicked problems—global access to clean drinking water, for example—I am not sure what Critical Design's contribution would be. Another t-shirt?[17]

Take the turbulence that surrounds us from every side and divide it by the time we have to discover proactive and winning solutions to poverty, lack of clean drinking water, corruption, and discrimination (to name but four) and it becomes hypocritical to continue granting artists and designers special dispensation because what they are producing is merely worthwhile, or even relevant. From a postcritical vantage, there are a great many stones left to turn over. This means becoming proactive in a true modernist sense: engineering both methods and means for producing results across disciplines. In abandoning the ambiguities of postmodernism, the door to modernism's ambitious engagements and action-agendas can open again.

Let me demonstrate what I mean. In 1972 Hans Haacke exhibited *Rhinewater Purification Plant* at the Museum Haus Lange in Krefeld, Germany. The project was a matter-of-direct engagement in gray-water reclamation and an early voice from the cultural side responding to what we now understand as the ecological crisis. Even more importantly,

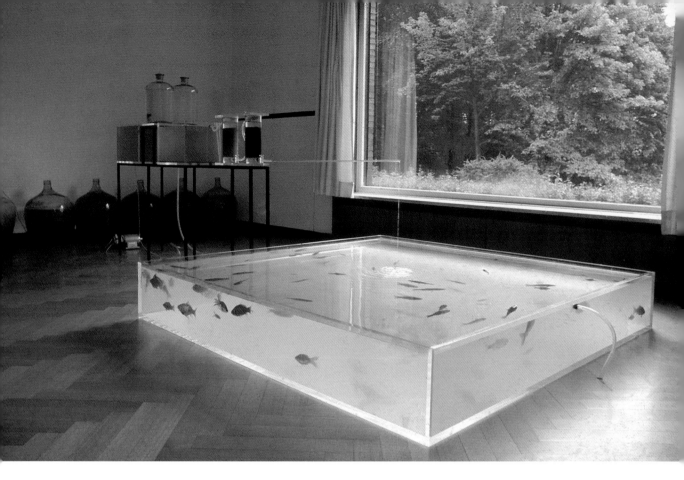

Hans Haacke, *Rhinewater Purification Plant*, 1972. Glass and acrylic containers, pump, polluted Rhine water, tubing, filters, chemicals, goldfish, and drainage to garden. Installation view, Museum Haus Lange, Krefeld, Germany. © Hans Haacke; VGBild-Kunst; Artist Rights Society (ARS), New York. Courtesy of Paula Cooper Gallery, New York.

Haacke's project was a demonstration of exactly how to use ecological science to change governmental policy. In the sense that Moholy-Nagy wanted to use design to win wars, Haacke used art to help change ecological policy in Germany, and it is fair to say that his Krefeld project played a measurable role in resetting that policy. He pumped the foul water released from the Krefeld Sewage Plant though an additional filtration system, making it clean enough for fish to thrive in, thereby making it evident that the sewage plant was itself collapsing the Rhine river's ecosystem. Haacke's project was no mere critique; it was a pragmatic, scalable, and achievable solution to a specific, wicked situation. This is to say, using Orwell's voice, the project was not merely another platitude, but a *constructive* alternative to a real ecological problem. With hindsight, it appears clear that Haacke designed not simply an artwork but a postcritical system for water reclamation. He succeeded where Moholy-Nagy failed, by merging the metrics for success from two disciplines—art and ecology—into a third, creating an instrumentalized hybrid. Is this a work of art or the pragmatics of gray-water reclamation? Answer: both.

Haacke created a codependency between disciplines with especially low alignment—art and public policy—which is exceedingly difficult to do.[18] Had it not motivated new ecological policies, *Rhinewater Purification Plant* would have been little more than an

enthusiast's science fair experiment, and had they not responded to Haacke's project, public policy makers dealing with environmental issues would have become irrelevant.

Tomás Saraceno, my second example of a postcritical artist, also knits together disciplines with low alignment. Using them as his means, he creates methods promoting their reciprocal relations. In a 2010 issue of *Artforum* I wrote, "In Saraceno's art, such collaborations [with physics, engineering, and even arachnology] result in visionary and entertaining spectacles but with hard science baked-in. Saraceno's design methodology is akin to what science historian Alex Pang called 'tinkering to the future'; it fuses customized technology with artistic innovation."[19] The example I gave was *59 Steps to Be on Air* (2003), a solar-powered vehicle capable of lifting a passenger off the ground. This was hard science—NASA, DARPA, and Lockheed Martin have long been devoted to developing solar-powered flight, but Saraceno's original research delivered a DIY model. And because it is scalable, it promises to reduce the carbon footprint of air travel. It's real science, real art, and real fun all at the same time.

My third example of the postcritical comes from Freeman Dyson, the renowned physicist and professor at Princeton's Institute for Advanced Study. Dyson envisions that in the near future artists and designers will use genomes to create new forms of plant and animal life that will proactively reverse the effects of global warming. In the *New York Review of Books* he writes:

> If the dominant science in the new Age of Wonder is biology, then the dominant art form should be the design of genomes to create new varieties of animals and plants. This art form, using the new biotechnology creatively to enhance the ancient skills of plant and animal breeders, is still struggling to be born. It must struggle against cultural barriers as well as technical difficulties, against the myth of Frankenstein as well as the reality of genetic defects and deformities. If this dream comes true, and the new art form emerges triumphant, then a new generation of artists, writing genomes as fluently as Blake and Byron wrote verses, might create an abundance of new flowers and fruit and trees and birds to enrich the ecology of our planet. Most of these artists would be amateurs, but they would be in close touch with science, like the poets of the earlier Age of Wonder.[20]

If you doubt the feasibility of the future role Dyson assigns artists and designers, pass by a local flower show and visit the hobbyists who are successfully experimenting with trigeneric orchids. Dyson is not talking about so-called Bio Art of the stripe Eduardo Kac represents with his *GFP Bunny* (2000), a green fluorescent rabbit named Alba that he produced by transgenetic manipulation. Chimerical adult mammals were first created in 1971, and Kac's rabbit is far from the kind of research Saraceno is up to. Is it fair to ask why Alba was brought into the world? According to Kac's own website, she was created to whip up a quarrel.[21] And this goes to the heart of the matter: Kac stirs up tepid sociopolitical critique by breeding a pet (Alba lived with his family), and the art world is once again reduced to a mere debating club. What's missing with Kac is precisely what's shared

László Moholy-Nagy, self-portrait, 1944. © The Moholy-Nagy Foundation; Artists Rights Society (ARS), New York.

between Haacke, Saraceno, and Dyson: postcritical, pragmatic, interdisciplinary, scalable, and achievable solutions to crisis. This is the face of the postcritical.

If artists and designers are to be postcritical, if they are to reset agendas, revise their doctrines, they will have to develop methodologies that will allow them to affect spheres of influence beyond their own, realms as diverse and yet interconnected as the environment and policy-making. They will have to be proactive, moral, and courageous. Let me give Moholy-Nagy the last word. In his essay for *War Art* he wrote, "With such an integrated training of art, science and technology, the students of the school were able to attack civilian and military tasks with courage, achieving surprising results, many of which may have good possibilities."

Notes

1. László Moholy-Nagy, quoted in Paul Betts, "New Bauhaus and School of Design, Chicago," in *Bauhaus*, ed. Jeannine Fiedler and Peter Feierabend (Cologne: Könemann, 2000), 67.
2. See in this volume, Maggie Taft, "Better Than Before: László Moholy-Nagy and the New Bauhaus in Chicago."
3. László Moholy-Nagy, quoted by Sibyl Moholy-Nagy, "Moholy-Nagy: The Chicago Years," in *Moholy-Nagy, An Anthology*, Ed. Richard Kostelanetz (New York: Praeger, 1970), 24.
4. Ibid.

5. See the IDEO website: http://www.ideo.com.

6. School of Design, "Courses in Rehabilitation: Orientation Course in Occupational Therapy," 2, Institute of Design Records, Illinois Institute of Technology.

7. See Paul A. Boghossian, *Fear of Knowledge: Against Relativism and Constructivism* (Oxford: Clarendon Press, 2009).

8. Tim Brown, "Design Thinking," *Harvard Business Review* (June 2008), 84–92.

9. United States Army, *Field Manual 5-0, The Operations Process (Final Approved Draft)* (Washington, DC: Headquarters, Department of the Army, 2010), 3-1.

10. Lt. Gen. William B. Caldwell IV, "Foreword," in Jack Kem, *Design: Tools of the Trade* (Leavenworth: US Army Command and General Staff College, 2009), iii.

11. Colonel Stefan J. Banach, "The Art of Design: A Design Methodology," *Military Review* (March–April 2009), 105. http://usacac.army.mil/CAC2/MilitaryReview/Archives/English/MilitaryReview__20090430__art016.pdf.

12. See SAMS blog, http://usacac.army.mil/CAC2/blog/blogs/sams/archive/2010/02/04/improving-the-army-s-design-approach.aspx.

13. Bruno Latour, "Why Has Critique Run out of Steam? From Matters of Fact to Matters of Concern," *Critical Inquiry* 30, no. 2 (2004): 225–48, http://www.uchicago.edu/research/jnl-crit-inq/issues/v30/30n2.Latour.html.

14. I take up this subject in greater detail in my essay "Fail Again. Fail Better," in *Learning Mind: Experience into Art*, ed. Jacquelynn Baas and Mary Jane Jacob (Berkeley: University of California Press, 2009).

15. Theodor Adorno, "Kulturkritik und Gesellschaft" (Cultural Criticism and Society, 1951), in *Prisms*, trans. Samuel and Shierry Weber (Cambridge, MA: MIT Press, 1981).

16. George Orwell, "Charles Dickens," in *Critical Essays*, ed. George Packer, (London: Harvil Secker, 2009), 4–5.

17. Rolf Hughes and Ronald Jones, "Modern 2.0: Post-Criticality and Transdisciplinarity," in *Transdisciplinary Knowledge Production in Architecture and Urbanism: Towards Hybrid Modes of Inquiry*, ed. Nel Janssens and Isabelle Doucet (New York: Springer-Verlag, 2011).

18. See Lee Fleming, "Perfecting Cross Pollination," *Harvard Business Review* (September 2004), 1–2.

19. Ronald Jones, "Tomás Saraceno," *Artforum* (May 2010), 168.

20. Freeman Dyson, "When Science and Poetry Were Friends," *New York Review of Books* (August 13, 2009), http://www.nybooks.com/articles/archives/2009/aug/13/when-science-poetry-were-friends/.

21. See *Bio Art*, http://www.ekac.org/transgenicindex.html.

Designers in Film: Goldsholl Associates, the Avant-Garde, and Midcentury Advertising Films

AMY BESTE

In the late 1950s and 1960s, a small design firm in America's heartland played a key role in bringing the aesthetics and ethos of the European avant-garde to advertising films. Headed by Morton Goldsholl with assistance from his wife Mildred (Millie), Chicago-based Goldsholl Design Associates made a name for itself with its "designs-in-film"— playful, constructivist collages, stylized graphic animation, and dazzling light displays in spectacular industrial films, television ads, title sequences, and short independent art films.[1] The couple's experimentation with form and exploration of collage and abstraction reflected the their training at the Bauhaus-inspired School of Design in Chicago—one of the first educational institutions in the United States to teach film within the context of art and design. From the time the Goldsholls began making films in the late 1950s through the 1980s, their work reached millions of viewers in conference rooms, living rooms, and film festivals across the country. Additionally, through numerous lectures, speeches, and the organization of key design conferences and film festivals, Morton and Millie spread their aesthetic vision and philosophy about media, as shaped by their formative years at the School of Design, to a generation of designers and art directors around the world.

In spite of their importance to design and moving-image advertising, the Goldsholls are virtually unknown today. Yet even before they moved into motion picture production in the late 1950s, Morton and Millie were widely respected designers. Their studio's work was regularly featured in design and trade journals like *Graphis*, *Print,* and *Business Screen* and often with distinction; when Morton retired in the early 1990s, he had amassed nearly 450 awards from across the film and design industries. Morton opened the duo's first office in 1941 after attending the School of Design, designing print materials for forward-looking clients like the Container Corporation of America, Paul Theobald Press, the Society for Typographic Arts, and the Museum of Modern

Art's ongoing *Good Design* exhibitions.[2] In 1955 the Goldsholls formed Goldsholl and Associates, expanding their business to take on logos, letterheads, company insignias, packaging, and even products for major corporations like Motorola (the Motorola *M*), Kimberly-Clark, IMC (International Minerals & Chemicals Corporation), and Martin-Senour Paints. Through their work for these clients, the Goldsholls designed countless everyday objects and, in addition to their efforts in film, pioneered both products (including an electronic paint-mixing machine, the precursor of the computerized versions now found in every local paint store) and whole new approaches to design, including the nascent field of corporate identity.

In light of these accomplishments, what factors have led to the Goldsholls' omission from both film and design histories? There are several possible explanations. Goldsholl Associates was a small, independent studio that worked in numerous media. While ubiquitous, the majority of its output was also highly ephemeral—many of the studio's films, print pieces, and package designs were in circulation only briefly—unlike the work of their better-known designer counterparts like Saul Bass, who made titles for popular Hollywood films, or Charles and Ray Eames, who also produced furniture. While Morton and Millie actively promoted the studio's work in exhibition monographs and trade journals, as a small studio in the Midwest, they did not have access to the same resources or design community as their peers in New York or Los Angeles. Finally, after Morton's death in 1995, the archive was neglected. The couple's motion pictures, particularly those from the late 1950s and early 1960s, were largely unavailable to the public until the Chicago Film Archives acquired a selection of their work in 2009, creating an opportunity to reassess their legacy.

This essay is an effort to recuperate the history of the Goldsholls and their contribution to midcentury moving-image culture. It is also an attempt to illuminate a forgotten chapter in the history of media education, one that directly connects the European avant-garde's revolutionary ideas about motion pictures to the business and advertising culture of the American Midwest. The Goldsholls were trained by the Hungarian artist, designer, and educator László Mohly-Nagy, widely recognized as the Bauhaus's foremost thinker on film and related media. When Moholy-Nagy founded the New Bauhaus in 1937 as the American iteration of the famed German Bauhaus, he incorporated many of his ideas about motion pictures into the curriculum.

While the connections between European modernism and midcentury American design, print advertising, and architecture have been taken up in numerous books and essays, the influence of the European avant-garde's aesthetics and philosophies on American advertising, sales, and public relations films (and related moving-image media like television) has been, for the most part, overlooked.[3] Additionally, histories of design generally view the American adoption of European avant-garde aesthetics as one largely of style, shorn of the revolutionary or socially oriented politics they had originally served.[4] The example of the Goldsholls provides an opportunity to reexamine the nuances of the relation between avant-garde and commercial forms of media. Their films not only serve as an important link between the European avant-garde and American motion picture industries but provide insight into some of the ways the designers used the medium to

reconcile the social and political aims of the Bauhaus while working in a rapidly growing multinational corporate environment.

I begin this reassessment of the Goldsholls, their aesthetic lineage, and their legacy by first exploring how ideas about motion pictures that circulated through the School of Design's curriculum in the late 1930s and early 1940s. Then I consider several of the studio's early films to examine the ways in which they were shaped methodologically, aesthetically, and philosophically by their training with Moholy-Nagy. Finally, I'll examine two interrelated projects they produced—the 1959 International Design Conference in Aspen and a 1960 public relations film for the paper company Kimberly-Clark, titled *Faces and Fortunes*. While the projects solidified the couple's reputations as "designers-in-film," they also represent a turning point in the Goldsholls' relationship to their profession, big business, and their training. In doing so, they demonstrate some of the ways the Goldsholls attempted to negotiate the lessons of their avant-garde education within a changing corporate climate.

László Moholy-Nagy and Film at the School of Design

When the Goldsholls enrolled at the School of Design in the early 1940s, they expected to learn the basic skills for a professional career in the industrial arts: drawing, drafting, and layout.[5] Instead, they encountered a vibrant, hands-on institution where students were introduced to an array of materials and approaches, from weaving to industrial plastics, as well as a wide range of art and design practices, including motion pictures.[6] The school characterized film as a kind of modern *Gesamtkunstwerk*. Within the curriculum, the medium was positioned as an extension of the photographic and commercial arts.[7] More informally, however, it touched nearly all aspects of the institution. Faculty wove discussions of cinema throughout the curriculum, integrating its examination into a broader exploration of art and design. They also hosted regular screenings, many with established avant-garde artists and filmmakers, such as Fernand Léger, Luis Buñuel, and Salvador Dalí, who discussed their works for both students and members of the public.[8] The school also used motion pictures as a promotional medium, showcasing its pedagogical approach and students' work in a series of lecture films tailored to potential funders and attendees. It even took early advantage of television, broadcasting information on Chicago's first commercial TV station in 1944.[9]

Film's strong presence at the School of Design was due to its founder, László Moholy-Nagy, who had long been interested in the medium. Moholy-Nagy had begun to experiment with graphic, photocollaged film scripts, first in Berlin and then while on faculty at the Weimar Bauhaus in the early 1920s.[10] He moved into actual filmmaking at the end of the decade, producing a series of dynamic urban portraits of Marseilles, Berlin, and a nomadic Roma tribe, as well as an abstract film, recording the reflections and refractions cast by his famous kinetic sculpture, the *Light-Space Modulator*.[11] He started writing extensively about film during this same period, publishing critical reviews and theoretical essays in both avant-garde journals like *i10 International Revue, Kokunk*, and *Telehor* and books, including the Bauhaus publication *Malerei, Fotographie, Film* (Painting, Photogra-

László Moholy-Nagy, *Ein Lichtspiel schwarz weiss grau* (Lightplay black white gray), 1930. Composite of film stills. © The Moholy-Nagy Foundation; Artists Rights Society (ARS), New York.

phy, and Film) (1925). By the early 1930s Moholy-Nagy had even begun to envision an experimental film studio where artists and commercial filmmakers would work together to explore new possibilities for motion pictures, including, for example, the impact of color on viewer emotion, the technical requirements for 360-degree projection, and screen formats like gauze, paper, and even water vapor.[12]

Like many within the avant-garde circles he traveled in Europe, Moholy-Nagy believed film to be the "medium of the century." Built from technologies of the modern mechanical age, motion pictures could both capture and express the dynamic new world that those same technologies had produced. More radically, he viewed film as a revolutionary perceptual and communications tool. "[It] will enlarge not merely the visual and acoustic capacities of mankind," he proclaimed in 1930, "but also his consciousness."[13] Moholy-Nagy's particular conception of film took shape through two interrelated ideas. First, he understood film to be, like all the photographic arts, essentially a medium of light. Manipulation of its photosensitive qualities—whether through camera techniques (changes in exposure, shutter timing, etc.) or direct treatment of the film emul-

sion (as in the production of photograms)—could produce new modes of depicting and potentially comprehending the objective world. Similarly, when projected, film's luminescence could act directly on the senses of the viewer, transforming both perception and the experience of space itself. Second, Moholy-Nagy believed film's essential characteristic to be that of assemblage, which provided the motion picture with both "its form and substance."[14] Drawing photomontage, typophotography, and filmmaking into close relation, he argued that the process of film editing could be understood as the extension of collage into time. Montage brought disparate parts into a dynamic interrelationship, communicating new and ever-shifting visual, intellectual, and even emotional associations between objects, people, and places for his viewers. Moholy-Nagy eventually dubbed this process "vision in motion," the title of his last book and the summation of his views on art and design in the modern world.[15]

Moholy-Nagy saw the founding of the School of Design as an opportunity to establish the experimental film laboratory he had envisioned throughout the decade.[16] While he saw great aesthetic and social potential in the moving image, he found the commercial pictures dominating local movie houses to be severely limited in both form and content. As a corrective, he hoped to train his students to be the innovative successors to the industry. He placed motion picture study at the center of a curriculum that ranged from the formal study of light to the advertising arts, emphasizing both its possibilities as an aesthetic medium and its potential as a dynamic mass communications tool. In their course of study, students produced photograms, light-space modulators, and photographs of light to examine the effect of light and shadow on the representation and perception of space. They also created typographic and photographic collages, exploring new possibilities for the shape and efficiency of advertising and public service messages.

While limited funds for film equipment and supplies at the newly formed school initially prevented full-fledged courses in production, faculty encouraged students to make motion pictures with their own equipment as an extension of their coursework.[17] The Goldsholls themselves experimented in this fashion, applying lessons in light and collage to their own amateur efforts. In one surviving fragment from 1942, the two transform vacation footage shot in Union Pier, a resort town on the banks of Lake Michigan, into a dynamic set piece with multiple camera angles, slow motion, and negative and positive imagery.[18] When the school was finally able to secure funding for a production class in 1942, it cast its pedagogy as distinctly avant-garde. The catalog for the 1941–1942 academic year announced that because the school was "convinced that fruitful film work and a healthy development of the motion picture can be achieved only when the compromises of the commercial film are overcome," it would "offer fundamental training and opportunities for research" in order to "continue the avant-garde work which has been so essential in making the film a prominent part in the search for contemporary expression."[19]

For Moholy-Nagy, experimentation was not, however, an end to itself. Film's true potential lay in its ability to "remodel through vision in motion the modes of perception and feeling and to prepare for new qualities of living."[20] Following the ethos of

the original Bauhaus, Moholy-Nagy insisted that the artist-designer must be deeply engaged with the world. His or her purpose was not oriented toward the finite demands of one particular design problem or client but toward the improvement of society at large. Arguing that "the healthy function of a man's body, his social performance and welfare, his nutrition, clothing and housing needs, his intellectual pursuits and emotional requirements, his recreation and leisure, should be the center of [our] endeavors" at the School of Design, he emphasized a practice that would bring people into harmonious relation with themselves, each other, and the objects and environments around them.[21] For Moholy-Nagy, all of these efforts ultimately converged into one great design problem: reorienting contemporary society through the intellect and the senses—sight, touch, spatial perception—to a new, revolutionary gestalt. In this effort, he saw film as "sensuous and moral instruction for the eye,"[22] an essential component in what he came to call a "design for life."[23]

The Goldsholls

The Goldsholls' move into motion pictures in 1957 was both an outgrowth of their time at the School of the Design and an ambition toward which they had been working their entire careers. In dozens of articles and interviews, the two characterized the school's pedagogy as fundamental to the direction of their practice. It was there, as a 1958 profile in *Print* acknowledged, that they "realized that film . . . was the most potent means by which designers could reach people."

The school's milieu inspired Morton and Millie's far-ranging interest in the medium even before they actually began making films. Throughout the 1940s and 1950s, as Morton was solidifying the studio's reputation in the design world, the Goldsholls also began to establish themselves in Chicago's film scene. They attended showings of experimental, animated, documentary, and advertising films, cultivated relationships with the city's filmmakers and technicians (the first design award Morton received was for the letterhead he created for the filmmaker Haskell Wexler), and organized screenings for film societies, design groups, and the general public. Through these efforts, the Goldsholls effectively extended the environment they had experienced at the School of Design to the city at large.[24]

Morton and Millie's earliest films clearly reflect the experimental ethos and aesthetic principles of the school, particularly its emphasis on light. Morton had begun his own experiments with light as a student, crafting luminous collages of organic material, including "feathers, decayed leaves, cotton fibers, [and] little scraps of pure gelatin color" on clear 35-millimeter slides. In later years, he began making photographs of the geometric light trails traced by swinging flashlights and lightbulbs, which he eventually incorporated into design projects for his clients.[25] The Goldsholls' first film, *Night Driving,* produced in 1957, similarly evolved as a photographic exploration of automobile lights on a commercial highway strip. Shot by Millie with a long lens and multiple exposures, the film considers the transformative potential of light in both subject matter and tech-

night driving

Morton and Millie Goldsholl,
Night Driving, 1957. Composite
of film stills. Courtesy of the
Goldsholl Estate and Chicago
Film Archives.

nique. Neon advertisements become washes of color; restaurant signs become streaking light trails; and automobile lights become syncopated red-, blue-, and yellow-tinged orbs. Cut to the driving rhythms of music by Bill Haley and the Comets, *Night Driving* both expresses the midcentury suburban American environment—built for and experienced from the automobile—and elevates it, transforming the strip's crass commercialism into a dazzling kinetic display.

Morton and Millie Goldsholl, *Mag*, 1959. Composite of film stills. Courtesy of the Goldsholl Estate and Chicago Film Archives.

When the Goldsholls began making motion pictures in the late 1950s, businesses were increasingly turning to the moving image to sell both specific products and brand image to trade and general audiences. Indeed, Chicago itself had become a major center for the production of business films. By the mid 1950s the city was home to nearly a hundred production companies, the majority of which produced promotional, public relations, advertising, and training films for industry and business use.[26] As Chicago

gained a reputation as the "Hollywood" of industrial filmmaking, more companies turned to producers in the city for their expertise. Accordingly, the Goldsholls split production between short, independently financed art films—like *Night Driving*—and design-oriented business films often for clients whom they had already cultivated for other projects. The couple had found that these companies were attracted by the medium's potential to explain complicated industrial processes and demonstrate products, as well as the opportunity to extend their message's life and reach. In 1954 the National Association of Advertisers estimated that business films circulated, on average, for two to five years (as opposed to a few months for print campaigns) and among a wide range of venues, from trade shows and business meetings to professional clubs and even high school and university classrooms.[27] Capitalizing on this outlook, the Goldsholls often pitched their films to clients they had already cultivated as innovative corollaries to print campaigns.[28]

While light played an important role in the Goldsholls' filmmaking practice, the defining aspect of their early client-driven films was assemblage, a method and style the couple developed after *Night Driving*.[29] As with light, their interest in assemblage had taken root at the School of Design. Morton produced photocollages and typophotographs in his advertising arts classes, learning to convey dynamic messages of product reliability for hypothetical manufacturing businesses.[30] Afterward, he consistently utilized the approach in designs for clients, often juxtaposing eighteenth- and nineteenth-century print imagery, blocks of primary colors, graphic forms, and floating lines of type to create visually and intellectually rich communications.

The Goldsholls viewed their move into motion pictures as an opportunity to extend these ideas into time. In their early sales and public relations films, the two animated collages of paper cutouts and real-world objects to create dynamic product demonstration sequences and abstract interludes. Like their mentor Moholy-Nagy, they were most interested in their ability to draw objects and images into new relations. "It is not so much in the components of the film structure that its art resides," noted Millie in an early 1960s article about their studio, "but rather in *relationships, interaction and transitions* that it assumes its significance. In [assembling a film], the film maker gives wings to the parts . . . cleaving them from their place in time and space . . . releasing them into a designer's stratosphere there to be juggled, taken, rejected, extended, clipped, superimposed, and recomposed. A new *'relativity'* is shaped, evolving out of the theme of the film."[31] For Morton and Millie, their moving-image assemblages allowed them to craft new, thematically based worlds for their viewers. In these first films, they repurposed the chaotic visual material of everyday life into a bright and exciting "gestalt," providing their audiences with—in their words—a "lift to their eyes, ears, psyches, and intellects."[32]

The International Design Conference in Aspen and *Faces and Fortunes*

In 1959 and 1960 the Goldsholls embarked on two projects that secured their reputations—and their legacy—as designers-in-film. First, they organized the 1959 Interna-

Morton and Millie Goldsholl, *Faces and Fortunes*, 1960. Composite of film stills. Courtesy of the Goldsholl Estate and Chicago Film Archives.

tional Design Conference in Aspen (an important annual gathering of design heavyweights), which proved to be a zeitgeist moment in the history of advertising, marking the field's movement into moving pictures. Second, they produced a motion picture for the Kimberly-Clark Corporation entitled *Faces and Fortunes* (1960), the most aesthetically and professionally ambitious film of their early career, sweeping awards, attracting press, and garnering important new business. While both projects drew upon lessons the couple

had first encountered at the School of Design, they are also evidence of the Goldsholls' growing ambivalence about their relationship to big business and hint at some of the strategies they turned to in film to realize the social imperatives of the Bauhaus while working in a rapidly expanding corporate environment.

The Goldsholls had been involved with the International Design Conference in Aspen (IDCA) for several years when the organization asked Morton to oversee its ninth annual event. Founded in 1951, the conference was a major meeting ground for artists, designers, intellectuals, and business leaders and functioned as an important barometer for the design field.[33] Drawing upon their long interest in and recent move into filmmaking, Morton, with Millie, used the appointment as an opportunity to organize a major part of the conference as a comprehensive dialogue about film and its relationship to design—the first time the IDCA had seriously addressed the medium. They invited speakers from all facets of the motion picture and design industries, including Saul Bass, CBS creative director William Golden, experimental filmmaker and animator Norman McLaren, commercial producer Jerry Schnitzer, documentary photographer and filmmaker Roman Vishniak, and French film theorist Gilbert Cohen-Seat, among hundreds of attendees.[34] In addition, Millie organized a six-day series of screenings, featuring short documentaries, public relations films, television ads, title sequences, animated shorts, and experimental films from around the world.[35] In effect, the Goldsholls devised a crash course regarding the possibilities of the midcentury moving image.[36]

The couple's focus on film at IDCA '59 was a landmark moment for the field. The conference attracted one of its largest audiences to date, including many graphic designers who had never before attended.[37] It signaled the start of an extensive reorientation of the graphic design and advertising industries toward the moving image, as designers moved into positions as art directors, producers, and directors in newly formed advertising film departments throughout the 1960s. The conference also marked a major change in the aesthetics of motion picture advertising, particularly on television. As TV historian Lynn Spigel has argued, IDCA '59 marked a shift in televisual style, away from the "static talky feel of 1950s demonstrational ads" to advertising that demonstrated more visual panache and aesthetic experimentation, exemplified by "montage sequences, moving camera, mood lighting, location sets, and/or color photography."[38] The shift, in other words, was toward a wide adoption of the techniques and approaches of the avant-garde and art cinema traditions the Goldsholls had featured in their organization of the event.

Following the close of IDCA '59, the Goldsholls began work on *Faces and Fortunes*, their most professionally and aesthetically ambitious film from this early period. The picture was the outgrowth of a major redesign undertaken by the burgeoning multinational Kimberly-Clark Corporation to reposition itself as a leader in fine business papers after adding three large stationery producers to its portfolio.[39] Marketed to businesses, clubs, designers, and commercial artists, the film helped Kimberly Clark both to clarify the concepts behind the production of corporate identity and to sell its business papers as an important component in that endeavor. Morton had played a central role in the entire

project, designing advertising and packaging and even advising on production processes in addition to producing the film.

By the time of the film's release in 1960, much of the studio's work was already directed toward the nascent field of corporate identity. The Goldsholls had entered the field of corporate design in part with the belief that it was within corporations that designers could have the most immediate social impact, potentially answering Moholy-Nagy's call to "design-for-life." Corporate work provided Morton with an opportunity to influence the lives of the worker, the consumer, and the company itself. "The designer can ... help build what is now called corporate culture," he argued. "[Designers] are important participants in the means of production and very close to the leaders of the process."[40] Yet despite Morton's attraction to corporate design for its tangible applications, the majority of the Goldsholls' work in the field centered around the production of the corporate image, organizing the many ideas their clients hoped to project about themselves into a syncretic, comprehensible whole.

Faces and Fortunes drew upon Morton's deep engagement with and research into corporate design. It opens by tracing the development of corporate identity from medieval heraldry to midcentury trademarks, laying out an argument for the importance of a coordinated system of identification symbols. The film goes on to stress the necessity for a company to develop a coherent "personality"—the total impression it makes on the public through its products, advertising, customer, and public relations. After demonstrating the symbolic relationship between a company and its public mark, the film closes with a pitch: "Put your best face forward—your corporate face may be your fortune!" In the process, *Faces and Fortunes* unspools a visual tour de force featuring fifteenth-century woodblock prints collaged with abstract forms, marks scratched directly into the film emulsion, stylized animation, and a stop-motion assemblage of real-world objects.

At the center of the film is a section illustrating the function of "modern day heraldry." Quick shots of industry in action—a speeding long-haul truck, a crane loading cargo onto a ship, and moving machinery—are intercut with moving shots of office buildings, men unloading boxes, women at store counters, and letterhead, envelopes, and brochures. Each shot begins frenetically, emphasizing movement and speed, until each is stamped—and stopped—with an anonymous red dot. Applied to trucks, office buildings, and clothing, the dots render what was once visual chaos into visual order. They link seemingly disparate shots into a new whole and create sensibility and meaning where none existed before. In fact, the entire sequence operates as an object lesson, teaching viewers to see the world anew. In the world that *Faces and Fortunes* depicts, the viewer is reoriented to a visual landscape that brings the corporation's face into focus. In creating this vision, the Goldsholls—who were deeply invested in their mentor's socially progressive aims—actually demonstrate the ease with which a modernist aesthetic can be redirected from the social and political goals of the avant-garde toward corporate branding and global consumerism.

During the period in which the Goldsholls were preparing to make *Faces and Fortunes*—and as they were solidifying their own reputation as leaders in the field of corpo-

rate design—they had also begun to register a growing anxiety among designers about the field's relationship to big business, particularly in the construction of the corporate-focused visual landscape their film illustrates. Indeed, as the intellectual historian James Sloan Allen notes, belief in the possibility of the socially oriented "progressive corporation" had begun to fade by the end of the 1950s, in the wake of persistent news coverage implicating big business in social corruption and environmental disaster.[41] In fact, this theme had played out at IDCA '59 as an undercurrent to the main proceedings. The intellectual Lancelot Hogben had diagnosed the conference as suffering from a malaise of "guilt by association."[42] This malaise sharpened into critique during a presentation by the designer and consultant James Real. Real launched an attack on the very practice of corporate design, arguing that the corporate image gestalt that designers helped to produce was actually a façade that concealed potentially damaging economic and environmental practices. He asked his colleagues whether the modern designer is actually improving the world, "or is he building masks, behind which the verities and strengths of the free society are slowly eroding away?"[43]

While it might be possible to read the modern-day heraldry sequence in *Faces and Fortunes* as an abandonment of modernist principles, I want to suggest another possibility. The sequence can also be understood to reveal the ways the film both responds to Real's critique and engages a new set of strategies that the Goldsholls deployed in an effort to reconcile their role in the industry of corporate image-making with the socially oriented imperatives of their modernist training, particularly as the studio moved into the 1960s. Even as the film employs a modernist aesthetic to visually remap the world along corporate lines, it does so within the context of audiovisual instruction. As *Faces and Fortunes* teaches its viewers how to create the corporate image gestalt, it also dismantles that image as a construction. By breaking down the process of corporate-image production, the film arms its viewers with critical tools to see through the veneered edifice big business had begun to erect, and past the trademark to the structure that puts the mark in place. While this particular lesson would not have meant much to the members of the business trade to whom the film was initially marketed, the film was eventually distributed by the Goldsholls to schools, universities, and the general public, where it would come to have a very different impact.[44] In fact, after the production of *Faces and Fortunes*, instruction and education—some of it around themes of social consciousness—played an increasingly important role in the Goldsholls' productions, to the point where the studio eventually opened an educational division in the early 1970s.

• • •

Faces and Fortunes was hailed as a success, winning more awards from industry groups than any of the Goldsholls' other early motion pictures, and acclaimed in the trade journals for its witty compositions and smart script.[45] Its achievement firmly established the duo's standing as "designers in film," whose creative approaches to complicated messages yielded effective and exciting results.[46] Four years after the film's production, the National Society of Art Directors named Morton Goldsholl art director of the year, one of the field's highest honors, in large part because of his work with the moving image.[47]

In its aesthetic, interpretative possibilities, and its financial and critical success, *Faces and Fortunes* can be viewed as a kind of précis of the Goldsholls' involvement with motion pictures. Deeply influenced by Moholy-Nagy's conception of film and his call to social engagement—approaches the artist had first formulated within the context of Europe's avant-garde in the 1920s and 1930s—Morton and Millie found themselves working in a vastly different environment in the United States at midcentury. Even as their work had a major impact on the design field, they, like many other designers, began to question the politics of producing a corporate-funded visual landscape. Their move into filmmaking coincided with a growing ambivalence about the relation between design and big business. But, rather than representing an aesthetic or philosophical impasse, this provided the couple with an opportunity to adopt and adapt the aesthetic principles they had learned at the School of Design to new ends. Throughout the 1960s, 1970s, and 1980s, the Goldsholls' studio continued to produce innovative films and TV spots for clients while also developing educational pictures and its own self-financed experimental films.

The Goldsholls' career also suggests the many avenues the European avant-garde took into the everyday visual environment of the United States at midcentury. Specifically, their work points to the potentially broad influence of Moholy-Nagy's program at the School of Design. The Goldsholls are likely not the only "designers-in-film" to have emerged from the school. New historical research, I believe, can point to additional links between the School of Design and commercial filmmaking. Such work is also likely to reveal new information about Moholy-Nagy's influence on American media production.[48] And beyond Moholy-Nagy, the circuitous role the European avant-garde likely played in the increased social consciousness and cultural upheaval in the US in the 1960s and 1970s, is seen through such unlikely avenues as the business film, educational pictures, or TV advertising. This essay endeavors to be part of the effort toward charting the reverberating impact of the School of Design and Moholy-Nagy's own vision for moving images throughout the visual landscape of the latter half of the twentieth century.

Notes

1. See, for example, "Designers in Film," *Print* 11(1958): 33.

2. Both Morton and Millie enrolled at the School of Design in 1939—Millie in the full-time degree program and Morton in the part-time evening program so that he could continue working to support them. Alumni records indicate that Millie graduated in 1945. Morton maintained a connection with the school through this period, even after he was no longer taking classes. "Institute of Design Alumni List," (n.d.), Institute of Design Collection, Daley Library Special Collections, University of Illinois at Chicago; Robert L. Even, "Transcripts of Interviews for Chicago Design: A Video Documentary of Influencial Designers in Post–WW II Chicago, Part II, Series V: Morton Goldsholl" (Chicago: Northern Illinois University School of Art, 1992), Robert L. Even Collection, Daley Library Special Collections, University of Illinois at Chicago.

3. Some important exceptions include Norman Klein and Amid Amidi's work on midcentury American animators, many of whom, the two argue, found inspiration for the graphic and minimalist style that came to define 1950s animated television and advertising in modernist European design journals and magazines. See Klein, *Seven Minutes: The*

Life and Death of the American Animated Cartoon (New York: Verso, 1996); Amidi, *Cartoon Modern: Style and Design in 1950s Animaton* (San Francisco: Chronicle Books, 2006).

4. For example, see Lorraine Wild, "Europeans in America," in *Graphic Design in America: A Visual Language History*, ed. Mildred Friedman and Phil Freshman (Minneapolis: Walker Art Center, 1989), 152–69; Stephen J. Eskilson, *Graphic Design: A New History* (New Haven, CT: Yale University Press, 2007).

5. As described by Morton in Even, "Transcripts of Interviews … Morton Goldsholl."

6. For a history of the School of Design and its program, see Alain Findeli, *Bauhaus de Chicago : L'oeuvre pèdagogique de Lászlò Moholy-Nagy* (Sillery, Quèbec: Septentrion, 1995); Lloyd C. Engelbrecht, *The Association of Art and Industries Background and Origins of the Bauhaus Movement in Chicago* (PhD diss., University of Chicago, 1973). On the relation between film and photography at the Institute, see Elizabeth Siegel, "Vision in Motion: Film and Photography at the Institute of Design," in *Taken by Design : Photographs from the Institute of Design, 1937-1971*, ed. David Travis, Elizabeth Siegel, and Keith F. Davis (Chicago: Art Institute of Chicago/University of Chicago Press, 2002), 214-23.

7. For example, see "The New Bauhaus: American School of Design Course Catalog," (1937–1938); "School of Design Course Catalog," (1939–1940); "School of Design Course Catalog 1942–43," (1942), Institute of Design Collection, Daley Library Special Collections, University of Illinois at Chicago.

8. Morton Goldsholl describes this atmosphere in Even, "Transcripts of Interviews … Morton Goldsholl." Also see Lloyd Engelbrecht, "Laszlo Moholy-Nagy in Chicago," in Terry Suhre, *Moholy-Nagy: A New Vision for Chicago* (Springfield: University of Illinois Press/Illinois State Museum, 1990), 32.

9. For an example of these films, see Lászlò Moholy-Nagy, "Design Workshops," (1944; Ann Arbor, MI: Moholy-Nagy Foundation, 2008). The School of Design aired its work on Balaban & Katz's WBKB TV station, only a year after its first commercial broadcasts. See letter to Murrel Fisher (Container Corporation of America) from Don Fairchild (Institute of Design), December 7, 1944, Institute of Design Collection, Daley Library Special Collections, University of Illinois at Chicago.

10. These scripts grow out of Moholy-Nagy's experiments with photomontage and typophotography. See Eleanore M. Hight, *Picturing Modernism: Moholy-Nagy and Photography in Weimar Germany* (Cambridge, MA: MIT Press, 1995).

11. Lászlò Moholy-Nagy, *Impressionen vom alten marseiller Hafen* (Impressions of Marseille's old port) (1929), *Berliner Stilleben* (Berlin Still Life) (1931), *Gross-Stadt Zigeuner* (Gypsies) (1932), and *Ein Lichtspiel Schwarz Weiss Grau* (A Lightplay black white gray) (1930). For a detailed discussion of these films, see Jan-Christopher Horak, "Laszlo Moholy-Nagy: The Constructivist Urge," in *Making Images Move: Photographers and Avant-Garde Cinema* (Washington, DC: Smithsonian Institution Press, 1997), and Hight, *Moholy-Nagy: Photography and Film in Weimar Germany* (Wellesley, MA: Wellesley College Museum, 1985), 109–35.

12. See Lászlò Moholy-Nagy, "Problems of the Modern Film," *Korunk*, no. 10 (1930), reprinted in Richard Kostelanetz, ed., *Moholy-Nagy* (New York: Praeger, 1970), 131–38; Lászlò Moholy-Nagy, "An Open Letter," *Sight & Sound* 3, no. 10 (1932), reprinted in Moholy-Nagy, *Vision in Motion* (Chicago: Paul Theobald, 1947), 272–75.

13. Lászlò Moholy-Nagy, "Problems of the Modern Film," in Kostelanetz, *Moholy-Nagy*, 135.

14. Moholy-Nagy, *Vision in Motion*, 280.

15. Ibid., 68, 267–68.

16. The school opened as the New Bauhaus in 1937, then closed, reorganized, and reopened as the School of Design in 1939. It changed its name to the Institute of Design in 1944.

17. Elizabeth Siegel, "Interview with Myron Kozman" (1999), Department of Photography, Art Institute of Chicago; Even, "Transcripts of Interviews … Morton Goldsholl."

18. Mildred Goldsholl and Morton Goldsholl, *Union Pier Experiments* (1942), Goldsholl Collection, Chicago Film Archives.

19. "School of Design Course Catalog 1942–43."

20. Moholy-Nagy, *Vision in Motion*, 58.

21. Ibid., 64.

22. Lászlò Moholy-Nagy, "New Film Experiments," *Korunk*, no. 3 (1933), reprinted in Krisztina Passuth and Lászlò Moholy-Nagy, *Moholy-Nagy* (New York: Thames and Hudson, 1985), 320.

23. Moholy-Nagy, *Vision in Motion*, 42.

24. See Morton Goldsholl, *Inside Design: A Review, 40 Years of Work*, 1st ed. (Tokyo: Graphic-sha, 1987), 71.

25. Even, "Transcripts of Interviews … Morton Goldsholl." See also a column in *Print* on Goldsholl's experiments with light and an advertisement for Kimberly-Clark Texoprint paper in the same magazine: "Trends," *Print* (February 1957), 64; "Texoprint Science + Beauty," *Print* (June 1957), n.p.

26. Terri Schultz, "'Toddlin Town' Is the Place, Most Film Makers Agree," *Chicago Tribune* (March 12, 1970), S8. For more on this history, see Anthony Slide, *Before Video: A History of the Non-Theatrical Film* (New York: Greenwood Press, 1992), 19–32.

27. *The Dollars and Sense of Business Films* (New York: Association of National Advertisers, 1954), 21, 25.

28. This practice was outlined by filmmaker and animator Larry Janiak, who worked for the Goldsholls in the late 1950s and early 1960s. Janiak, interview with author, Chicago, April 27, 2010.

29. Shortly afer the Goldsholls began producing client-driven films, the couple hired Larry Janiak and Wayne Boyer, two local filmmakers and animators who had studied at the Institute of Design in the mid-1950s as assistants. By all accounts, Morton and Millie maintained creative control over all projects, but encouraged Janiak and Boyer to experiment with new techniques and approaches. Janiak worked for the Goldsholls from 1959 to 1962 and again from 1964 to 1972, Boyer from 1958 to 1965. Janiak, interview with author; Boyer, interview with author, Evanston, IL, April 14, 2010.

30. Morton Goldsholl's early experiments were featured in his professor György Kepes's 1944 primer on the approach to visual design taught by the school. Kepes, *Language of Vision* (Chicago: Paul Theobald, 1944), 98, 221.

31. Rhodes Patterson, "Morton Goldsholl Design Associates," *Communication Arts Magazine* (July/August 1963), 43.

32. "Designers in Film," 35.

33. The conference was founded by the visionary industrialist Walter Paepcke, head of the Container Corporation of America and a funder of the School of Design, Egbert Jacobson, the director of design at the Container Corporation, and former Bauhaus artist and architect Herbert Bayer.

34. "The Ninth Annual International Design Conference in Aspen Conference Papers" (1959), International Design Conference in Aspen Papers, Daley Libary Special Collections, University of Illinois at Chicago.

35. Films included *Information Machine* (Charles and Ray Eames, 1958), *At Land* (Maya Deren, 1944), *Bridges Go Round* (Shirley Clark, 1958), *Blinkety Blank* (Norman McLaren, 1955), *Cats Et Al.* (Robert Breer, 1958), *Title to Man with the Golden Arm* (Saul Bass), *In the Street* (James Agee and Helen Levitt, 1945), *Night Mail* (Harry Watt and Basil Wright, 1936), and *Paths of Glory* (Stanley Kubrick, 1957), among many others. Millie Goldsholl, "Report on Film Program" (June 1959), n.p. International Design Conference in Aspen Papers, Daley Library Special Collections, University of Illinois at Chicago.

36. *Report: Ninth International Design Conference in Aspen* (Chicago: IDCA, 1959), 42–43. International Design Conference in Aspen Papers, Daley Library Special Collections, University of Illinois at Chicago.

37. Even, "Transcripts of Interviews ... Morton Goldsholl."

38. Lynn Spigel, *TV by Design: Modern Art and the Rise of Network Television* (Chicago: University of Chicago Press, 2008), 217.

39. The redesign was helmed by the Goldsholls and Saul Bass. *Faces and Fortunes* was directed by the Goldsholls with assistance from Bass, who, while mentioned in articles on and advertising for the film, is uncredited. See H. U. Hoffman, "Corporate Design Programs: Kimberly Clark," *Print* 14 (1960): 39.

40. Goldsholl, *Inside Design*, 6.

41. James Sloan Allen, *The Romance of Commerce and Culture: Capitalism, Modernism, and the Chicago-Aspen Crusade for Cultural Reform* (Chicago: University of Chicago Press, 1983), 278.

42. *Report: Ninth International Design Conference in Aspen*, 49.

43. James Real, "Image or Facade?" in *The Aspen Papers: Twenty Years of Design Theory from the International Design Conference in Aspen*, ed. Reynor Banham (New York: Praeger, 1974), 97.

44. For example, the film is advertised in *Educational Screen*'s 1961 *AudioVisual Guide* under "Cinema Arts and Communication Arts," *Educational Screen* (June 1961), 311. It is also listed in *Educational Film/Video Locator of the Consortium of University Film Centers*, vol.1 (Ann Arbor, MI: R. R. Bowker Company, 1986), 1301. This practice was also confirmed to me by Boyer; interview with author, Evanston, IL, April 14, 2010.

45. For examples of press coverage, see "Faces and Fortunes," *Business Screen* 21, no. 7 (1960) and Hoffman, "Corporate Design Programs: Kimberly Clark," 39.

46. "Faces and Fortunes," *Business Screen* 21, no. 7 (1960).

47. Eugene M. Ettenberg, "Morton Goldsholl: Art Director of the Year," *American Artist* 28 (1964): 22–27, 70.

48. Some possible names include Norman Platt, who attended the School of Design in the mid- to late 1940s and went on, in the 1950s and 1960s, to become an important animator and art director at Encyclopaedia Britannica Films, one of the largest and most influential educational film companies in the world at the time; Robert Kostka,

who, like Platt, studied at the School of Design in the late 1940s (Kostka is known as a painter, but he began his career in 1955 as the art director for WTTW, Chicago's first public television station); and Madeline Tourtelot, an artist and gallerist who studied at the School of Design with Kostka and later made a series of important films with the musician Harry Partch. In addition, there are hundreds of artists and filmmakers who attended at the School of Design after Moholy-Nagy's death in 1946, studying with faculty, who, while influenced by Moholy-Nagy, gave new shape and character to film studies and production at the school.

Modern Mind and Typographic Modernity in György Kepes's *Language of Vision*

MICHAEL J. GOLEC

Entering the Eye

Kay Rosen, *Divisibility* (detail), 2009. Installation view, in *Learning Modern*, Sullivan Galleries, School of the Art Institute of Chicago. Artwork © Kay Rosen; courtesy of Sikkema Jenkins & Co., New York. Photo: James Prinz.

In 1944 the Hungarian émigré and School of Design instructor György Kepes (1906–2001) published *Language of Vision: Painting, Photography, Advertising-Design*. After having spent several years collaborating with his compatriot László Moholy-Nagy in Berlin and London, Kepes arrived in the United States in 1937. It was Moholy-Nagy's efforts as head of the School of Design—formally the New Bauhaus and now the Institute of Design at the Illinois Institute of Technology—that brought Kepes to Chicago and that established him as head of the Light and Color Department. He would soon depart to take other positions in Texas, in New York, and finally in Cambridge, but while he was at the School of Design, Kepes capitalized on its lablike environment. Moholy-Nagy had based the school's educational program on Bauhaus principles of foundations and specialized workshops, with, in the American context, a greater emphasis on technology and science.[2] In setting up the curriculum, he was explicit in his desire for the workshops to function like laboratories in their exploration of new materials and techniques and with an emphasis on functionalism.[3] Kepes advanced Moholy-Nagy's conception of a lablike curriculum in *Language of Vision*, yet exceeded his mentor's formulations by producing what Frederick Logan would identify as the most important book of the 1940s and 1950s that dealt with the problems of sense perception and expression in contemporary art and design. "Art teachers by the thousand," wrote Logan, "have through Kepes enriched the scope of their teaching by a larger understanding of what the contemporary artists are doing."[4] A good part of the book's success can be attributed to Kepes's focus on human adaptability to new visual surroundings and typographically saturated environments.

In 1941 Kepes had published "Entering the Eye" in *Illustration*, a magazine for advertisers, agencies, designers, and illustrators, in which he summarized, in text and image, crucial aspects of a thesis that would appear in his subsequent book. *Language of Vision* is a study in "optical communication," a culmination of experiments Kepes carried out while

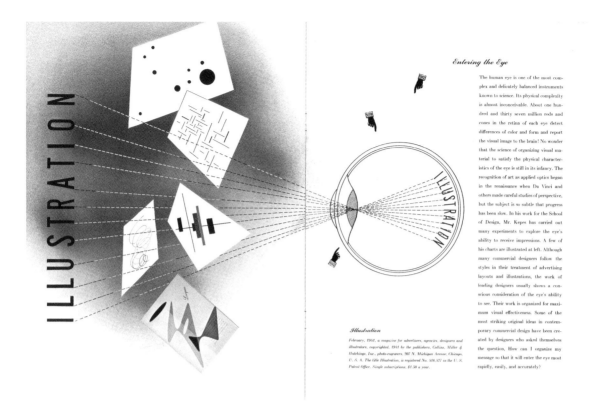

The text within the illustration reads:

Entering the Eye

The human eye is one of the most complex and delicately balanced instruments known to science. Its physical complexity is almost inconceivable. About one hundred and thirty seven million rods and cones in the retina of each eye detect differences of color and form and report the visual image to the brain! No wonder that the science of organizing visual material to satisfy the physical characteristics of the eye is still in its infancy. The recognition of art as applied optics began in the renaissance when Da Vinci and others made careful studies of perspective, but the subject is so subtle that progress has been slow. In his work for the School of Design, Mr. Kepes has carried out many experiments to explore the eye's ability to receive impressions. A few of his charts are illustrated at left. Although many commercial designers follow the styles in their treatment of advertising layouts and illustrations, the work of leading designers usually shows a conscious consideration of the eye's ability to see. Their work is organized for maximum visual effectiveness. Some of the most striking original ideas in contemporary commercial design have been created by designers who asked themselves the question, How can I organize my message so that it will enter the eye most rapidly, easily, and accurately?

Illustration

February, 1941, a magazine for advertisers, agencies, designers and illustrators, copyrighted, 1941 by the publishers, Collins, Miller & Hutchings, Inc., photo-engravers, 207 N. Michigan Avenue, Chicago, U. S. A. The title Illustration, is registered No. 418,327 in the U. S. Patent Office. Single subscriptions, $1.50 a year.

Gyorgy Kepes, *Entering the Eye*, 1941. Institute of Design Collection, IDR_0006_0172_neg27. Courtesy of *Illustration* and the University of Illinois at Chicago Library, Special Collections.

teaching at the School of Design. The article in *Illustration* spans a single two-page spread. Viewed from left to right, it features the word "illustration" running vertically and in sans serif capitals; four abstract compositions and a brochure cover for "Lacquer" floating at various angles in an airbrushed cloud; a section diagram of a human eyeball from which emanate twelve dotted lines, each linking a letter in the large "illustration" to the left to a corresponding letter, scaled down and set within the eyeball (recalling Descartes's diagram of optical perception from *La dioptrique*, 1637); three nineteenth-century, woodcut-style dingbats of pointing hands constellated around the eyeball; and two columns of type, the rightmost comprising the main text of the article. In the text, Kepes argues for the complexities of human visual perception, "applied optics," and "visual effectiveness." He states, "Some of the most striking original ideas in contemporary commercial design have been created by designers who ask themselves the question, How can I organize my message so that it will enter the eye most rapidly, easily, and accurately?" Kepes intends for the whirling compositions caught in the rays projecting from the eye to show the quick flow of visual data moving from the external environment of art and commerce to the interior of the human eye. What is crucial here is his attempt to map the penetrating nature of perception, or as he remarks, the "eye's ability to receive impressions." The plotting of things infiltrating the eye in the *Illustration* article turns to control in *Language of Vision*: "Vision is primarily a device of orientation; a means to measure and organize spatial events," he observes in the book. "The mastery of nature is intimately connected with the mastery of

LA DIOPTRIQUE

René Descartes, diagram of ocular refraction from *La dioptrique*, 1637. Courtesy of the Wellcome Library, London.

space; this is visual orientation."[5] His goal is to determine how best the modern mind can navigate an increasingly chaotic—or "formless"—modern world.

Kepes threads together elements of the human eye, the letterpress, and human psychology into a fibrillar structure; all three are present in latent or explicit forms throughout *Language of Vision* and are best summed up in the following statement: "The living fiber of our unconscious responses is given by the concrete images of the surrounding environment."[6] Fiber, concrete, and environment are terms that reinforce the positivist character of Kepes's book, a text that explicitly argues for the importance of the discernible structure of visual communications deployed in the integrated, planned, and progressive efforts of midcentury modernism. Yet, as Kepes asserts, the patterns of the observable world are mirrored in unconsciously determined patterns of behavior. The order of the unconscious replicates the order of the visible world; thus the modern mind, according to Kepes, is cast in the matrix of the "language of vision." This idea is anticipated in the "Entering the Eye" diagram, which introduces an image of this network of heterogeneous discourses.

Like Kepes's *Language of Vision*, this essay mixes studies of optics, typography, and the "modern mind," all of which are related but not reducible to one or the other. Of the three discourses present in Kepes's book, optics acts as an intermediary between typography and mind. But because Kepes intends his book, as a material object, to enact what its text prescribes—the images on its pages are to enter the reader's eye such that the book's examples penetrate his or her mind—it is helpful to use as a guide the diagram that makes up the bulk of the *Illustration* article. "Entering the Eye" provides a lens through which to read *Language of Vision*; the cutaway eyeball shows a mediating technology or transpositional device that, for Kepes, exists between language in the environment and language in the mind. Following this prompt, this essay will closely examine Kepes's proposal that an optically enhanced modern mind is structured according to the coordinates of typographic modernity. By typographic modernity, I mean the multiple grids and compositional strategies that arise in the 1920s and embody the organizational forces of modern society underwritten by the interwoven histories of mathematics, mechanical reproduction, and pictorial perspective. I argue that Kepes's emphasis on the reproducibility of visual data in the structuring of the unconscious is, for him, akin to the mechanical reproducibility of typographic modernity, exemplified by the legend "illustration" and expanded on in *Language of Vision*. Both typography and the unconscious are infinitely repeatable. For Kepes, typographic modernity is a precondition for human subjectivity. Following and anticipating typographically inflected theories of psychoanalysis, Kepes's under-

The psychological field

Subjective forces tending toward balance are manifested in the emotional and intellectual faculties as well as on the physiological level. The plastic image is an organism that reaches out to the dimensions of understanding beyond the sensory radius. The fascination of a sunset or a sunrise, the irresistible interest aroused by the ever-changing shapes and colors of flames, or the rhythmical patterns and reflections of waves on the water, have a revealing meaning. We never tire of these optical transformations which, in spite of all variations, retain their unity. We follow the innumerable mutations without any feeling of compulsion. The significant aspect of such experiences is that they mobilize wider responses, thoughts, and feelings not directly connected with the actual seen image. As a little boy is able to move a large church-bell by the rhythmical addition of one pull to another, the rhythmical order of flames or waves can induce larger and larger, wider and wider, dimensions of experience. From the perception of sensory patterns, one moves to corresponding structures in emotional and intellectual realms. The experience becomes complete. To reach balance in this wider dimension, the dynamic bases, the space-time span of the plastic experience must be secured.

The dynamic tendency to organize the optical forces into a unified whole acts within the psychological field against a background of readiness to perceive—a field of attention. Attention, however, suffers from two limitations: first, its limitation in the number of optical units it can encompass; and second, its limited duration in time of focus on one optical situation. And just as the limitations of the two-dimensional picture field serve as a necessary frame of reference to the virtual locations of the optical units, so the limitations of the psychological field serve as the necessary condition to the laws of plastic organization.

The space span of plastic organization

To be seen in a purely sensory way, an optical unit must fall on the small retinal region of clear vision; to be seen in terms of perceptual grasp, the image must fall within the limited field of the attentive act. "The process of visual organization might be considered as a figure against the background of the field of consciousness. In the blurred general field an area of clearness and intensity is formed—the field of attention." Within this field of attention one can see clearly, and at one time, only a limited number of visual units. The extent of this vividness and clearness is determined by the energy of the attentive act. This attentive energy is sufficient for grasping and relating only a limited number of optical units. In fact, only five or six optically distinct elements can be seen together clearly in their individual characteristics and relationships.

44

Confronted with a complex optical field, one will reduce it to basic inter-relationships. Just as in nature there is a tendency to find the most economic surface unity in every formation, so in the visual organization there is a tendency to find the most economic spatial unity in the ordering of optical differences. Facing the turmoil of optical impacts, one's first reaction is to form in the shortest time interval the greatest possible spatial span.

Certain optical characteristics tend to be seen together as a spatial configuration. As we look at a greatly-enlarged half-tone screen, what we actually see are different sizes of black dots and different white intervals. But instantly we organize and group these visible differences. Some units of black dots are seen in one form; some in another. Some elements are seen together because they are close to each other; others are bound together because they are similar in size, direction, shape. Only after this instantaneous organization is achieved can one see the resemblance of the picture to a human eye.

This organization of optical belonging is more basic than the recognition of the objects themselves. The numerous optical devices which nature employs in the animal world to conceal animals from their enemies reveal the workings of this law of visual organization. A snake camouflaged by nature is no longer a snake. It is an aggregation of small units of color-shape. Because kinship of elementary visual qualities is more fundamental to image building than the relations of empirical experience, the patterns on its body are more easily seen together with corresponding patterns in its background than is its form—knowledge of which is acquired in one's other experience. The snake disappears into its background.

45

Gyorgy Kepes, *Language of Vision* (Chicago: Paul Theobald, 1944), 44-45.

standing of "the living fiber of our unconscious" is situated between Freud's imprint-like nature of unconscious identification (e.g., the presence of typography and printed materials in dreams, and the mnemonic medium of the mystic writing pad)[7] and Lacan's idea of the structure of language and its relevance to the structure of the unconscious (e.g., neon urban signage, washroom placards, and lowercase Garamonds and Didots).[8] Importantly, *Language of Vision* documents the proliferation of optical communications that cybernetically readjust the modern mind to the contemporary standard of typographic modernity.

Typography, Vision, and Habit

Language of Vision seeks to answer the question first asked in "Entering the Eye": "How can I organize my message so that it will enter the eye most rapidly, easily, and accurately?" The answer, to put the issues in extremely reductive terms, supposes the permeability of the human eye and its ability not only to receive perceptual data but to store it in such a way that it can be *read* or interpreted by the mind. The issue of permeability suggests that the eye is tuned to visual transmissions emanating from the exterior world to the interior mind. A history (however brief) of the Western representation of human optical phenomena bears this out. From the diagram that accompanies Descartes's fifth discourse, "Of the Images that Form in the Back of the Eye," to Kepes's diagram, there has been a tendency to explicate visual perception of the environment in terms of the graphic representation

of lines converging to a point within the lens, such that coordinates in an external environment are transferred, as the lines again diverge, to corresponding coordinates on the retina. Descartes describes the process in terms of a "picture" forming within the eye on an "interior membrane."[9] As David Krell explains, Descartes's diagrams represent objects striking the eye. Convergence, therefore, marks the point of impact and of entry. From this, Krell gathers, visual sense perception is typographic (and iconographic and *engrammatic*).[10] By using "typographic" to refer to optics and memory, Krell underscores the underlying impressive or imprint-like structure of Descartes's optical physiology, hence *typos*. Kepes's diagram takes up the Cartesian graphical interpretation when he maps the *typos* of the physiology of visual perception. He emphasizes the *typos*-graphic with the legend "illustration" and with the scattering of pointing-hand dingbats (ornamental pieces of type used for visual impact) on the periphery of the cutaway eyeball. Apart from his use of the word "illustration," it would seem that these three typographical elements *finger* the eye, as if to put even more typographic pressure on the optic nerve. Given the priority lent to imprinting in the history of optics, the answer to the question—How to?—is to maximize the visual impact of the visual communication so as to be sure it enters the eye. While such a recommendation is visualized in the "Entering the Eye" diagram, *Language of Vision* approaches the typographical nature of the physiology of perception in more complex terms that further advance the logic of print media—imprint *and* repetition—as more than a metaphor for the mind.

Of and *for* printing: typography is a technology of inscription and reproduction. It is the standardization of written language and of the printed surface in the guise of the letterpress. As language *of* and *for* vision, typography is as much a modern textual technology as it is an optical one. It exploits reproducibility both in its capacity to make exact copies and in its mobility through the distribution of those copies. While it is most certainly mobile, as in vehicles for reference, the letterpress *goes out of its way* to mobilize its audiences to construct what Benedict Anderson defines as "imagined communities."[11] And as Elizabeth Eisenstein observes, printed materials construct "forms of sociability."[12] Printed matter and human matter populate social collectives; letters are entangled with humans and vice versa. In other words, the letterpress and human imagination make up the social in assemblies of actants: human imagination acting on the mechanization of language acting on human imagination, and so on. In this sense, a fabricated nonhuman fabricates a human to produce what McLuhan calls, "typographic man."[13] Or as Bruno Latour puts it, "A fabricated nonhuman that has nothing of the character of society and politics, but that builds the body politic all the more effectively because it seems completely estranged from humanity."[14]

Likewise, entanglement and estrangement are key terms for Kepes:

The *language of vision*, optical communications, is one of the strongest potential means both to reunite man and his knowledge and to re-form man into an integrated being. The visual language is capable of disseminating knowledge more effectively than almost any other vehicle of communication.[15]

Estranged from the world and oneself—the classic problem of the modern mind—the language of vision reconnects or re-forms. The eye intertwines with the stuff of the visual—paintings, sculpture, architecture, photography, and typography. Kepes claims that these are all visual artifacts and that they "teach us to see." Moreover, he continues, "The social value of the representational image is, therefore, that it may give us education for a new standard of vision."[16] Typography is visual, material inscription and social instruction; it is *of* and *for* the social.

A generative and universal structure of language is at the core of Kepes's *Language of Vision*. As I have discussed elsewhere, Kepes argues a thesis that bridges the gap between a pictorial mode of representation and a syntactical model of language.[17] "Just as the letters of an alphabet can be put together in innumerable ways to form words which convey meaning," he writes, "so the optical measures and qualities can be brought together in innumerable ways, and each particular relationship generates a different sensation of space. The variations to be achieved are endless." And "Visual representation operates by means of a sign system based upon a correspondence between sensory stimulations and the visible structure of the physical world."[18] Taken together, these two statements indicate that Kepes follows a symbol theory of visual representation: pictures are composed of symbols much as words are composed of letters, sentences of words, and paragraphs of sentences. Furthermore, composition and legibility are key issues for Kepes, such that he takes perception as primarily a mode of identification and classification; thus, perception is never *mere* perception but is always fraught with meaning by way of its organizational character. "Visual experience," he argues, "is more than the experience of pure sensory qualities."[19] For Kepes, "more than" marks something beyond mere affect. Indeed, the *language of vision* throws the visual into a field of meaning where sensations are tied to objects and environments. The language of vision is of the order of the typographic both as *typos*—impression—and as *logos*—word. No doubt, this is what Kepes means when he remarks on the "eye's ability to receive impressions."

Typographic meaning arises at the interstices of affect and action. This is less a matter of what words *say* on the page than of how typographically composed words *speak* to the world of human action. If the letterpress is an instance where the media technology of mechanical reproduction interfaces with human sense perception, and thus exploits the responsive character of the human sensorium to produce new sensations and perceptions, then the thickness and density of texts and images arranged in this way impact the senses such that they potentially reconfigure (or rewire) perceptions of the world. For Kepes, habits result from the generative structure of the letterpress: "Symmetrical arrangements of letters and simple rectangular elements blazed a trail for a new typography whose inner spatial logic is dictated by the nature of visual perception."[20] The dynamic "inner spatial logic" of typography reconstitutes human thoughts and actions. "Thinking and seeing, in terms of static, isolated things identical only with themselves have an initial inertia which cannot keep pace with the stride of life, thus cannot suggest values—plastic order—intrinsic in this dynamic field of social existence."[21] If typography ceases to be dynamic—becomes *fossilized*—it cannot reform the social.[22] Both visual-perceptual

organization and technological standards "bring into social action the dynamic forces of visual imagery."[23] Typographically coded habits propagate in pathways and trajectories that shoot through the social and make meaning where they intersect with, as Kepes implies, a longing for homeostasis.

Kepes's Modern Mind

In *Language of Vision*, Kepes commits himself to the idea that both technological and aesthetic advances not only alter human experiences of the world but also ameliorate human habits of skill and predilection. He does not discuss textual representation in the abstract, as if words were free-floating entities without concrete grounding or framing, however much they may appear to be cut off from the world. Rather, the logic of the letterpress mobilizes somatic realities within the affective range of the materiality of print. Human subjectivity is, therefore, an *effect* of technologies of mechanical reproduction that populate the world. This is how humans come to read, or *take* readings of the world in an effort to measure their mimetic capacity and to internalize new habits.

Walter Benjamin argues that effect and affect are part and parcel of the human mimetic faculty. Language holds the remnants of past mimetic activities, according to Benjamin, in an "archive of *nonsensuous similarity*."[24] Effect and affect are present in the first strike of the letterpress, its character impressions sending somatic reverberations throughout and organizing perception in its wake. In both Kepes and Benjamin, there is a tendency to assume that mechanical reproducibility fine-tunes visuality, as in Benjamin's comments on the "optical unconscious" and the deepening of both the perceptual and apperceptual.[25] Furthermore, the archive that Benjamin refers to reveals itself as the typographic unconscious—as in an unconscious imprint or impression—in passages from his writings, especially where he comments on a signet and wax seal in "Goethe's Elective Affinities" and a red neon sign and the "fiery pool reflecting it in the asphalt" in "One Way Street."[26] As Benjamin observes, the modern conditions of textuality are taken from the prompting language of advertising.[27] Like Benjamin, Kepes argues for the capacity of communications technologies to both prescribe and inscribe new patterns of human behavior.[28] According to McLuhan, "Kepes specifies this explicit visual thinking as 'literary' and as the immediate occasion of the dissociation of the interplay of various properties of all the senses."[29] This is why Kepes argues for the "new typography" to move away from mere "literary imitation" and take up a "dynamic iconography."[30]

As Kepes put it, and this bears repeating, "The living fiber of our unconscious responses is given by the concrete images of the surrounding environment."[31] In 1944 much of that environment was in disarray. "Today," Kepes laments, "we experience chaos"—a chaos, or experience of "tragic formlessness," that results from "a contradiction in our social experience."[32] In another context, he writes:

> The formlessness of our present life has three aspects. First, the economic chaos which accounts for economic insecurity, inadequate living conditions, waste of human and

material resources, wars and revolutions; second, the human chaos, the lack of common ideas, common patterns, common purposes; the third is inner chaos, the inability to live in harmony with oneself because of lack of confidence in the oneness of all human levels.[33]

Kepes measured the need for readjustment in relation to an all-pervasive sense of disorder. He witnesses a "failure in the organization of that new equipment with which we must function if we are to maintain our equilibrium in a dynamic world."[34] Kepes charges painters, photographers, and graphic designers with the task of producing ever more exacting configurations of an organized world, to construct a "new standard of vision" from image and type: "This historical challenge calls him [painter, photographer, designer] to assimilate the new findings and to develop a new sensibility, a new standard of vision that can release the nervous system to a broader scale of orientation."[35]

Where typography and printing had once been artisanal activities, the rise of industrial production transformed not just the technology of mechanical reproduction but also the content of what is being reproduced. For Kepes, the designers involved with managing the production of contemporary culture had lost their way (if not their minds). If, as C. Wright Mills observes, the "management of symbols" forms the basis of the lives of humans and determines "what men see," then something has gone awry in the "cultural apparatus."[36] Importantly, according to Mills, the culture industry's management of symbols is not in the service of enlightening experience but rather is a means to organize perception in service to the ruling order. In *Language of Vision*, Kepes presents this correlation as the evolution of knowledge that affects human patterns of thought and action. For Kepes, as for Mills, the designer is "a maker of his own milieu."[37] An organized world, one that mimics the structure of printed words, in all its manifest variations, could be assimilated to, in Kepes's words, "a new-thinking habit."[38] The need for a "new" habit of thought implies that current thinking habits are in synch with the calamities of contemporary life. "We do not see things, fixed static units, but perceive instead living relationships," Kepes remarks. And adds, "The contradiction inherent in the associations of the respective elements keeps our mind moving until the contradiction is resolved in a meaning; until that meaning, in turn, becomes an attitude to things around us and serves as a ferment for protest against life under inhuman conditions."[39] Kepes tasks the designer with fixing a broken world.

Typography and the language of vision make the mind modern. If enveloped in a world of and molded by things, humans repudiate their own existence in the production of a world they hardly recognize but, in multiple instances of the uncanny, are at home with. Repudiation is what humans are most accustomed to, thus, for an aesthetic reformer like Kepes, perception becomes distorted over time. Things may not be what they seem. The grounds of human subjectivity are shaky, subject to the nagging feeling that all modern cultural production may be deception. The result of the mind-boggling confrontation with deception is the difficulty of having to always maintain a skeptical view of the world. The things that populate the modern world may be deceptive in terms of traditions of the aesthetic, conditions of perceived utility,

economic value, epistemological stability, and ontological status. This means that when confronting a modern thing in the world one asks, Is it beautiful? Is it functional? Is it valuable? Is it meaningful? Is it . . . it? In every instance, the question reflects the final question of the ontological status of the modern thing in the world: Does it exist? As difficult as the question of the object's existence might be, there is an even more vexing question that has as much to do with modern humans as it does with modern things. The proper form of the question that results from the traumatic shock of modernity is: Do I exist in the world if this thing does? In other words, is there any room for me if—through mass production and mechanical reproduction—things increasingly populate the modern world? Where do I fit in to this world of things? What is my place? This is the gist of Benjamin's observation: "The representation of human beings by means of an apparatus has made a highly productive use of human being's self-alienation."[40] A lack of recognition of ourselves in the world underscores a Weberian tone in the ringing casualties and disenchantments of advanced industrial societies.[41] And, as Sigfried Giedion remarks in his introduction to Kepes's book, both the public and those who administer the culture industry are haunted "by a split which exists" between experience and reality.[42] By putting typography at the service of mind, Kepes's *Language of Vision* seeks to awaken a new consciousness in contemporary society, so as to heal the psychic wounds of alienation and to reshape the cultural apparatus.[43]

Typo-Homeostatic

The strike of the letterpress, an impression, is a move toward homeostasis. Kepes is attuned to the by-products of the letterpress and the streams of alphabetic characters arranged according to the geometries of the Guttenberg era. For him, the medial conditions of the unconscious arise from a system of communication that is structured according to how humans organize information. Kepes's interest in cybernetics and homeostatic systems as a "basis for an aesthetic project" is well documented.[44] He cites Helmholtz's *Physiological Optics* (1867) in his *Language of Vision* and adapts Helmholtz's theory of the feedback-like relationship between sense nerves, sensations, and external environment. Much like the diagram in "Entering the Eye," a sensing subject arranges sensations into images of external objects in the world through a process of unconscious inference. Like Helmholtz, Kepes maintains that sensory impressions are signs for properties of the external world, the meaning of which are acquired through experience of the social mediated by the graphic and the typographic. In 1944 he writes of the homeostatic import of his project: "The dynamic tendency to integrate optical impacts into a balanced, unified whole acts within the field of the physiological and psychological make-up of man."[45] Yet, twenty-two years later, Kepes's goal is still far from certain:

> Today's life confronts us with deeper devastation than the sensory deprivations caused by a mistreated environment. . . . The responses of the artists' imaginative power and sensibility to the life-menacing impacts of an unresolved society have a fundamental biological basis. Physiologists recognized that to withstand the relentless impacts of

disturbing external forces an organism has to retain certain relative stability; an "inner constancy."[46]

Despite the myriad examples from the visual arts and the impacts of graphic design and typography represented in *Language of Vision*, the bliss of homeostasis remains out of reach for Kepes. The formlessness of the external environment still threatens the human psyche, because Kepes's desired examples of "dynamic iconography" have not penetrated the eye to reconfigure the unconscious. Or if they have, then contemporary language of vision has impacted the psyche in negative ways. Contemporary typography in advertising and urban signage neither, as Kepes might like, delivers "messages that are justified in the deepest and broadest sense" nor "contribute[s] effectively in preparing the way for a positive popular art."[47] While hedonism was certainly on the rise in the late 1960s, Kepes considered advertising messages to be appealing to what was too individualistic in humans. At this stage, he was still searching for an example of popular visual and typographic culture that could answer the question asked in "Entering the Eye": "How can I organize my message so that it will enter the eye most rapidly, easily, and accurately?"

These problems in the late 1960s are similar to those Kepes addressed in *Language of Vision*. "The rediscovery of order in terms of plastic experience was conditioned by the social background, by the urgent need of an equilibrium on the socio-economic plane."[48] The two-dimensional plane of the page, impregnated and furrowed, should enfold and unfold the "socio-economic plane." The two are not distinct, but rather are parts of a continuum. Ink spreads and furrows run deep. Yet the folds can misalign, causing the lines of connection to become uncertain. The result of avant-garde experiments, as exhibited in *Language of Vision*, is, according to Kepes, an emphasis on individual freedom, which unfortunately too soon ran amok. Counterutopian and reactionary attitudes will prevail. "Regimentation, the sacrifice of the individual, became the new social concept of regression and half-measures." Order imposes itself such that it becomes an end in itself in the administrative and bureaucratic rationalism of modernity. "It [order] created its own world—a world of puritan restrictions."[49] As Freud says, "Order is a kind of compulsion to repeat."[50] For Kepes, there is good order and there is bad order, both of which are infinitely repeatable. To counter the reign of the puritanical bad order, Kepes prescribes a good order, an organizing framework that allows "room for the individuality of the elements."[51] He is now back to the drawing board, or, better yet, the typographer's cases. If, for Kepes (as for Freud and Lacan), typographic modernity is a precondition for human subjectivity, then it is also a precondition of the social. The letterpress constructs social collectives, intertwining humans and letters so as to produce a new standard of vision and of life. In going out of its way to mobilize its audiences, the letterpress is a form of the social. *Language of Vision* proposes that a resolution of social and psychological disharmony must rely on humankind's natural capacity to organize discrete elements into a whole.[52] Perhaps it is not by chance that the task of the typographer is to organize individual elements into a legible whole, into

a coherent message that impacts the unconscious. As Moholy-Nagy first proposed and Kepes proved, modern worlds and modern minds are built from the letterpress.

Notes

1. László Moholy-Nagy, *Painting, Photography, Film* (1926; Cambridge, MA: MIT Press, 1969), 38.

2. Alain Findeli, "Moholy-Nagy's Design Pedagogy in Chicago (1937–46)," *Design Issues* 7, no. 1 (Autumn 1990): 7.

3. Ibid., 10.

4. Frederick M. Logan, *Growth of Art in American Schools* (New York: Harper, 1955), 257.

5. György Kepes, *Language of Vision* (Chicago: Paul Theobald, 1944), 13.

6. Ibid., 209.

7. For example, in Freud's *Interpretation of Dreams* the illegible nature of a "printed notice, placard or poster" in the dream is a defense mechanism that reduces the impact of internal stimuli as if they were external stimuli, lest one reading or the other upset the equilibrium of the psychic system. As Frederich A. Kittler observes, "All of Freud's case histories demonstrate that the romanticism of the soul has yielded to a materialism of written signs." The materialism Kittler refers to is not that of handwriting but of typography: "methodologically this means that Freud (to use a pervasive metaphor of 1900) was a proofreader." Kittler, *Discourse Networks 1800/1900* (Stanford, CA: Stanford University Press, 1990), 283. See Sigmund Freud, *The Interpretation of Dreams* (New York: Avon, 1965), 352. In reconsidering this same book, Jean Laplanche asks whether it is possible to think of the Freudian unconscious as "open to communication"—i.e., of communication *in* the dream as opposed to communication *of* the dream. (He does not here mean communication in the strict sense of language, but rather communication as and in the workings of the stimulations of "material actions.") Laplanche, "Closing and Opening of the Dream: Must Chapter VII be Rewritten?" in *The Dreams of Interpretation: A Century Down the Royal Road*, ed. Catherine Liu (Minneapolis: University of Minnesota Press, 2007), 177–78, 185. Martin Jay takes the passage considered by Kittler, with its emphasis on one eye winking or overlooking, to possess "antivisual implication[s]." He refers to this moment as Lacan's "linguistic turn" but overlooks Lacan's investment in the perceptually available material support of language—typography. Jay, *Downcast Eyes: The Denigration of Vision in Twentieth-Century French Thought* (Berkeley: University of California Press, 1993), 330.

8. Lacan's investment in typographic media is best shown in his example of washroom signage and "urinary segregation" in "The Agency of the Letter." In this well-known passage, Lacan examines how language as a system of differences appears in the division between washrooms, concluding that an act of urination behind a closed door performs the somatic materiality of language, in that the typographic sign and the subject's place in one gendered interior space or the other are coordinated. Lacan, *Écrits: A Selection* (New York: W. W. Norton, 1977), 150–51. As an instance of the typographic unconscious, Lacan posits a neon sign he observed in Baltimore in 1966, reading "Enjoy," as an instruction measured by its relation to a world bereft of enjoyment. Lacan, "Of Structure as an Inmixing of an Otherness Prerequisite to Any Subject Whatever," in *The Languages of Criticism and the Sciences of Man: The Structuralist Controversy* (Baltimore: Johns Hopkins University Press, 1970), 194. As I mention elsewhere, "Enjoy"—in the normative sense of conforming pleasures and the perverse sense of *jouissance*—marks, for Lacan, the beyond of the pleasure principle and the horizon of potential disturbances to the self-regulating organism. Michael J. Golec, "Logo/Local Intensities: Lacan, the Discourse of the Other, and the Solicitation to 'Enjoy,'" *Design and Culture* 2, no. 2 (2010): 177.

9. René Descartes, *Discourse on Method, Optics, Geometry, and Meteorology* (Indianapolis: Hackett Publishing, 2001), 94, 97.

10. David Farrell Krell, *Of Memory, Reminiscence, and Writing* (Bloomington: Indiana University Press, 1990), 68, 69.

11. Benedict Anderson, *Imagined Communities: Reflections on the Origin and Spread of Nationalism* (London: Verso, 1991), 37–46. On "immutable mobile" and "vehicle of reference," see Bruno Latour, "Drawing Things Together," in *Representation in Scientific Practice*, ed. Michael Lynch and Steve Woolgar (Cambridge, MA: MIT Press, 1990), and Latour, "How to Be Iconophilic in Art, Science, and Religion," in *Picturing Science, Producing Art*, ed. Caroline Jones and Peter Galison (New York: Routledge, 1998).

12. Elizabeth L. Eisenstein, *The Printing Revolution in Early Modern Europe* (Cambridge: Cambridge University Press, 1993), 94.

13. Marshall McLuhan, *The Gutenberg Galaxy: The Making of Typographic Man* (Toronto: University of Toronto Press, 1962).

14. Bruno Latour, "Pragmatogonies: A Mythical Account of How Humans and Nonhumans Swap Properties," *American Behavioral Scientist* 37 (1994): 799.

15. Kepes, *Language of Vision*, 13.

16. Ibid., 67.

17. Michael Golec, "A Natural History of a Disembodied Eye: The Structure of Gyorgy Kepes's *Language of Vision*," *Design Issues* 18, no. 2 (Spring 2002): 3–16.

18. Kepes, *Language of Vision*, 23, 67.

19. Ibid., 200.

20. Ibid., 122.

21. Ibid., 202.

22. A close reader of Kepes's *Language of Vision*, McLuhan argues that Gutenberg's printing revolution created new aesthetic effects through the organization and composition of typography. The distribution of applied knowledge in the age of mechanical reproducibility, to borrow from Walter Benjamin, suddenly became exclusively visual, degrading all other modes of sensorial experience. See McLuhan, *Gutenberg Galaxy*, 125.

23. Kepes, *Language of Vision*, 202.

24. Walter Benjamin, "On the Mimetic Faculty," in *Reflections: Essays, Aphorisms, Autobiographical Writings*, ed. Peter Demetz (New York: Harcourt Brace Jovanovich, 1978), 336.

25. Walter Benjamin, "The Work of Art in the Age of Mechanical Reproduction," in *Illuminations*, ed. Hannah Arendt (New York: Schocken Books, 1968), 235.

26. Benjamin, *Reflections*, 86. For a further elaboration on this theme, see Mark Seltzer, "The Graphic Unconscious: A Response," *New Literary History* 26, no. 1 (Winter 1995): 21–28.

27. Benjamin, *Reflections*, 61.

28. When Benjamin refers to the "optical unconscious" he is making claims for the innervating capacity of film. But the essay where this appears is titled "The Work of Art in the Age of Mechanical Reproducibility [or Reproduction]," which accounts for all manner of optical communications—woodcuts, lithographic reproduction, and photography. *Typos* is everywhere present in Benjamin's essay, especially where he discusses the "optical unconscious" and "penetrated" conscious and unconscious spaces" (Benjamin, *Illuminations*, 236–37).

29. McLuhan, *Gutenberg Galaxy*, 126–27.

30. Kepes, *Language of Vision*, 200.

31. Ibid., 209.

32. Ibid., 12.

33. György Kepes, "Form and Motion," typescript (1.14), October 23, 1947.

34. Kepes, *Language of Vision*, 12.

35. Ibid., 67.

36. C. Wright Mills, "The Cultural Apparatus," in *Power, Politics, and People: The Collected Essays of C. Wright Mills* (London: Oxford University Press, 1967), 405–6.

37. C. Wright Mills, "The Designer in the Middle," in *Power, Politics, and People*, 383.

38. Kepes, *Language of Vision*, 209.

39. Ibid., 202.

40. Walter Benjamin, "The Work of Art in the Age of Its Technological Reproducibility: Second Version," in *Walter Benjamin: Selected Writings*, vol. 3, *1935–1938*, ed. Howard Eiland and Michael W. Jennings (Cambridge, MA: Belknap Press, 2002), 113.

41. As Susan Buck-Morss argues, Benjamin did not adhere to Weber's notion of modernity ushering in "the demythification and disenchantment of the social world." According to her, "Benjamin's central argument in the Passagen-Werk was that under conditions of capitalism, industrialization had brought about a reenchantment of the social world." Susan Buck-Morss, *The Dialectics Of Seeing: Walter Benjamin and the Arcades Project* (Cambridge, MA: MIT Press, 1991), 253.

42. Sigfried Giedion, "Art Means Reality," in *Language of Vision* (Chicago: Paul Theobald, 1944), 6.

43. In his extremely important study of modern visuality, Jonathan Crary interrogates the intersections of perception and alienation in terms of power relations and the institutional construction of the modern subject. Crary, *Suspensions of Perception: Attention, Spectacle, and Modern Culture* (Cambridge, MA: MIT Press, 1999).

44. Reinhold Martin, *The Organizational Complex: Architecture, Media, and Corporate Space* (Cambridge, MA: MIT Press, 2003), 67.

45. Kepes, *Language of Vision*, 34.

46. György Kepes, "Aesthetics of Everyday Life," n.d., 13. Undated lecture transcript in György Kepes Papers, Archives of American Art, Washington, DC.

47. Kepes, *Language of Vision*, 221.

48. Ibid., 126.

49. Ibid.

50. Sigmund Freud, *Civilization and Its Discontents* (New York: W. W. Norton, 1961), 46,

51. Kepes, *Language of Vision*, 126.

52. Golec, "Natural History," 5.

American Bauhaus, however,
School of Design, Institute
still incomplete. The history
ing is exhaustively related
Engelbrecht's unpublished
The Association of Arts and
Background and Origins of
Movement in Chicago
University of Chicago, 1973),
which appeared in the
Centre George Pompidou's
exhibition (Paris 1976).
complete monograph of the
Archives
exhibition,
(Berlin 1987).
Nagy biography of her
this period Moholy
Industry (Cambridge
edition, 1969)

From Chicago to Berlin and Back Again

KATHLEEN JAMES-CHAKRABORTY

Every historian of American architecture and design learns the basic story. In the 1880s Chicago architects invented the steel-framed office building. In more exaggerated versions, they are credited with the skyscraper, although until the completion of the Sears Tower the tallest of these were always in New York. Chicago walked away from modernism when it hosted the World's Columbian Exposition in 1893. Nonetheless, a pair of talented architects, Louis Sullivan and Frank Lloyd Wright, forged ahead. Wright's protocubist approach to space, in tandem with skeletal frame construction, prompted the interwar European avant-garde, and especially Germans like Walter Gropius, Erich Mendelsohn, and Ludwig Mies van der Rohe, to invent what we know as modern architecture or the international style. This in turn reached its maturity only when these architects, especially Mies, immigrated to the United States as refugees from National Socialism. In Chicago they, and others associated with the Bauhaus, found the opportunities and understanding that had been missing at home. The result was another golden age in Chicago architecture, one that ensured the city's permanent position as the best face of both America's architectural past and its present.[1]

The amazing thing is that the general outlines of the story, which one might think a local booster had invented to attract tourists (as it certainly does), are true. Although it is a Cold War narrative, intended to promote the export of American capitalism and democracy by winning over skeptical foreign intellectuals, there is no disputing that the interaction between Chicago and Berlin and their satellites at the University of Illinois and the Bauhaus, was one of the most productive interchanges in the history of late nineteenth- and twentieth-century architecture.[2]

In 1892 Mark Twain entitled an article about a recent trip to Berlin "The German Chicago." With his tongue only slightly in cheek, he noted, "Chicago would seem venerable beside it; for there are many old-looking districts in Chicago, but not many in Berlin. The

Narelle Jubelin and Carla Duarte, *Key Notes* (detail), 2009. Installation view, in *Learning Modern*, Sullivan Galleries, School of the Art Institute of Chicago. Photo: Jill Frank.

main mass of the city looks as if it had been built last week, the rest of it has a just perceptibly graver tone, and looks as if it might be six or even eight months old."[3] Although Berlin is centuries older than Chicago, exponential increases in population brought the number of inhabitants in each in Twain's time to about one and a half million, and each would peak at well over twice that. Such explosive growth attracted architectural talent open to new ideas like bees to a honeypot. No two cities, despite considerable destruction, better showcase the architecture of the last century and more. And yet the architecture of Berlin and Chicago and their immediate environs has usually been discussed in very different terms. While Chicago has always been branded as little more than a brash diagram of the interface between technology and capital, Berlin's cityscape is more often credited to the intersection of art and politics.[4]

From the years immediately after the Chicago fire to the present, no foreign architectural culture has had so great an influence upon Chicago buildings as Berlin's. That Americans building upon what they perceived to be virgin land turned to Europe for inspiration is hardly surprising. The influence always went both ways, however. Chicago's warehouses, office buildings, and grain elevators were among the first American buildings to have a significant impact upon European architecture, and nowhere was their apparent primitivism more celebrated than in Berlin.[5] The story of the architectural interchange between the two cities begins with the way in which architecture was taught in Illinois and proceeds through several generations of German enthusiasts for the buildings erected in and around what they saw as the somewhat crude new American city. It comes full circle when such Germans, having arrived in Chicago to practice and teach, then erect prominent buildings back in Berlin.

In an era when most architects apprenticed rather than receiving an academic education, the ties between Berlin's Bauakademie, the oldest architecture school in German-speaking Europe, and the University of Illinois, the second American university to offer formal training in architecture, are particularly important. The École des Beaux Arts in Paris dominated architectural education both on the European continent and in the United States, but the Illinois program, directed from 1873 to 1910 by Nathan Clifford Ricker, was oriented along German lines.[6] Ricker, who had studied at the Bauakademie, translated major works of German architectural education and theory into English. Following German precedent, he emphasized the engineering aspects of architecture, especially construction and materials, above mastery of the classical orders, which remained a prominent component of a Beaux-Arts education. Although the school was located downstate in Urbana, its graduates gravitated to Chicago. The campus itself was dominated in its early years by Ricker's own buildings, whose vague medievalism was influenced by Henry Hobson Richardson, whose geologically inspired metaphors of stability were America's first major architectural export to Europe.[7]

The buildings designed in Chicago in the 1880s by Richardson and by the local firms that grew out of William Le Baron Jenney's office represent the first of Chicago's many notable contributions to the history of modern architecture. Their enduring importance, although recognized by contemporary Americans, was above all a product of their celebra-

tion by generations of German visitors, as well as German architects who originally knew them only through photographs. This process began in the 1880s and accelerated in 1893 as a result of Chicago's world's fair.

Chicago fascinated late nineteenth-century Germans. Its emergence from the prairie and its rebirth after the disastrous fire of 1871 epitomized for them the primitive energy of American capitalism.[8] Generations of Germans dissatisfied with how heavily the past weighed upon their own architecture, whose ponderous masses were often encrusted in historicist details, found the apparent pragmatism of Chicago's commercial architecture magnificently liberating. Compare, for example, Jenney's Second Leiter Building of 1891 with the German pavilion at the 1893 fair. The warehouse lacks the rhetorical flourishes of the pavilion, designed to resemble a German Renaissance city hall. The contemporary German audience for this comparison was, by the way, enormous. Germans comprised one of Chicago's largest ethnic communities (working-class Germans were known particularly for their socialist politics and their musical talent), and both the German government and private industry were determined to make a strong showing at the fair.[9]

Simplistic interpretations of Chicago served German purposes more than they described American reality. Even before work began on the White City fairgrounds, Chicagoans determined to patronize culture and not have architecture determined by the bottom line alone had sponsored the construction of the Rookery and of the first two American civic buildings modeled on Boston's new public library, then still under construction—the Chicago Public Library and the Art Institute, both designed by Shepley, Rutan and Coolidge.[10] The fair did not signal the end of architectural innovation in the city, as Sullivan and his followers would begin to assert in the 1920s. The construction of Sullivan's Carson Pirie Scott store and Wright's Robie House amply testify to the city's sustained ability to foster innovation well into the new century.[11] Both buildings would have an enormous impact upon Germans who would, however, largely ignore the city's neoclassical civic infrastructure.[12]

Nor did Germans have a monopoly on creative misinterpretations. When Wright traveled to Germany in 1910 with Mamah Cheney, he was fascinated by the neo-Assyrian sculpture Franz Metzner was carving for the bombastically nationalist Völkerschlachtdenkmal in nearby Leipzig.[13] This reworking of primeval precedent impressed Wright, one of the first American architects of European descent to draw upon Mesoamerican precedents. The integration of the human figure into the body of the architecture was an effect he repeated in Chicago at Midway Gardens, his first substantial commission following his return.

Distance encouraged a trio of Berlin architects to envision Chicago as the birthplace of an aesthetic of pure construction that not even its own most radical architects would have recognized. Between 1913 and 1927 Walter Gropius, Erich Mendelsohn, and Ludwig Hilberseimer each published a seminal work of architectural theory in which Chicago examples figured prominently. The sheaf of photographs of grain elevators and daylight factories that accompanied Gropius's essay on industrial architecture in the *Werkbund* yearbook introduced a generation of avant-garde architects from across Europe to a bold

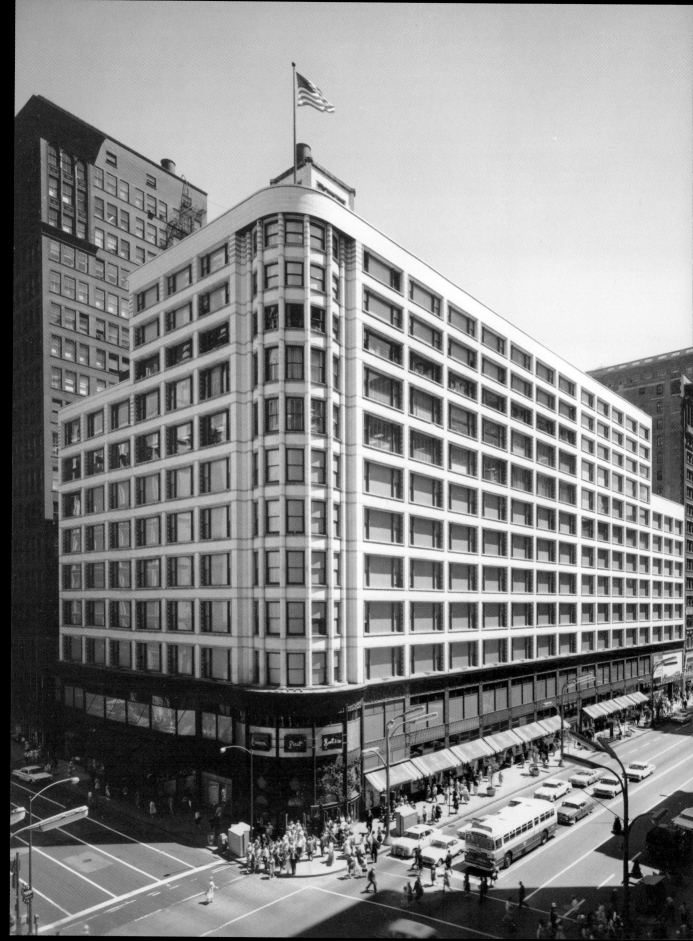

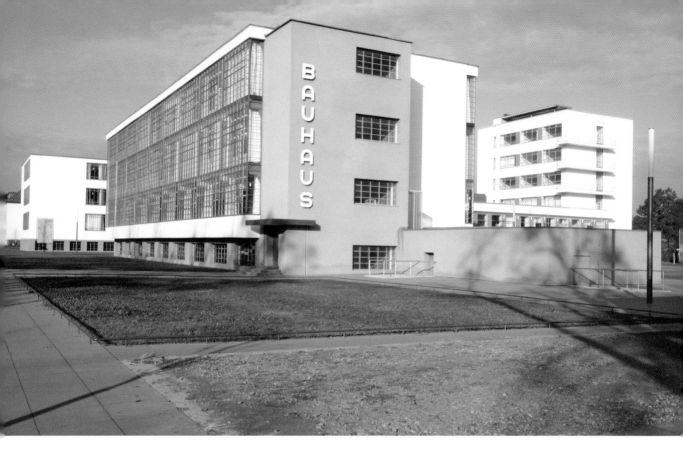

simplicity they would soon seek to match.[14] That these buildings were already well known to their elders through publication in German engineering literature did not deter a new generation, which famously included Le Corbusier, from understanding them as providing a recipe for abstraction.[15] In 1924 Barry Byrne led Mendelsohn around Chicago in return for the hospitality he had received earlier in Germany.[16] Mendelsohn's *America: Picturebook of an Architect*, published in 1926, influenced not only fellow architects and visual artists but also the playwright Bertolt Brecht.[17] The photographs he published of the city's grain elevators and high-rises, taken from a low vantage point and aimed toward the sky, conveyed a dynamic sense of towering height to Germans, for whom new church steeples of Ulm and Cologne remained the tallest local structures. Hilberseimer's *Metropolitan Architecture*, published the following year, included more straightforward views of an array of Chicago office buildings.[18]

The impact of this accumulated knowledge of the city was almost immediate. Gropius's entry in the 1922 Chicago Tribune Tower competition, Mendelsohn's Schocken department store in Stuttgart, and even Gropius's Dessau Bauhaus all show the influence of buildings like Sullivan's Carson Pirie Scott store. Gropius undoubtedly believed that his use of the iconic Chicago window rendered his design contextual.[19] From Berlin he would have had little sense of the ornament that had in fact enveloped many such windows or of the local thirst for obviously European culture. Mendelsohn reworked the department

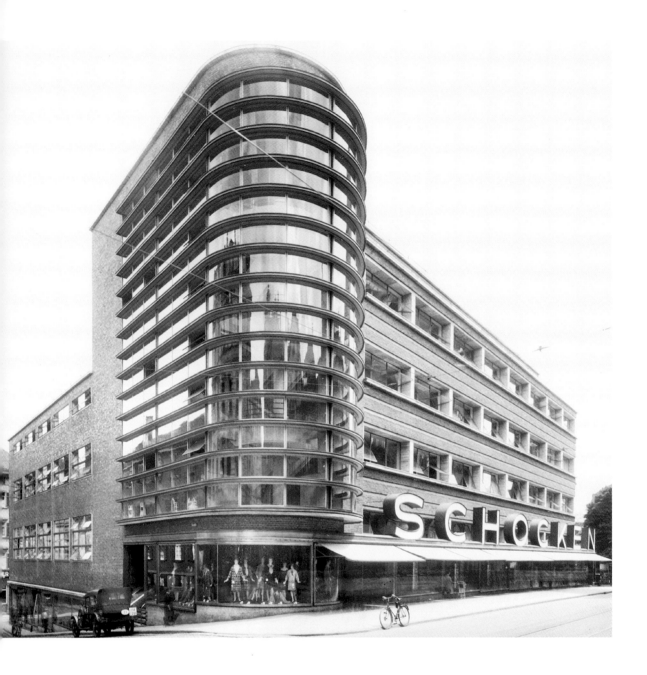

store to expose rather than conceal the factory origins of many of the products sold within the Target of its day, a chain that specialized in a limited but well-designed and inexpensive product range.[20] Although Gropius generally paid more attention to concrete-framed factories than to Chicago office buildings, he too followed the example of Sullivan's Carson Pirie Scott Building, one of the first department stores not to be organized around a central atrium, when he inserted factory-like floors into the studio block.

A salient characteristic of architecture in both Chicago and 1920s Germany was the

romanticization of an exotic other. Raymond Hood's winning design for the Chicago Tribune Tower boasted all of the cultural grace notes that Gropius had so carefully stripped from his Chicago models. Its patron, who had reported from the French front during World War I, greatly appreciated the history and craftsmanship of Hood's late Gothic sources. By contrast, Gropius and Mendelsohn, antinationalist architects from a defeated country, espoused shocking alternatives to a discredited past. In Chicago they located the sources of an optimistic, even utopian, celebration of technology, whose appeal to clients lay in part in its modest cost but also in its patent demonstration that despite political and economic instability, Germany remained at the cutting edge of modernity.

This symbolic and communicative dimension of modern architecture is often neglected by those who instead place too much credence in the words of its creators, who tended to emphasize its objectivity over their own skills as propagandists. From the beginning the German use of Chicago sources to create a radically abstract architecture appealed to Americans, not so much because of the reduction of architecture to beautifully proportioned construction that characterizes the work of Mies, which remained difficult for many laypeople to appreciate, as because of the degree to which it validated what they had already achieved, above all through the elevation of the Loop's early high-rises and Frank Lloyd Wright's Prairie Style to the status of international icons. Two of the first figures to recognize this utility were friends Mendelsohn had made in 1924, Wright himself and the young critic Louis Mumford.

Since the publication of the *Wasmuth Portfolio* in Berlin in 1910, Wright had become a hero to many young German architects.[21] Gropius and his partner Adolf Meyer drew upon it almost immediately in their design of the model factory for the Werkbund Exhibition held in Cologne in 1914.[22] Mendelsohn's interest in Wright was greatly strengthened when in 1921 he hired the young Viennese architect Richard Neutra, who was already planning to emigrate to America and, if possible, to work for Wright. Neutra's widow recounted how well Mendelsohn and Wright got along in 1924, not least because Neutra's adept translation smoothed over the substantial differences between them. Each was glad to make a friend who delighted in the "organic," no matter that each understood something quite different by it.[23] For Europeans Wright was *the* protocubist, whose play with space demonstrated how lessons from new styles of paintings, including expressionism, De Stijl, and constructivism, could be translated into built form.

Wright was to remain skeptical of European modernism all his life, but not of the prestige it brought him, which by the 1930s had catapulted him back into the top of the American architectural profession. Where once H. Allen Brooks could blame the fickle taste of women for Wright's years in the wilderness, we now know it had much more to do with the scandals in his personal life.[24] But the wilderness it certainly was, particularly in the latter half of the 1920s. The only glimmer of hope at this time was the respect of pilgrims like Mendelsohn and the movement they represented.[25] Although Wright himself was probably unaware of it, Mies was among his chief German admirers. Mies's brick country house project of 1924—in many ways an exploded, abstracted version of Wright's

Ward Willets House—was one of the projects through which the rather conventionally neoclassical architect joined the avant-garde.[26]

Equally important, however, was the construction of a story that would convince potential clients and their publics of the importance of what came to be known as the international style. The term was popularized by two young curators, Henry-Russell Hitchcock and Philip Johnson, in the title of an influential exhibition held at the fledgling Museum of Modern of Modern Art in 1932. It was actually coined, however, by the Austrian émigré Friedrich Kiesler.[27] Hitchcock would become America's principal historian of modern architecture, but it was Mumford who put Chicago on the map by popularizing for an American audience the story being told by Gropius, Mendelsohn, and Hilberseimer.

Mendelsohn was the most scenographic of his generation of German modernists, and his Einstein Tower in particular had already attracted considerable attention in America before he crossed the Atlantic for himself.[28] Immediately upon its publication in 1926, Mendelsohn sent Mumford a copy of his book *America: Picturebook of an Architect*. Its receipt prompted Mumford to make his own tour of Chicago, again guided by the invaluable Byrne.[29] The result was *The Brown Decades: A Study of the Arts in America: 1865–1895*.[30] Published in 1931, this work of literary as well as architectural history challenged the primacy of those, like Fiske Kimball, who had seen the fair of 1893 rather than the office buildings of the Loop as Chicago's key contribution to the development of American architecture (note the importance of Chicago whichever story is told!).[31] In particular, *The Brown Decades* set the scene for respectful new appraisals of the careers of Henry Hobson Richardson by Hitchcock and of Louis Sullivan by Hugh Morrison. Hitchcock would follow up with the first scholarly survey of Wright, *In the Nature of Materials*, published in 1942.[32]

By this time, Germans émigrés from National Socialism had begun to wash up on American shores, including those of Lake Michigan.[33] The degree to which all German modernists were stalwart opponents of National Socialism has, however, been called into question by two generations of probing scholarship. We know now that both Gropius and Mies tried to compromise with the new regime, which at first evinced considerable support for Mies. Bauhaus product design was showcased in numerous official exhibitions, not least within the walls of Albert Speer's notorious pavilion for the world's fair held in Paris in 1937.[34] Nonetheless, many modernists rightly feared for their lives. Mendelsohn and Anni Albers, both of whom were Jewish, were among the first to leave. The Chicago arrivals came relatively late, but almost immediately assumed influential positions. After being passed over for the Harvard position that ended up going to Gropius, Mies came in 1938 to what was then the Armour Institute of Technology, now the Illinois Institute of Technology, to which he also brought Walter Peterhans and Ludwig Hilberseimer. The year before, László Moholy-Nagy, one of the most influential faculty members at the original Bauhaus, where Mies had been the last director, was invited to direct the Chicago school he named the New Bauhaus.

I have argued elsewhere that the impact of the German modernist diaspora has been exaggerated, and that it must share credit with indigenous developments and with other

immigrants, above all Eliel Saarinen, who founded Cranbrook in 1932, for the apparent postwar ubiquity of modern architecture and design in America (the limits of which I have also tried to define).[35] There is nonetheless no doubt that the presence in Chicago of Mies and Moholy-Nagy, and to a lesser extent Hilberseimer and Peterhans, transformed the face of the city as well as art instruction within it. Furthermore, Mies especially can be credited with cementing the centrality of Chicago in the history of both American and modern architecture.

Of the four, Moholy-Nagy had the shortest and most difficult stay in the city. Between 1923 to 1928 he and Josef Albers had led the groundbreaking preliminary course at the Bauhaus.[36] Rose-Carol Washton Long has credited Moholy-Nagy with shifting the legendary school's emphasis away from painting and toward photography, just one of the many media with which he experimented.[37] In his photographs, photograms, and kinetic sculpture, Moholy-Nagy consistently played with light. He arrived in Chicago after a group of local businessmen interested in product design unsuccessfully sought to hire Gropius to lead the new school and Gropius recommended Moholy-Nagy for the position. The New Bauhaus quickly folded, but Moholy-Nagy remained in Chicago for the rest of his life. From 1939 until his premature death seven years later, he focused his attention upon founding and running the School of Design, which in 1944 became the Institute of Design and in 1949, after Moholy-Nagy's death, became a department of IIT. Supported by Walter Paepcke, the chairman of the Container Corporation of America, the school promoted experimental photography and developed furniture and textile designs. George Fred Keck and Buckminster Fuller taught architecture there.[38]

Moholy-Nagy initially adhered quite closely to the curriculum of the German Bauhaus during his years in Chicago, but from the beginning there were important differences between the two schools. Not least because of its sponsorship, the Institute of Design was always more patently commercial in its outlook. Although the degree to which Gropius intended the Bauhaus to serve industry has been downplayed in many later accounts, he had been unsuccessful in building an economic base for the school upon such linkages. Moholy-Nagy was far more successful in this regard. Institute of Design students such as Arthur Siegel, who later became chair of the photography department, for instance, pioneered lighting techniques with broad applications for commercial work.

Teaching at the Institute of Design became a stepping-stone to significant careers beyond Chicago. György Kepes, a fellow Hungarian, worked under Moholy-Nagy from 1937 to 1943. He would go on to have a significant career at MIT, where he founded the Center for Advanced Visual Studies, and to write an important textbook, *Language of Vision*, based on the courses he had offered at the Institute of Design. Kepes helped pioneer the integration of new technology such as lasers and holography into art.[39] The institute's second director, Serge Chermayeff, taught at Harvard and Yale as well as MIT and was a coauthor with Christopher Alexander and Alexander Tzonis of equally influential texts.[40]

Only after Moholy-Nagy's untimely death in 1946 did Mies definitively emerge, largely

through the auspices of an exhibition held the next year at the Museum of Modern Art in New York, as the single most important German or American architect of his genera-tion—one who would, moreover, throughout his last decades continue to bind the archi-tecture of his native and adopted countries closer together. Curated by the ubiquitous Johnson, who would be for the next decade and more Mies's chief architectural disciple as well as publicist, the exhibit featured the new campus of the Illinois Institute of Technol-ogy. Also on display were the designs that set the stage for Mies's subsequent work: 860 and 880 Lake Shore Drive and the Farnsworth House.[41]

Insufficient attention has been paid to the way in which the buildings exhibited at MoMA differed substantially from Mies's German work, not least because acknowledg-ing such differences challenges one of the most potent postwar myths about American culture: that only on American shores could the European avant-garde, itself inspired by American precedent, finally achieve its full potential.[42] Another factor accounting for the adoption of modernist architecture by the postwar establishment was the per-ceived contamination of classical architecture by its apparent effectiveness as totali-tarian propaganda.[43] Both theories had flaws. The first discounted the way in which modernist architecture and architects had changed since the economic collapse of 1929. The second assumed that all Nazi (and for that matter fascist or communist) architec-ture had been classical. Neither was true. The eventually influential early IIT buildings did indeed have German precedents, but not the ones most Americans imagined. The exposed steel framing of the early IIT buildings derived not so much from Mies's own German work or the example of American daylight factories as from the architect's acquaintance with recent German industrial architecture.[44] Much of this had been built by the Nazis or, at the least, commissioned by businessmen who sympathized with the new regime.[45]

The Lake Shore Drive apartments conformed more closely with the myth. Their lin-eage certainly included both the amply glazed towers of the first Chicago school, such as Burnham and Root's Reliance Building, and Mies's own almost unbuildable expres-sionist skyscraper projects of 1921 and 1922.[46] But their success had almost as much to do with changes in the American construction industry, themselves grounded in larger social transformations, as with their form. As the cost of labor rose in an increasingly egalitarian society, the masonry surfaces and carved stone ornament that had featured so prominently in Chicago high-rises of the interwar period skyrocketed as well. Even the increase in the cost of steel prompted by the Korean War did not prevent Mies's towers from being considerably less expensive than conventional counterparts.[47] And in a prag-matic construction industry, such differences mattered.

Mies's were scarcely the only curtain wall towers to be realized in the first years after the war. The Equitable Building in Portland, Oregon, designed by Pietro Belluschi, was the earliest.[48] Designs for the United Nations and Lever House by an interna-tional team led, respectively, by Walter Harrison and by Gordon Bunshaft of Skidmore Owings and Merrill were also noteworthy. The Lake Shore Drive structures achieved their canonical status for two quite different reasons. One was the brilliance of Mies's design. The application of I-beams as vertical mullions was an inspired gesture that

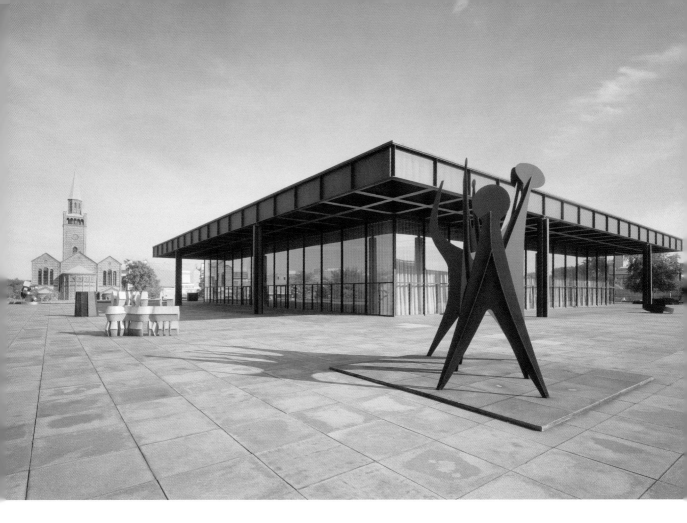

Ludwig Mies van der Rohe,
Neue Nationalgalerie, Berlin.
In the foreground, Alexander
Calder, *Têtes et queue*. In the
background, Saint Matthew's
Church. Courtesy Bildarchiv
Preussischer Kulturbesitz/
Art Resource, NY, and
Nationalgalerie, Staatliche
Museen, Berlin. © Artist
Rights Society (ARS), New
York. Photo: Gerhard Murza,
1993.

referred metaphorically to the steel skeleton underneath. The relation was so persua-
sive that only perceptive observers noticed that it was frankly ornamental. The second
reason, however, for the influence of Mies's curtain wall was its Chicago location. Here,
just north of the Loop, where so many precedents for its clarity were clustered (and
many more of them still stood in 1952 when it was finished than do today!) it con-
firmed the assessments of Gropius, Mendelsohn, Hilberseimer, Mumford, Morrison,
and Hitchcock regarding the importance of Chicago for contemporary modern archi-
tecture and paved the way for Carl Condit and Colin Rowe's influential analyses of the
first Chicago school in terms of construction.[49]

The story of the Farnsworth House, Mies's prototypical pavilion, is more complicated.
Here, despite producing an elegant jewel box, Mies misread American architecture and
culture in ways that significantly limited his impact upon domestic architecture. Like
many European immigrants, he imagined that the technology of high-rise construction
would translate easily to the much smaller scale of home construction. A book in German
on American construction by Richard Neutra, whose Lovell Health House in Los Angeles
was the country's first steel-framed house, was largely responsible for the confusion.[50]

Other émigrés, including Mendelsohn, would attempt to duplicate this achievement without realizing how exorbitantly expensive such construction was on so small a scale.[51] The enormous budget overruns on the Farnsworth House notoriously led Edith Farnsworth to sue Mies. Equally unsatisfactory was the lack of attention he paid to her privacy. Although Farnsworth was unsuccessful in court, her cause was taken up by Elizabeth Gordon, the editor of *House Beautiful*, and attracted the sympathy of none other than Wright. Unlike 860 and 880 Lake Shore Drive, the Farnsworth House failed to become a widely imitated prototype; its most famous progeny, Johnson's Glass House in New Canaan, Connecticut, was actually completed first.[52]

The Farnsworth House in some respects aside, Mies would in the twenty-two years between the MoMA exhibition and his death in 1969 go from success to success. His New National Gallery in West Berlin, completed in 1967, and his role as a teacher are particularly pertinent to an understanding of the relation between the architecture of Chicago and that of Berlin.[53] The gallery was designed in conversation with Karl Friedrich Schinkel's Altes Museum and its site in West Berlin's new Kulturforum. Mies's building was intended in part to serve as a replacement for the Altes Museum, then located on the other side of the Berlin Wall. The compelling synthesis of classical precedent and modern engineering injected Mies's postwar glass and steel pavilions into the city where he had first envisioned an entirely glazed architecture.

This is not the end of the story, however. Two of the most visible structures erected in Berlin and Chicago in the last two decades speak of the impact the architecture of each continues to have upon the other. Just as the work of one German-born, Chicago-based architect marked the division of Berlin, so that of another provided one of the first new landmarks following its reunification. Helmut Jahn's Sony Center, completed in 2000, is one of the linchpins of Potsdamer Platz. The largest single development built in Berlin directly after the fall of the wall, Potsdamer Platz also includes a sky-scraper by Josef Kleihues, the German architect of Chicago's Museum of Contemporary Art.[54] Within days of the fall of the Berlin Wall in 1989, speculation began to build about how Potsdamer Platz, once the city's busiest intersection, could be redeveloped as the heart of a reunited city. Somewhat ironically, there was immediate opposition to the possible insertion into the skyline of curtain-walled skyscrapers, now viewed as an American import despite their Berlin origins. For Chicagoans the Sony Center reprises in a frankly commercial manifestation the atrium of the jaunty James R. Thompson Center (originally the State of Illinois Center). In the context of its Berlin site, however, it accomplishes something distinctively local by weaving together the clashing inter-pretations of expressionism offered in the neighboring Kulturforum by Mies and Hans Scharoun.

The Kulturforum and Potsdamer Platz were both frankly political complexes. The first provided West Berlin with a civic infrastructure; the second reinjected capitalist com-mercialism into a wasteland that had earlier been bifurcated by the wall. Chicago was at the periphery and Berlin at the center of a Cold War whose primary battles were fought either over culture or in client states in the third world. Although many middle-class Americans remained skeptical about modern architecture and few emphatically embraced

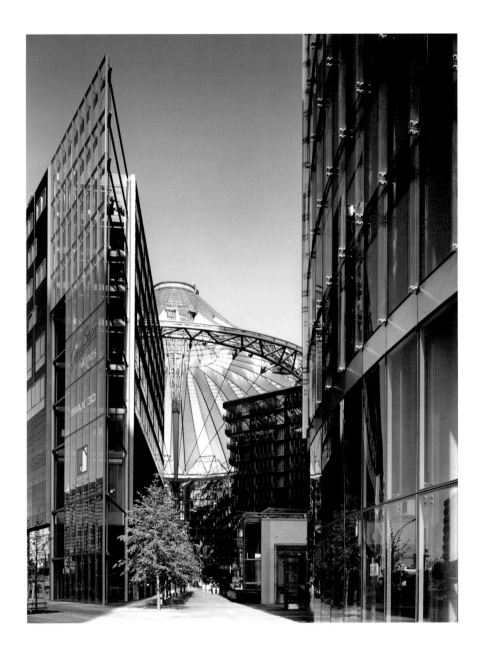

its abstraction (as opposed to its convenience and cheapness), the country's cultural and political establishment quickly grasped its effectiveness as propaganda for the United States, and by extension for capitalism and democracy. The US State Department commissioned a series of consulates and embassies that were showcases of a modernism that did not make such rapid inroads at home. A series of American government buildings in Germany designed by Skidmore Owings and Merrill helped solidify the reputation of the Bauhaus as providing an effective template for a renewed German democracy grounded in both indigenous precedent and American example.[55]

But it was Berlin that was at the center of Cold War debates over architecture. West

Berliners quickly responded to the construction of the Stalinallee along Soviet lines by building, with considerable American help, a new housing quarter called the Hansaviertel, designed by an international collection of star architects.[56] The jewel in the West Berlin crown was certainly the Kulturforum. This was West Berlin's (very successful) attempt to establish its own cultural infrastructure rather than remain dependent on the institutions located in the Soviet sector. Until the erection of the Berlin Wall in 1961, travel between the two halves of the city was relatively easy, so the complex was placed close to the border to attract East Berliners. The wall left the Kulturforum in a relatively marginal location within the city, but occupation of Hans Scharoun's Philharmonie, completed in 1963, by the Berlin Philharmonic under the legendary direction of Herbert van Karajan, assured the presence of audiences.[57]

Mies's National Gallery sits near the Philharmonie but retains a chilly remove from its eccentric forms. Both architects recall the expressionism of the first years after World War I, but in radically different ways. Scharoun focused on the literal construction of community by placing the orchestra near the center of his hall, with the audience seated in what he described as a vineyard rising around the musicians. Whereas Scharoun, who designed the concert hall from the inside out, left the core opaque, Mies appears at first glance to have favored transparency. The high light levels in the main floor of his gallery make it very difficult to exhibit paintings there, although it has proved to be an excellent location for sculpture and architecture. More conventional spaces, tucked into the high plinth on which the glazed pavilion is perched, subvert the popular neoclassical equation of the art museum with a temple by relegating most of the art to the basement where, paradoxically, it can be viewed without the distractions posed by the outside views found in the pavilion itself.[58]

One of the buildings now visible from that plinth is the Sony Center, located a mere three blocks away. Mies's distinctive teaching at IIT did not become a widely imitated model, as Gropius's at Harvard's did. It did, however, train a number of excellent architects, including many who came from abroad.[59] Jahn, a German who left IIT without completing his degree, was one of them.[60] Like many drawn to Chicago by Mies's presence, he stayed, becoming one of the city's most successful architects. German commissions, including buildings in Berlin, have been central to his firm's practice.

The earliest in Berlin was a sliver of an office building on the Kurfürstendamm, completed in 1994.[61] It was, with Jean Nouvel's far better known Galleries Lafayette, one of the first buildings in the city to follow up on the experimentation with night lighting that was such a prominent feature of the city's modern buildings, including those by Mendelsohn, during the 1920s.[62] Although the modern architecture of the Weimar Republic is often associated with utopian socialism, as typified by the Schocken Store in Stuttgart, much of its pulsing energy came from its frank commercialism. Despite being a supposed showcase of capitalism, West Berlin, heavily subsidized by the Americans and the West Germans, was anything but market-oriented. Jahn was at the center of the revival of commercialism that quickly followed reunification.

When Jahn traveled to Chicago to study, Mies, despite being over eighty, appeared to be one of the world's most up-to-date architects. The emergence of minimalism in

the early 1960s enhanced his standing, but within a decade of his death in 1969 post-modernism would threaten his legacy. By the early 1990s modernism was beginning its comeback, but there was no return to Mies's pristine geometries. Following a visit to IIT in 1950, Mendelsohn snidely commented to his wife that Mies had "found his formula and intends apparently to stand upon it to the end, square and academic . . . a rigid synthesis of principles which will kill (quickly as well as painlessly) the new hope of a free humanity."[63] What was originally an outrageous minority opinion became widely shared by the 1970s. To survive postmodernism, the most serious threat to its existence since the 1930s, modernism needed to be reinvented yet again. Its reincarnation in the last two decades incorporates a real respect for history, albeit for that of modernism, and even for ornament, as long as it is abstract and technological. This is modernism with the pizzazz that Mies so consciously eschewed.

In the Sony Center, Jahn fused divergent aspects of expressionism to create a frankly populist modernism. Once again he demonstrated his mastery of the curtain wall, in whose development German expressionism in general and Mies in particular played such a crucial role. But at the same time he integrated the aspects of expressionism that Mies had definitively purged. No one could accuse Jahn of being a dried-out onion. The Sony Center is exuberant. Its roof dances on the skyline, and the quasi-public space inside serves as a gathering place for events like big-screen live showings of football matches. Crass and commercial in comparison to the Philharmonie, it is nonetheless one of the few truly popular places within the mostly banal Potsdamer Platz.

Nor was Jahn the only American architect of his generation inspired by Scharoun. Although Frank Gehry's buildings of the last twenty years, including his Jay Pritzker Pavilion, completed in Chicago in 2004, are widely understood to be both wildly original and completely novel, most are in fact inflected by his admiration for Scharoun. Gehry's German work, beginning with the Vitra Design Museum in Weil am Rhein, which opened in 1989, and including the Deutsche Bank in the shadow of Berlin's famous Brandenburg Gate, finished eleven years later, are among the many examples of contemporary modernism that are, in fact, postmodern in their respect for history. The only difference is that Gehry manipulated modernism rather than classical order and ornament. In turning away from Miesian understatement toward the more overtly theatrical Scharoun, he provided Chicago with a gathering place that fused the cultural character of the Philharmonie, the template for his Walt Disney Concert Hall in Los Angeles (2003), with the populist energy of Jahn's Sony Center.[64]

Together with Renzo Piano's frank citation of Mies's New National Gallery in his Modern Wing for the Art Institute of Chicago, opened in 2009—and by extension Mies's Crown Hall at IIT of 1956—Gehry's pavilion demonstrates the continued vitality of modernism and of the dynamic interchange between Europe's and North America's leading showcases for architecture since about 1880.[65] There was never a singular modernism in either city. Instead diverse expressions of the complex relationship between art, function, and technology flourished in both. These were almost always informed by an interest in what was afoot in the other city and how it could be harnessed to push what appeared to be expressions of the new, even as these have become increasingly historicist. Although

both politics and the marketplace colored these interchanges, neither ever completely controlled them.

Thus, a consideration of the multiple links between the architecture of Chicago and Berlin reveals not only a fruitful interchange, but also the limitations of many of the ways historians of both cities have told architectural history. Their narratives have tended to privilege narrow definitions of modernism that have focused on abstraction, function, and construction, on the one hand, and capitalism and politics on the other, without paying sufficient attention to the way in which architects, clients, and the public of both cities have used architecture to construct their own identities and that of their cities. Architecture has often expressed what was not obvious, and perhaps not even true. The ornamental I-beams of Mies's Lake Shore Drive apartments, which implied structure rather than carrying the actual weight of the building, can stand for many other complexities and contradictions—from the European determination to view as uncultured and primitive buildings that were, in fact, often gracefully decorated, and to ignore neighbors that were sophisticated examples of the latest imported fashions, to the American misreading of the early IIT buildings as exemplars of the Bauhaus architecture of the Weimar Republic, when they more closely resembled factories of the Third Reich. Just as a revived modernism continues to inspire hope for a utopian future that can never be achieved through architecture alone, such myths allowed champions of the two cities to see themselves as uniquely urbane but eminently pragmatic sophisticates, not least in times that actually seemed, as almost every era does to people of a certain age living through it, deeply uncertain. Chicagoans and Berliners have been sophisticated consumers of multiple architectural traditions, but it has been the conversation between them that has pushed both to make the modern.

Notes

1. Carl Condit, *The Rise of the Skyscraper* (Chicago: University of Chicago Press, 1952), outlined the opening chapters of this narrative, which was confirmed a generation later in William Jordy's magisterial *Progressive and Academic Ideals at the Turn of the Twentieth Century* and *The Impact of European Modernism in the Mid-Twentieth Century*, volumes 4 and 5 of *American Buildings and Their Architects*, ed. William Pierson (1970; Garden City: Anchor Press/Doubleday, 1976), and Vincent Scully's *American Architecture and Urbanism* (New York: Praeger, 1979).

2. Kathleen James-Chakraborty, "From Isolation to Internationalism: American Acceptance of the Bauhaus," in *Bauhaus Culture from Weimar to the Cold War*, ed. James Chakraborty (Minneapolis: University of Minnesota Press), 153–70.

3. Mark Twain, "The German Chicago," in *Literary Essays*, vol. 24 of *The Writings of Mark Twain* (New York: Collier, 1918), 244.

4. Contrast, for example, Robert Bruegmann, *The Architects and the City: Holabird & Roche of Chicago, 1880–1918* (Chicago: University of Chicago Press, 1997), or Colin Rowe's chapter "Chicago Frame," in *The Mathematics of the Ideal Villa and Other Essays* (Cambridge, MA: MIT Press, 1976), with Barbara Miller Lane, *Architecture and Politics in Germany, 1918–1945* (Cambridge, MA: Harvard University Press, 1968). Rowe's essay first appeared in 1956 in the *Architectural Review*.

5. Leonard Eaton, *American Architecture Comes of Age: European Reaction to H. H. Richardson and Louis Sullivan* (Cambridge, MA: MIT Press, 1972).

6. Mary N. Woods, *From Craft to Profession: The Practice of Architecture in Nineteenth-Century America* (Berkeley: University of California Press, 1999), 71–81.

7. See Barbara Miller Lane, *National Romanticism in Germany and the Scandinavian Countries* (Cambridge: Cambridge University Press, 2000), as well as Eaton, *American Architecture Comes of Age*.

8. Arnold Lewis, *An Early Encounter with Tomorrow: Europeans, Chicago's Loop, and the World's Columbian Exposition* (Urbana: University of Illinois Press, 1997).

9. A point repeatedly made in Joseph Siry, *The Chicago Auditorium Building: Adler and Sullivan's Architecture and the City* (Chicago: University of Chicago Press, 2002).

10. Daniel Bluestone, *Constructing Chicago* (New Haven, CT: Yale University Press, 1991). Joanna Merwood Salisbury, *Chicago 1890: The Skyscraper and the Modern City* (Chicago: University of Chicago Press, 2009), 52, 74, argues for Adler and Sullivan's Stock Exchange and Burnham and Root's Woman's and Masonic Temples, rather than the Rookery, as the definitive artistic and civic skyscrapers.

11. Here I counter Louis Sullivan, *The Autobiography of an Idea* (1924; New York: Dover Publications, 1956), 318–25, and the generations of critics and historians who have followed his example. An important exception is Rowe, *Mathematics of the Ideal Villa*, 92. Merwood-Salisbury, *Chicago 1890*, 1, notes the impact of the economic crash that occurred the same year.

12. The exception was Werner Hegemann and Elbert Peets, *The American Vitruvius: An Architects' Handbook of Civic Art* (Princeton, NJ: Princeton Architectural Press, 2000). See Merwood- Salisbury , *Chicago 1890*, 135–43, for a summary of German writing about Chicago skyscrapers from Ludwig Hilberseimer through Sigfried Giedion.

13. Anthony Alofsin, *Frank Lloyd Wright, the Lost Years, 1910–1922: A Study of Influence* (Chicago: University of Chicago Press, 1993), 127–32.

14. Walter Gropius, "Die Entwicklung moderner Industriebaukunst," *Deutscher Werkbund Jahrbuch* (1913), 17–22; Reyner Banham, *A Concrete Atlantis: U.S. Industrial Building and European Modern Architecture, 1900–1925* (Cambridge, MA: MIT Press, 1985).

15. Most of these photographs can be found in the two editions of *Handbuch für Eisenbetonbau*, ed. Max Foerster, Rudolf Saliger, and Fritz von Emperger (Berlin: Wilhelm Ernst & Sohn, 1907–1909 and 1910–1923).

16. Kathleen James, *Erich Mendelsohn and the Architecture of German Modernism* (Cambridge: Cambridge University Press, 1997), 63–70.

17. Erich Mendelsohn, *Amerika: Bilderbuch eines Architekten* (Berlin: Rudolph Mosse Verlag, 1926).

18. Ludwig Hilberseimer, *Großstadt Architektur* (Stuttgart: Julius Hoffmann Verlag, 1927).

19. Katherine Solomonson, *The Chicago Tribune Tower Competition: Skyscraper Design and Cultural Change in the 1920s* (Cambridge: Cambridge University Press, 2001).

20. James, *Mendelsohn*, 178–93.

21. Alofsin, *Lost Years*, challenges some of the details of this story, but the influence remains incontrovertible.

22. Karin Wilhelm, *Walter Gropius: Industriearchitekt* (Braunschweig: Vieweg, 1983).

23. James, *Mendelsohn*, 64, 95–107.

24. H. Allen Brooks, *Frank Lloyd Wright and the Prairie School* (New York: Braziller, 1984), 336–48—a view brilliantly contradicted in Alofsin, *Lost Years*.

25. Neil Levine, *The Architecture of Frank Lloyd Wright* (Princeton, NJ: Princeton University Press, 1997), 191–215.

26. Wolf Tegethoff, "From Obscurity to Maturity: Mies van der Rohe's Breakthrough to Modernism," in *Ludwig Mies van der Rohe: Critical Essays*, ed. Franz Schulze (New York: Museum of Modern Art, 1989), 28–94.

27. Terence Riley, *The International Style: Exhibition 15 and the Museum of Modern Art* (New York: Rizzoli, 1992); Frederick Kiesler, *Contemporary Art Applied to the Store and Its Display* (New York: Brentano's, 1930), 39.

28. A 1921 article on Mendelsohn by Hermann George Scheffauer in the *Dial* drew the attention not only of Mumford but of the young Bruce Goff and Harwell Hamilton Harris. See James, *Mendelsohn*, 2.

29. James, *Mendelsohn*, 64–65; Robert Wojtowicz, *Lewis Mumford and American Modernism: Eutopian Theories for Architecture and Urban Planning* (Cambridge: Cambridge University Press, 1996).

30. Lewis Mumford, *The Brown Decades: A Study of the Arts in America: 1865–1895* (New York: Harcourt Brace and Company, 1931).

31. Fiske Kimball, *American Architecture* (Indianapolis: Bobbs-Merrill Company, 1928).

32. Henry-Russell Hitchcock, *The Architecture of Henry Hobson Richardson and His Times* (New York: Museum of Modern Art, 1936); Hugh Morrison, *Louis Sullivan: Pioneer of Modern Architecture* (New York: Museum of Modern Art, 1935); Hitchcock, *In the Nature of Materials: The Buildings of Frank Lloyd Wright* (New York: Duell, Sloane and Pearce, 1942).

33. For two general accounts of the émigrés see Stephanie Barron with Sabine Eckmann, *Exiles and Émigrés: The Flight of European Artists from Hitler* (Los Angeles: Los Angeles County Museum of Art, 1997) and Georg-W. Kölzsch and Margarita Tupitsyn, eds., *Bauhaus: Dessau, Chicago, New York* (Cologne: DuMont, 2000).

34. Richard Pommer, "Mies van der Rohe and the Political Ideology of the Modern Movement in Architecture," in Schulze, *Mies van der Rohe*, 96–145. For a comprehensive account of Bauhäusler working during and for the Third Reich see Winfried Nerdinger, ed., *Bauhaus-Moderne in Nationalsozialismus, zwischen Anbiederung und Verfolgung* (Munich: Prestel, 1993), the final chapter of which appears in English as "Bauhaus Architecture in the Third Reich," in James-Chakraborty, *Bauhaus Culture*. See also Karen Fiss, *Grand Illusion: The Third Reich, the Paris Exposition, and the Cultural Seduction of France* (Chicago: University of Chicago Press, 2009).

35. James-Chakraborty, "From Isolation to Internationalism."

36. Achim Borchardt-Hume, *Albers and Moholy-Nagy: From the Bauhaus to the New World* (London: Tate, 2006); Jeanine Fiedler, *László Moholy-Nagy*, trans. Mark Cole (London: Phaidon, 2001).

37. Rose-Carol Washton Long, "From Metaphysics to Material Culture," in James-Chakraborty, *Bauhaus Culture*.

38. Alain Findeli, *Le Bauhaus de Chicago: l'oeuvre pédagogique de László Moholy-Nagy* (Paris: Mérédiens Klinksieck, 1995); László Moholy-Nagy et. Al., *The New Bauhaus: School of Design in Chicago: 1937–1944* (New York: Banning and Associates, 1993), and Stephen S. Prokopoff, *The New Spirit in American Photography: Gyorgy Kepes, Henry Holmes Smith, Harry Callahan, Art Sinsabaugh, Nathan Lerner, Arthur Siegel, Aaron Siskind* (Urbana, IL: Krannart Art Museum, 1985).

39. "Gregory Kepes, Founder of CAVS, dies at 95," January 16, 2002, http://web.mit.edu/newsoffice/2002/kepes.html (accessed July 2, 2009); Reinhold Martin, *The Organizational Complex: Architecture, Media, and Corporate Space* (Cambridge, MA: MIT Press, 2005).

40. Alan Powers, *Serge Chermayeff: Designer, Architect, Teacher* (London: RIBA, 2001).

41. See the exhibition catalog: Philip Johnson, *Mies van der Rohe* (New York: Museum of Modern Art, 1947). That this was the first monograph devoted to the architect shows how far off the radar he had fallen since the closure of the Berlin Bauhaus in 1933. See also Terance Riley, "Making History: Mies van der Rohe and the Museum of Modern Art," in *Mies in Berlin*, ed. Terence Riley and Barry Bergdoll (New York: Museum of Modern Art, 2001), 11–25.

42. Paul Betts, "The Bauhaus as Cold War Legend: West German Modernism Revisited," *German Politics and Society* 14 (Summer 1996): 75–100.

43. See, for instance, Alfred Barr, as quoted in the *Museum of Modern Art Bulletin* 15 (Spring 1948): 7.

44. Buschmann, Walter, ed., *Zechen und Kokereien im rheinischen Steinkohlenbergbau: Aachener Revier und westliches Ruhrgebiet* (Berlin: Gebr. Mann Verlag, 1998), 145.

45. See Kathleen James-Chakraborty, "Inventing Industrial Culture in Essen," in *Beyond Berlin: German Cities Confront the Nazi Past*, ed. Paul Jaskot and Gavriel Rosenfeld (Ann Arbor: University of Michigan Press, 2007), 116–39.

46. The classic study of these buildings remains Jordy, *Impact of European Modernism*.

47. "Mies van der Rohe," *Architectural Forum* 97 (November 1952): 96–102.

48. Meredith Clausen, "Belluschi and the Equitable Building in History," *Journal of the Society of Architectural Historians* 50 (1991): 109–29.

49. Condit followed his *Rise of the Skyscraper* (1952) with *The Chicago School of Architecture: A History of Commercial and Public Buildings in the Chicago Area, 1875–1925* (Chicago: University of Chicago Press, 1964). His earlier essay "Chicago Frame" is reprinted in Rowe, *Mathematics of the Ideal Villa*, 89–117.

50. Richard Neutra, *Wie baut Amerika* (Stuttgart: J. Hoffmann, 1927).

51. Peter Winston, interview with the author, June 1998. See also Bruno Zevi, *Erich Mendelsohn: Complete Works* (Basel: Birkhauser Verlag, 1999), 287.

52. The classic study of these aspects of the Farnsworth House is Alice Friedman, *Women and the Making of the Modern House* (New York: Abrams, 1998), 126–59. See also Kathleen Corbett, "Tilting at Modern: Elizabeth Gordon's 'The Threat to the Next America,'" dissertation, University of California Berkeley, 2010.

53. See Mark Jarzombek, "Mies van der Rohe's New National Gallery and the Problem of context," *Assemblage* 2 (1987): 32–43; *Mies van der Rohe: Architect as Educator*, ed. Rolf Achilles, Kevin Harrington, and Charlotte Myhrum (Chicago: Illinois Institute of Technology, 1986).

54. As the signature development of a reunited city, Potsdamer Platz has spawned a huge literature. For an introduction to the subject see *Potsdamer Platz: urbane Architecktur für das neue Berlin*, ed. Yamin von Rauch and Jochen Visscher (Berlin: Jovis, 2000).

55. Jane C. Loeffler, *The Architecture of Diplomacy: Building America's Embassies* (New York: Princeton Architectural Press, 1998). For more on the relation between modern architecture and Cold War politics, see Annabel Jane Wharton, *Building the Cold War: Hilton International Hotels and Modern Architecture* (Chicago: University of Chicago Press, 2001), and Kathleen James-Chakraborty, "Architecture of the Cold War: Louis Kahn and Edward Durrell Stone in South Asia," in *Building America*, vol. 3, *Eine große Erzähluung*, ed. Anke Köth, Kai Krauskopf, and Andreas Schwarting (Dresden: Thelem, 2008), 169–82.

56. Debi Howell, "Berlin's Search for a 'Democratic' Architecture: Post–World War II and Post-Unification," *German Politics and Society* 16, no. 3 (1998): 62–85; Herbert Nicholaus and Alexander Obeth, *Die Stalinallee: Geschicte einer deutschen Strasse* (Berlin: Verlag für Bauwesen, 1997); Simone Hain, *Warum zum Beispiel die Stalinallee? Beiträge zu einer Transformationsgeschichte des modernen Planens und Bauens* (Erkner: Institut für Regionalentwicklung und Strukturplanung, 1999).

57. Edgar Wisniewski, *Die Berliner Philharmonie und ihr Kammermusiksaal: Der Konzertsaal als Zentralraum* (Berlin: Gebr. Mann, 1993). See also Hugh Campbell, "The Bright Edifice of Community: Politics and Performance in Hans Scharoun's *Philharmonie*," *Architectural Research Quarterly* 11 (2007): 159–66.

58. Jarzombek, "Mies van der Rohe's New National Gallery."

59. These were not all from Germany. For Robin Walker, from Ireland, see John O'Regan, ed., *Scott Tallon Walker Architects: 100 Buildings and Projects, 1960–2005* (Kinsale: Gandon Editions, 2006).

60. Werner Blaser, *Helmut Jahn, Werner Sobek, Matthias Schuler: Architectural Engineering* (Basel: Birkhauser, 2002).

61. Werner Blaser, *Helmut Jahn: Transparency*, trans. John Dennis Gartrell (Basel: Birkhauser, 1996).

62. Dietrich Neumann, *Architecture of the Night: The Illuminated Building* (Munich: Prestel, 2000).

63. Erich Mendelsohn, letter to Louise Mendelsohn, January, 27 1950, Mendelsohn Archive, Kunstbibliothek, Staatliche Preußischer Kulturbesitz, Berlin.

64. All of these are included in Casey C. M. Mathewson, *Frank Gehry: Selected Works: 1969 to Today* (Richmond Hill: Firefly Books: 2007).

65. James Cuno, Paul Goldberger, Joseph Rosa, and Judith Turner, *The Modern Wing: Renzo Piano and the Art Institute of Chicago* (Chicago: Art Institute of Chicago, 2009).

Buckminster Fuller in Chicago: A Modern Individual Experiment

TRICIA VAN ECK

This essay examines the influence of Chicago and its surroundings upon Buckminster Fuller's modernist enterprise—a fifty-six-year utopian personal experiment that sought to advance society through singular achievement, which he called guinea pig B (for Bucky).[1] Fuller's key ideas were initially conceived in Chicago between 1926 and 1929, compiled in his book *4D Time Lock*, and later developed in his 1948-1949 classes at the Institute of Design (now part of the Illinois Institute of Technology), where he produced his Standard of Living Package. His ideas were further refined from 1959 to 1972, when he lived and worked at Southern Illinois University, in Carbondale, where he initiated the World Resources Inventory and World Game, a think tank and educational game concerned with global resource allocation. His last project in Illinois—the Old Man River communal city project, a large, dome-covered low-cost housing complex for the city of East Saint Louis—was never realized, but Fuller considered it the most important project of his life.

Early Years in Chicago, 1926-1934

In 1926 Fuller moved to Chicago to further develop, with his father-in-law, J. Monroe Hewlitt, the Stockade Building System. The system, which made use of two types of cement-bonded, compressed-fiber blocks, functionally similar to contemporary concrete blocks, promised a kind of revolution in construction: vertical holes through the blocks allowed for the insertion of load-bearing poured concrete with reinforcing rods. As they were fibrous, the blocks could also be cut to insert floor beams. When connected by means of horizontal channels and tie-rods, they could be used to create a reinforced structure of vertical columns and horizontal beams.[2] Although over two hundred homes were built

using the system, in 1927 Fuller was forced to resign from his position as president and later left the company.[3]

In 1927 Fuller's second daughter, Allegra Fuller, was born. Tormented by professional and personal crises (including the earlier death of his first daughter), the thirty-two-year-old Fuller purportedly contemplated committing suicide in Lake Michigan, but instead he redefined his life's mission. The suicidal intentions may be apocryphal, but he did make a decisive shift from selling individual building parts to analyzing the socioeconomics of the housing industry as a whole. He also came to accept personal failure as inextricably linked to the experimental method of trial and error. This led, he reported, to an outpouring of ideas, which he claimed set in motion his lifelong experiment to "see what a penniless unknown human individual . . . might be able to do effectively on behalf of all humanity."[4] He always referred to 1927 as his life's turning point, the year when he began to systematically apply universal principles and advancements in technology, industry, and materials to solve society's ills, particularly with regard to shelter.[5] This approach—which he would later call comprehensive anticipatory design science and at other times synergetics—informed his responses to a heterogeneous array of problems throughout his subsequent life's work.

Lightful and 4D Ideas

Fuller's first holistic reflections on housing can be seen in his early drawings. *One Ocean World Town Plan* (1927) and *Sketch of Lightful Houses* (1928) reflect his view of the world as a circular, inhabited whole, connected through natural patterns, shapes, and resources, a relatedness best advanced through the allocation and utilization of new materials and technologies. In *Comparison of Lightful Homes and Traditional Homes* (1928) he cynically wrote above the Traditional Home, "no structural advance in 5000 years." This drawing contrasted the Traditional Home's six-month construction to the one-day construction, at one-tenth the cost, of his own Lightful Home, which also featured built-in utilities and self-contained water and power supplies.

Blaming social problems on the market's misallocation of resources and accusing industry of primarily producing nonessentials, Fuller wrote, "We are at a point when those in charge of capital must realize that we have overlooked the most essential product for industrial production,—the home."[6] His solutions—first Fuller House, then Lightful House, and finally 4D—were standardized, mass-produced structures that could be economically prefabricated from lightweight, new materials that required minimum labor and waste, and could be delivered by air, planted like trees, and easily moved. Compiling these ideas in his treatise *4D Time Lock*, Fuller explained his technically and industrially advanced, visionary approach to a four-dimensional world articulated through architecture. To Fuller, the term "4D" represented a quasi-mystical confluence of space and time that blended a range of concurrent but divergent ideas, including Einstein's theory of relativity, market notions of time as an economic standard, and architect Claude Bragdon's

geometric analysis of architectural ornamentation as a tool for a democratic integration with nature rather than a symbol of class distinctions.[7]

• • •

Fuller had read Le Corbusier's *Towards a New Architecture* and, like the French architect, believed in the potential for radical change in housing to transform social ills.[8] Both put their faith in new, standardized homes, advocating their use in place of what they viewed as the existing feudalist, archaic building system. Like Le Corbusier, Fuller stressed that it was imperative to effect radical change in both social and technological realms. In doing so, Fuller also aimed to elevate the hygienic standards of housing to match those of other industries:

> Our great cities ... are but revolutionary movements prior to adjustments. Persons intelligently informed in scientific and economic advance today, will be shocked to realize ... the rotten, dank, pestilence breeding, construction of the homes of the great 95% of the population. They will be astonished to learn that the majority of houses today are still without even bathrooms, toilets, or sewage disposal, and are pasted, piled, and tacked together, after any plan or fashion of the dark ages.... We don't manufacture yachts, busses, ocean liners, or pullman cars of brick, stone, wood or concrete, in fact we couldn't. Why should we manufacture houses of these unscientific materials? Is there any virtue in excess weight?[9]

While Fuller shared Le Corbusier's ideas for architectural change—designing from within rather than from without, embrace of the machine and the aesthetic of engineering, deference to geometry and the laws of nature—his self-published, mimeographed *4D Time Lock* was intended as an entrepreneurial venture to raise interest and capital to develop a new industrial method of home construction. Through the economic and efficient use of technology, industry, economics, and materials, Fuller's 4D home was to be mass-produced, standardized, time-saving, and economical; made of lightweight metal, it would function like a machine. It drew less on his Stockade experience with architecture than on his knowledge of industry, materials, and systems analysis, acquired from his work in the cotton-mill industry in Boston and Quebec and the meatpacking industry in New York, his training in efficiency at the Naval Academy and subsequent stint in the US Navy, and his technocratic theory studies.[10] By applying Henry Ford's assembly-line approach to commercially mass-produced housing, using resources and time more efficiently, Fuller asserted that society could be housed affordably. Built in a day, his compact homes would incorporate modern, labor-saving conveniences previously available only in hotels and hospitals. Through "lightful" design, the 4D house would enrich the lives of its occupants as well as jump-start the economy. As if pitching a sale, Fuller wrote optimistically, "The new home is the only salvation of economic chaos.... The industrially produced home, with its combined facilities ... has no limit to its production."[11]

While Le Corbusier similarly advocated a "mass-production state of mind" for conceiv-

ing, building, and living in standardized housing, he was careful to promote himself as the architect of this new modern home. In contrast, Fuller presented himself as a designer-developer, writing that only 5 percent of the individual residences of the United States were designed by architects. He printed only two hundred copies of *4D Time Lock*, and though Chicago publisher Charles Scribner approached him about publishing the book commercially, this never came to fruition.[12] Few architects received the book, and it was not critically reviewed. At the time Fuller was relatively unknown within the architectural community, which, moreover, was not in favor of standardization.[13] His father-in-law, who by then was vice president of the American Institute of Architects, wrote a personal letter to Fuller in July 1928 summarizing the architectural community's resistance to prefabrication: "The sort of standardization now going on in the many branches of the industry is definitely hurtful to the development of architecture as an art."[14] Standardization was perceived as a modernist threat to both jobs and *aura*, or local character. Fuller subsequently dismissed architecture in a personal letter to architect Paul Nelson: "As soon as we have adjusted people to our 4D purposes, we will drop the use of 'architecture' in conjunction with 4D designing. It has no 'archaic' materialistic reference, its only common truth with the 'past' being the external abstract truths themselves, and consideration of temporal dynamics."[15] In effect, Fuller's ideas presented a potential threat to eliminate architecture.

Resistance prevailed until the 1960 publication of Reyner Banham's book *Theory and Design in the First Machine Age*. In Banham's concluding chapter, he reassessed Fuller's importance, placing him in a line of succession with the futurists' use of technology. Fuller's knowledge and application of technology and building techniques were presented as revolutionizing how the home functioned. And Banham quoted Fuller's refutation of the international style as "a machine aesthetic rather than a profound application of technology to what should have been perceived of as architectural problems."[16] Banham's elevation of Fuller over Le Corbusier and Gropius was generally dismissed, and in architectural monographs even today Fuller is often left out or discussed only briefly, with the focus on his Dymaxion House. The characteristic positioning of Fuller's architectural contribution can be seen, for instance, in *A History of Architectural Theory: From Vitruvius to the Present*, in which the author states that with Fuller, "we find all conventional concepts of architecture scattered to the winds," continuing: "Fuller's lightweight constructions serve a function as large temporary buildings for exhibitions and similar purposes but they cannot be considered as architecture, nor should the principles behind them be considered as relevant to architecture."[17]

The Dymaxion House and Dymaxion Car

In April 1929 the Interior Decorating Galleries at Chicago's Marshall Field's department store displayed a model of Fuller's redesigned 4D house. It was billed as an attraction—a way to sell modern furniture that the store had bought at the 1926 Paris Exposition[18]—and renamed "Dymaxion." An amalgamation of "dynamic," "maximum," and "ion," the term was coined by Marshall Fields's marketer Waldo Warren using Fuller's idiosyncratic

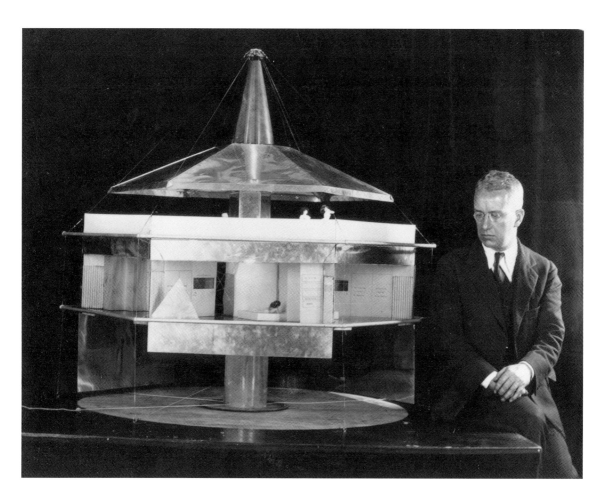

Buckminster Fuller with model
of 4D Dymaxion House, 1927.
Courtesy of the Estate of R.
Buckminster Fuller.

vocabulary. Fuller would later define Dymaxion as meaning "maximum gain of advantage from the minimal energy output."[19]

In the time between the original publication of Fuller's patent in *4D Time Lock* and this presentation of the model, the rectangular 4D plan had given way to a hexagonal form, reflecting Fuller's desire to situate the home within a modernist understanding of the world, correcting what he called "the fallacy of right angles . . . when people thought the world to be flat."[20] Although Le Corbusier's "5 Points of a New Architecture" had not yet been translated into English, Fuller likely knew about its argument, since his friend, architect Paul Nelson, had studied with Le Corbusier.[21] The Dymaxion model—similar to Le Corbusier's early prefabricated Domino home plan, with its two identical stacked floors—gained a roof terrace, an open plan, and horizontal windows that allowed for a completely transparent façade. But where Le Corbusier's levels were supported on pilotis, or columns, Fuller's hexagonal floor was suspended from a central caisson mast, stabilized by cables. The house was fully equipped, with built-in appliances and environmental systems (hidden in the central core in the model as in the original plan), which offered the potential for time- and labor-saving maintenance. Describing the house in the *Chicago Evening Post*, Fuller compared its system to a human backbone or tree, its construction

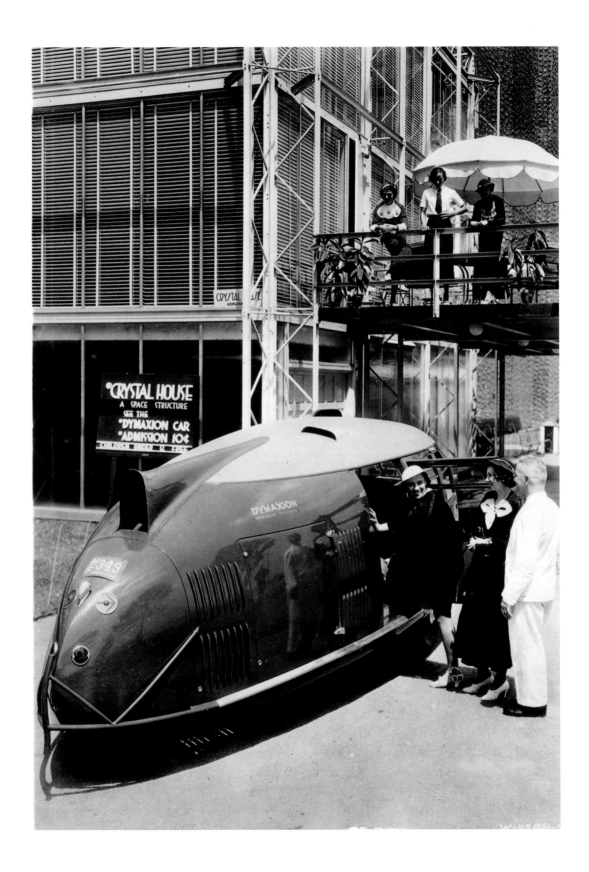

to an airplane's in lightness and strength, and its central-core design "to the battle-ship mast, radio lighthouse, or dirigible mooring tower," all of which are able to withstand great pressure.[22]

Fuller moved to New York in 1929, but he frequently returned to Chicago in 1930 to give lectures and present his Dymaxion House at private homes and venues such as the Fortnightly Club, the Arts Club, and the Renaissance Society.[23] Because he thought it imperative to explain his ideas through prototypes, Fuller also hoped to display a full-scale, production-ready model at the Century of Progress, Chicago's 1933 world's fair.[24] Instead, he presented the first prototype of his more recent invention, the Dymaxion Car, in front of Chicago architects Keck & Keck's Crystal House. Fuller's nineteen-foot, lightweight, fuel-efficient, aerodynamic three-wheeled car could carry ten passengers and reach speeds of up to 120 miles per hour, while getting thirty to forty miles to the gallon of gas.[25] Powered by a front-wheel drive Ford V-8 engine, it was codesigned with a ship-builder, Starling Burgess. The single rear-wheel steering enabled easy parking and gave the car a turning radius equal to its length. The streamlined car received a great deal of attention, partly due to a fatal accident just outside the fairgrounds.[26] While the car was eventually exonerated, its reputation was marred. Yet word of the car spread, and a new more technically advanced prototype returned to the fair in 1934.

Teaching as a Lab

In 1948 and 1949 Fuller taught classes at the Institute of Design in Chicago. For his spring 1949 product design and architecture seminar, he asked the forty students, many of whom were GIs and married: "What is high standard of living in mechanical facility as of Spring 1949?" He charged his students with developing an "autonomous dwelling structure" for use in disaster that would offer the highest standard of appliances and mechanical systems and be affordable, portable, off-the-grid, and completely sustainable. Many of the ideas investigated had been mentioned in Fuller's *4D Time Lock*, such as creating a centralized lighting system that combined natural and artificial light sources. This teaching post gave Fuller his first major opportunity to have students test the implementation of his ideas, working like assistants in a lab or an architectural studio.[27] Fuller did not have an architectural studio of his own but instead, throughout most of his career, relied on ad-hoc working relationships and personal connections to advance his ideas.

While Fuller's advancements in the design of his Dymaxion Home are well known, his concurrent attempts to improve living standards within the home are less familiar. From unpublished papers in the Illinois Institute of Technology's archives we learn that his students researched the specifics of how to construct a lightweight mechanical core; recirculate, purify, and conserve water; capture water from the atmosphere, rain, and wells; and design elements to reduce waste, space, and weight, as well as to control natural light. In addition to their experimentation and analysis, Fuller had them interview engineers, manufacturers, researchers, and scientists.

The resulting *Autonomous Dwelling Unit: Group Report* concluded, "The autonomous living package demonstrates that its super-mechanical standard of living may be available

Buckminster Fuller with Dymaxion car at the Century of Progress International Exposition, Chicago, 1933–1934. Courtesy of the Estate of R. Buckminster Fuller.

in mass production at $6000 per family . . . instead of as present for $18,000 per family." The $18,000 figure was also the US Defense Department allocation for a minimum standard home of 1,080 square feet for families of enlisted personnel and GI vets. The higher standard (as contrasted to a minimum standard provided by the government) Autonomous Dwelling Unit was also larger, at 1,548 cubic feet, and far lighter, at 12,910 pounds (Fuller had the students weigh each element). The report added, "Data indicates that one-third of the human family is doomed to premature death because of inadequate housing. The following documentation of research on the Autonomous Dwelling Unit constitutes an humble beginning toward eventual solution."[28]

Fuller also asked the students to design a package of furniture that could be folded and packed for transport by trailer and then easily assembled. When disassembled, the shipping container walls could be used as flooring. Fuller later developed this concept into his Standard of Living Package. When covered by a transparent, climate-controlled geodesic dome he called the Skybreak Dome, this collection of furniture and mechanicals would make possible a high quality of life within an off-the-grid, transportable shelter.

In summer 1949 Fuller traveled in an Airstream trailer from the Institute of Design to Black Mountain College in North Carolina. It has been widely assumed that his first, large-scale prototype for a geodesic dome was assembled the summer before in 1948 when he had constructed a supine dome at Black Mountain. However, research into Fuller's papers at Southern Illinois University reveals that this prototype was first constructed by Institute of Design students, who made thirty-one "great circles" or, as Fuller described them, "energetic-synergetic and geodesic models."[29] Fuller brought the circles with him, along with the Institute of Design's secretary and a dozen students, and the dome was then re-erected at Black Mountain.[30] In 1952 one of these students, Don Richter, advised Fuller on the construction of a dome for the Ford Motor Company's rotunda in Dearborn, Michigan.[31] In 1954 Walter Paepcke, a primary supporter of the Institute of Design and chairman of Chicago's Container Corporation, which rose to prominence with the introduction of manufactured corrugated boxes, invited Fuller to design a cardboard geodesic dome for the Tenth Triennale in Milan; his construction won the distinguished design exhibition's highest prize. These commercial successes brought international exposure and commissions for Fuller's geodesic dome, his most successful patent.

World Resources Inventory and World Game, 1959-1972

In 1955 Fuller began teaching at Southern Illinois University in Carbondale, and four years later the university offered him a research professorship. Fuller traveled extensively thereafter, but from 1959 to 1972 Carbondale remained his home base—complete with geodesic-dome house. Fuller taught in the Design Department, where students were offered a bachelor's degree in "comprehensive anticipatory design science"—his holistic, methodological approach to solving present and future problems through design that followed natural principles. It was here that Fuller initiated both his World Resources Inventory, which tracked global reserves, needs, and wants to solve issues of scarcity, and his World Game.

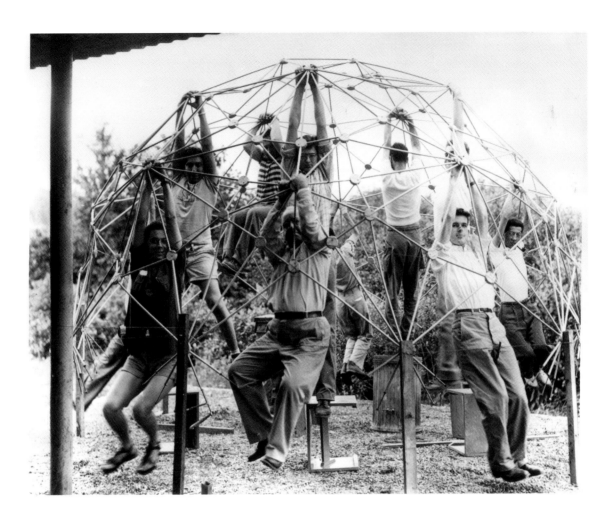

Buckminster Fuller with students at Southern Illinois University, Carbondale. Courtesy of the Estate of R. Buckminster Fuller.

According to Fuller, the World Game was "a precisely defined design science process for arriving at economic, technological, and social insights pertinent to humanity's evolvement about our planet Earth."[32] It was originally proposed as the core curriculum at the university's then-new Edwardsville campus in 1961, and three years later proposed to be an interactive installation at the US pavilion at Expo 67, the upcoming world's fair in Montréal. This was not approved, and Jasper Johns's 1967 painting *Map (Based on Buckminster Fuller's Dymaxion Airocean World)* became the extent of the World Game's inclusion in the Expo.

Both the Inventory and the World Game were extensions of Fuller's holistic thinking, grounded in faithful observation of the universe and extensive information gathering—elements he thought were the basis of all successful invention. And both drew upon his Vector-Equilibrium map.[33] This map, which in 1954 he renamed the Dymaxion Air-Ocean Map, was developed to minimize the distortion caused by projection maps' depictions of a round world onto a flat surface. In addition, Fuller changed the orientation of the commonly used Mercator and other projection maps, which were based on east-west sailing routes. Instead, his map drew on aviation technology—as seen in his 1927 *One*

Ocean World Town Plan, drawn the year Charles Lindbergh made his solo flight across the Atlantic—to reflect the global orientation of north-south jet streams. The map presented the planet as a one-ocean world, with landmasses appearing as islands surrounded by a single, connected ocean.

In 1966 Fuller inaugurated the World Game to foster an understanding of how design, technology, ecology, and renewable resources, including solar and wind energy, could work to the benefit of all humankind. He made a football-field-size Dymaxion Air-Ocean Map that would afford participants attempting to address the world's challenges a clearer depiction of the global consequences of their strategic decisions regarding the management of population, energy, communication, and transportation. Decades before widespread use of the Internet, Fuller envisioned the use of advanced computer technology to retrieve and display data from his World Resources Inventory. He hoped that the World Game, coupled with precise information and a more efficient reorganization of the world's resources, could counteract Darwinian and Malthusian predictions of scarcity, save the world's environment, and eliminate war. He believed that the standard of living of the 44 percent he deemed underprivileged could be raised without taking away from the privileged 56 percent, encouraging everyone to work for 100 percent of humanity. In essence, Fuller countered Ludwig Mies van der Rohe's "less is more" dictum with the challenge of "doing more with less."

The World Resources Inventory and World Game were perhaps the fullest expression of Fuller's modernist experiment. In *Utopia's Ghost: Architecture and Postmodernism, Again*, Reinhold Martin writes that the World Game was "thoroughly modernist, in the sense that it posited a space mapped and modeled by the geodesic dome itself in which something more than a temporary consensus could be reached . . . a modernist game of optimization at the scale of the world system, rather than a postmodernist game of perpetual, competitive innovation." While Fuller claimed the game was apolitical, Martin wrote that it "enacted a displacement of politics to the level of cartography. It was a road map to a utopian future, but one in which the political question was, in part, who was in charge of the cognitive maps."[34]

With the 1960s countercultural rise of communal living and interest in protecting the earth's resources, the inventory and game prompted renewed interest in Fuller, as Anthony Vidler points out in "Whatever Happened To Ecology? John McHale and the Bucky Fuller Revival." John McHale, who would later become the World Resources Inventory's executive director and research associate and who managed the vast research for this enterprise in Carbondale, initiated an early appreciation of Fuller as a new type of environmental architect. In a 1956 *Architectural Review* article McHale described Fuller as "a phenomenon which lies outside the customary canons of architectural judgement."[35] For McHale, Fuller represented a radical "change in the climate of ideas, not only in design."[36] Made famous by Stewart Brand's *Whole Earth Catalog* and the hippy movement's embrace of his dome, Fuller's utopian ideas of protecting Spaceship Earth through systematic optimization of resources achieved heroic status among counterculturalists and ecologists, as well as architects such as Archigram, Norman Foster, and the Metabolists.

Old Man River Communal City Project

From 1970 to 1978 Fuller collaborated on Old Man River, which was to be the largest-ever, dome-covered low-cost housing complex, in East Saint Louis, Illinois. The name of the project came from a song most famously sung by Paul Robeson in the 1936 film *Show Boat*. In Fuller's words, it "dramatized the life of Afro-American blacks along the southern states' banks of the Mississippi River in the days of the heavy North-South river traffic in cotton." Fuller believed the area became overwhelmed by unemployment and poverty when "the east-west railway network outperformed the north-south Mississippi, Mexican Gulf, and Atlantic water routes, which left many of its riverbank communities, such as East St. Louis, marooned in economic dead spots."[37]

His response to the community's request for revitalization was an experimental housing complex with an immense dome roof that drew on the massive domes he had previously built for Chicago's Union Car Tank Company.[38] Fuller's solution would have cost $800 million (the price of the Alaskan pipeline or the World Trade Center's Twin Towers), but its projected effect would have been to revive the city economically and socially.[39] Like Fuller's Tetra City idea for San Francisco, it would have offered terraced garden dwellings for the entire city's population. The dome would have created a mild climate, increasing energy efficiency and sheltering a self-contained community with shops, schools, hospitals, churches, and light industry.

Like all of Fuller's projects, Old Man River aimed to follow his dictum "reshape environment; don't try to reshape man." He had designed a thousand-foot high glass dome a mile in diameter to be placed over the area, shielding it from the elements. Nine thousand new individual homes would have been separated by ten-foot private terraces. This glass "geodesic sky parasol-umbrella" would have allowed each unit views similar to those on the side of a mountain.[40] Of his plan for a uniform structure that nonetheless would cradle individuality, Fuller wrote, "The experience will be that of living outdoors in the garden without any chance of rain and out of sight and sound of other humans, yet subconsciously aware that your own advantage is not at the expense of others' zonal advantaging." He described the dome as "a horizontal wire wheel suspension consisting of an octahedronal-tensegrity trussed, one-quarter sphere geodesic dome suspended from the 100 circumferential columns." Although it was never realized, Fuller wrote, "I have never engaged in a development that I have felt to have such promise for all humanity."[41]

Results of Fuller's Personal Experiment

Born in 1895, Fuller began his life at the end of the Victorian era and the beginning of the modern era, when scientific knowledge and technical innovation would be envisioned as solving large-scale social problems. By the age of eighty he had documented his life in his Chronofile, a vast chronological scrapbook of all of his correspondence, bills, notes, sketches, and clippings. With this, he assessed the results of his lifelong comprehensive experiment to help humanity. In 1975 Fuller produced a poster entitled *Grand Strategy of World Problem Solving: Demonstrating Technical and Economic Efficacy of Individual Initiative*

in the Twentieth Century, in which he charted the major events in his life and his "artifact inventions—technical reductions to practice," as well as his failures. The poster also cross-referenced his inventions with other major inventions in the fields of communication, transportation, and music. There was no reference to the built environment, except for his own inventions.

Why would Fuller, who cultivated an image as an outsider questioning the system, summarize his life's work within a history of canonized solutions? Perhaps the answer can be seen in his World Resources Inventory and in his design science philosophy. At the end of his life, Fuller proved to be his own best subject. For this poster he systematically analyzed and tracked his own resources, needs, and wants to comprehensively analyze and define himself and his failures. As Felicity Scott has written in *Architecture or Techno-Utopia*, in the late 1960s Fuller's dome became what has been subsequently characterized as an "externalized manifestation of a new consciousness."[42] For Fuller, his life's experiments were the manifestation of the new consciousness that he was trying to develop and advance.

While Le Corbusier's, Gropius's, and other modernists' manifestos and buildings brought about a new functional aesthetics and use of technology in architecture, Fuller's lasting achievement is the attention he brought to the question of how transforming architecture can enhance the individual and his or her standard of living. What began as a personal experiment developed into a public design science approach—a way of designing the world. His first concepts of the home as applied philosophy led to the design of autonomous dwelling units that could be dropped anywhere, freed from "the feudal real-estate racket."[43] But to solve social problems on a grand scale, Fuller needed the capitalist, industrial, mechanized system, and his *4D Time Lock* reads as a struggle over how to best advance his utopian ideas within this system. Attempting to bring change to both the house and the industry, Fuller devised a philosophy that could incorporate all change. His methodology—later called comprehensive anticipatory design science—was a machinelike approach to solving problems. The scientific method in reverse, it began by inductively defining the situation in a holistic way or, as Fuller said, "starting with the universe." Once defined, solutions could be realized through a systems-theory approach to reviewing means for technological solutions, looking to the universe for patterns and taking into consideration the impact of those possible solutions on that very universe and its resources.

While Fuller's utopian ideas were complicated and often considered quasi-mystical, they encouraged—and continue to encourage—individuals to effect change on all scales and in multiple modes. Despite his many failures and difficulties working within the system, he optimistically embraced the modern state of mind with its belief in progress and technology constantly producing change. He consistently asked how technology, science, communication, and industry might be harnessed to elevate the standard of living for all of humanity. Fuller was not advocating taking from the haves and giving to the have-nots; he was attempting to optimize modes of usage, distribution, and production for the benefit of all. He consistently asked individuals to think of how society might be transformed through design and ephemeralization (doing more with less). Thus, he urged them to approach life in a utopic manner, often using himself as the guinea pig. If he could succeed amid failure, so could others.

In 1983, in *Guinea Pig B: The 56-Year Experiment*—the last manuscript he finished before his death—Fuller again revisited his life, writing:

> I saw in 1927 that there was nothing to stop me from trying to think about how and why humans are here as passengers aboard this spherical spaceship we call Earth … to make this ship work for everybody … assuming only one goal: the omni-physically successful, spontaneous self-integration of all humanity into what I called in 1927 "a one-town world."[44]

Echoing this insistence on the importance of an individual's choices, Fuller said in his forty-two-hour lecture *Everything I Know*: "Everybody is born genius, and if there is anything important about me at all, it is that I am a demonstration of what an average, healthy human being can do if he … really commits himself to what the Universe is trying to do."[45] Two weeks before Fuller died, his close friend Harold Cohen received this note from him in the mail: "The possibility of the good life for any man depends on the possibility of realizing it for all men. And this is a function of society's ability to turn the energies of the universe to human advantage."[46] Although Fuller's utopian attempts toward comprehensive social change were perhaps destined to fail, his modernist victory lies in being a catalyst.

Toward the end of his life, Fuller requested that his epitaph read, "call me trim tab." "Think of the *Queen Mary*," he told an interviewer:

> The whole ship goes by and then comes the rudder. And there's a tiny thing on the edge of the rudder called a trim tab. It's a miniature rudder. Just moving that little trim tab builds a low pressure that pulls the rudder around. It takes almost no effort at all. … [In the case of an individual,] society thinks it's going right by you, that it's left you altogether. But if you're doing dynamic things mentally, the fact is that you can just put your foot out like that and the whole ship of state is going to turn around. … [Y]ou get the low pressure to do things. … And you build that low pressure by getting rid of a little nonsense, getting rid of things that don't work and aren't true until you start to get that trim-tab motion.[47]

This is how Fuller viewed his role on "spaceship earth." Though just one individual, his navigational potency is still being realized. And in today's world—in which the need for holistic, technological, and environmental thinking is being reasserted—Fuller's belief in the individual's ability to redirect the world one person at a time may be his true legacy.

Notes

1. This essay draws upon new research for and materials presented in the 2009 showing at Chicago's Museum of Contemporary Art of *Buckminster Fuller: Starting with the Universe*, originally organized by the Whitney Museum of American Art.

2. The Stockade Building System patent can be found at http://www.freepatentsonline.com/1633702.pdf.

3. Loretta Lorance, *Becoming Bucky Fuller* (Cambridge, MA: MIT Press, 2009), 41–46, 61–64. Lorance writes that

Fuller resigned after his father-in-law sold his controlling interest and the new owner appointed himself president. Although Fuller's letters are contradictory, Lorance surmises that his practices were not liked and that he may have worked on a patent with a coworker that would have competed with Stockade.

4. R. Buckminster Fuller, *Grunch of Giants* (New York: St. Martin's Press, 1981), 5. Fuller told this story often and in varying ways (as, for example, in *Critical Path* [New York: St. Martin's Press, 1981], 124) but always emphasized the aspect of an individual working on behalf of humanity.

5. Allegra Fuller, discussion with the author at the 2009 Chicago opening of the Buckminster Fuller exhibition (see note 1). She states that her father felt personal guilt over his first daughter's death from pneumonia and spinal meningitis, which he believed was aggravated by poor housing conditions.

6. R. Buckminster Fuller, *4D Time Lock* (Chicago: R. Buckminster Fuller, 1928; 3rd ed., Albuquerque, NM: Lama Foundation, 1972), 2.

7. Bragdon's essays "Four Dimensional Vistas" and "Architecture and Democracy" were among those that influenced Fuller. See Jonathan Massey, "Necessary Beauty: Fuller's Sumptuary Aesthetic," in *New Views on R. Buckminster Fuller*, ed. Hsiao-Yun Chu and Roberto G. Trujillo (Palo Alto, CA: Stanford University Press, 2009), 99–124, for Bragdon's influence on Fuller's ideas about geometry, and, on Bragdon more generally, Massey, *Crystal Arabesque: Claude Bragdon, Ornament, and Modern Architecture* (Pittsburgh: University of Pittsburgh Press, 2009).

8. Fuller, *4D Time Lock*, 79: "My own reading of Corbusier's 'Towards A New Architecture,' at the time when I was writing my own, nearly stunned me by the almost identical phraseology of his telegraphic style of notation with the notations of my own set down completely from my own intuitive searching and reasoning and unaware even of the existence of such a man as Corbusier." See also Loretta Lorance, "Buckminster Fuller—Dialogue with Modernism," *PART* (Journal of CUNY PhD Program in Art History), no. 7, "Technology and the Home" (Spring 2001), 8–11, http://web.gc.cuny.edu/dept/arthi/part/part7/articles/loranc.html.

9. Fuller, *4D Time Lock*, 2.

10. Massey, "Necessary Beauty," states that Fuller was influenced by Columbia University's Committee on Technocracy, particularly Howard Scott's energy surveys that measured productivity and efficiency. He also claims that Fuller adopted Frederick Taylor's philosophy of scientific management, but I would argue that Fuller, with his emphasis on the elimination of work's drudgery, sought efficiency through advancements in technology, transportation, materials, and waste reduction rather than through the labor of workers.

11. Fuller, *4D Time Lock*, 2.

12. Ibid., 24. Fuller's second edition included his original *4D Time Lock* as well as "4D Appendix No. 3," which included his 4D Chromochronofile, "a continuous file of all of the communications, incoming or outgoing, by letter, wire, or phone, internal or external" that related to *4D* (ibid., 38).

13. Lorance, *Becoming Bucky Fuller*, 98–108. Although Fuller attended the May 1928 AIA convention in Saint Louis, whose theme was "The Mobilization of the Forces Which Make for Better Architecture," and had a draft of a speech on 4D prepared to be delivered, Lorance states that Fuller did not speak officially at the convention but instead met with a few architects.

14. Fuller, *4D Time Lock*, 74.

15. Ibid., 85.

16. Reyner Banham, *Theory and Design in the First Machine Age*, 2nd ed. (New York: Praeger, 1967), 325–28. Nigel Whiteley, in *Reyner Banham: Historian of the Immediate Future* (Cambridge, MA: MIT Press, 2002), 155, criticizes Banham for being ahistorical and influenced by John McHale. Banham quotes Fuller's critique of the internationalists in a 1955 letter to McHale, an artist in England's Independent Group (with which Banham was also involved) who would later become Fuller's head of technological research at Southern Illinois University. Banham could instead have quoted *4D Time Lock*, where Fuller writes, "Europe as usual is leading the world tremendously in design, but it is merely designing surfaces" (156).

17. Hanno-Walter Kruft, *A History of Architectural Theory: From Vitruvius to the Present* (New York: Princeton Architectural Press, 1994), 438–39.

18. Studs Terkel and John Walley, "An Interview with Buckminster Fuller" (pt. 3 of 3), *WFMT Perspective*, October 1961, 65. Buckminster Fuller Collection, Special Collections Research Center, Morris Library, SIUC, Carbondale.

19. "The Dymaxion American," *Time* (January 10, 1964), 34.

20. Fuller, *4D Time Lock*, 7.

21. Fuller may also have seen Le Corbusier's work in the architectural exhibition that he wrote about in "Tree-Like Style of Dwelling Is Planned," *Chicago Evening Post Magazine of the Art World*, part 3 (December 18, 1929), 25: "In

January, 1929, there will be exhibited in Chicago models and drawings by well-known European and domestic architects, embodying new compositions."

22. Ibid.

23. These 1930 visits occurred April 19, May 8–13, and May 18, respectively. See timeline of Fuller's lectures and exhibits, 1928–30, Special Collections and University Archives, Daley Library, University of Illinois at Chicago.

24. Lorance, *Becoming Bucky Fuller*, 194–96.

25. Robert W. Marks, "The Breakthrough of Buckminster Fuller," *New York Times Magazine* (August 23, 1959), 42; Ben Discoe, "3D Model of the Dymaxion Car," *Washed Ashore*, http://www.washedashore.com/projects/dymax/ (accessed March 15, 2010); "Fuller's Works & Word-Coinings," booklet accompanying *R. Buckminster Fuller Thinks Out Loud* (audio recording), performed by Fuller, Society of Typographic Arts, 1965.

26. For a full explanation of the technical innovations and design problems of the Dymaxion Car, see Martin Pawley, *Buckminster Fuller* (London: Trefoil Publications, 1990), 57–83. Pawley claims that Fuller and Burgess "greatly underestimated the tail-lifting effect," which caused steering problems at high speeds. For more on the car and its recent restoration by architect and Fuller colleague Norman Foster, see http://www.guardian.co.uk/artanddesign/2010/oct/05/norman-foster-dymaxion-buckminster-fuller.

27. For a history of the early years of the Institute of Design, see Peter Selz, "Modernism Comes to Chicago: The Institute of Design," in *Art in Chicago 1945–1995* (Chicago: Museum of Contemporary Art, 1995), 44–45.

28. *Autonomous Dwelling Unit: Group Report*, Institute of Design (Spring 1949), Buckminster Fuller Files, Illinois Institute of Technology, Chicago.

29. Robert W. Marks, *The Dymaxion World of Buckminster Fuller* (Carbondale: Southern Illinois University Press), 178.

30. Buckminster Fuller, letter to Kenneth Snelson, March 1, 1980, 21, Harold Cohen Papers, Special Collections Research Center, Morris Library, SIUC, Carbondale, IL.

31. Michael John Gorman, *Buckminster Fuller: Designing for Mobility* (Milan: Skira, 2005), 124.

32. Hal Aigner, "World Game," *Peter Max Magazine* (1970), 47–50.

33. This was produced in 1946 for *Life* magazine when Fuller was living in New York.

34. Reinhold Martin, *Utopia's Ghost: Architecture and Postmodernism, Again* (Minneapolis: University of Minnesota, 2010), 35.

35. John McHale, "Buckminster Fuller," *Architectural Review* 120, no. 714 (July 1956): 13.

36. Anthony Vidler, "Whatever Happened To Ecology? John McHale and the Bucky Fuller Revival," *Architectural Design* 80 (2010): 29.

37. R. Buckminster Fuller, "Old Man River," *Architectural Design* (December 1972), 771.

38. The two domes Fuller built for the Union Tank Car Company, one in Baton Rouge, Louisiana (1958), the other in Wood River, Illinois(1961), were at the time the world's largest circular buildings, enclosing 110,000 square feet without interior or exterior supports, relying on tensile rather than compressive strength.

39. Chart of comparative building spans and costs from James Fitzgibbon, *The Notebooks: Old Man River Project*, James Fitzgibbon Papers (b.4 f.12), Missouri History Museum.

40. Fuller, "Old Man River," 771.

41. Fuller, *Critical Path*, 316, 321, 323.

42. Felicity Scott, *Architecture or Techno-Utopia* (Cambridge, MA: MIT Press, 2007), 157–75. See also Ed Halter, *Thinking Global*, http://rhizome.org/editorial/15 (July 2008).

43. Fuller, *4D Time Lock*, 129.

44. R. Buckminster Fuller, *Guinea Pig B: The 56-Year Experiment* (Clayton, CA: Critical Path Publishing, 1983), 9.

45. R. Buckminster Fuller, *Everything I Know*, "Session 2—Part 13" (Buckminster Fuller Institute, 1997), http://www.bfi.org/our_programs/who_is_buckminster_fuller/online_resources_/session_2_part_13 (accessed March 15, 2010).

46. R. Buckminster Fuller, note to Harold Cohen, Harold Cohen Collection, Special Collections Research Center, Morris Library, SIUC, Carbondale, IL.

47. "Playboy Interview: R. Buckminster Fuller—A Candid Conversation with the Visionary Architect/Inventor/Philosopher," *Playboy* 19, no. 2 (February 1972): 199–200.

Keck and Keck: The Chicago Modern Continuum

ANDREAS VOGLER AND ARTURO VITTORI

Swiss architectural historian-critic Siegfried Giedion highlighted Chicago's leading role in the nineteenth century in the development of modern architecture in his book *Space, Time and Architecture: The Growth of a New Tradition*, which was published in 1941 and has been influencing architectural education for decades.[1] However, as European modern architecture formulated itself in the 1920s, Chicago seemed to have lost its position or rather, as Lewis Mumford stated in 1927, "the architecture of Chicago was lost in a deluge of meaningless vulgarity." But the modern mind was there, even before the advent of Mies van der Rohe. In those early decades of the twentieth century Buckminster Fuller conceived the Dymaxion House and Keck and Keck designed and built the House of Tomorrow and the Crystal House for the Century of Progress International Exposition in Chicago in 1933–1934. These buildings, driven by a modern spirit, preceded even the midcentury Eames House in Los Angeles and Norman Foster's later work for his own residence in Hampstead, London. Keck and Keck were leaders in solar residential architecture at a time when not many cared, and many of their houses probably still outperform some of the so-called green houses fashionable today. Their work, however, like that of many early modern American architects, was not considered by the mainstreams of twentieth-century architectural critique. Keck and Keck's architecture was not driven by style, "international" or otherwise, but by observation of the world, people, and nature. They applied progressive technology to improve the way we live. Maybe this is the mark of the true modern architect.

• • •

Architects mainly learn from architects.—LORD NORMAN FOSTER (1999)

For us, as architects, the modern mind implies a continuum. It is not a heroic episode in history. Our knowledge about our planet and our worldview are changing faster and more

Arturo Vittori and Andreas Vogler, *Atlas Coelestis*, 2009. Installation view, in *Learning Modern*, Sullivan Galleries, School of the Art Institute of Chicago. Photo: Jared Larson

intensely than before. The modern architect was no longer bound to concepts of style, but took from architecture to create a new synthesis that addressed a given set of problems. European architects of the 1920s, for example, reacted to poor housing in tuberculosis-ridden cities and broke open the building volume, claiming *"Licht, Luft und Sonne"* as their credo. Supported by modern construction technologies, they opened up façades with larger windows, following the lead of Louis Sullivan's Carson Pirie Scott Building. This development went hand in hand with the increased availability of cheap and comfortable energy for heating and air conditioning. Unfortunately, however, most architects gave little thought to their buildings' energy usage until finally, with the oil crisis in the 1970s, modern architecture faced a profound dilemma.

Parallel to this, we entered the space age and, with this, our understanding of the limitation of terrestrial resources and of our planet as itself a spaceship has grown. A spaceship must reduce, to the maximum degree possible, material, energy, and resource usage. And here we come straight back to Chicago of the 1920s, where Buckminster Fuller presented his Dymaxion House. Although architecturally not very elegant, it represented what was then the most radical reduction of material and resources and remains one of the most important thought-models for modern architecture. "Do more with less" was Fuller's credo, and were there spaceships in that time, for sure people would have compared them to his house.

Keck and Keck undoubtedly knew of Fuller's work when they designed the House of Tomorrow in 1933.[2] The Dymaxion House had been presented at Marshall Field's department store in 1929 and a year later at the Arts Club of Chicago. But the Kecks did not mention Fuller's work in the brochure for their house. Rather they referred to an octagonal house built in Watertown, Wisconsin, in 1853. That house, made out of bricks, had a central core staircase, a rainwater collection system on the roof, and a very good distribution of sunlight over the cycle of the day. About that house the Kecks wrote:

> If the inventive spirit and direct expression as exemplified in this house, built in the middle of the last century, had been carried on, we should have escaped the inanities of the post–Civil War period and the first thirty years of this present century. We might now have an architectural technique comparable to the technical development in our industries.

The House of Tomorrow also responded to modern mobility. It had not just a garage for cars but also one for an airplane. Like the Dymaxion House, it was constructed around a central steel column, from which the floors were suspended; there were no load-bearing walls. But unlike Fuller's project, its central core—evoking the Watertown house—contained only a staircase and no utilities. The kitchen and bathroom were dedicated rooms with large windows; otherwise, the plan was open. The house was surrounded by large decks for sunbathing. All the furniture was specially designed, showing the influence of the Bauhaus and its steel-tube constructions and further contributing to the sense of openness.

While the House of Tomorrow may appear less radical than Fuller's project, it was a

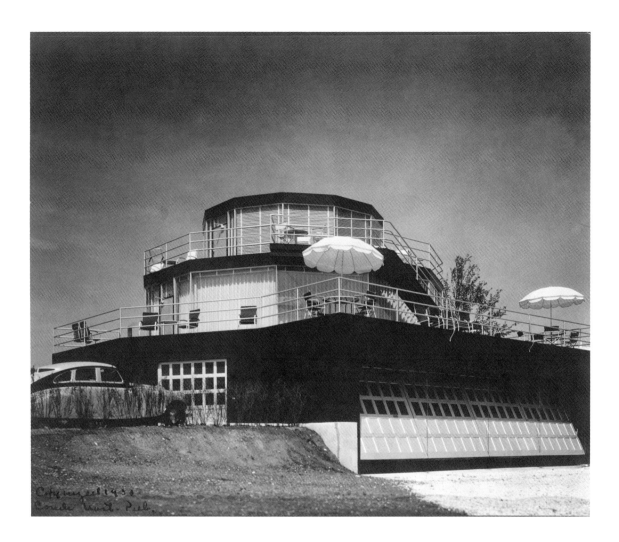

Keck and Keck, House
of Tomorrow, Century of
Progress International
Exposition, Chicago,
1933-1934. Courtesy of the
Chicago History Museum.
Photo: Hedrich-Blessing.

successful test case for new technology that has yet to be fully realized in the field. It was in this house that the Kecks came to understand the power of the sun.[3] As lightweight construction, the house turned out to be much too hot in summer, but it did collect a considerable amount of solar energy even in cold Chicago winters. This realization led them to integrate passive solar collectors into many of the houses they subsequently built in the Chicago area, such as the 1940 Howard Sloan House in Glenview, Illinois. Thus, Keck and Keck became the first American architects to apply solar principles to residential architecture, despite the opposition of the American public to the idea of an all-glass house.[4] This fact should not be underestimated.

However new the House of Tomorrow may have been—"America's First Glass House," the 1933 exhibition pamphlet called it—the really radical building was soon to come. In 1934 Keck and Keck built the Crystal House, a three-story building with fully glazed façade and exterior steel structure.[5] Like its predecessor, the house had no load-bearing walls; its truss frame, made of lightweight prefabricated latticework, carried the weight of both floors and walls. The floors were made of reinforced concrete, the exterior walls of plate

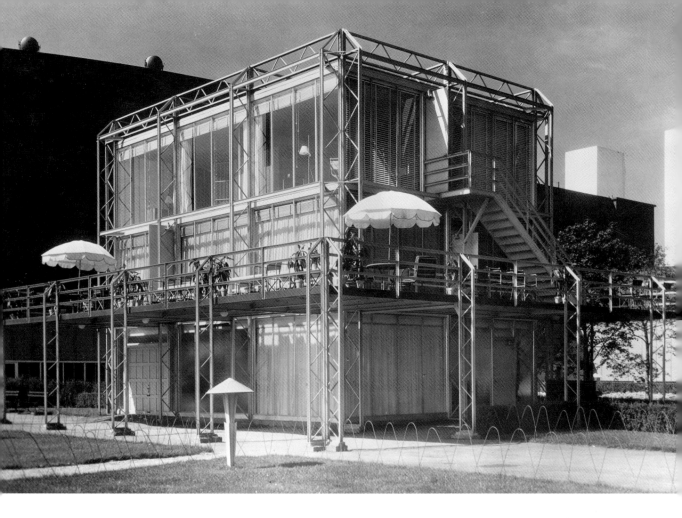

glass: translucent ripple glass for the ground floor, aqua-tinted glass for the second level, and clear glass for the top floor. Learning from the heat gain in the House of Tomorrow, the Kecks designed exterior aluminum venetian blinds to keep the heat out. However, they could not find a supplier and had to install them on the interior. Drapes were used to soften the mechanical appearance of the structure and allow additional control of privacy in the open-plan house. Partitions were used to enclose the kitchen and bathrooms, while elsewhere movable wardrobes served as both closets and space dividers. A large deck at the second level provided a generous outdoor space and was accessible from the living room. In the garage was Buckminster Fuller's Dymaxion Car.

Some of the houses from the Century of Progress, including the House of Tomorrow, were acquired after the fair by Robert Bartlett, a Chicago real estate developer, who shipped them on a barge to Beverly Shores, Indiana, where they still stand along the Indiana Dunes National Lakeshore. The House of Tomorrow had been quite altered, however, when visited in 1993. Unfortunately, the Crystal House was dismantled and the pieces auctioned by its contractor to pay off debts incurred during its construction.

The Crystal House transferred Paul Scheerbart and Bruno Taut's expressionistic visions of a crystalline architecture, formulated in 1914, into a functional building, typi-

cal of Chicago modernism. Thus, it anticipates the celebrated Farnsworth House by Mies van der Rohe (1945–1951) and the Glass House by Philip Johnson (1945–1949), as well as the Eames House (1945–1949).

I first learned of the Crystal House in 1993 while researching American modern architecture at the Rhode Island School of Design. It immediately reminded me of Norman Foster's studies for his own, never-built house in Hampstead. We do not know if Foster was aware of the Crystal House by Keck and Keck. However, it was this line of modern architecture, which continued through to California in the 1950s and 1960s, that Foster so much admired when he came as a student to Yale in the 1960s. The exterior structure as an expressive part of the building, combined with large glass panels, became an important part of Foster's architecture. And Foster's interest in the work of Buckminster Fuller and collaboration with him on the Climatroffice project has to be mentioned in this through-line, as well as Foster's interest in the "green agenda."[6] As much as early European modernism was influenced by developments in Chicago in the late nineteenth century, through the publication of projects by Louis Sullivan and Frank Lloyd Wright, the American modernism represented by Keck and Keck—and later, architects of the California School, such as Eames, Koenig, Ellwood, and Frey—influenced the work of British architects in the 1970s, and from then through the 1990s had its impact on the continent.

We find it inexplicable that the Crystal House and the House of Tomorrow have been so completely ignored in architectural history. For us as architects, the Crystal House has the same iconic significance as Le Corbusier's Villa Savoy. It could well have been a symbol of American modernism. The California architects of the 1960s were, until recently, similarly ignored by the Harvard-dominated architectural historians on the east coast. But international style modernism was phased out by its second generation, becoming "less is a bore" and devolving into deconstructivism, postmodernism, and, more recently, computer-generated iconism. This is probably a fruitful time to inquire into the state of the modern mind today and where it will lead us in the future.

As practicing architects, we are intrigued by Keck and Keck's own commentary on their intent in designing these houses:

> to demonstrate mechanical equipment and new building materials; . . . to not find a specific form of a house, but to find solutions to the many and varied contemporary requirements of a residence in a simple and direct manner. . . . They were laboratory houses and were designed not primarily to be different or tricky but to attempt seriously to determine whether better ideas and designs for living could be found. Probably the most important function of the Crystal House was to determine how a great number of people attending the exposition would react to ideas that entirely upset conventional ideas of a house.[7]

The concept of "laboratory houses" is very modern and in line with our research for the MercuryHouse series, in which we explore new ways of living and new technologies. We don't know how we will live in the future, but we can start exploring the possibilities

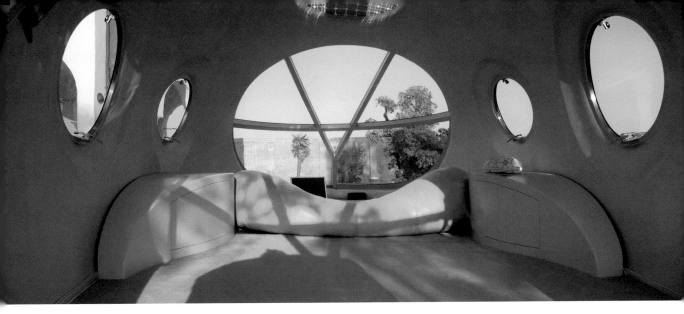

Arturo Vittori and Andreas
Vogler, MercuryHouseOne,
2000. Courtesy of
Architecture and Vision.

today. The MercuryHouses are characterized by an aerodynamic shape, like that of a car or airplane; prefabricated construction, with readymade parts transported to the site; and integral furniture. They are intended to explore as well as to challenge preconceptions about how we live and how we could live in the space age. Their inherent agenda is to change the paradigm of the house from a consumer of resources and energy to a producer of resources and energy. They can integrate into nature in a way that actively supports the recycling process of nature, which is the basis of our life on this planet.

Modern architecture, from its beginnings, has been influenced by increasing personal mobility. Keck and Keck's vision of the airplane garage has not been realized, but flying has become a normal reality for many of us. Mobile spaces like cars, trains, airplane interiors, and even spaceships are increasingly spaces where people live and work, at least temporarily. They are all characterized by relatively small scale, efficient, lightweight technology, and many offer beautiful views into nature. Modern times can be equated with mobility. Mobility is connected to exploration. It allows us to explore the planet and far beyond. The concept of temporary, moving spaces frees architecture to become like a car: a vehicle to explore the environment. It can enhance our perception of the environment, as well as our relationship to it.

The cross-fertilization of transportation design and architecture is an increasingly interesting topic and one that we studied in the MercuryHouseOne project, which is situated somewhere between being a car and a building. Inaugurated at the Venice Biennale d'Arte 2009, it is a mobile living pod designed for a modern experience of our natural and urban environments. Its shape, inspired by nature, recalls the beauty and perfection of a water drop. It is powered by solar panels. The glass-fiber monocoque body is covered with an ultrathin, white marble skin. The large openings expand the inner space to the surrounding environment, including, at night, to the starlit sky, creating a source of refreshment for the mind, body, and spirit. The grotto sculpture *bocca spalancata* in the Baroque Parco dei Mostri in Bomarzo, Italy, is another source of inspiration, lending to

the structure organically shaped spaces and openings and allowing it to integrate more naturally into the landscape.

MercuryHouseOne consists of a three-meter-high drop-shaped cabin; its footprint is 4.5 by 8.8 meters, and its total weight 4,500 kilograms. A ramp gives access to the cabin, which is entered through a large, remotely controlled window that opens upward with electric actuators. When open, it creates a canopy over the entrance. The organic shape of the building allows a fluent integration into either a natural or an urban environment. The concave interior feels cocoonlike, protective yet open. The shell has large windows on the front and back and two small portholes on each side. Additionally, two skylights filter daylight through the integrated solar cells. The placement and dimensions of the windows creates an interesting balance between protection and exposure to the outside space.

The oval floor plan includes a large sofa and two sideboards, which are integrated into the cabin to create a harmonious flow of surfaces. Its light blue color scheme balances glare inside and reflects the color of the sky. The soft carpeting and the large, low organic sofa in the same color generate a soft and relaxing atmosphere. The floor plan enhances the efficiency of the space and allows the user to find comfortable positions for different activities. Lighting, video, and sound are integrated into the cabin, and all can be controlled remotely from a mobile phone. The sideboards provide enough space for personal gear to allow stays of a day or two inside the house. It also contains drinking water, supplies, and even a coffee machine.

The structure is a fiberglass monocoque construction; the lower portion contains the floor, and the upper hull all of the systems. It rests on three metal feet, whose height can be electrically adjusted to level the building. The entrance ramp is made of aluminum with an antislip surface. The windows, cut through the shell, have aluminum frames and slightly tinted, 10-millimeter-thick acrylic glass. Solar cells are integrated into the skylight and during the day continuously recharge the batteries located in the raised floor. These provide enough energy for the electrical needs of the cabin, making the unit self-sufficient with regard to energy. At night the interior is lit by LED lights, whose color can be changed to suit the desired mood; LED floodlights allow the gentle illumination of the surrounding exterior area. The portholes on each side can be tilted open to allow for effective cross-ventilation in summer. A small battery-powered air-conditioning unit is integrated and can be switched on to meet individual comfort needs.

Our MercuryHouseTwo scheme looks into the future, serving as a criticism of the waste of space and resources typical of the modern housing development industry. It is a vertical, transportable, single-family house designed for customizable serial production. The revolution of materials fostered by nanotechnology will result in an evolution of architecture and a radical change in the paradigm of the house. Within twenty years the control of material properties by applied nanotechnology and embedded systems will revolutionize the building skin. Here we envision a chrome-vanadium film applied to the unit's glass front that will effectively act as a thermostat. This coating will be so thin that the glass stays transparent, allowing passive solar heating until a specified room temperature is reached, at which point the glass will become translucent and block out further heat and infrared rays. This technology is currently in the laboratories. The house might

STREET TRANSPORTATION MODE DEPLOYMENT CONTROLLED PULL-UP WITH ROPES WATER ADDED INTO HULL

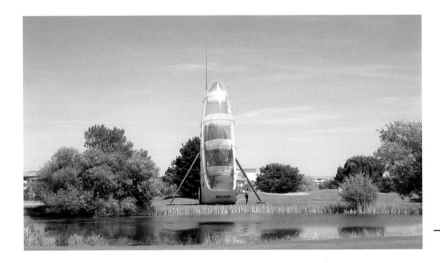

13 m

SECTION

Arturo Vittori and Andreas Vogler, MercuryHouseTwo, 2004. Impression and diagrams showing transportation and cross-section. Rendering: Jean-Francois Jacq. Courtesy of Architecture and Vision.

also be turned on its own wheels to adjust and optimize the passive solar energy intake; the solar cells will be transparent.

The MercuryHouseTwo will come prefabricated from the factory. Its big wheels allow for its being pulled by a truck and will also facilitate fast removal in emergencies. Once on site, it will be pulled into vertical position by ropes, then water tanks integrated into the hull are filled to add weight and heat storage. The water may be provided by a local service or collected on-site, thus minimizing transportation weight. Two side legs further ensure stability, eliminating the need for concrete foundations. The organization is vertical—like a tree—with a muscle-powered elevator, which occupies less space than a staircase while also offering personal fitness training. Again, the furniture is integrated, as in a yacht or aircraft.

The ground floor has a storage room and a living room, which allows several people to sit together with a view of the landscape. On the next floor is a small kitchen and a dining room. The upper floors contain the bedrooms with bathroom or shower and toilet. Monitoring systems for small children are built in, and older children can be allowed to explore their natural drive for climbing and experiencing three dimensions. Most of the housekeeping tasks are done or supported by small robots.

The house comes with an inflatable greenhouse, also maintained by robots, which provides several important functions: it collects heat in winter and provides cooling in summer; its plants clean water and air, compost waste, and provide food. Exhaust air is collected through the composting toilets and passed through a series of green filters into the greenhouse. The high oxygen production of the plants during the morning is used,

and the oxygen-rich air is buffered to be fed into the house during the day through controllable outlets located near the beds and in the living room. Water is collected over the roof of the greenhouse and is filtered using a plant system. The house itself has a gray-water cycle for the dishwasher and washing machine, and the toilets only use minimum water; humidity from liquid and solid human waste is vented into an air-cleaning recovery system in the greenhouse. Electricity is produced using solar and wind power and stored in fuel cells or other technology as available.

The development of greenhouse technology to provide a safe biogenerator for a house or apartment building is an interesting challenge. There have been different, dispersed developments in space exploration and food industry, but none directed to the building technology market. Sharply rising costs for energy, water, and waste removal, as well as the homeowners' desire for independence, will open up a big market for autonomous systems in the Western societies. There is again a clear trend toward houses that can be self-sufficient. The development of a biogenerative greenhouse system for gardens scaled to houses or rooftops will fulfill this demand and have a highly positive effect on the environment.

Twenty years from now the first human beings may be on Mars. To get there, fully autonomous energy- and life-support systems will be needed, systems that run on little energy and are small and lightweight. Here on earth, there is also an urgent need to develop houses that are energy independent, collecting their own water and recycling most of their inhabitants' waste. Dependency on centralized infrastructure makes communities vulnerable, as periodic power blackouts have shown. The rich Western world can develop these houses and thus keep its technological lead. Mass-marketing will benefit not only the domestic economy, but also the developing world by making economic water- and energy-recovery systems available.

Our MercuryHouses have been designed in the spirit of the Keck and Keck. As architects working in the field of innovation and challenging preconceptions, we find it very reassuring to discover individuals who in decades past did exactly that, who did not follow the mainstream but rethought what modern architecture could be, and how it could contribute to improving the quality of life on our planet. With the Crystal House, Keck and Keck banished all structure to the exterior of the house. In the MercuryHouses, structure merges with shape and is no longer visible as such. The houses' construction is more like that of a boat, car, or airplane than of a conventional house, which has not yet broken the duality between structure and skin. In the MercuryHouses the skin is the structure.

An ongoing theme in modern architecture—and this may serve to remap the modern mind, at least in our profession—is an incredible openness to crossing professional boundaries. For us, architecture is not limited by what is published in the architectural magazines. It is not limited by scale; it is present everywhere, wherever people live. Architecture starts with the design of the key in your pocket and expands through the small, carefully articulated spaces in an aircraft cabin to the planning of housing, offices, neighborhoods, large cities, and even schemes on a planetary level or extending out into space. Le Corbusier was fascinated by cars, airplanes, and ships—objects formed by engineering ingenuity—not by Beaux-Arts architects. Now, again, the modern architect tends to

become an engineer. The architect Renzo Piano and the engineer Peter Rice had a close and productive relationship; they even collaborated on a car design for Fiat. Norman Foster is a passionate pilot himself and also designs boats. Buckminster Fuller, not an architect by education, used the design of buildings, houses, and domes as well as cars, airplanes, and boats to apply his modern ideas and philosophy. The fascination with technology is intrinsic to the modern world. But there is more than technology. Architects often talk about social responsibility. This is important, but the responsibility of the architect and his client is much larger; it is encompassing the way we live together, not only as humans, but also with nature—the basis of our lives. Architects and designers position their objects in the universe. The universe is a concept: it can be very small or tremendously large. Design is a universal concept. Architecture is a universal act and has to be understood as such, even as a given building responds to a very specific set of problems. If we don't recognize this element of the *Gestaltung*, we will be always designing nice keys, but never the key that may open the door to a whole new universe.

Giedion's *Space, Time and Architecture* outlined this modern tradition. The modern tradition is not about using certain shapes, forms, or compositions; nor is it about keeping an ideal alive, as in classicism. It is the tradition of reinventing the world based on scientific and creative processes and on respect for nature. This requires openness and curiosity about the new, the willingness to challenge preconceptions and to change paradigms. This is what drives the modern world in all fields: in science, engineering, architecture, and art. This is the engine that continuously develops and puts to discussion the architecture and vision of our future. These were the ingredients of the Keck and Keck houses for the Century of Progress exhibition.

Notes

1. Sigfried Giedion, *Space, Time and Architecture: the Growth of a New Tradition* (Cambridge, MA: Harvard University Press, 1941).

2. There are even hints that a draftsman named Atwood, who was employed by Keck in 1933, had had a substantial influence in the conception and design of the Dymaxion House. The House of Tomorrow was designed in February/March 1933 and it opened at the end of May at the fair. See Robert Boyce, *Keck and Keck* (New York: Princeton Architectural Press, 1993), 44–47.

3. William Keck, interviewed by Andreas Vogler at Keck's office, Chicago, 1993.

4. Boyce, *Keck and Keck*, 72.

5. George Fred Keck applied for permission to build a new house for the reopening of the fair in 1934. He was denied permission in February 1934. Finally on April 10, 1934, blueprints for the Crystal House were accepted; the building was completed for the fair's opening on May 25, 1934. See ibid., 47.

6. The Climatroffice was a theoretical project in the 1970s that suggested a new rapport between nature and the workplace, its energy-conscious enclosure resolving walls and roof into a continuous triangulated skin. Many of Norman Foster's recent projects can be linked to ideas formulated in this period. At the 2007 DLD Conference in Munich architect Foster discussed his work in terms of the "green agenda" to show how computers can help architects design buildings that are green, beautiful, and "basically pollution-free." http://www.ted.com/talks/norman__foster__s__green__agenda.html.

7. Boyce, *Keck and Keck*, 52.

Mies Is in Pieces

BEN NICHOLSON

It is hard to know whether the good sequences in one's life are pure luck or due to careful forethought, but the buildings I have worked in read like a perfect hand of poker cards. Student days were spent first in John Hejduk's internal reworking of Cooper Union (1975), followed by Eliel Saarinen's Cranbrook Academy of Art (completed in 1942), capped off with a stint in the Charnley House (1892), designed by Frank Lloyd Wright in Louis Sullivan's office. A career of teaching has taken place in a crucible of remarkable buildings, beginning at Walter Netsch's University of Illinois at Chicago (1968), then down to Texas for Philip Johnson's University of Houston College of Architecture (1985), back to Chicago to spend sixteen years in Mies's Crown Hall at the Illinois Institute of Technology (1956), and currently beneath the eaves in Louis Sullivan's masterwork Carson Pirie Scott Building (1899). While this hand is not laid out in sequence chronologically, it does form an almost perfect history of American modernism, which I have been lucky enough to know literally from the inside.

Strange as it may seem, my hands-down favorite is Crown Hall. My years of teaching in this building induced about eight thousand visits, and during that time things happened and stories got told that brought the building to life in startling ways, akin to the intensity of a love affair that cannot end. I was hired by Dean Gene Summers, the protégé of Mies van der Rohe, as part of his plan to reexamine the Miesian curriculum and acted as his field officer. To some on the faculty my presence was a long bad dream of disturbed sleep. For them the nightmare finally ended in 2006, when the cozy familiarity of a walking army of Bob-the-Builders was able to return the curriculum to its earlier stride. I don't think Mies really liked my being there. His ghost was ever present, and by my count he made three assassination attempts that nearly did me in.

To the environmental engineers who know the building from beneath the hood, Crown

Iñigo Manglano-Ovalle, *Always After (The Glass House)* (detail), 2006. Film still. Collection of the Art Institute of Chicago, restricted gift of David Teiger Foundation. Courtesy of the artist.

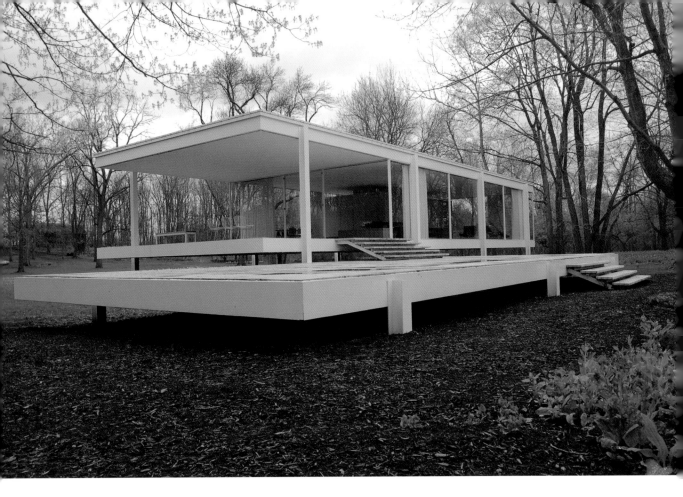

Hall is a very taut place in the winter. The building's steel and glass façades are super-cooled by icy northeasterly winds from Canada. By two o'clock in the afternoon, the near horizontal solstice sun has heated up the black painted steel, creating an impossible situation. The stresses in the corner column are gigantic: 220 feet of heated steel in the south façade expanding against 120 feet of freezing iron on the east façade. While standing at a desk after lunch one afternoon, I heard a southside pistol crack accompanied by the whiz of a spinning projectile flying over my head. A three-eighths-inch stud bolt had sheared off with the built-up pressure of the twisting walls and nearly blinded me. The nervous laughter of a near miss rippled through the studio, but I understood that Mies had fired a warning shot. A couple of years later I was moved to the southwest corner of the building, and the scenario repeated: Mies's ghost was at it again.

In my middle years at IIT I bought a Dodge Swinger that coincidentally had come off the assembly line the same year Mies died, 1969. A friend borrowed the car to drive out to Mies's Farnsworth House in Plano, Illinois. Peter Ippolito is German, and he loved driving the classic steel and glass car with its generous engine, black bench seats, and wide panoramic glass window, past which the modern marvels of America could flow unimpeded. The Farnsworth House is located at the bottom of a long hill that leads down to the floodplain of the Fox River. As you travel down the hill there is a sharp turn to the

left that leads to the gate of the Farnsworth property a couple of hundred yards down the road. Always running late, Peter was known for his fast driving. As he thrashed down the hill he stomped the brakes to make the turn, but nothing happened, except that the pedal went through the floor. A brake line had rusted through and burst open. Not to be outdone by man or machine, Peter swung the wheel in a spray of stones and squealing tires, and the car rolled to a halt right outside the Farnsworth gate. This was Mies's third attempt on my life, but he nearly got the wrong man.

My point in telling these tales is to suggest that great buildings engender narratives of this kind. They are necessary to reify the space that lies outside of conventional perception through the five senses. (If not, then why did we spend so much time back then reading Freud's essay *Unheimlich*, immortalized by Tony Vidler's *Architecture of the Uncanny*?) Every visit to *Crown Hall* is a sublime experience, the kind of feeling you get when you sink your head into a bouquet of peonies; it's simply uplifting. In my eight thousand visits I have never *not* been inspired. What is it that makes this so?

It starts with the way the building sits on the ground, or rather hovers. To the north is a wide expanse of grass where, in the good old days, trim-and-buff ROTC cadets would march drills in perfect time, mirroring the ranks of draftsmen lined up at desks on the other side of the glass. Today this ground has been desecrated by misanthropic landscaping. A plastic sheet was laid out in a long roll at the bottom of a scooped out trench, four feet deep, and landscape soil was poured into the shallow depression. In this simple act of bulldozing, Crown Hall lost its bearings: no longer does the building float transcendentally above a hard flat plane of grass, a Campo Marzio for the cadets. From the landscaped depression you gaze up at the building, which now feels mired in mud, reminiscent of a trench in World War I. I asked the great landscape architect Paul Thomas what he thought of the hole. In a line that could have come from Chance the gardener, played by Peter Sellers in the movie *Being There*, he said slowly, "Ben, in time the hole will fill with dust." That's modernism for you—patient and timeless.

Fortunately the view of the south front of Crown Hall is in pretty good shape. There are no holes to fall into, but it's not without its difficulties, this time of a more serious nature. In 2001 Krueck and Sexton magnificently restored the building, but on their path to truth they exposed a little more than perhaps they should have. In the manufacture of long, heavy beams, the surface of the steel can get a little gnarly as it is extruded through the rollers. It is not quite the surface that an aesthete like Mies would have wanted. I could swear that in the sandblasting of the beams during the restoration, a whole lot of Bondo was blown out of the cracks and dimples, for the columns used to feel smoother. Today, the hi-tech black epoxy paint applied directly to the steel reveals too much truth of surface: even modernists have to lie a bit to get the quality they need.

Nowhere is this more evident than at the top of the column holding up the enormous girder located second from the west. If you look carefully at the steel surface something does not seem right; the steel leans infinitesimally to the east at a feather-delicate angle. The story (related by either Professor Emeritus David Sharpe or Professor Majoub Elnemeri) goes like this: Mies wanted his steel columns to rise up from the ground and needle their way through the air, terminating in the sky. To do this, the columns would have had

to be aligned perfectly in advance in order to accept the enormous 7-foot-deep, 120-foot-long roof girder that would be carefully lowered between them and then welded in place. The contractor was not happy about having to do this, and it is here that Mies made a fatal mistake: the architect went away for the weekend. When he returned on Monday morning the girder was in place, and from a distance it looked magnificent. But when he got closer he realized that the contractor had cut off the tops of the columns, welded them to the beam, lifted the whole unit up, and then welded the tops of the columns back onto their slender lengths, hoping no one would be the wiser.

It is in moments such as this that the ineffability of modernism is shattered. The pure thought of an endless length of steel reaching to the heavens was corrupted, but in such a slight way as to be almost imperceptible. Modernism uses craft in the decoration of its buildings, not by carving bunches of grapes and shocks of corn, but in the riveting care with which something is assembled, its perfection resembling the liquid spirit of ether. It is here that God is in the details. But sometimes, as in this case, the Devil gets there first.

Crown Hall learned something from the ghetto row houses it displaced, as essentially the building is a walk-up. At the south entrance a hesitant plane of travertine steps raises you up five feet so you can slip through one of its double doors. These are hinged in a way that makes space enough for a cat to pass between the jamb and the door, releasing the doors from their attachment to the building so that they seem to hang in space. Once inside the 220-by-120-foot clear span, known for its singular lack of walls, you find yourself on an endless sea of terrazzo—a polished surface of white-and-black flecks of sharpstone set into a gray cement matrix and divided into rectangles at a 2:1 ratio. The entire floor is bounded and fixed in place by a wide C-channel of steel welded onto the columns, and it feels as if you are walking on the skin of hard-set porridge. Overhead, the ceiling forms a continuous plane of white tiles interspaced by flat banks of flourescent light. Of the many buildings in the world, this seems the only one that actually benefits from incessant shadowless neon strip lighting, for neon is the quintessential light for late American modernism, and Mies made it into an art form. The hung ceiling stops short of the curtain wall so that it is clearly a suspended plane rather than a ceiling proper. Visitor and occupant alike are held between these two expanses of endless floor and endless ceiling in a not-so-endless house: here humans walk between planes, within a stasis of gravitational pull.

In one respect, there is so little to the main floor of Crown Hall (just three white oak dividing walls measuring about eight feet high), that the place of interest is the window walls, and they deserve a close read. Mies gives us three kinds of view out into the world. The immediate view out the lower window is arrested by translucent, sandblasted glass that glistens in the winter sunlight. Above a horizontal bar are huge expanses of transparent plate glass, giving us a view of sky, treetops, and, in the distance, the city. The third view, and the most surreptitious, is through operable gun-slit windows that pull the gaze downwards, to the earth below. Thus, the window walls frame a hazy mirror of ourselves between sky and treescape and a close-up look into the ground.

The gun-slit windows are interesting for many reasons. They were put there to allow a breeze to course across the floor and act in concert with the air nacelles set into the ceiling to force fresh air down to the ground and draw up hot air that accumulated in the building. Before the days of air conditioning, these window-flaps were opened to create a chimney effect, drawing in cool air, which would be taken up through vents in the suspended ceiling. It was an elemental green technology forty years before the word *green* had been invented. Walter Peterhans, IIT's venerable teacher of visual training, is reputed to have been the bosun of this crystal ship. He worked the building as if it were a

Ludwig Mies van der Rohe, S.
R. Crown Hall (interior detail).
Photo: Daniel Kuruna.

sailboat, constantly adjusting the air vents and window blinds to maximize and mollify the Chicago weather.

To this day, each year in the springtime Crown Hall is completely stripped of furniture, and the floors and windows are polished to a high shine. It is the best time to visit the building, to see it in its virginal glory. It is a moment akin to the Nile's annual inundation, when the earth is covered with water, the season in which worldly time is set back to naught. During the first week of May, Crown Hall is purged of the energy of study, readying it for an exhibition of the work of winter. At this transformative moment in the academic calendar, all the flaps to the gun-slit windows are opened simultaneously and a sliver of air and light cuts along the baseboard above the floor plane. The effect is monumental, for it gives the appearance of the building having transubstantiated and elevated to a point where it seems as if the whole is rising from itself. At moments like this there can be no doubt that Mies was Catholic.

Being a college of architecture, you would expect the building to teach the students something about architecture. It is no surprise that its underlying grid is measured in ten-foot modules, subdivided into five-foot and then again into two-and-a-half-foot parts. In this way students can pace out their designs and transfer the dimensions to their drawing boards. Pedagogical detailing is also provided in the third dimension, for the

hexagonal stud nuts holding together the components of the columns are spaced at one-foot intervals, allowing students to rough out the volume of a proposed building within Crown Hall. The façade, however, does not follow its own design rules. The horizontal members dividing the glass wall are not spaced according to the vertical one-foot module: they move to another beat. Something else is at work here, for the measurements of the glass panes are not made in whole numbers, either in American feet and inches or, God forbid, in Mies's native metric.

Architecture has always had an age-old conundrum in its lineage: the uneasy relationship between measurement and proportion. Great buildings are generated off a single measurement with the logic of the rest of the structure created by one or another system of proportions. To this are added discretionary curveballs, where the architect nudges and cheats a little, to ensure that the building looks and feels right. A well-versed architectural geometer can reverse-engineer measurements made with poetic license and divine which mathematical system the architect is basing his or her adjustments upon. The clue to a building's proportion system is often found in the division of its pavement: a floor plane is most akin to a drawing, and Crown Hall's is no exception. The module of the terrazzo measures five feet by two and a half, a 2:1 ratio. A 2:1 ratio can become many things when the series is spun out, but one of the most intriguing is the Fibonacci series, in which the last two terms are added to make the next term; thus, 1, 1, 2, 3, 5, 8, 13, 21, 34, 55, and so on. Architectural geometers are especially taken with the series because the longer the series runs, the closer it comes to the golden mean. This implies that the golden mean grows from whole number lengths of measurement, which is a paradox of sorts, as it is itself irrational. Mies took advantage of this paradox and utilized the Fibonacci series to resolve difficulties in the measurements within the façade.

From center-line to center-line, the grid of the glass wall measures ten feet with a subdivision of five feet. He situated the industrial steel columns on this grid and then welded and bolted all sorts of stock-size angles onto the main I-beam. The result of his collaging the steel together in this way is that the horizontal dimensions of the windowpane openings are a real mess: 51 $\frac{13}{32}$ inches. Added to this difficulty is the placement of the horizontal steel member that divides the large sheet of plate glass above from the pair of smaller panes below. It could have been sized in a whole number dimension, but that would not have related to the horizontal dimension of the pane; it's a Catch-22. Mies solved this by sizing the glass by *ratio* rather than *measure*. For the lower panes to the left and right of the entry doors, he accepted the horizontal messy measurement of 51 $\frac{13}{32}$ inches and divided it into three parts. The vertical dimension of the glass was divided into five of these parts, thus making a ratio of 3:5, the fourth and fifth terms of the Fibonacci series. Mies positioned the horizontal member dividing the upper pane from the lower fields of glass by *proportion* rather than *measure*. Now students could gaze through a window to a world whose ratio is 3:5.

The next problem of sizing was what to do with the gun-slit operable windows that run around the building. Here too, Mies resorts to ratio rather than measurement. This time he divided the messy horizontal measurement of the glass pane by two, then extended the vertical dimension into three parts, making a 2:3 rectangle. This is shorter than a

3:5 rectangle, and in this space he put the operable window. In mathematical poet-speak this is an especially elegant solution, as the golden mean lies somewhere between the difference between a 2:3 and 3:5 rectangle, so the air that passes into Crown Hall is combed by the golden mean!

The interior height of Crown Hall is also perplexing, as the metal studs spaced at one-foot intervals do not line up as expected to the underside of the ceiling, which is approximately nineteen and a half feet high. The solution to this messy measurement is that the window frame that includes both the upper and lower panes is calculated at a ratio of 2:1, once again making clean a messy measurement that is a by-product of the all too real dimensions of the off-the-shelf steel industry, whose smoke stacks in Gary, Indiana, are almost visible from the building.

Before ending this detour into the proportions of Crown Hall, it is necessary to mention the ratio of its bays. There are twelve bays on the short axis and twenty-two bays on the long axis: why so? Numerologically speaking, twelve is the number associated with Christ's disciples and twenty-two is the number of letters in the Hebrew alphabet. If the building were cut in half, the ratio would be twelve to eleven. Eleven is an uncomfortable number, as it is one more than the ten laws of Moses and one less that the twelve disciples (after Judas was lost), and therefore would be a valid number for a place of education and the cultural questioning that it engenders. I very much doubt that this was on Mies's mind when he chose the ratio of the bays, but the spirit does move in mysterious ways.

Now, you might think that all of these measurements would have added up to something of a major moment among the old-timers in Crown Hall who "knew Mies." Quite the opposite: the discovery was met with absolute indifference, save from the eagle eye of architectural historian and museum director Phyllis Lambert. Since 9/11 America has learned a great deal about Islamic culture, especially the difference between Shia and Sunni Muslims. In essence, the difference is one of lineage: Shia Muslims believe that the leading imam should be in the bloodline of the Prophet Muhammad, while the Sunni believe that the leading imam should be the most qualified person, the wisest, and the one with the most perfect command of the texts. Followers of Mies are the same: for those who were taught by Mies the central issue is to ensure that they teach the following generation of students precisely what he taught, so that subsequent teachers can know the truth of Mies from the purest blood line—these are the Shia Miesians. Sunni Miesians, on the other hand, are those who study Mies without benefit of a direct bloodline and are thus free to explore truths about him in a different way. As with Sunni and Shia Muslims, Sunni and Shia Miesians coexist best at some distance.

It should be no surprise, then, that old-time, Shia Miesians dismissed a scholarly investigation from a Sunni Miesian like me, because critical analysis disturbs the divine spirit of Mies and suggests that he was mortal. Yet Shia and Sunni Miesians alike know that there was something at work in Mies's vision of modernism, and that his talent was well beyond the measure of reason, but proportioned by it nevertheless. The reading of space as a divine construct was a central tenet of American modernism, and it requires our tapping into qualities that defy category to articulate its value. The five senses are tools

that can do only so much to detect the ineffable space of modernism. To get at its essence, it is necessary to reach further down into the craw of visceral intelligence and make sense of modern space using whatever extrasensory tool may be at hand. Perhaps you could count the goose bumps on your forearm that each visit prompts, or put an electric sensor on your pineal gland, or whatever else moves you. The usual terminologies of sensory perception pale when called upon to capture the essential spirit of modernism, whatever that may mean, whichever way you believe.

Iñigo Manglano-Ovalle's Reckonings with Mies

ELIZABETH A. T. SMITH

The typically modern practice … is the effort to exterminate ambivalence.

Zygmunt Bauman[1]

Things are always moving, but there is immobility at the same time … things always return to the same status.

Iñigo Manglano-Ovalle[2]

Ângela Ferreira, *Crown Hall/ Dragon House* (detail), 2009. Installation view, in *Learning Modern*, Sullivan Galleries, School of the Art Institute of Chicago. Photo: Jill Frank.

For more than a decade artist Iñigo Manglano-Ovalle has pursued an ongoing and intensive dialogue in his work with modern architecture, using the buildings of modernist Ludwig Mies van der Rohe as essential points of departure for many of his most significant works in sculpture, installation, video, and photography. This essay will examine the scope and implications of Manglano-Ovalle's engagement with Mies as a means of interrogating the reformist and purist intentions of modernism. It will aim to position this body of his work in a broader terrain of inquiry about modernism's legacy for both artists and architects, and its wider social and cultural meaning today.

Each piece in this corpus of Manglano-Ovalle's work is set in a specific residence or public building designed by Mies. In these works, the buildings play dual roles as protagonist and as supporting actor—a framework within which action of a quasi-narrative but ultimately unresolved nature unfolds. Despite commonalities, each work is distinct in the nature of its critical commentary and its emotional tenor. From the gentle caresses bestowed on the expansive glass windows of the Farnsworth House in *Le Baiser* (*The Kiss*) to the disquieting aftermath of destruction evident in *Always After* (*The Glass House*) to the destabilizing inversion of *Gravity Is a Force to Be Reckoned With*, Manglano-Ovalle evokes a range of psychological responses that in turn elicit a number of questions and ambivalences which simultaneously reference specific works by Mies and make a broader commentary on modernism.

Undertaken "not [as] a study of Mies, [but as] a use of Mies … as a stage,"[3] Manglano-Ovalle's deployment of modern architecture grew out of earlier projects that reflected on or forcefully engaged with ideas about modernism. In the early *Bloom* series (1995–1996), he shot bullets into objects resembling sculptures by minimalist artist Donald Judd, aggressively violating these objects and thereby literally injecting politics into their otherwise neutral presence. *The El Nino Effect* (1997–1998), a work using sensory depriva-

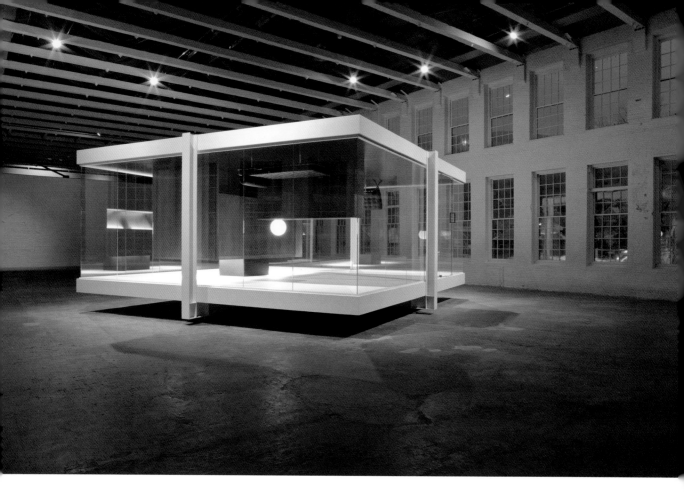

Iñigo Manglano-Ovalle, *Gravity Is a Force to Be Reckoned With*, 2010. Installation view. Collection of the Massachusetts Museum of Contemporary Art. Courtesy of the artist.

tion tanks, was influenced by the ideas in writer-sculptor Robert Morris's essay "Notes on Sculpture."[4] With the work discussed here, the reductive yet ideologically charged architecture of Mies offered fertile ground for a spectrum of critical responses, taking the form of interventions and performance-based works. In this Manglano-Ovalle was also inspired by the example of artist Mierle Lederman Ukeles and her incorporation of menial physical labor as a sculptural practice that challenged the heroic premises of modernism.

While the clarity, elegance, and rigor of Mies's architecture and his stature as the quintessential modernist will always assure his standard-setting work a place in history, it is Mies's unswerving belief in the universal and the absolute that Manglano-Ovalle calls into question. Highlighting contradictions and failures in unyielding adherence to any "one size fits all" ideal, he comments on the rupture between high modernism and social reality by referencing the passage of time and the significant, complex juncture between belief systems and orthodoxies of the mid-twentieth century and those of today. Manglano-Ovalle's sustained treatment of these issues, probed with varying degrees of intensity and evidence throughout his Mies-inspired works, offers an intricate interplay of temporal, psychological, social, historical, spatial, and sensory features and an ambiguity that casts tension and contradiction into high relief.

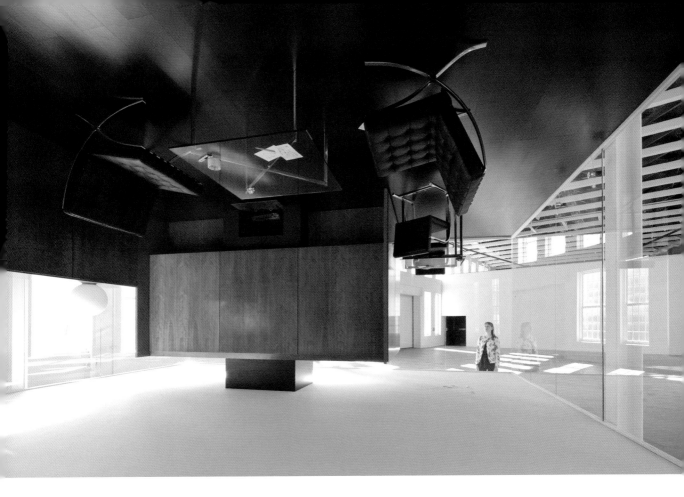

Iñigo Manglano-Ovalle, *Gravity Is a Force to Be Reckoned With* (detail), 2010. Courtesy of the artist.

Manglano-Ovalle's most recent reckoning with Mies is the 2009 installation *Gravity Is a Force to Be Reckoned With.* The work takes physical form as a half-scale re-creation of Mies's unbuilt 1951–1952 design for a House with Four Columns, positioned upside down in space. Conceived as the prototype for a mass-produced house for a family of four, the fifty-foot-square House with Four Columns was configured as an almost completely open plan, sparsely furnished with a smattering of modern objects also designed by Mies. As with many other modern architects, there is little difference between the houses Mies designed for wealthy clients and those for clients with modest incomes, nor is there much, if any, distinction between environments conceived for institutional and residential use. In Mies's case, the conscious disregard for context or social circumstances in favor of a universalizing ideal is extreme; thus, the House with Four Columns, intended for family living yet oblivious to the realities and necessities of social life, epitomizes an elevated, unattainable ideal.[5] Foregrounding this disconnect, Manglano-Ovalle conflates his over-turned Miesian glass box with references to critiques of futuristic utopias from early twentieth-century film and literature, specifically, an unrealized film, *The Glass House* (1930), by Sergei Eisenstein and the dystopic science fiction novel *We* (1921) by Yevgeny Zamyatin.[6]

In doing so, he positions his own work within a larger context of critical discourse and as part of an ongoing, unfinished project of assessing the implications of modernism.

With the entire structure, including furniture and a handful of small objects atop two glass tables, literally suspended upside down—except for a lone coffee cup lying spilled on the ground plane below—the significance of Manglano-Ovalle's title, *Gravity Is a Force to Be Reckoned With*, becomes clear. Despite Mies's and the high modernists' commitment to an architectural ideal based on simplicity, reductiveness, and rationality, they failed to reckon with forces that would undermine and overturn that ideal, especially in the realm of the social. Manglano-Ovalle's introduction of the spilled coffee cup—a potent signifier of human presence and the mundane quality of daily life—as well as the intermittent sound of a loudly ringing iPhone with messages left by a series of individuals whose faces are displayed on its screen—points to the unstoppable capacity of human nature and social reality to render useless such ideal configurations as those envisioned by Mies.

On the videophone in *Gravity* appear several recurring characters who are named in Manglano-Ovalle's screenplay for the work: the Seductress, the Poet, and the Authority Figure. As they direct cryptic, foreboding messages to the absent occupant, their faces provide the only notable infusion of color into the otherwise muted environment of the inverted house. A fragment of one message tells us, "I promise you if you continue to take the path you're on, you'll only arrive at something empty. Better to just discard it, leave it. Abandoned ideas have their place you know; they serve as markers for the rest of us, as to what to avoid."[7] The work suggests a new twenty-first-century hybrid: a technologically panoptic "cell phone house," fraught with hubris. Our attempts to grasp narrative, however, are frustrated; no causal events or resolutions can be discerned.

An earlier work by Manglano-Ovalle, *Le Baiser* (*The Kiss*) of 2000 (see frontispiece), most closely resembles *Gravity Is a Force to Be Reckoned With*, despite the decade separating the two. Like *Gravity*, it consists of a half-scale mockup of a Miesian structure, in this case a portion of the framework of his first private house built in the United States—the Farnsworth House (1945–1951) in Plano, Illinois. Designed for Dr. Edith Farnsworth as a weekend home outside of Chicago, it became an icon of midcentury modern residential architecture for its purity and extreme minimalism. *Le Baiser* references the house in both two- and three-dimensions. A metal frame suspended from the ceiling suggests the severe, rectilinear outlines of the house's perimeter at ground plane and roofline; a screen, perpendicular to the metal frame and resembling a wall plane, serves as a locus for video imagery. Within this static framework—into which the viewer can enter—video images present a series of views from the outside looking in and from the inside looking out. From the exterior, one sees a man in a workman's jumpsuit slowly and methodically cleaning the house's large glass windows, while inside a casually dressed young woman plays records on a turntable, listening through headphones. The two are in close physical proximity, yet each seems completely oblivious to the other's presence and actions. In contrast, views shot from the interior reveal a changing panorama of the vivid natural landscape surrounding the house, devoid of human presence.

Manglano-Ovalle constructed the piece to foreground a number of contrasts and parallels. These include quotidian gestures—whether of labor or leisure—in the context

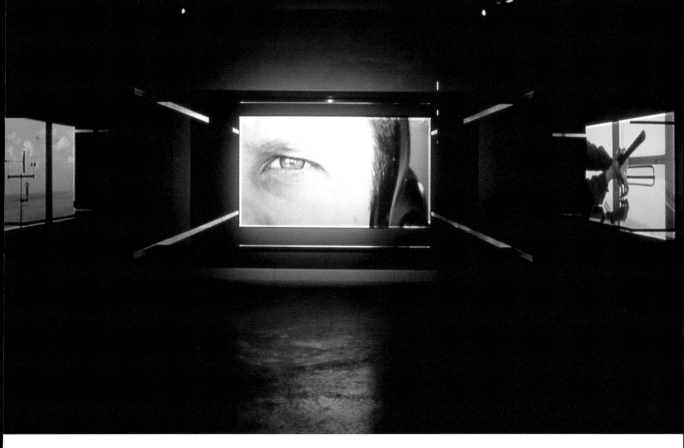

of an iconic, idealized work of high modernism; the animation of human activity and the vitality of nature in contrast to the static architecture; and references to the present and the recent past, all in a kind of uneasy dialogue.

The intertwined visual and aural dimensions of *Le Baiser* further contribute to the way the piece functions to address space and time. The almost tender gestures of the window washer's long strokes with the squeegee against the floor-to-ceiling glass produce a kissing sound. This resonates with Jeremy Boyle's composition for the piece, based on a single sampled note from the guitar solo of the 1974 song "Strange Ways" by the band Kiss.[8] Complicating the suggestion of bringing the heroic aspirations of the architecture down to earth and problematizing the apparently loving attempt to interact with the building is the undercurrent of emotional distance and psychological tension between the two figures, despite their physical proximity. The absence of interaction between the male laborer outside (enacted by the artist himself) and the woman relaxing within evince class and social differences, yet both are merely supporting actors in a drama, the protagonist of which is clearly the house itself and as an embodiment of an earlier time and set of social attitudes. The glass skin of the house seems to present an insurmountable barrier—a metaphor for the inability of modernism to be humanized and a symbol of its perceived failings.

Le Baiser presents the house as a sensory deprivation chamber; the universalist aspirations of modernism obstruct and deaden the realities of class difference, popular culture, and other less pure yet vital manifestations of the postmodern or contemporary condition. Yet *Le Baiser* is not just a critique of but also an homage to this iconic work, which is widely esteemed for its gemlike beauty. The artist describes the process of making the work as a response to the limitations placed on its use by the owners; wanting to enact a performance, the artist traded places with the house's actual window washer so as to be able to touch the building. In this respect he also approximates the role of the architect, whose desire to control every aspect of the house became infamous as it led to emphatic disagreements and litigation with Dr. Farnsworth. In this reading, the young woman inside the house in *Le Baiser* can be understood as a stand-in for Farnsworth, giving the scenario presented by Manglano-Ovalle an added dimension of complicated human drama and messy emotional resonance.

Manglano-Ovalle's 2000 installation *Climate* also depends on video situated within a spatial framework and again utilizes images of people listening to headphones, psychologically within the space of their own heads while physically within the confines of a work of high modern architecture. The setting is Mies's 860 and 880 Lake Shore Drive apartment towers in Chicago (1948–1951), the architect's first high-rise buildings in the United States. Here, Manglano-Ovalle offers a more open-ended and mysterious set of conditions and casts the architectural setting as backdrop rather than protagonist. Several individuals populate the space, each part of a scenario fraught with chance, uncertainly, or ominous qualities reinforced by the placeless, undifferentiated character of the architecture. The spaces of individual apartments and the entrance lobby of one of the buildings are used as settings for scenes ranging from individuals standing at windows looking outward while listening to commentary over headphones; a man's hands methodically disassembling, cleaning, and reassembling a 9-millimeter semiautomatic weapon; and a seated young woman waiting nervously in the building's lobby.

The sound track of *Climate* consists of commentary in English and Korean on the weather and its implications for worldwide economic upheaval—a disembodied, science-fictive dimension that Manglano-Ovalle intends as a metaphor for the processes of globalization—a contemporary condition that can be taken as an escalation of the universalizing ideals of modernism. Occasionally, the voice on the sound track repeats the phrase, "Everything for everybody and all at the same time." This enigmatic work is redolent with a menacing sense of unpredictability and randomness that challenges and undermines any notion of stability or universal benefit associated with the values of modernism. It is the work in the series that most overtly comments on the social implications of modernism "into what has become our own current condition—a virtual globalism where individuals are sightless, contained in isolation and are in acts of communication without meaning."[9]

The 2006 Super 16-millimeter film *Always After (The Glass House)* also exudes a sense of disquieting tension and ambiguity. The most abstract of the corpus of Mies-inspired work, it centers on images of broken glass in movement across a floor where windows have been shattered. Shot at Crown Hall, the centerpiece of the Mies-designed Illinois

Iñigo Manglano-Ovalle, *Always After* (*The Glass House*), 2006. Film still. Collection of the Art Institute of Chicago, restricted gift of David Teiger Foundation. Shown in *Learning Modern*, Sullivan Galleries, School of the Art Institute of Chicago. Courtesy of the artist.

Institute of Technology campus in Chicago, it opens with the breaking of windows (by Mies's own grandson, Dirk Lohan) at a ceremony marking the start of a long-awaited renovation of the building. Manglano-Ovalle's film transforms this celebratory event into a mysterious portrait of destruction and its aftermath. The camera lingers lovingly over the shards of broken glass, being swept this way and that by the brooms of a cleanup crew—another reference on the part of the artist to the processes of maintenance necessary to the care of these iconic environments. Shot in slow motion and moving in and out of focus, the piece assumes an almost dreamlike quality, heightened by an insistent emphasis on the ground plane where the action is occurring. Only the feet, legs, and hands of humans are visible in scenes that transition between black and white—primarily views of the feet of a well-heeled crowd leaving the building, presumably after the ceremony—and color, where we witness the work clothes, heavy shoes, and the brown hands of African-American custodians as they sweep up the glass.

References to disjunctions between past and present, order and chaos, and different classes are leitmotifs in Manglano-Ovalle's work, yet *Always After* is further complicated by a highly sophisticated visuality, a seductive, dangerous beauty, and the sheer multiplicity of references. Muted allusions to a range of natural and social phenomena proliferate: the shattered glass variously evokes chunks of ice, piles of diamonds, and sinister historical episodes, from the 1938 anti-Jewish pogrom known as Kristallnacht to more recent events involving the destruction of architecture as a symbolic act. Here again, sound is critically important, ebbing and flowing in volume. The alternately accelerated and slowed pace of

both the camera and the audio underscores temporal dislocations, restlessly oscillating between past and present.

Also addressing the passage of time is the sixteen-minute, 35-millimeter film *Alltagzeit* (*In Ordinary Time*) from 2001, shot in the interior of Mies's Neue Nationalgalerie in Berlin (1962–1968). Here, the hours from sunrise to sunset are condensed so that the viewer experiences the entire diurnal sequence of figures moving within the space. Technically, this was accomplished by using two cameras, one roving, shooting in real time at twenty-four frames per second, and the other stationary, shooting in time-lapse mode. In this work, as in most of Manglano-Ovalle's oeuvre, the presence of human figures is essential not only to animate and revivify the architectural setting but also to infuse it with a dimension of performance. The scenography of *Alltagzeit* underscores the phenomenological experience of changing light effects within the predominantly glass-enclosed interior. The haunting sound track by Jeremy Boyle, featuring a composition based on the first and last note of Beethoven's *Moonlight Sonata*, was developed in response to the movements of the figures and light through the space. In this respect, it is less pointedly conceptual or equivocal than Manglano-Ovalle's other works about Mies and modernism; the artist mused in a recent conversation with this author that it veers more into the territory of an homage to the building, departing from the critical sensibility that has underpinned his other reckonings with Mies.

Manglano-Ovalle's knowledge of and familiarity with the work and ideas of Mies were extensively shaped by his role as designer of the traveling exhibition *Mies in America*,

initiated in 2002 at the Whitney Museum of American Art. At the invitation of architect and Mies scholar Phyllis Lambert, the exhibition's curator, Manglano-Ovalle conceived a physical layout and created several films and videos chronicling aspects of Mies's architecture. (One of these was *Alltagzeit*.) In probing essential spatial and psychological qualities of the architecture rather than adopting a more conventional documentary approach, these were formative for the artist's own further engagement with and reflections on Mies and modernism. Manglano-Ovalle explains that he undertook the assignment as a kind of conceptual project and because of the degree of access it afforded him to Mies's built works and to his original drawings and archives.[10]

Besides *Le Baiser, Climate,* and *Alltagzeit,* Manglano-Ovalle has realized additional physical interventions in buildings designed by Mies. These projects play upon and underscore social, political, historical, and other contradictions inherent in the buildings and the circumstances surrounding their conception and execution. He describes a 2002 work titled *White Flags,* situated in Mies's Barcelona Pavilion in Spain, as follows:

> Two white flags are raised in front of the Barcelona Pavilion. The flags replace the German and Spanish flags that flew in front of the original 1929 Pavilion.
>
> A solitary white soccer ball is placed in the interior pool. The ball floats alongside the statue of a female nude.
>
> A white architectural model is displayed in the interior of the Barcelona Pavilion. The model is an interpretation of Mies's proposed German pavilion for the 1935 Brussels World's Fair. (Mies's proposal was part of a competition organized by the Third Reich, then in power in Germany.)
>
> A small white drawing is hung in the interior of the Barcelona Pavilion. The drawing is a copy of Mies's 1934 sketch of the façade and flags of the proposed pavilion.
>
> A photograph of a Moroccan boy is hung in the interior of the Barcelona Pavilion. The boy is standing in front of the Barcelona Pavilion, holding a small white flag.[11]

In 2005 Manglano-Ovalle created a project on the site of two Mies-designed buildings in Krefeld, Germany—the Museum Haus Esters and the Museum Haus Lange—that extended the metaphors explored in his earlier piece *Climate*. In these works, the movements of visitors in the space initiate aural and cinematic effects. Furthering the climatic references of the earlier work, Manglano-Ovalle utilized historical photos of a drifting iceberg taken during the late 1920s—approximately the period when the houses were built—and used sculptural and visual interventions to draw parallels between nature and architecture as a "geo-political time horizon.... The melting ice caps and the large-scale drift of supposedly perpetual pack ice have permanently shaken a central tenet of Modernism: that humankind can gain complete control over natural forces."[12]

The scope and range of Manglano-Ovalle's treatment of Mies's architecture as emblematic of modernism is notable both in terms of its temporal quality, continuing over more than a decade, and the distinctions between the individual works themselves, even as they retain certain features in common. During the last two decades numerous artists have found modernism to be a subject matter ripe for social and cultural critique, yet

Manglano-Ovalle has mined the subject in a more sustained and focused way than others of his generation. In contrast, for instance, to the photographic treatments of iconic modern buildings by such artists as Luisa Lambri, James Welling, and Christopher Williams, or the work of Irit Batsry, Josiah McIlheney, and Tobias Putrih, who have pursued provocative, ongoing dialogues with the legacy of Buckminster Fuller, or of others who have engaged with modern architecture in various ways, Manglano-Ovalle has delved deeply into a complex, discursive relationship with Mies and with modernism as it is manifested within an increasingly broad set of social and philosophical conditions. In this respect, his substantive yet varied engagement with these ideas most closely approximates that of artist Liam Gillick, who has also utilized modern architecture as a vehicle for social, spatial, and conceptual investigation over time.[13]

Manglano-Ovalle's rumination on the aspirations and deficiencies of globalization through parallels drawn between weather conditions and broader social and economic forces with the capacity for universal impact situates his treatment of Mies and modernism in an expanded sphere of intellectual and artistic inquiry, one that is reinforced by the potency and clarity of the images and spaces he creates to present highly suggestive, open-ended scenarios. In this respect his work resonates with a surrealistic, haunting clarity of disquieting, dreamlike sequences, the meaning of which is opaque and ambiguous. It is intriguing to contrast his sensibility, for instance, with that of Renee Green's 1993 work *Secret*, a group of videos, photographs, and sound installations set in the interior of Le Corbusier's Unite d'Habitation in Firminy, France. Green's work emphatically reveals the utopian failures of modernism from the viewpoint of human habitation and the presence of the "other," but in a manner that slyly references cultural anthropology.

In his book *Architecture Depends,* author and architect Jeremy Till points to the mechanism of autonomy in architecture as a continual striving to delimit the boundaries of the discipline in order to expunge contingencies.[14] When critiquing modern architecture, using it as a source of inspiration, or conveying ambivalence, artists tend to exploit these contingencies, creating conceptual and formal hybrids. The products of such artistic practices are often at odds with the nature of the discipline itself; by introducing contingencies and hybridities, they challenge many of the inherent features of architectural discourse that has largely continued to resist incursions from other fields. Till comments:

> Where in the modern project the end is overseen by the values of truth and reason, and thus to a large extent predetermined, in the contingent world the exact end is uncertain and the choices made along the way are exposed to other forces and in particular the hopes and intents of others. Contingency thus demands that we share our destinies; it does not overpower the intents that people bring to the table, it just shapes them and obliges them to be less dogmatic.[15]

Asked whether, with the completion of *Gravity Is a Force to Be Reckoned With*, Manglano-Ovalle believes he may have come to the end of the cycle of works on modernism using Mies's architecture as a point of departure, the artist equivocates. He comments that while he often thinks that he has completed this body of work, he ends up "coming back to

Mies," still driven by a sense of curiosity about the aftermath of the unfinished project of modernism. His keen meditations on the production of space, the concept of a universal language, and the politics of display as inherent aspects of modernism have resulted in a corpus of work that is also very much about incompleteness and a sense of unfulfilled aspirations. A mood of anticipation and waiting permeates all of these works, yet is never realized. Endings are thwarted.

Notes

1. Zygmunt Bauman, *Modernity and Ambivalence* (Cambridge: Polity Press, 1991): 7.

2. Valerie Palmer, "In Ordinary Time: An Interview with Iñigo Manglano-Ovalle," *New Art Examiner* (January–February 2002), 33.

3. Michael Rush, "Interview with Iñigo Manglano-Ovalle," in *Iñigo Manglano-Ovalle* (Bloomfield Hills, MI: Cranbrook Art Museum, 2001), 58.

4. Robert Morris, "Notes on Sculpture," four-part series of essays, *Artforum*, 1966–1969.

5. "I said incredulously one day to Mies, 'Do you mean you can raise this family with parents, children, in this open plan and adjust some walls?' 'Ja,' said Mies, 'there's distance and it reminds me of some ski lodges or on a yacht or sailboat.'" Myron Goldmith, quoted in Phyllis Lambert, "Mies Immersion," in *Mies in America* (Montreal: Canadian Centre for Architecture; New York: Whitney Museum of American Art/Harry N. Abrams, 2001), 457. The differences between Mies's attitude and that of Walter Gropius, Richard Neutra, Eero Saarinen, and other of his contemporaries who designed homes both for families and individuals and for clients of means as well as those in more modest economic circumstances is notable; the latter altered materials, configurations, or other elements to acknowledge differing circumstances while maintaining a modernist vocabulary.

6. The relationships between the Mies design, the Eisenstein film, and the Zamyatin novel are detailed in Denise Markonish, "You Say You Want a (Infinite) Revolution," in *Gravity Is a Force to Be Reckoned With* (North Adams: Massachusetts Museum of Contemporary Art, 2010).

7. Spoken by character R-13 in Manglano-Ovalle's script for *Gravity Is a Force to Be Reckoned With*.

8. A frequent collaborator with Manglano-Ovalle, Boyle composed his own album *Songs from the Guitar Solos* following his creation of the sound track for *Le Baiser*.

9. Rush, "Interview with Iñigo Manglano-Ovalle," 59.

10. The exhibition traveled from the Whitney Museum of American Art, New York, to the Canadian Centre for Architecture, Montreal, and the Museum of Contemporary Art, Chicago, in 2001–2002.

11. From the artist's description of *White Flags*, 2002, typescript.

12. Martin Hentschel, "An Introduction," in *Iñigo Manglano-Ovalle: The Krefeld Suite* (Krefeld: Museum Haus Esters, Museum Haus Lange/Kerber Verlag, 2005), 9.

13. See Monika Szewczyk, ed., *Meaning Liam Gillick* (Cambridge, MA: MIT Press, 2009), for the most comprehensive analysis to date of Gillick's multifaceted practice and its relation to and critique of modernism.

14. Jeremy Till, *Architecture Depends* (Cambridge, MA: MIT Press, 2009).

15. Ibid., 59.

be made by the reader. Frank Whitford's *Bauhaus* (London: Thames and Hudson, 1984) and Gillian Naylor's *The Bauhaus Reassessed* (New York: Dutton, 1985) provide the reader of English with a reasonable general overview of this history. The history of the American Bauhaus, however (New Bauhaus, School of Design, Institute of Design) is still incomplete. The history of its founding is exhaustively related in Lloyd C. Engelbrecht's unpublished dissertation, *The Association of Arts and Industries: Background and Origins of the Bauhaus Movement in Chicago* (Chicago: University of Chicago, 1973), an abstract of which appeared in the catalog of the Centre George Pompidou's *László Moholy-Nagy* exhibition (Paris 1976). The first complete monograph of the subject is the Bauhaus-Archive's catalog of the anniversary exhibition, *50 Jahre new bauhaus* (Berlin 1987). Sibyl Moholy-Nagy's biography of her husband provides a very lively although very personal, general framework to this period. *Moholy-Nagy: Experiment in Totality* (Cambridge MIT Press, 1950, second edition, 1969). Additional information is provided in chapter 1.2 of J.S. Allen's *The Romance of Commerce and Culture* (Chicago: The University of Chicago Press 1983) and the general Chicago background is summarized by J. Fiske Mitarachi in "Dramatic Bauhaus." *I.D. 3 (October 1956): 67–80.* Finally a comprehensive survey of its first ten years (1937–46) is to be found in book II of the author's *Du Bauhaus à Chicago: les années d'enseignement de László Moholy-Nagy* (Paris: Université de Paris VII, 1989).

Artists' Mind

Narelle Jubelin and Carla Duarte, *Key Notes* (detail), 2009. Installation view, in *Learning Modern*,

Sullivan Galleries, School of the Art Institute of Chicago. Photo: James Prinz.

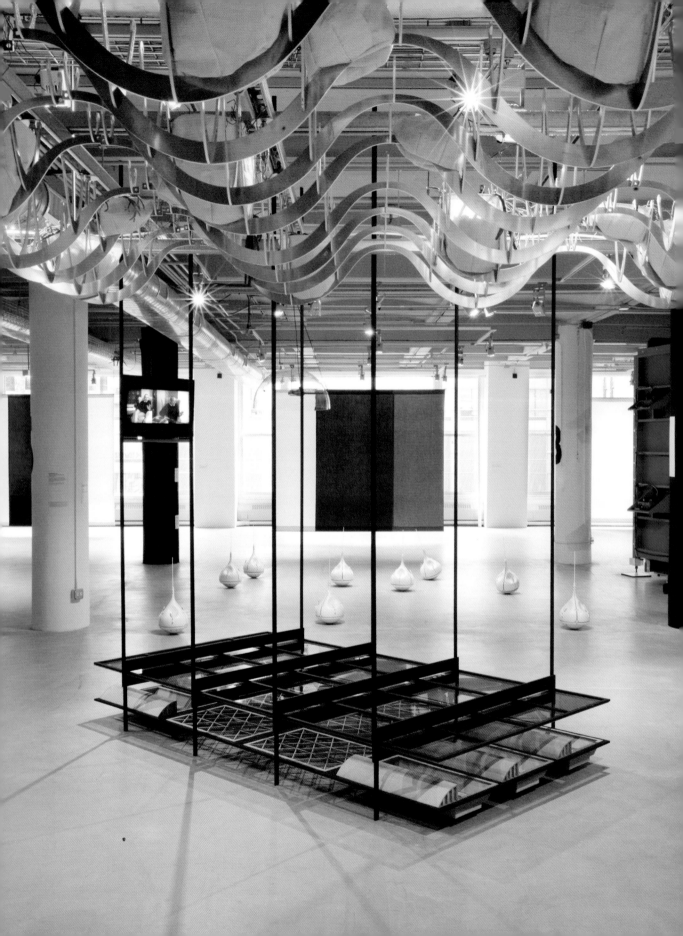

My Modern: Experiencing Exhibitions

KATE ZELLER

Learning Modern, 2009.
Installation view, Sullivan
Galleries, School of the
Art Institute of Chicago.
Left to right: Walter Hood,
Bioline; Narelle Jubelin and
Carla Duarte, *Key Notes*;
Staffan Schmidt, *Modernity
Retired*; Joshua Cotton,
Justin Nardone, and Douglas
Pancoast, *Sonotroph*; Ângela
Ferreira, *Crown Hall/Dragon
House*; Ken Isaacs, *Knowledge
Box*. Photo: Jill Frank.

Department (Store): A Collaboration with J. Morgan Puett

The potential for an exhibition to engender experiential modes of thought, altering perceptions and creating connections in and out of the gallery space, is part of J. Morgan Puett's vision for *Department (Store)*, the first show of the modern program. Looking back to the Sullivan Galleries' original function as part of the Carson Pirie Scott department store, this exhibition fills the gallery floor with 130 display cases. Required to enter bodily into the massive installation to determine the contents of each case, you begin to weave through its sea of glowing, glass surfaces. These containers, which once displayed consumer goods, now hold the products of personal responses to questions posed by Puett: What is important? What *case* would you make? How will you display it? You come upon cases converted into greenhouses, filled with striated layers created by neatly stacking every pink piece of clothing from someone's wardrobe, displaying an antique jewelry collection, documenting the search for a biological father . . .

Seemingly independently executed installations, the cases are actually part of a system set up by Puett wherein each case is a piece on a game board, each participant a player. The movement of the cases is determined by an elaborate algorithm that factors in the past (dates of historical significance), the present (average temperature), and the site (number of visitors on a given day). The game board, the path along which the cases travel, is the ornamentation that frames the windows, its organic form imposed directly onto the gallery's gridlike interior.

On the gallery walls, you notice the charting of this "play." Notations in graphite record the cases' contents, their exact movements, their projected interactions (colli-

The exhibitions *Department (Store)* and *Learning Modern* took place at the School of the Art Institute of Chicago's Sullivan Galleries. *Moholy: An Education of the Senses* was held at the Loyola University Museum of Art

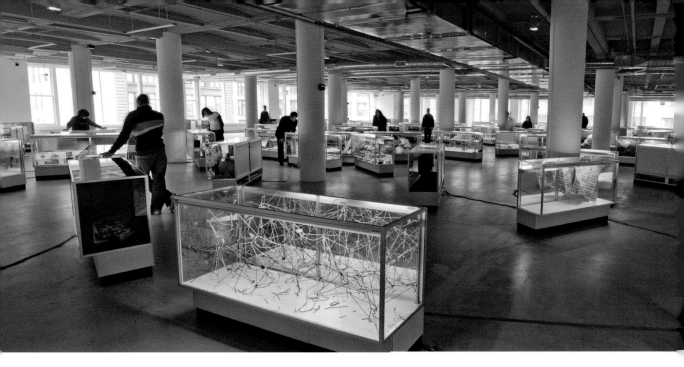

sions), and the calculations that determine their positions. You consider what it is that this information documents. Is it the nature of individual experience within the greater system? You realize that with each visit to the gallery the installation will change; new players will provide responses and each previous movement will affect the next. With most games there is a pursuit, an objective. As you stand within the playing field, you consider that perhaps it is up to you to decipher this data, to formulate responses to the questions it evokes: How does the individual relate to the whole? In what ways are they interconnected? Following the trajectory of the game board beyond the gallery, out into the city, into stores with similar cases and contents, along a street that was reconceived for commerce at the moment this building was born, you consider too the question of your relation to the world. Puett's initial questioning appears to result in a game with no end, with no single victor; it is a game that generates only deeper inquiry and elicits continued response.

Learning Modern

Art sensitizes man to the best that is immanent in him through an intensified expression involving many layers of experience.

László Moholy-Nagy

Upon entering *Learning Modern*, you feel small. The vastness of the space is overwhelming. Even if other people are present, there are too many places for them to hide. You feel alone. No clear path is evident, no singular course reveals itself. You are left to your own devices—no maps, no guides, only minimal descriptions that tell you what's what. You get the sense, perhaps daunting, that you're on your own.

J. Morgan Puett, *Department (Store)* (detail, case movement diagram), 2008. Installation view, Sullivan Galleries, School of the Art Institute of Chicago. Photo: Szu Han Ho.

What results is a heightened awareness. You become conscious of sensory cues that encourage your entry into and navigation of the space. Overhead, the sinuous aluminum forms of Walter Hood's *Bioline* draw your eye in and down the long hall. They terminate at a hanging wool panel, part of Jubelin and Duarte's *Key Notes*, whose bright green hue echoes the stream of plants suspended above. The panels' fields of color connect one to the next and lead you around the gallery's perimeter, following an idiosyncratic spectrum along the expansive Sullivan windows. The prominent letters and alternating black and white columns of Kay Rosen's *Divisibility* punctuate your visual path, pulling you back and forth within the space. And then there are sounds, many sounds, from all directions, a cacophony of voices, crashing glass, clicking slides, air-vent rumblings—all encouraging you to investigate their source.

You proceed into the space with apprehension but also with a sense of agency. Part of you is compelled to explore this unknown and feels empowered with the knowledge that you alone will determine your course. As you move through the exhibition, you engage the works and begin to uncover, decipher, and interpret the layers of meaning and processes embodied in them. You notice connections between the works as they relate to each other, to the space, to yourself. Every turn yields a new perspective; each encounter, a changed perception. There is a sense of unlimited potential; your path

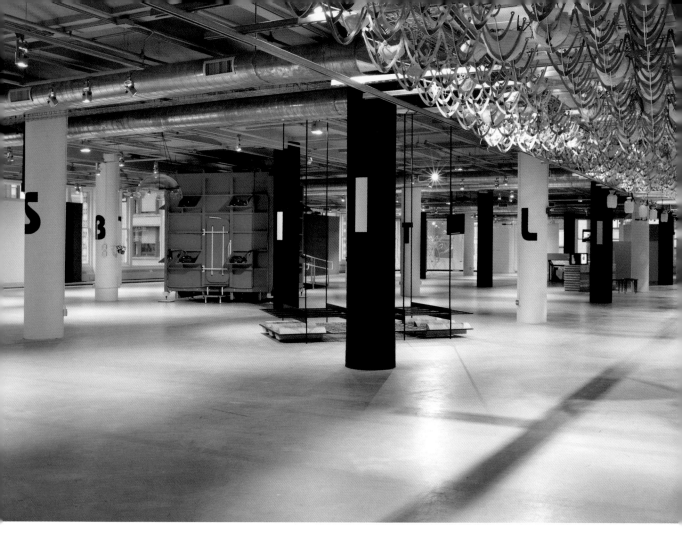

Learning Modern, 2009.
Installation view. Left to
right: Kay Rosen, *Divisibility*;
Ken Isaacs, *Knowledge Box*;
Narelle Jubelin and Carla
Duarte, *Key Notes*; Ângela
Ferreira, *Crown Hall/Dragon
House*; Andreas Vogler and
Arturo Vittori, *Atlas Coelestis*;
Mark Anderson, Mark Beasley,
and Matt Nelson, *Infinite
Sprawl*; Walter Hood, *Bioline*.
Photo: James Prinz.

will be different with each visitation. Yet you are the fulcrum, the point on which these experiences center. You learn of others' understandings and ideas of the modern and are left to determine your own.

At this particular moment, you stand before the tall, steel beams of Ângela Ferreira's *Crown Hall/Dragon House*. It emits a deep orange glow. On the opposing wall hang large, black-and-white photographs from the artist's research—images of Mies van der Rohe's Crown Hall and Pancho Guedes's Dragon House. Ferreira's sculpture merges together these two structures, upending Crown Hall and turning it into a container for wood panels that replicate Dragon House's façade. The artist relates these two modernist buildings, which were constructed at nearly the same time on opposite sides of the world, as a result of her personal connections with Africa and continued reflections on the continent's role in a greater global dialogue. In doing so, she considers the plurality of modernism, how its message and vision may not have been singular (and Miesian) but multiple.

Just beyond *Crown Hall/Dragon House*, your attention is drawn to a large, blue cube

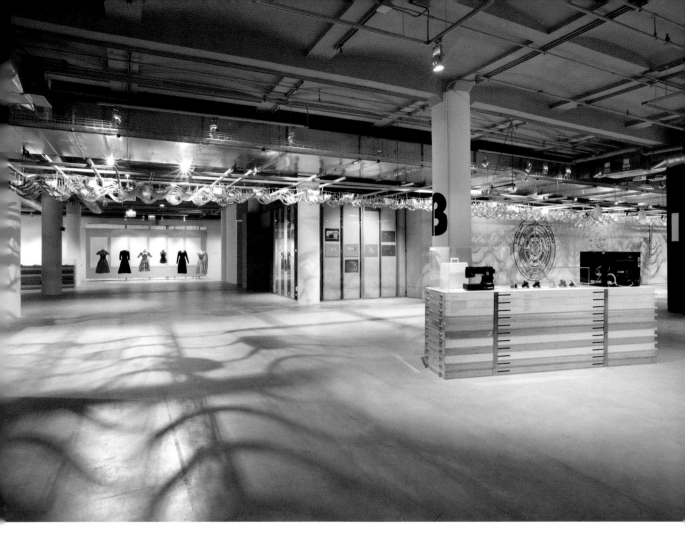

Learning Modern, 2009.
Installation view. Left to
right: Walter Hood, *Bioline*;
Claire McCardell, garments;
Charles Harrison, drawings,
sewing machine, and View-
Master designs; Kay Rosen,
Divisibility; Walter Gropius,
Paul Klee, and László Moholy-
Nagy, pedagogical diagrams.
Photo: James Prinz.

that hums with a somewhat ominous presence. Its regularly sectioned, geometric
façade echoes the Miesian grid at the base of Ferreira's sculpture, and like Guedes's
signature orange, the artist's bright blue accentuates the structure's commanding pres-
ence. Ken Isaacs's *Knowledge Box* is also a container, not unlike Mies's Crown Hall,
intended as a space for learning, but related as well to Ferreira's repurposing of Mies's
form; it too contends with the nature of historical narratives. When you enter this oth-
erwise empty wooden box, you are immersed in a constantly changing flow of sounds
and images. The experience is similar to that of the original *Knowledge Box*, constructed
in 1962, ironically, inside Mies's Crown Hall. In this re-creation, Isaacs chose, again,
to project slides of 1950s *Life* magazine photographs on the interior, which are accom-
panied by a new but similar sound track of music and speeches from that same decade.
Though the artist selected and choreographed the sensory information you encounter,
the interpretation is left to you. Directly implicated in this process, with images cast
on your body as you wander through the interior, you form connections and create
meanings—understandings that inevitably differ from those of the next occupant, or

Learning Modern, 2009.
Installation view. Left to right:
Narelle Jubelin and Carla
Duarte, *Key Notes*; Kay Rosen,
Divisibility. Photo: Carla
Duarte.

of viewers in 1962, when such sounds and images were closer to everyday reality than history. As you exit the *Knowledge Box*, your conception of this history informs your subsequent course.

You turn to find, painted on the wall, diagrams—other structural systems intended for learning—the pedagogical charts of Walter Gropius from 1922, an interpretation of this system by Paul Klee from the same year, and Moholy-Nagy's 1937 plan for his new Chicago school, the New Bauhaus. Designed as series of concentric circles, each of these curricular plans focus on the development of the individual, as the student moves through an integrated study of theory, techniques, and materials. Art is joined with technology, and Moholy-Nagy adds science to the equation, reflecting his belief that these fields should be simultaneously engaged. Suspended above these charts is a manifestation of Moholy-Nagy's concept in practice. Here, Hood's installation *Bioline* calls attention to the gallery's existing infrastructure—its air circulation system—in a striking, curved mesh of lucent metal and abundant green. This interior landscape

Learning Modern, 2009. Installation view. Left to right: Charles Harrison, Sears Kenmore sewing machine; Narelle Jubelin and Carla Duarte, *Key Notes*; Staffan Schmidt, *Modernity Retired*. Photo: Carla Duarte.

supplements the system's mechanical function as the assembled plants also filter the air through their natural processes. Such a merging of nature and utility alludes also to the building itself, in which Sullivan's complex, organic patterns surround the immense, factorylike windows.

Shadows cast by *Bioline*'s flowing, functional mass spread across the gallery floor and wind through the space. Their layered, tangled forms stand in contrast to the rows of columns that delineate the gallery's gridlike layout. Rosen's installation *Divisibility* engages these structural supports and, like *Bioline*, draws your awareness to existing infrastructure. Letters painted on each column, spelling out "divisibiliti," emphasize the columns' division of the otherwise open space into (nearly) equal sections. The alternating of black and white, the pattern of I's, which appear on every other column, and the repetition of the word twice around the gallery, meeting at the center where they overlap with "iti," further divides the existing grid. In actuality, the gallery is far less uniform than *Divisibility* suggests. Not only are the distances between columns on the north-south axis much greater than on the east-west axis; slight variations throughout the space result in nearly all of the sections being unique. You consider that perhaps *Divisibility* calls into question the semblance of order, control, and equality implied in this structural system.

Beyond *Divisibility*, the brightly colored wool panels of *Key Notes* draw your focus to the perimeter of the gallery. They too contend with Sullivan, as each panel is scaled to the window before which it hangs, and these, like the columnar sections, vary in dimension. Thus, the seemingly uniform panels vary in size; the dimensions of each are unique. The panels also allude to the collaboration of Mies van der Rohe and Lilly Reich, whose exhibition designs often used panels to delineate space. Other historical connections are also woven into *Key Notes*. On the windows, the artist has inscribed footnotes from an essay on Moholy-Nagy's pedagogy for his New Bauhaus,[1] and when the sun shines, the texts project onto the colored panels, bringing together Mies and his colleague Moholy (though it is said there was much animosity between them).

In front of several of the *Key Notes* panels hang large monitors, screening videos in which artist Staffan Schmidt engages with modernism's story. The interviews that make up *Modernity Retired* narrate history at the time of Mies and Moholy-Nagy as it was experienced firsthand. On the five screens hanging throughout the gallery you pick up the thoughts of octogenarians as they recount their memories of what "modern" was like when modernism was new. At times the image on the screen before you doubles—the single, talking head transposes to face itself or repeats across the monitor. You begin to question, as with *Knowledge Box* and *Crown Hall/Dragon House*, the nature of these historical narratives. Here, individual ideas of the modern are noticeably affected by the mutability of memory. Also, Schmidt played a role in assembling these productions, as did Isaacs with *Knowledge Box*. Periodically, you can hear his voice and glimpse his body within the frame. Each individual's account is conveyed through Schmidt's perspective—his lens, his editing and cutting, splicing and layering.

In the distance, just past one of the *Modernity Retired* monitors, you notice a circular aluminum form suspended from the ceiling. Andreas Vogler and Arturo Vittori's sculpture *Atlas Coelestis* fills the gallery's rounded corner, its concentric rings rotating, with the city as a backdrop. Confronting this work, you get the sense that the focus of the interview has now been turned to you. Drawing inspiration from Galileo's innovations to the telescope, the sculpture references the Renaissance humanist vision that led the way for a modern view of the relation of the individual to the world. *Atlas Coelestis* is also situated almost directly above the intersection which marks the zero point, the origin, in Chicago's city grid. You are thus asked to contemplate not only your relation to the work but your position within the gallery, which is itself contained within the city, and within the greater system that lies beyond.

Turning away from the windows, you again notice the pedagogical diagrams, which now appear in the distance as seemingly static versions of *Atlas Coelestis*'s concentric rings. You consider how they too are reminders of structural systems in which you may play a part. And just beyond the charts is another work that evokes your awareness of the city and your relation to it. In Catherine Yass's film *Descent*, projected on the other side of the wall with the pedagogical diagrams, you encounter architectural forms that recall those you previously contemplated outside Sullivan's windows, but these provoke apprehension and uncertainty. You suddenly feel unsure of your footing. A dense fog fills the screen, obscuring your perception of the surroundings. From this abyss

Learning Modern, 2009.
Installation view. Left to right:
Arturo Vittori and Andreas
Vogler, *Atlas Coelestis*; Staffan
Schmidt, *Modernity Retired*;
Narelle Jubelin and Carla
Duarte, *Key Notes*. Photo: Jill
Frank.

emerges an architectural skeleton—a skyscraper under construction. You pass by the unfinished floors one by one, yet something is awry. The building has been upended, the motion inverted as you climb toward its base. You are unsure what will happen as you rise toward the ground.

Your sense of uncertainty persists as you enter the projection room on the other side of *Descent*. The film here, Iñigo Manglano-Ovalle's *Always After* (*The Glass House*), presents another building in a state of flux but triggers disorientation through the ambiguity of the event it depicts. Positioned inside a building and focused on its floor, you watch as diamondlike shards of glass are swept across the screen. There is a low rumbling, punctuated by sounds of shattering glass and intermittent digital tones. If not for the didactic text, you might not suspect that you are situated in Mies's Crown Hall during the groundbreaking for its renovation, which took the form of smashing its walls of windows. The closely cropped shots never show the windows being broken; you seem to have arrived just after. You consider what will be left once all the panes are removed: the steel frame—an essential element of Mies's architectural innovation.

It is this Miesian structure you now revisit, poised just outside of the projection rooms. Leaving *Always After (The Glass House)*, you return to *Crown Hall/Dragon House*, its upended Crown Hall now recognizable as a merging of *Always After*'s venue and *Descent*'s inverted cityscape. You perceive details of Ferreira's work that seem also to share a resonance with the building you have just traversed. The sculpture's supporting steel beams appear to mimic Sullivan's columns—spare, vertical forms interrupting open space. Sullivan's design is also recalled in *Always After*, as Mies's glass curtain is suggestive of the immense windows that surround the gallery. And beyond these windows, the cityscape recalls *Descent*'s truncated views. In each of these works and within the gallery, the buildings' frameworks are exposed, seemingly inviting your consideration of the structural supports that divide, define, and organize space. Their minimal, gridlike frames are of obvious importance to the buildings' integrity, yet you question just what it is they are supporting. A vision for the future? The legacy of the past? Alternative, parallel perspectives? In the works, the structures are rendered in tentative states—construction, renovation, suspension—leaving such questions unresolved.

Having returned to where you started, at *Crown Hall/Dragon House*, you notice again the pedagogical diagrams on the wall. Reconsidering these conceptual frameworks, their mapping of a student's path as they progress through each layer, from one level to the next, you reflect on your experience in the exhibition. Perhaps it would not be captured by these diagrams; the form it has taken may be more like a web, a system of connections. With each encounter a new line was drawn—links between yourself, the artists, the works, the installation, the gallery, the city. Such a network, though similar in form to the circular diagrams, enables you to traverse space in ever new ways, each return taking on a new path and alternate meanings. *Key Notes* changes with the time of day; sound clips are heard in different areas; you turn a corner and see the works in a new context and relation to each other. As these experiences accumulate your perception shifts, expanding to reveal an interconnectivity with you at the center of boundless possibility, possessing an ever-evolving concept of your modern.

Moholy: An Education of the Senses

The final exhibition in the modern series, *Moholy: An Education of the Senses*, also engages these questions of how we understand the world and our role in it. The show looks to the methods and theories of László Moholy-Nagy not only to illuminate his innovations but also to translate his vision through a contemporary vocabulary. The works in the show are not organized chronologically, nor are they accompanied by descriptive texts. Navigation instead relies upon sensory attention, evoking Moholy-Nagy's own desire for an education of the senses.

In the first gallery, you encounter Moholy-Nagy's investigations of perception, images of city life that challenge conventional perspective. Disoriented by *Berlin Still-life*, a film projected onto the floor, implicitly penetrating its horizontal plane, you are forced to question habitual modes of viewing and interacting with the world. You reconsider the

Opposite:

Moholy: An Education of the Senses, 2010. Installation view, Loyola University Museum of Art, Chicago. Photo: Helen Maria Nugent.

otherwise quotidian scenes in the photographs around the room, engaging them as complex visual experiences.

In the next gallery, geometric forms slowly shift across three large screens, confronting Moholy-Nagy's experiments with space, time, and motion as the film appears to activate the prints and photograms on the surrounding walls—seemingly abstracted versions of the works in the previous gallery.

The first instance of color seeps into your visual field as you come upon Moholy-Nagy's constructivist portfolio in the subsequent gallery. In this series of lithographs, the artist's theory of the relation between the individual and society is evident, as the transparent forms are simultaneously independent and interconnected.

Low murmurs and intermittent metallic clashes from the adjacent gallery next provoke your interest. You enter to find Moholy-Nagy's *Light Prop for an Electric Stage (Light-Space Modulator)* in motion, bringing into three dimensions the planar structures of the previous works. You are immersed in a dynamic environment of light and shadow generated by Moholy-Nagy's rotating sculpture. Its energy pervades the final gallery as you discover the artist's strong motivation to engage others in these investigations, considering it fundamental to the learning process. Projected in the center of the room is *Do Not Disturb*, a film he created with his students.

Moholy-Nagy's methods of experimentation and collaboration are evident not only in his works but in the design for this exhibition. In developing their plans, Jan Tichy and Helen Maria Nugent continually asked, What would Moholy-Nagy do today? Departing the exhibition, you realize that this spirit of inquiry has been imparted to you. Moholy-Nagy often advocated for the development of the individual through the experience of art, changing perception in order to see and make a new society. What you take away from this exhibition—and the same could be said of *Department (Store)* and *Learning Modern*—is a process: a way of seeing, thinking, and learning that goes beyond a moment of encounter and continues to inform your future interactions and experiences in the world.

Note

1. Alain Findeli, "Moholy-Nagy's Design Pedagogy in Chicago (1937–46)," *Design Issues* 7, no. 1 (Fall 1990): 14.

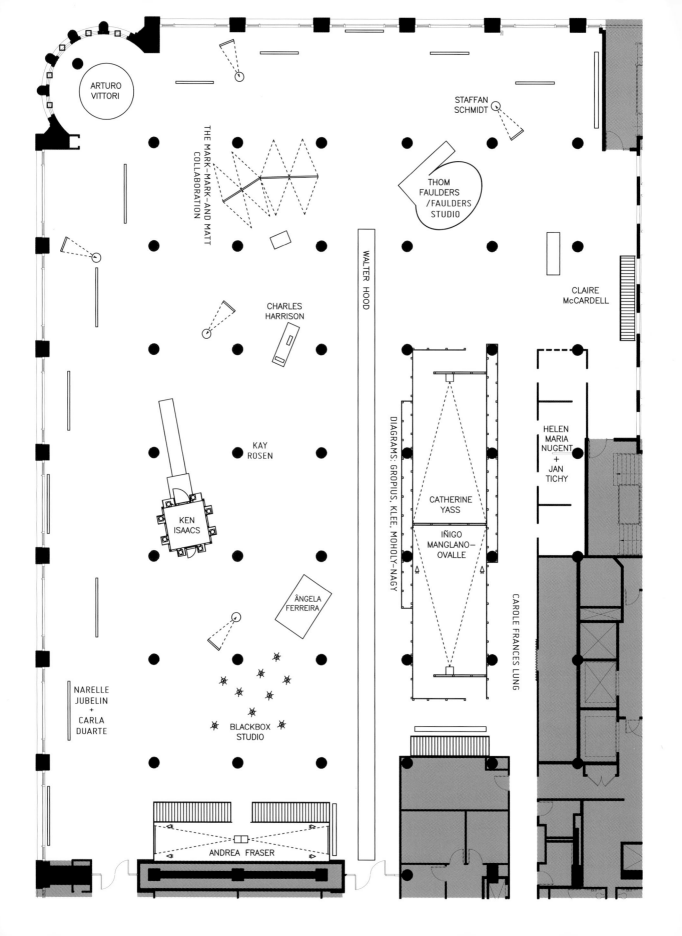

ARTURO
VITTORI

STAFFAN
SCHMIDT

THE MARK—MARK—AND MATT
COLLABORATION

THOM
FAULDERS
/FAULDERS
STUDIO

CLAIRE
McCARDELL

WALTER HOOD

CHARLES
HARRISON

KAY
ROSEN

DIAGRAMS: GROPIUS, KLEE, MOHOLY-NAGY

HELEN
MARIA
NUGENT
+
JAN
TICHY

KEN
ISAACS

CATHERINE
YASS

IÑIGO
MANGLANO—
OVALLE

ÂNGELA
FERREIRA

CAROLE FRANCES LUNG

NARELLE
JUBELIN
+
CARLA
DUARTE

BLACKBOX
STUDIO

ANDREA FRASER

Incomplete Final Checklist (Unconfirmed)

MARCOS CORRALES

How to patch a hole in the wall:
1. Scrape down the edge of the hole with a scraper.
2. Apply a thin layer of Joint Compound over the hole. Make sure that there is enough Joint Compound to fill the hole but not so much that it will be difficult to sand later.
3. Wait one to two hours.
4. Sand the Joint Compound flush with the wall.[1]

. . . lightness[2]

As an exhibition architect you are someone who takes part in a conversation or dialogue, an interlocutor, listener, viewer, interpreter, and reader; a kind of outsider, a stranger, a foreigner, enough of an outsider to be able to remain independent of the institution, of the gallery, of the sponsors, of the curator, and of the artists, even of the city in this case. Isolated to a certain degree, at a distance—but only partially, in order to be able to come and go among those other worlds. A kind of sounding board for everyone else, but always able to step back and offer a birds-eye view of the whole, and then return to the individual elements. A kind of psychologist who relies on common sense, the man in the middle of the line of performers, between and in between; a kind of stenographer or court reporter who seems not to be paying attention but is gathering as much informa-tion as possible, an eye on every stage of the overall process, from the most pragmatic to the most delicate, in the unspoken exchanges that take place between one meeting room and another, between the institution, the artwork, the artist, the curator, the expecta-

Marcos Corrales, *Learning Modern* floor plan, 2009. Courtesy of the artist.

Corrales was the exhibition designer for *Learning Modern* at the School of the Art Institute of Chicago's Sullivan Galleries.

tions, the circumstances, the technical possibilities, the economical factors, the context, and the space. A simultaneous translator, almost a spy; a detection device for analyzing spatial components, the dynamics, the synergies, the flow, the turbulences, the lumps, the noise. Able to listen to what is heard and what is not heard, to what is said and what is left unsaid, to the relation of each part to the whole and the relations between the different parts, as when someone tunes an instrument. A kind of veiled paranoiac, unchangingly alert at all times, picking up all the signals through semiconcealed antennae, trying to balance multiple obligations.

. . . quickness

Go through the space as often as possible, with or without conversation. Look at the ceiling, the floor, the walls, the columns, the people, the objects, the light, the door; at your own shoes, out the window, at the city, at different times of day, at the offices, at the entrances, at the air-conditioning units, at the lighting tracks, at the emergency exits; forwards, backwards, in a wheelchair—and then do it all again until you can recognize every bay, every oddity, every current, every corner, the back side of everything, what is seen from every window, what is hidden behind every column. And then do it all again, after having slept on it overnight. Let the space carry you along, let its currents carry you, let it show you its dead zones and obstacles. Bump into every corner, blow hard if you have to in order to see where the air doesn't flow or where it swirls and eddies. Discover where the space draws you in, where it takes you, where it doesn't encourage you to spend time. Scan it each time as if it were the first time, like a small child who notices each and every change in a room she is familiar with.

But in an exhibition, what is important is not the space. It is something else that permits you to work without detail, with other manifestations of architecture, without symbolism or rhetoric, trying to obviate language because language is supposed to be somewhere else.

Within the design and installation you necessarily have to concentrate on a piece, sometimes on a concept, and that is what matters. You do what you can do for that piece and what you can to neutralize anything else, consciously making what is required for people to see the show, while attempting to make that intervention imperceivable.

What I am trying to say is that working on exhibitions is an opportunity for working in a different way, working with what you might call the nonmaterial. You have to put things in place without presenting them. To present something can be too much. You need to clear out, liberate, or compress the space, and within its synergies search for moments of movement or stasis, attempting to find a pace—the psychological time—for thinking or breathing. That's where I talk about silence. You have to think about the air around a piece, or between pieces, the air that relates one piece to another. And that's where I ask: can you blow air in a building?

What takes place in any exhibition project is a gathering of information, too much information on many different levels, an avalanche of information. Each work and each

part of the space acquires a set of contingencies and circumstances, possibilities and requirements.

Everything about the space must be carefully gathered: its scale, its proportion and character, its variable signs, its prominent geometries, the elements that threaten to turn into visual noise. The works must be studied and grasped, even beyond their technical or spatial requirements. You have to find their weak spots, to identify not only their optimum conditions, or the conditions you are told are optimum, but also the conditions under which they might fail. How they can adapt to the space and how the space can adapt to them. Here you have to be especially careful in order to avoid situations that cannot be solved later, especially in an exhibition that has accepted the challenge and risk of not imposing any separations, of accepting the continuity and flow among the works within the space itself, with the potential for visitors' using the temporary interstitial spaces in ways that cannot be foreseen at the moment.

. . . exactitude

Chicago, color, light, structure, context, views, regulations, grid, Burnham/Sullivan, floor, ceiling, electric light, mechanics, scale, proportions, typology, topology, space, place, landscape/windowscape, and the city.

Execute a kind of fieldwork. Explore the site, analyze, identify the context in all its relevant, specific, and basic aspects. All those elements, recognizable or not, that make it unique, from the most originally genuine to the most recent layers that are still incomplete and still in process of development.

Try to articulate identity (changing identities): Chicago. From the structural grid of the Sullivan building to the urban Burnham grid; from the rectangular bays in the space to rectangular city blocks; from bullnose to point zero; from the spectacular diagonal views toward the windowscapes to Milwaukee, Clark, Clybourn, and Lincoln avenues (the original trading paths to the port that is now the city, still evident in high-rise views); from the precast decorative panels to the prefab homosote solution; from the 1906 carpet-stacking display of Carson Pirie Scott & Co. to stacking temporary wall panels; from strategies of commercial product display to repetition, dissemination, variation, mixture, and interrelation of products.

Start with three differentiated exhibitions: preexisting contemporary artists' work, new work "between software and hardware," and modern Chicago design. Challenge: put the three exhibitions in one, in the same space, at the same time; attempt to blend the treatment of each group and strengthen their interrelationships.

Move in different spaces with complicated schedules in overlapping times, coinciding with class works in progress. Work-in-progress exhibition, plus the need for a changing project space. Student workshops, presentations, interactive public projects, multidisciplinary, open laboratory.

Interrogate the concept in order to formulate new conditions of thought. If we understand modern culture as something already solidly inherent within ourselves, we should

try to base our actions not on references from Bauhaus teaching of the 1920s and 1930s but rather from a contemporary ethos, from the here and now, to intensify the experience.

. . . visibility

From imagining what represents the modern, shift to a sustainable-local-available modern.

Instead of superimposing onto the Sullivan Galleries another kind of physical and mental grid—translucent sliding partitions, polycarbonates, smart film, floating plastic strip doors, or vinyl structures as technical industrial materials that meet building code—activate a kind of global/local rethink, reuse, other-use, minimizing the use of surrounding references and existing material: from constructed new materials to existing, local, available, low-key, raw-finish, prefab, recyclable ones.

Another kind of learning process.

Pile existing temporary wall panels so as to store them (reuse), producing plinths, benches, tables, or vitrines within a repetition and punctuating mode. It's already there.

Homosote, existing material, integrated products, drywall, their own finish, unfinish, low-tech, everyday basis, a commonness that you don't even notice, prefab, renewable, possible, existing, mountable, demountable, sustainable, unsustainable.

A sense of the do-it-yourself, make-your-own, kit-like; an aesthetic of nonimportance, proximity to people and students, everyday use; like Staples stationery, affordable, comprehensible, recognizable. And once recognized a couple of times, you just don't notice it anymore . . . materials within the reach of anybody, of common memory.

Use forms that are simple and recognizable (so that they can slip into the background) for punctuation, dissemination, repetition, accumulation. Small relational guidelines among pillars, walls, ceiling, and floor, with the exterior among the works themselves, like playing all the angles in a game of billiards.

Alternate emptier spaces, less charged, and almost uncomfortably evident. Evident and with the potential to be used, intervened in, occupied, traveled through, activated, or emptied.

Introduce slight and subtle changes so as to reinforce the introduction of smaller-scale sequences that play off the omnipresent grid structure and the overwrought placement and presentation of the building's infrastructure (air conditioning, lighting tracks, lighting, signage, etc.).

. . . multiplicity

The way the work is exhibited is at the same time the work itself. The exhibition is constructed of and shaped by what is exhibited: to some degree both the work and the display become the exhibition content, activated only by the wanderer, inhabitant, or viewer who becomes part of the exhibition.

Space is punctuated rather than confined. Try to enhance the sense of movement within an interior, a kind of self-guided, free-flowing sense in which the specific position

of the works and their interrelations are the only boundaries that define the space. The viewer becomes object and subject in the exhibition.

A space without partitions, without separations, without indications. Try to change the conditions in which relations are created in an exhibition: between works and people, cultural institutions and their publics, schools and students. Attempt to deactivate control devices so as to make possible a new collective usage, in a kind of interchangeable, in-progress, continuous process of exploration, interpretation, experience.

. . . consistency

Without the option of seeing the works through to their final installation, of taking care of them personally, the process of "emptying the vessel" has to become even more extreme, delegating to various individuals and circumstances the developments and decisions. Having renounced the ego during the extensive process of sorting out the information, allow the self to disappear in order to reach a kind of nothingness, to do nothing. Very carefully, do nothing.

After having given and marked some guidelines, try to transmit certain traces of sensibility, perception, and awareness to the team so that they become conscious of the complexity and interdependency of the various elements, so that when they have to act they can do so without so much information, so that they can make their own decisions as if they really had forgotten most of the contingencies.

. . .

Rollers and how to clean them:
1. Separate the roller from the handle.
2. Wash off your handle . . . in the slop sink.
3. Wash paint out of roller using a five in one or your hands. . . . Do so until the water runs clear off the roller.
4. Dry your roller using the zippy spinner . . . in the slop sink.
5. Shake your handle off in the sink and you're done.
The roller may now be used again.[3]

Notes

1. James Barry, posted at the Sullivan Galleries of the School of the Art Institute of Chicago, 2009.
2. Section breaks follow the chapter titles in Italo Calvino, *Six Memos for the New Millennium* (Cambridge, MA: Harvard University Press, 1988).
3. C. J. Matherne, posted at the Sullivan Galleries of the School of the Art Institute of Chicago, 2009.

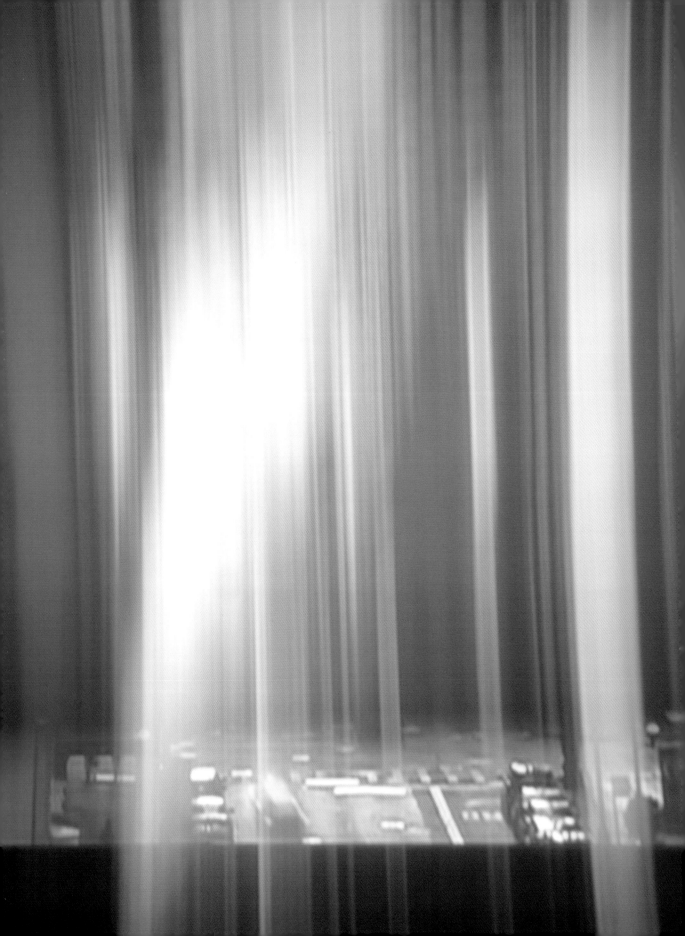

Lightplaying

HELEN MARIA NUGENT AND JAN TICHY

We were invited to design *Moholy: An Education of the Senses*, an exhibition of the work of László Moholy-Nagy in Chicago. The curator, Carol Ehlers, was looking to envelop the viewer in a physical experience of his film and photography. This would be our first project together. Jan had previously worked with video projections as time-based light sources, and Helen Maria had created design-focused works including etched dichroic glass shelving systems that split white light into color fields in overlapping patterns. While exploring directions for the design of the Moholy-Nagy exhibition, we came up with ideas that would ultimately become our first artwork together, called *Delineations* (2009) and included in the *Learning Modern* exhibition. One project nurtured the other, developing side by side, one presenting Moholy-Nagy's own work, the other inspired by his legacy.

• • •

It wasn't a coincidence that *Education of the Senses* was initiated within educational institutions and produced as a collaboration of three Chicago schools, with educators involved on all levels of the creative production. Moholy-Nagy was the Comenius[1] of art education, committed to making knowledge available and accessible through active participation, creative experimentation, and collaboration.

Rather than working independently, we offered each other our individual tools, knowledge, and experience. We choose to work together in the studio—letting the ideas and experiments evolve in real time and real space through trial and error. In so doing, we came to learn from each other rather than to teach. The windowless studio deep below the Art Institute of Chicago was a perfect place for our light experiments. With one of us contributing knowledge of projection and the other experience with light refraction, the outcome might seem predictable, but we were surprised.

In one of our early experiments we digitally projected a strip of white light onto a translucent acrylic tube that a maintenance crew had left in the hall after replacing fluo-

Helen Maria Nugent and Jan Tichy, *Delineations* (detail), 2009. Installation view, in *Learning Modern*, Sullivan Galleries, School of the Art Institute of Chicago. Photo: Jared Larson

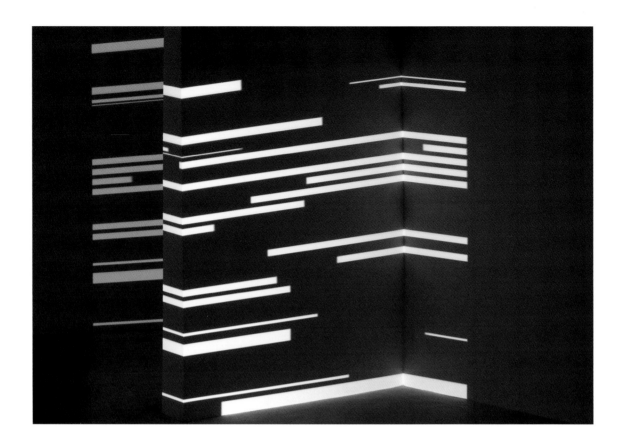

Helen Maria Nugent and Jan Tichy, *Delineations* (detail), 2009. Installation view. Photo: Jan Tichy.

rescent lights. The immediate effect of the beam being dispersed around the room by the round shape was irresistible. We recognized the similarity to the concept of Moholy-Nagy's *Light Prop for an Electric Stage* (1929–30) and realized that the difference between the analog prototype and our digital tools lay in the possibilities of motion. Unlike the analog mechanical motion of the *Light-Space Modulator*, as this work is commonly known, which compromised the activation of the original and subsequent exhibition copy, digital motion, coming from a projector, is virtually perpetual.

Our explorations of digital projections on translucent materials and cylindrical forms led to a number of installations for both exhibitions. In one of the five rooms in *Delineations* we used a cast acrylic cylinder to delineate video footage of the sun setting onto the Chicago grid. For the *Lightplay* installation, in one of the five galleries that comprised the Moholy-Nagy show, we created a translucent projection screen using the architecture of the room itself, stretching and wrapping an expanse of paper between and around the room's two large cylindrical columns. In both cases the motion of digital projection and the use of cylindrical forms activate the space. In both instances, light is physically and spatially modulated.

• • •

We came across Moholy-Nagy's text "Production-Reproduction: Potentialities of the Phonograph," surprised to find this visual artist in a book dealing with modern music. The

article, exploring the productive possibilities of reproduction apparatus, was visionary, foreseeing the social nature of electronic music many decades later. He writes:

> What is this apparatus good for?
> What is the essence of its function?
> Are we able to extend the apparatus' use so that it can serve production as well?[2]

In our studio-lab the digital video projector played the part of Moholy-Nagy's phonograph. Brought in as a tool of reproduction of his films, we recognized the essence of its function as light projection and started to experiment with producing light objects and light spaces.

Moholy-Nagy's perception of sound came into account during the last stages of the design work for the exhibition when we decided not to play any of the sound tracks that came with his movies. These musical tracks were mostly applied to the films after his death, and we felt that, mixed into the space, they would interfere with the visual experience we hoped for. Rather we let the machines in the space pronounce their sounds. The humming of the projector's ventilators underscored by the rhythm of a slide projector was interrupted once in a while by the majestic mechanical noise of the *Light-Space Modulator*.

"The primary condition for such a work is laboratory experiments."[3] Although Moholy-Nagy is referring here to experiments with the phonograph, we understood the spirit of exploration and experimentation to be essential to all of his activities and took this as an invitation to dive open-minded into our own collaborative laboratory practice.

Realizing that we each had great respect for aspects of Moholy-Nagy's creative work, we were a little intimidated to make direct reference to the art he made in our preferred mediums. Instead we turned to his paintings and works on paper, which were less familiar to us. We were both particularly attracted to the tectonic qualities of images such as *A 18* (1927) and *Composition Z VIII* (1924). These are spatial compositions with intersecting geometric forms and planes depicted in varying degrees of transparency. We effectively read these works as blueprints for how we could activate the static, rectilinear space of the installation rooms for the *Learning Modern* show and the five interlinked galleries of *Moholy: An Education of the Senses*.

When working on both shows we sketched a lot in plan, literally drawing over and over the floor plans of the gallery spaces as we experimented in the studio. The archetypical plan view allowed us to imagine where we might locate video projectors and screens, how we would orient the throw of light, and how the viewer would navigate through the space and projects. Looking back at our sketches, we can see the influence of Moholy-Nagy's drawings on the experience we created in the galleries. The various projections and screens intersect the physical architecture, creating layers of surface, images, and light that the viewer moves through and between. The screens and projection elements are fabricated from common materials, including lightweight metal wall studs, sheets of clear acrylic, and semitranslucent paper. Some were materials that Moholy-Nagy used in his own works and experiments because of their accessibility or because of their novelty at that time. We chose these everyday materials as well as because they did not attract much attention in and of themselves and allowed the "effect" of their interaction with light to come to the fore.

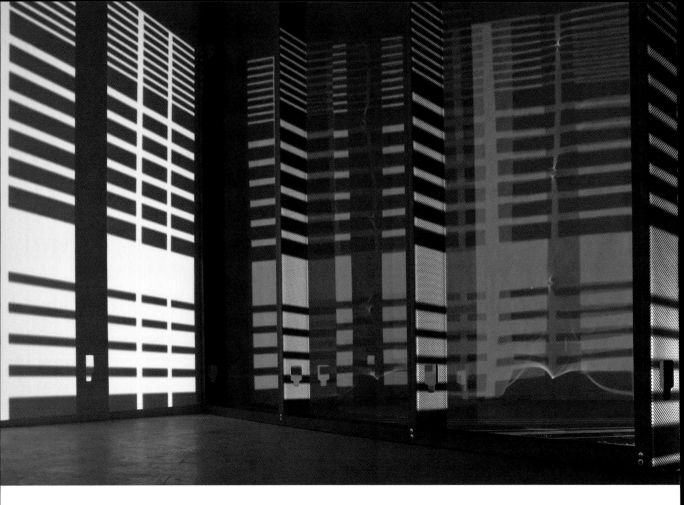

Helen Maria Nugent and Jan Tichy, *Delineations* (detail), 2009. Installation view. Photo: Jan Tichy.

With spatial installations in mind, the concept of orientation became significant. Moholy-Nagy explored new ways to experience light and space, as well as to understand the possibilities of movement in it. His stage and exhibition designs were always dynamic, and we tried to evoke that in the movement through our spaces.

The most dynamic places to experience Moholy-Nagy's spatial vision are his films. When watching his films one can literally experience the world as he saw it. Through our exhibition design, we aimed to create an environment where the viewer could tag along with the artist on his journey from representation to abstraction and back again. We positioned the *Light-Space Modulator* alone in the fourth gallery and illuminated it with a single spotlight to intensify the quality of the reflected light and to cast shadow.

To heighten (and potentially educate) the senses of the viewer, we created an orchestrated experience of animated light and shadow, pulling the audience through the space by allowing glimpses of activity, stillness, or unexpected color in the gallery just beyond. Tracing the path of the exhibition, the visitor began in a gallery of faces projected and presented on all planes and from all perspectives. Then came an immersive environment of projected abstraction, followed by a room containing a still, yet rhythmic, arrangement of printed compositions from Moholy-Nagy's *Constructions: Kestner Portfolio 6* (1923).

From within these prints the viewer can sense the motion of the *Light-Space Modulator* in the next gallery. The last gallery, filled with works in multiple media created in Chicago during his last years, invited the viewer into a space of vivid color.

• • •

Various fields of art production require different levels of collaboration. In *Do Not Disturb* (1945), Moholy-Nagy's last film and a product of an educational collaboration with his students at the Institute of Design, the studio photography set is not just a location. It is the light laboratory where the artists experimented together and explored new effects of light and color. It is a place that allowed an exchange of creative ideas. In *Berlin Still life* (1931), one of his first films, Moholy-Nagy explores the city of Berlin from new perspectives—creating both visual and social point of view. He shoots from above, but it is not a disconnected, omnipotent, and generalizing point of view. Instead the film takes us from above, all the way down to the city, to people and the texture of the sidewalk. When we were looking for a vertical projection solution for this film that could underscore this perspective, the concept of the photography studio, with its paper backdrops, came to mind. We were working already with paper as a projection surface and realized that such backdrops would allow us to combine vertical and horizontal projection in one installation and so to connect between *Berlin Still life* and *Impressions of Marseille's Old Port* (1929).

As practicing artists we were concerned with the spatial and conceptual changes we were proposing to impose on Moholy-Nagy's work. Could we project *Berlin Still life* (1931) onto the floor? Could we edit out parts of *A Lightplay black white gray* (1930) and show them as separate projections. Could we allow the viewer to experience the color slides in *Untitled (Color Light Show)* (1937–1946) from both sides of the screen, such that some would see them flipped? These were moments of true dialogue with Moholy-Nagy, the answers coming from our deepening understanding of his practice. He was always interested in a new, up-to-date point of view and aware of changes in perception over time, and he was always ready to experiment. We wanted to update the perception of space and image in today's gallery, remembering that he did too, when working on a never-executed proposal for the Hanover Museum in 1933.

And we were glad there were two of us on this side of the discussion. Our collaboration, based on a strong mutual respect, offered more than another set of eyes and a sharing of responsibility. Moholy-Nagy moved fluidly between the disciplines of art and design; our reenactment of this aspect of his practice allowed us to be both problem solvers and creators. By including Moholy-Nagy in our conversation, instead of discussing him, we were able to create a contemporary experience rather than a historical archive.

Notes

1. John Amos Comenius (1592-1670), author of *Orbis Sensualium Pictus* (1658) and *Schola Ludus* (1630), is often considered the father of modern education.

2. László Moholy-Nagy, "Production-Reproduction: Potentialities of the Phonograph," in *Audio Culture: Readings in Modern Music*, eds. Christoph Cox and Daniel Warner (New York: Continuum, 2004), 331–332.

3. Ibid., 332.

Mies as Transparent Viewing Cabinet for Pancho's Crazy Façade

ÂNGELA FERREIRA

By the time I started working on *Crown Hall/Dragon House*, I had already spent some time dwelling on the modernist phenomenon, particularly on modernist architecture in Africa. A constant factor in these thoughts was the lack of a single approach that could explain, condemn, or celebrate the larger modernist architectural phenomenon that had spread almost worldwide and included Africa. At first, the fact that the issue was not simple was a great source of frustration. Later the complexity proved to be a field of richness and served as a metaphoric parable for a larger understanding of the Africa that I am trying to fathom: the Africa that has struggled to create healthy economic and democratic societies; the continent with countries that remain painfully underdeveloped or devastatingly corrupt and poor; the unending prejudice and disrespect that prevails in the West's relationship with Africa. So the possibility of studying the origins of the modernist movement was too tempting to ignore. The difficulty for me lay in how to make it artistically meaningful and politically pertinent.

Most of my initial thoughts centered on questioning modernism's exportability. I wondered how it appeared in Africa, whether architectural modernism could make any sense in such disparate locations as India, Brazil, Mozambique, and the United States. I have never been able to shake the uncomfortable feeling that this imposition of "style" is at once inappropriate to African needs and context and yet one of the most marked and interesting features of some contemporary African cities. The way modernism was appropriated by the colonial project and imposed on several countries was to me obviously offensive. I also suspected that the high-minded principles of early modernist thought (even Team 10!) were rather too easily co-opted by autocratic political ideologies.[1] And for me this was a great sign of weakness. For many years I looked for the "fascist" side of modernism—its unquestioning belief, sustained without consulting anybody, that it was good for everybody—as a problem to identify and condemn. This sense

Ângela Ferreira, *Crown Hall/ Dragon House* (detail), 2009. Installation view, in *Learning Modern*, Sullivan Galleries, School of the Art Institute of Chicago. Photo: James Prinz.

of ambivalence has prevailed. The utopian project of modernism reveals some shocking failures. No doubt internationalization has physically taken place, as one can't question that the buildings exist, but modernism's principles do not flourish and multiply with equal success and its architectural manifestations are not equally useful or admired by all societies. The other unique factor is that there seems to be a right and a wrong time for modernist architecture; sometimes derelict buildings may be "rediscovered" and become flourishing museological and commercial examples (this was explored in my project *Maison Tropicale*, 2007).

Unable to settle for outright condemnation, I was compelled to look further. I began to see buildings as a key to the complex trail of history and as containers that permitted further thinking about the end of colonial power and the early years of independence. I had learned from other artists, like photographer David Goldblatt, that one could interpret buildings, and so I developed my own way of reading them. I began by looking at older Portuguese fortifications along the coast of Africa that point to the history of the Portuguese sailors and serve as memory containers for the history of the slave trade. I went on to look at modernist architecture in Africa that tells us parts of the more recent history. I was driven by a desire to push beyond the initial, if still dauntingly valid, inclination to blame slavery and colonialism for the prevailing problems. So, for example, more recently, while investigating a Cape Town shopping mall, Werdmuller Centre, I studied modernism as a possible model for South Africa. I found that although produced with apparent democratic intent, the building failed during apartheid, as it does now in the new free South Africa. One cannot help but continue to wonder about the validity of the modernist proposal? My intuition is that the buildings can be seen as thinking models or prototypes that may help us understand contemporary society.

Shortly after being invited to participate in the *Learning Modern* project, I decided to work with Mies van der Rohe's Crown Hall in Chicago. I chose it because it was the paradigmatic building in the early establishment of Mies's own architectural discourse and therefore played a role in the formation of the mainstream modernist narrative. I set to work with the spirit of a learner. I began by accepting that Mies's buildings would have much that I could learn from. In the back of my mind I also knew that I could never do a work based solely on one of Mies's buildings or on his oeuvre alone. His relevance for me was based on the widespread acceptance of the part he played as a modernist discourse maker and, inevitably, as a reference for the architects who had designed the buildings that held my curiosity. The buildings that I loved were clearly not part of the mainstream modernist discourse. They were strange and eccentric peripheral manifestations. They were mostly the buildings I had lived with throughout my life in Africa and whose formal language I was familiar with: the many works by Pancho Guedes in Maputo, which include the famous Smiling Lion and Dragon House apartment buildings; Gawie Fagan's own house, Die Es in Cape Town; and the Werdmuller Centre by Roelof Uytenbogaardt.

I was acutely aware that I had learned the principles of modernism (art and architec-

ture) by looking at these buildings, as well as through a panoply of slide images of other buildings in different parts of the world. I had even contemplated the possibility that my view of modernism was warped because my introduction to it had not come from *the* source. After all, I had been "underprivileged" and only experienced pure modernism very late in life! Although now I see this apparent disadvantage as the trigger that pushed me to a critical analysis, at the time it drove me on in an attempt to make sense of my ideologically incoherent fear. I had learned to recognize formal traits in buildings. The fundamental structure of the buildings I liked were mostly rooted in a modernist form but also exhibited the most amazing formal deviations, by way of which African architects attempted in various ways to integrate their work into the land and social fabric of Africa. Most of these architects had started working in the colonial time, and their buildings lived through the most amazing political changes and upheavals. I was interested in how these modernist buildings exhibited such changes. Going to study Mies was accepting a part of the origins of a movement, as well as a personal strategy to try to understand it.

I started my study of Crown Hall like studying the enemy—with a half measure of respect and mistrust. I assumed that understanding Crown Hall would help me decipher some modernist codes and, therefore, serve as a key to understanding some of the architecture in Africa. And in many ways it did. So let me take you through an example of my quasi-comparative initial thought process.

• • •

I already had these two images present in my work space. I paired them off, deciding that Pancho Guedes's work should be brought into this project at the time I attended a talk by Salah Hassan at the Maumaus School of Visual Arts in Lisbon.[2] This talk on comparative modernisms proved to be an important factor in shifting my critical discourse. I was ready to learn my lesson here for two reasons. First, Maumaus was my milieu in Lisbon and was part of my own discursive context. Second, Hassan, as a fellow African analyzing the political future of historical buildings on the continent, had previously engaged in a dialogue with me about *Maison Tropicale*. So, with like-minded people and common preoccupations, I was ready to learn to acknowledge the axiomatic but simple fact that there are many modernisms rather than one, that modernism resulted in a complex network of manifestations of varying degrees and interpretations. This comparative approach was the key to deciphering the images I was focused on, the reading of Mies's Crown Hall and Guedes's Dragon House, and the starting point of my sculpture project.

I had perceived the original mainstream modernist narrative as monolithic and belonging to faraway places. In my initial uncritical and naive approach, I had surrendered to this rule. And I had been trying to read architectural modernism in Africa through that monolithic canon. I had been falling into modernism's trap of autocratic thought, of accepting that there was only one main discourse. Even worse, I had accepted that there was only one *correct* discourse. And now, obviously, because this was an erroneous assumption, I found myself unable to untangle the aesthetic and conceptual

Ludwig Mies van der Rohe
with model of S. R. Crown Hall,
1954. Courtesy of the Chicago
History Museum. Photo:
Arthur Siegel.

knots that presented themselves when I looked at Mies's oeuvre next to Guedes's. I was just using the wrong critical tools.

With this refreshed approach, I started to unpack the images, which presented symbolic evidence of two diametrically opposed manifestations of modernist thought. Both portraits of architects: Ludwig Mies van der Rohe, photographed with his model of Crown Hall, and Pancho Guedes, photographed in his studio in Polana, Lourenço Marques (now Maputo), in Mozambique in the 1950s. In the photo of Mies we see the domineering male, a single figure, proudly towering over the maquette of his pièce de résistance. The image is all about power, male pride, egocentric confidence, authorial space. The architect is larger than the building, and the latter functions as a balustrade for him to lean on. The building's most important factor—its lightweight structure, which enfolds the most

Pancho Guedes in his studio,
Polana, Lourenço Marques,
Mozambique, ca. 1950.
Courtesy of Pancho Guedes
and David Crofoot.

transparent and luminous of spaces—is shown off fairly well, but only if the viewer knows what to look for. The portrait is about Mies the man. It bears no connection to context, no Chicago, no IIT. It could be anywhere in the world.

The second image is quite different. The architect chose to be portrayed in his studio. His own studio space is a modernist one, showing off his visual and architectural language too. But Pancho Guedes (the bald man seated on the left, behind the woman), chooses to present himself as part of a community. A surprisingly multiracial community too, if we consider this is Mozambique before the end of colonial rule. His role is unclear, probably intentionally so, but it is certainly not a central, omnipotent role. He has included his wife, his children, his collaborator and artist-friend Malangatana Valente, which further emphasizes his position within a complex society. It speaks of

his wish to share credit and authorship. In the foreground of the image there is no building but rather a sculpture, possibly alluding to Pancho's wish to present architecture as an art form. It is well known that he saw himself as a multidisciplinary artist.

Having devised a point of view through my appraisal of the portraits helped me tackle the conceptual challenge of the work. I was able to understand that *my* modernism was not what Mies had presented as *the* modernism. The whole concept of modernism needed to be revised. I needed to look at different modernisms side by side. Sculpturally I needed to look at them all through a new lens of equality. So the idea was born of making a sculpture that would be the visual rendering of the idea of looking at different modernisms together and simultaneously.

The early stages of the thinking behind the sculpture *Crown Hall/Dragon House* were fully occupied by the structural analysis of Mies's discoveries of how to build a large, free space inside a building. This was done through a series of photographs that showed the implanting of the structure on the site by a system of cranes. (The modernist/minimalist, Serra-like sculptural references were very alluring.) This caption set this process of investigation and sculptural design in motion:

> One of Mies van der Rohe's last buildings erected on the Illinois Institute of Technology campus is Crown Hall, a superb example of his clear span designs. The roof is suspended from the underside of four steel plate girders which in turn are carried by eight exterior steel columns. These columns are spaced 60 feet apart with the roof cantilevered 20 feet at each end…. Crown Hall, in which architecture, city planning, and design are taught, has a symmetrical plan about its short axis.[3]

I was immediately taken by the hierarchical role played by the four arched beams in devising the system of Mies's discovery. I was also taken by the evocative idea of hanging a space from a structure. I particularly liked the double-hanging system shown in the photographs and facilitated by the cranes that put the four arched beams in position. I knew that these would be the crucial part of my sculpture too, so I played with them by distorting and enlarging and trying to move them around. I finally observed that I could metaphorically "hang" Mies's idea on the same principle that he had proposed, by creating four more arched beams, inverting them, and forming a system of hooks to hang the sculpture from the ceiling. Ironic. By hanging the structure upside down, I could use Mies's own trick on him. By taking the hanging principle and turning it back on itself, I intended to create a sculptural rendering of Crown Hall in the Sullivan Galleries, thereby activating the exhibition space— itself an important architectural landmark in Chicago.

I realized I could create a large "open space," a transparent viewing cabinet. I imagined that this second level or plane would be based on Pancho Guedes's façade on the Maputo apartment building I so admire—Dragon House—rendered like the surface of a precious and delicate lace doily, light and fragile, waiting to be preserved and looked after. Looking through a sheet of transparent Plexiglas in Pancho's favorite

color, orange, I could bring new focus to this other masterpiece of modernism. Looking through one structure to see the other, the two buildings are distinct yet here share a space and time.

Notes

1. Team 10 was a group of architects and others at the 1953 Congrès International d'Architecture Moderne whose dissenting views led to a schism within the organization over the approach to urbanism. Through their teaching and publications, they had an impact on the architectural thought in the latter twentieth century, primarily in Europe.
2. Salah M. Hassan, "Contemporary 'Islamic': Art and the Global War on Terror," lecture at Maumaus School of Visual Arts, Lisbon, May 15, 2009. Published as Hassan, "Contemporary 'Islamic' Art: Western Curatorial Politics of Representation in Post 9/11," in *The Future of Tradition/The Tradition of Future: 100 Years after the Exhibition "Masterpieces of Muhammadan Art" in Munich* (Munich: Hausa de Kent, 2010).
3. A. James Speyer, *Mies van der Rohe* (Chicago: Art Institute of Chicago, 1968), 73.

Bioline: Activating the Mundane

WALTER HOOD

On arrival at the School of the Art Institute of Chicago's Sullivan Galleries, visitors encounter a highly polished, galvanized-metal air duct overhead. Four meters wide, the duct levitates through the space, leading the eye through an open-column grid and then outward into the city view. Recently restored, the building has undergone architectural and mechanical changes to accommodate its new occupants. The original design for Louis Sullivan's Schlesinger and Mayer department store (begun 1899) called for a new approach: "Instead of a stack of undifferentiated office rooms, the department store required broad horizontal open spaces where goods could be displayed."[1] The horizontal open space with its column grid, absence of walls, and Sullivan's large-pane windows deconstructs the hermetic, allowing the surrounding city to merge with this interior condition. Light, reflection, and the adjacent skyline together create an enmeshed experience of the city and gallery, "one where foreground, middle and background merge together."[2]

Bioline was a gallery installation for the exhibition *Learning Modern*. Inspired by environmental performance, it objectifies a mundane piece of architectural infrastructure, sampling its scale, material, and performance, resulting in a hybrid condition in the gallery environment. The dissimilarity between the gallery's forced-air vent and *Bioline* produced a symbiotic effect, greater than that of the individual pieces. Within this context, *Bioline*'s machined aesthetic, hand-sewn recycled bags, and epiphytes— plants that can grow without soil—serve as commentary on modernism's earlier tenets, wherein machine, craft, and nature were inspirations for art and architectural pedagogy.

In its first manifestation, in 2007, I explored *Bioline* as a potential landscape design for a five-acre office park adjacent to the San Francisco Bay. I was fascinated

with the possibility of creating a biological sculpture at a one-to-one scale with the environment it would inhabit. Could I objectify the infrastructural landscape, recruiting it to a new purpose: catching rainfall and cleaning gray water, which would pass through a verdant filtration system that inhabited the buildings' ramps and overhangs and the perimeter of the parcel? The "bioline" concept emerged from this interest in the objectification of landscape form—particularly the infrastructural techniques used to catch, clean, and distribute water, such as bioswales, storm drains, perforated pipes, and green roofs.

So upon entering the Sullivan Galleries I was immediately drawn to the building's interior infrastructure—the mechanical forced-air vent. This venting, its material and function, is a closed system. Standing there I could actually imagine the air moving inside this galvanized tube. Sculpturally, its form and scale produced a visual effect in the gallery space, reflecting light from interior spotlights as well as the natural light from the city outside. Would it be possible to merge environmental process with a purely physical, mechanized object? I found this question particularly interesting in a space that afforded a strong physical and environmental spatial experience, one that enmeshed gallery and city.

The Mundane

The environment around us is host to dormant sculptures, bound to their context by clear and definable means. To see them clearly, we must disregard their normative function and see their material possibility. The hermetic characteristic of modern architecture in relation to site miniaturizes our experience of the natural environment. Yes, there are early exceptions, but contemporarily two predicaments arise. First, buildings are autonomous in their setting, and second, human relationships to the natural environment are hierarchical. We consider ourselves first and foremost when building in most settings, relegating the natural environmental systems around us to a secondary position. The possibility exists for objects around us to be multiplicitous—part of the natural and built world simultaneously—giving expression to the abstract and the mundane. This is the context for the creation of the concept "bioline": a set of ideas that attempt to create a one-to-one relationship between the natural environment and the built world. More importantly, this work attempts to objectify material things that embody and express abstract ideas and principles about space and technology, but have become ordinary and commonplace objects in the environment around us.

The synonym of objectify, reify, is especially useful in understanding this transformation or reinterpretation of the functional and spatial environment that we live in. Reify suggests the simple idea of making something that may seem abstract into something particular and specific. It suggests actualizing, as in making the thing become a place or anchoring the object to its situation. Scale becomes particularly important when we seek to engage a larger and broader environmental context. The large-scale landscape,

with its mundane and not-interesting material, can become a process or event that we pay attention to, appreciating its nuances and alterations. Sculptor Carl Andre in his 1970 essay "Sculpture Is a Road" liberates the mundane and utilitarian built infra-structural landscape by stating, "All my works have implied to some degree or another, a spectator moving around them."[3] Objects bound to their immediate context can be set free such that we can experience moving around them, can experience all sides. A road-way, streets, curbs, and walks can all be set free. By simply revealing its edges and thickness, a sidewalk springs forth a line! In the natural world, too, the objectification of landforms and flora in the public realm can give rise to new meanings; the objectifying of stone and water has long existed in garden art, but not in the day-to-day landscape. A road in the desert, objectified, may give expression to the material of the road, while simultaneously elucidating the horizontality of the landscape surface.

As people enter the Sullivan Galleries, many overlook the forced-air vent. The over-

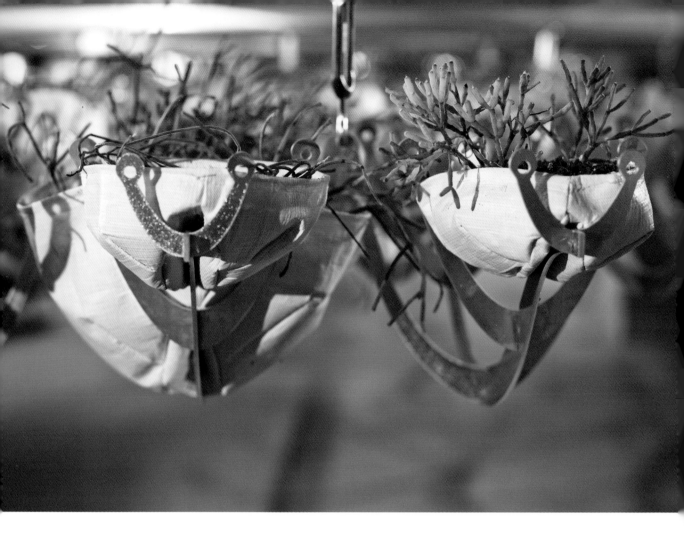

Walter Hood, *Bioline* (detail), 2009. Installation view. Photo: Jill Frank.

head network of shiny material is familiar, common to in most buildings. It is sculpture, something we can move under and about, and its scale connects the immediate environment. The *Bioline* installation is an attempt to free the vent from its mundane circumstance, activating this shiny material to create an event and an open, environmental process.

Sample and Sampling

Photographer and landscape author Anne Spirn writes in the *Language of Landscape* "that it is easier to copy or adapt an existing pattern than to invent a new one, but one learns from copying."[4] Spirn advocates copying in order to understand and make a self-producing landscape. This is significant when we are working within a dynamic environmental context. More importantly, when something clear and familiar is copied within the

natural environment and new layers of meaning are physically added while still keeping the familiar, its performative nature remains intact. If copying can allow us to make self-producing landscapes, then how can these ideas merge with physical objects set within dynamic environments?

In the first manifestation of *Bioline*, as a five-acre landscape design, a method emerged in the process of design to connect the site and building with the larger landscape environment of the San Francisco Bay. Five-acre samples from the bay marsh were selected and assessed to determine their scale and formal logic, which would then be applied to a new context. The collection of "samples" here served to give physical structure, form, and scale to a natural process of capturing, filtering, and draining water, connecting the subsequent physical intervention with a natural process. *Bioline* thus utilized a familiar formal and natural pattern, yet created something completely new. Likewise, in the sampling of sounds or music—from the early synthesized beats to the overly commercialized and commoditized music of Jay-Z, Common, Kanye West, et al.—the sampled beats and music provide a context, an element of familiarity, both a structure and a backdrop for contemporary artists to connect to old and familiar themes. I am interested in this aspect of the sample and sampling. Is it possible to bring forward environmental and physical forms so that their content and meaning remain intact and can mix with a new context?

More generally, does the possibility exist to bring along the old and familiar, whether natural or fabricated, through copying and transference effected through the act of sampling? This is counter to the use of precedent in design, particularly environmental design, where previous designs are reviewed and sometimes copied for their similarity to a given work or project. In many cases precedent studies are used without a clear method for the transference of information or knowledge.

In the Sullivan Galleries version of *Bioline*, the forced-air mechanical system became the subject to sample: its form, scale, material, and performance. Mechanical forced-air systems are used to control indoor air quality. They can remove excess humidity, odors, and contaminants. The air quality is controlled by means of dilution and replacement with outdoor air. So in sampling the mechanical venting system, its material, scale, and performance became the basic structural and formal logic. *Bioline* suggests that the complexity of "cleaning" air and water within the building can be objectified as a component of the existing mundane venting system and could become an event, brought to life, as performative infrastructure. Sampling the building's reflective ductwork, a new armature and infrastructure emerges to support plant life, a new reflective aluminum structure that, instead of being enclosed, is open visually. *Bioline* literally morphs. Small pods of planting are held under the shiny mechanical vent, tracing the circulation of air through the building's seventh floor, the Sullivan Galleries. The sculpture is a verdant line that measures and mitigates high levels of carbon dioxide and volatile organic compounds. Formal issues and symbolism emerge as the line engages lighting, sound, planting, and the gallery environment.

The Hybrid Landscape

Returning home to the San Francisco Bay Area by airplane, I look out the window as we land and am always struck by the red, yellow, and green lining the edge of the bay. These small, colorful salt ponds, contained by dikes, seem different and strange. But they also seem to belong to the bay. Contemporary environmental historians would refer to these as hybrid landscapes: the merging of culture with nature to produce new, sometimes strange, environmental and built conditions. This view challenges the more rational and historical understanding that the salt ponds are separate from the clear and definable natural system of the bay, that the dichotomy between the subject and object, that is, city and wilderness, is clear and definable. My visual experience of the bay landscape, along with the arguments of contemporary environmentalists, suggests that the constructed hybrid landscape is in people's perception, not in the original state. People may experience and perceive lake-stocked fisheries as an original setting and degraded lakes where fish are extinct as artificial. A pastoral setting such as San Francisco's Golden Gate Park may be experienced and perceived as original in comparison to the wind-blown sand dunes of nearby Ocean Beach. But it is the degraded and culturally altered landscapes that are closer to the original, not those that simply mimic or copy what we think was original.

Acknowledging and embracing the mundane and sampling its formal logic and performance can lead to a hybrid condition, as in the site for *Bioline*, to which the installation draws attention. The notion of similarity, not dissimilarity, elucidates the conceptual intent of the hybrid. What particularly interests me here, however, is dissimilarity. What is the linchpin that forces us to reconcile spatial and experiential relationships that are different? Hybrid spaces and objects exist around us, especially in places where cultural heterogeneity has shaped a diverse and, at times, conflicting set of cognitive readings of the environment. Of particular interest are the hybrids that arise through acculturation with place, as well as those that emerge from formal interventions. Culturally, we tend to describe typological hybrids through conjunctive nomenclature (plaza park, square park, car park, streetscape, light post, mail box) as a way of defining their function and normative rules. It is the hybrid nature of the salt ponds in the San Francisco Bay that reveals, not conceals, their true identity, thus transforming how we perceive and experience this constructed space. We do not have a name for its conjunctive beauty and function. In the sculptural arts, the opportunity exists to work within a context where there is a direct response between two dissimilar objects and spaces, one physical and the other environmental, that can give rise to something completely new, but strikingly familiar.

My interest in hybrid space and constructions, as presented in *Bioline*, is in exploring specifically how cultural and environmental issues can merge together in a constructed manner to create a new perception of space—one where type and function cease to be absolute. Akin to the San Francisco Bay salt ponds, *Bioline* looked strange and idiosyncratic in its setting, while concealing its performance and function within the scale and

logic of the forced-air venting system. Planting, water, and air commingled in one physical gesture. Visitors literally looked beyond the installation, taking in the rest of the show, not immediately noticing it overhead. As the crowds mingled in the gallery, people began to cluster underneath *Bioline*, activating the mundane venting system that lay dormant into an event space.

Notes

1. Leland M. Roth, *A Concise History of American Architecture* (New York: Harper & Row, 1979), 182–83.

2. Steven Holl, *Urbanisms: Working with Doubt* (New York: Princeton Architectural Press, 2009), 56.

3. Carl Andre, "Sculpture Is a Road" in *Cuts, Text 1959–2004*, ed. James Meyer (Cambridge, MA: MIT Press, 2005), 257.

4. Anne Spirn, *Language of Landscape* (New Haven, CT: Yale University Press, 2000), 196–97.

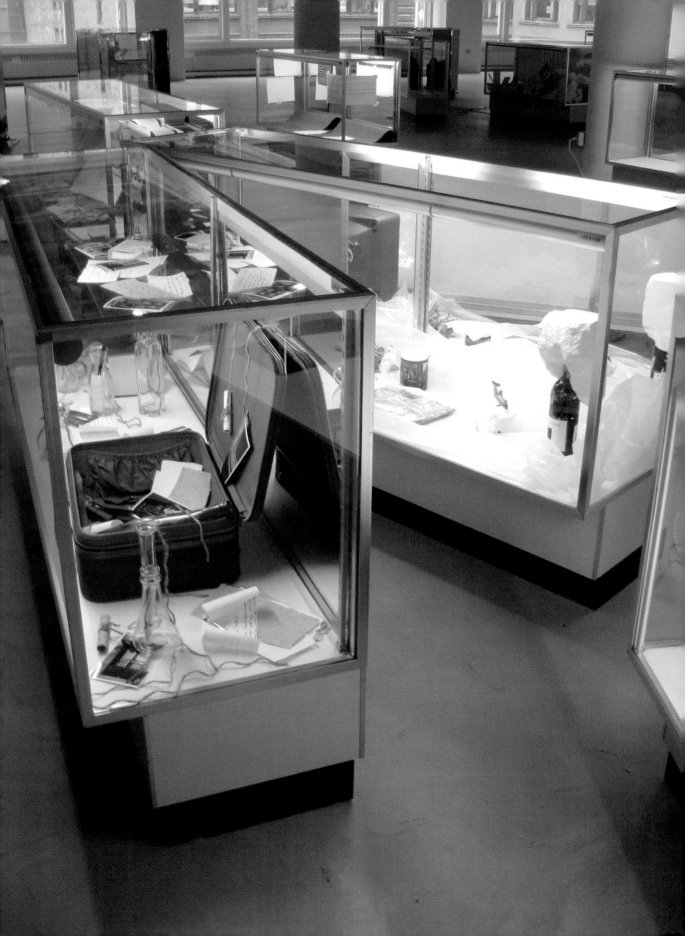

Minding

J. MORGAN PUETT

I live like a migrant worker—I go where there is work that allows for a responsive and democratic possibility. I do not make distinctions between art and life or their meanings, but I mind and care for their absolute, cyclical motion, the procession of all possible iterations. I gather the resemblances among the terms of biology, fashion, mathematics, architecture, physics, domesticity, psychology, business, nursing, fine art, and complexity theory in order to support a "smuggling-across-borders" migrant practice. Not to say that I am proficient in these areas, but simply encouraging new possibilities to incubate. I exist interstitially between disciplines. This affords me much freedom in seeking *new modes of being in the world*.

Being is my practice. This presents a social/political entanglement of relations to the environment, systems of labor, forms of dwelling, inventive domesticating, clothing apparatuses—all of which, together, constitute an ethics of comportment. Included in my migrant being is the fact that I am a single parent, a mother solving old problems and creating new ones. Within this domestically discursive interiority, my good instincts can construct the possibilities of change.

This leads me to Mildred's Lane, my home and my heart. Mildred's Lane is a wild site deep in the woods of rural northeastern Pennsylvania. Its creation and maintenance is an ongoing collaborative involvement with fellow artist Mark Dion, our son Grey Rabbit Puett, and our friends and colleagues: all coevolving pedagogical strategies and a rigorous engagement with every aspect of life. Mildred's Lane is both a generous working-living-researching environment and a new contemporary art complex(ity). The core philosophy is *workstyles*. This refers to any practitioner's autobiographical and experiential making-doing-thinking process that is intrarelational (an active *system-thinking*). Through a highly intuitive aestheticism of all things, I strive to understand how things influence each other

J. Morgan Puett, *Department (Store)*, 2008. Installation view, Sullivan Galleries, School of the Art Institute of Chicago.

J. Morgan Puett, *Department (Store)*, 2008. Installation view. Photo: Szu Han Ho.

within a whole. It is a process of cyclical thinking and doing, rather than linear cause and effect, origin and outcome.

All of my projects activate a turbulent multiplicity—from the early J. Morgan Puett, Inc. retail projects (1985–2001) to the current rhizomes of Mildred's Lane Projects, HumanU-factorY (an experiment in manufacturing-clothing-machining), and R21c (Retail Twenty-First Century). R21c is an ongoing think tank that convenes at Mildred's Lane every summer; it is a growing collective concern for the future of exchange; it is discursively encircling experimental forms of sociality. Global constructions of capital are evolving at an alarming pace, and everywhere new forms of subjectivity are emerging. The retail world is driven by forecasting systems that construct anticipatory thinking and trend prediction, thus fundamentally predetermining our lives and destroying any possibility for a coevolutionary and self-organizing future. My ongoing concern is this: what does this future actually look like? In seeking new arrangements of sociality, the experimental processes I seek are constantly being kneaded together. They are most transparent in the project *Department (Store)*.

Department (Store) took on this concern while dodging the ideological posturing of any singular discipline. In this project, I called myself an "Ambassador of Entanglement," putting aside questions of Art(ist)—high or low. It generated new questions of where to situate the space of praxis and action: in a storefront or a factory? a museum or home? In

such *workstylings*, one moves through and experiences transitions as they occur between spaces, not galleries, thus getting away from what we recognize as a tableau.

The quotidian is a launching point. I am interested in critical alternatives to what and how we produce and make things—do things—systemically and interpersonally, that retain both theoretically richness and a grounding in vernacular tactics of "getting by," "rearranging the furniture" for possible futures.

I try not to predetermine (a community), thus allowing *an emergent community*. Questions such as What will it look like? and What community will it speak to? can be counterproductive when seeking a collaborative, coevolving, and ultimately *shared* experience with learning "as you go" as a constant, generating collective research experience. People perceive projects by mingling and participating rather than merely ingesting didactics. Active listening (to the ambience of sewing machines whirring), smelling (oil or burnt wood), feeling (changes in temperature, music, and motion), and being involved are all proprioceptively omnipotent.

Department (Store) was an institution-wide project with the School of the Art Institute of Chicago. I was codirecting it with Mary Jane Jacob (curator/director) rather than being the *artist* (a term, ironically, that continues to get in the way of good complexity). Working collectively with the most generous SAIC department heads and professors, we issued an invitation to *play a game* within the school, in its historic Louis Sullivan building galleries at 33 South State Street. Though this game could be played in any city, with any institution, it was particularly poignant in Chicago, in this most architecturally famous of twentieth-century department stores—Sullivan's Carson Pirie Scott Building. The project was intended to evoke simmering curiosity about the question *What is really modern?*

We began by asking, What is important? What is the case you want to make? And how will you display it? *Department (Store)* was staffed with brilliant managers who operated the gaming system: Store Manager Rachel Moore; Supervisor of Interconnectivity Ellen Hartwell Alderman; Officer of Algorithms Szu Han Ho. As Ambassador of Entanglement, I was present too. The managers were vital to the flow and workstyles; each had an office and a custom-made uniform (constructed by the SAIC Fashion Department), complete with ID tags.

The entire seventh floor plan of the Sullivan building—at one time the department store's rug department—was raw and open, with large rectangular windows on two sides. We set up a Juddian (as in Donald) landscape: a vast grid of over 130 classic, horizontal glass department-store display cases. Countless participants, professors and their classes at SAIC and other institutions in the city, even persons off the street, all subscribed to play this thing, this game. They were presented with the opportunity to fill an assigned case with anything, as long as they responded to the questions posed.

These cases were repeatedly filled and emptied over the course of four months. But we wanted more, so we asked a series of questions of the building, taking into account time, temperature, history, timelines, cosmologies, and people. These human and nonhuman ingredients became the gaming algorithms, creating a perpetually calculated movement that caused each case to shift in direction at each lunar transition that intersected with

the show. These algorithms, or "Terms of Entanglement," playfully produced new problems rather than summing them up into static solutions. They created a possibility of *emergence* that reflected the complex and rich dialogue within the institution and among individuals, between *things and us*. They made way for a more constant and democratic sensing of things.

I use algorithms in all of my projects: in teaching, in making (clothing . . .), and even in cooking at Mildred's Lane. The game board for *Department (Store)* was the architectural plan of the building's seventh floor, sketched in graphite on the wall. The cases were drawn and erased as they were repositioned on the game board; each was represented by a bar code/number that identified the persons and things involved. Louis Sullivan's architectural ornament drawings were superimposed on the game board as directional guides for moving the cases. Everything was displayed, made transparent to the visitor—written in graphite on the white walls. We were constantly writing lists and more lists: daily managerial chores, jobs, people and their things. Participants listed the inventories of their cases, library lists of connected readings. Storage-area procedures, instructions, and documentation were also displayed on the walls. Lists grew everywhere, like mold.

Here, listing–mixing–flowing, processes, algorithms, people, and things activated a constant motion of the cases and their contents: in essence, a stop-frame experience from day to day, generating new arrangements of things and people throughout the duration of an academic semester. When the algorithms directed the cases to collide, another facet of the project emerged, a project-within-the-project. Each case collision produced trauma that caused the game to pause (in motion), and this, with tricky negotiations, ultimately unleashed the players into new cases. Players whose cases collided had until the next lunar phase shift to make contact with one another and discuss what was important between them (but first, they had to negotiate the time and place to have this conversation). So a collision called out to the players to actually deal with each other; it suggested that they collaborate with each other—that they share, exchange, or discover ways to create important connections, and then consider how this might be displayed. If there was any conflict (and there were many, to the point of downright unevolved childishness), the players could call upon me, the Ambassador of Entanglement. The office of the Ambassador was messy, full of things and more lists. A thing cosmology in itself, it functioned as a cross-referencing system, allowing the Ambassador to offer up another set of algorithms, freeing up collisions. Interestingly, these collisions were unannounced episodes, as most traumas are.

All the while, the interiors of the cases kept shifting, changing, filling by means of an elaborate management of things. Hundreds and hundreds of things and players erupted into an enormous amount of data and ephemera that we attempted to document (via film, journals, digital media, wall drawings). The sea of cases gradually slipped off-grid into chaos, into a magnificent self-organizing system, thus displaying emergent properties. In this eventful case/state, a strange phenomenon happened: while tracking the game on the wall, the case movements slowly fell into patterns imitating the building's terra-cotta ornamentation, crafted for Sullivan by sculptor Kristian Schneider. These pattern forma-

J. Morgan Puett, *Department (Store)*, 2008. Installation view. Photo: Szu Han Ho.

tions echoed a ghostly communication with history and with potentiality, dovetailing with this game of *thingness*.

For me, the managers, and the players this was wholly *moving*. Yet sadly, an unforgiving calendar shut the game down. So much detail evaporated in our current, overly forecasted, and determined modernity where our senses have gone dry. But in the end, the amorphous space of the institution proved fertile for producing new forms by recognizing and overcoming the constraints of critique, thus allowing us to migrate change openly and generously. Such workstylings and entanglements have no beginning and no end, only rotational constancy. These experiments pleat, fold, curve, sweep, and transform, all at the same time, forever becoming. All in all, I remain an ambassador and seeker of new modalities of exchange—toward hopeful modernity—intuiting new tropes of corporeal knowledge at every curve, coming round to a new beginning.

End Notes

NARELLE JUBELIN AND CARLA DUARTE

0. The first sentence of any novel should be: "Trust me, this will take some time but there is order here, very faint, very human. Meander if you want to get to town."[1]

These annotations follow the spatial layout of *Key Notes*, our collaborative work—composed of fourteen woolen panels hung in front of fourteen windows, on which were written texts tracing Bauhaus ideologies from Weimar to Chicago—created for the exhibition *Learning Modern*.

The window texts are pieced together here with reflective descriptions of the project and citations from authors whose thoughts assisted us with the work.

1. *Key Notes* took its inspiration from various sources. Daylight, exterior views, and the ornate framing of the Chicago windows and bullnose of this Louis Sullivan building (first the Schlesinger and Mayer department store, then Carson Pirie Scott department store, and now the School of the Art Institute of Chicago's Sullivan Galleries, where the exhibition took place).

As the eye sweeps over the upper elevation the filigree of ornamental motifs creates a flickering pattern of light and shadow along the decorative courses of the clay. Such lyricism of detail helps to intensify perception of rhythmic movement evident in a larger scale in the proportions of the steel bays.[2]

The city, however, does not tell its past, but contains it like the lines of a hand, written in the corners of the streets, the gratings of the windows, the banisters of the steps, the antenna of the lightning rods, the poles of the flags, every segment marked in turn with scratches, indentations, scrolls.[3]

Narelle Jubelin and Carla Duarte, Key Notes (detail), 2009. Installation view, in *Learning Modern*. Sullivan Galleries, School of the Art Institute of Chicago. Photo: Carla Duarte.

2. *Key Notes* took its inspiration from various sources. The opaque white handwriting on the central pane of each window transcribed the notes from Alain Findeli's essay "Moholy-Nagy's Design Pedagogy in Chicago (1937–46)," *Design Issues* 7, no. 1 (Fall 1990). The artists, curatorial staff, and students working on *Learning Modern* read this text as background for the exhibition. Notes from the essay used in this text are identified as "Findeli note."

Findeli note 2. Although the author believes that the current historiography of the Bauhaus is missing some important points central to its philosophy, the general history of this institution and the main features of its pedagogical principles are assumed to be known by the reader. Frank Whitford's *Bauhaus* (London: Thames and Hudson, 1984) and Gillian Naylor's *The Bauhaus Reassessed* (New York: Dutton, 1985) provide the reader of English with a reasonable general overview of this history. The history of the American Bauhaus, however (New Bauhaus, School of Design, Institute of Design), is still incomplete. The history of its founding is exhaustively related in Lloyd C. Engelbrecht's unpublished dissertation, *The Association of Arts and Industries: Background and Origins of the Bauhaus Movement in Chicago* (Chicago: University of Chicago, 1973), an abstract of which appeared in the catalog of the Centre George Pompidou's *László Moholy-Nagy* exhibition (Paris: CCI, 1976). The first complete monograph on the subject is the Bauhaus Archive's catalog of the anniversary exhibition, *50 Jahre new bauhaus* (Berlin: 1987). Sibyl Moholy-Nagy's biography of her husband provides a very lively, although very personal, general framework to this period, *Moholy-Nagy: Experiment in Totality* (Cambridge: MIT Press, 1950, second edition, 1969). Additional information is provided in chapter 1.2 of J. S. Allen's *The Romance of Commerce and Culture* (Chicago: The University of Chicago Press, 1983) and the general Chicago background is summarized by J. Fiske Mitarachi in "Dramatis Personae," *ID*. 5 (October 1956): 69-80. Finally, a comprehensive survey of its first ten years (1937-46) is to be found in book II of the author's *Du Bauhaus a Chicago: les annees d'enseignement de László Moholy-Nagy* (Paris: Universite de Paris VIII, 1989).

3. *Key Notes* took its inspiration from various sources. The methodological structure of the preliminary course in Chicago by Moholy-Nagy, 1937.

Findeli note 3. In this opening speech, Moholy-Nagy described the content and intentions of the course. Only fragments remain of this manuscript in the archives, but a good summary appeared as an article by Moholy-Nagy: "Why Bauhaus Education?," *Shelter* (March 1938), 7-21.

Memory as a place, as a building, as a sequence of columns, cornices, porticos. The body inside the mind. As if we were moving around in there, going from one place to the next, the sounds of our footsteps as we walk, moving from one place to the next.[4]

Thought moves to grasp tenuous links, holds them for a time and then lets them go to follow other threads; to hold on too tightly is to become entangled in knots, imprisoned in congealed thought, a kind of paralysis. If this is a partial description of culture and cultural processes, it can also serve as a description even of the way neural pathways work, and in both culture and thought, we can see how important it is for a fluidity to occur and to be maintained by the

renewal of links with sources—cultural, historical, physical—through which we move in and out of being human. This is survival.[5]

4. *Key Notes* took its inspiration from various sources. The first draft of New Bauhaus curriculum as drawn by Moholy-Nagy while crossing the Atlantic, August 1937. (Source: Hattula Moholy-Nagy collection.)

> Ideas have special itineraries. Concepts have biographies. Exhibitions are the outcome of particular journeys and conditions. Through ever-evolving circumstances in our intellectual, social and cultural engagements with each other, we maintain the puzzling endeavor to describe how we construct and experience the world, and through our picturing, to readjust or transform it.[6]

5. *Key Notes* took its inspiration from various sources. Fourteen wool panels, made in one-to-one scale to Sullivan's central windows. The window sizes vary as they follow along Madison Avenue and State Street. Each panel was composed of collaged woolen cloth of different colors, cumulatively cut, without waste, then staggered within each bay along the markedly horizontal span of this modern building.

> . . . a disposition of unequal glass areas to the left and to the right, in oppositional dynamic balance.[7]

> Findeli note 5. Herbert Read, *Education Through Art* (London: Faber & Faber, 1943), *passim*.

6. *Key Notes* took its inspiration from various sources.

> Keynotes is a musical term; it is the note that identifies the key or tonality of a particular composition. It is the anchor or fundamental tone and although the material may modualte around it, often obscuring its importance, it is in reference to this point that everything else takes on its special meaning. Keynote sounds do not have to be listened to consciously; they are overheard but cannot be overlooked, for keynote sounds become listening habits in spite of themselves.[8]

> Findeli note 6. See, for example, Mark Gelernter, "Reconciling Lectures and Studio," *Journal of Architectural Education* 41/2 (Winter 1988): 46-52.

7. *Key Notes* took its inspiration from various sources. The red-yellow-blue colorway was an excerpt from the De Maistre Colour Harmonizing Chart (1924), published by Grace Bros. Department Store, Sydney. The panels ran outward along the two façades from the bullnose which, at the same time, formed the center of the superimposed color wheel to reflect early modernist experiments in "color music" and spatial abstraction.

> The basic wheel was formed by the addition of an 'impure' red-violet and the 'accidental' G sharp in the twelfth segment. De Maistre's next task was to insert the remaining four black notes. C sharp, for example, was placed in a segment of yellow-green colour, between C at yellow and

D at green. In this way, a graduated colour wheel was built up to represent the twelve notes of music. . . . Travelling round and round the wheel mimicked the cycle of musical octaves (from A' to A and so on up the scale), all the while accompanied by a smooth flow of changing colour.[9]

8. *Key Notes* took its inspiration from various sources.

Repetition is heard not just from one element to another, but the compositional principle of repetition emerges from behind the scenes into perception.[10]

The thing is born in time as well as space. It inscribes a specific duration and concrete boundaries within the broad outline of temporal succession or flow and spatial mapping. It emerges out of and as substance. It is the coming-into-existence of a prior substance or thing, in a new time, producing beneath its process of production a new space and a coherent entity.[11]

Findeli note 9. Moholy-Nagy, *Vision in Motion*, 26.

Findeli note 10. László Moholy-Nagy, *The New Vision* (New York: Brewer, Warren & Putnam, Inc., 1930), 13.

9. *Key Notes* took its inspiration from various sources. The fourteen suspended woolen panels took their cue from transparent curtain walls and floating panels employed in several exhibition design collaborations between modernists Mies van der Rohe and Lilly Reich prior to his leaving Germany for Chicago in 1938 to head up the architecture department at the Armour Institute, a predecessor of the Illinois Institute of Technology.

Findeli note 12. The Photo and Film workshop was also headed by Moholy-Nagy, with the assistance of James Brown, Robert Delson, Bob Graham, Eugene Idaka, William Keck, Nathan Lerner, Frank Levstik, Frank Sokolik, Edward Rinker, and Leonard Nederkorn. Its esthetical and technological principles derive widely from Moholy-Nagy's numerous publications on this subject. The Graphic Design workshop became the *oeuvre* of György Kepes, Moholy-Nagy's fellow Hungarian, associate, and close friend. Its basics are to be found in Kepes's still essential book, *Language of Vision* (Chicago: Paul Theobald, 1944) where Charles Morris's largely commented semiotical model is clearly apparent. The Architecture workshop was headed by George Fred Keck, followed by Ralph Rapson, assisted by Robert B. Tague and Jan Reiner. Its main concerns were industrialization and public housing, but, due to the war conditions, it never functioned at full capacity.

10. *Key Notes* took its inspiration from various sources. During the course of each day the window transcriptions projected across the floor and onto the Miesian panels as daylight passed along the façade and entered the interior. The fugitive projection of one discourse onto another, and text to the cloth, momentarily destabilized the philosophical breach

that existed between the two former American Bauhaus heads, Moholy-Nagy and Mies, and beautifully belied any simplistic reading of modernist heritage.

> Findeli note 15. See Moholy-Nagy's declaration and imaginary interview in Krisztina Passuth, *Moholy-Nagy* (Paris: Flammarion, 1984), 395–98.

> What's so political about chiffon?[12]

> . . . objects which now contain the whole intense energy of the carefully composed links and connectons between personal stories and global events, experiences and thoughts, so that they become almost flash points in a volatile architecture of interactivity.[13]

11. *Key Notes* took its inspiration from various sources. The nineteenth-century Germany poet Johann Wolfgang von Goethe organized the color wheel based on his theory that the perception of color is dependent on experience.

> Findeli note 21. Goethe's endeavors were despised and ignored by the scientific community of his time. Recalling one contemporary anatomist, he writes: "This remarkable man did not realize however that there is seeing and seeing, that the spiritual eyes had to work in constant and vivid alliance with the bodily eyes, otherwise one is faced with the danger of seeing and yet of seeing nothing," Goethe, *La métamorphose des plantes* (Paris: Triades, 1975), 171.

> Findeli note 22. The best interpreter of Goethe's philosophy and epistemology in the twentieth century was Rudolf Steiner (1861–1924). The pedagogic principles he developed for his Waldorf Schools seem to be most pertinent to our technological era. Although Steiner only visited the Bauhaus once for a lecture, there is a considerable affinity between the Waldorf and the Bauhaus pedagogies. Steiner's architectural work, on the other hand, usually classified as expressionist, is more exactly described by the Wrightian designation of *organic*, which bears the same meaning in the present essay. Most of the books of Moholy-Nagy's personal library have been lost or given to the Institute of Design. Very few remained in his private collection; among them: Goethe's *Farbenlehre*, considerably annotated.

> It's funny how the colours of the real world only seem really real when you viddy them on the screen.[14]

12. *Key Notes* took its inspiration from various sources.

> Findeli note 24. John Dewey, "The Psychology of Occupations," in *The School and Society* (Chicago: The University of Chicago Press, 1900, reprinted 1956), 132–33.

> Findeli note 25. For a more elaborate discussion of this aspect, see the author's "László Moholy--Nagy: Alchemist of Transparency," *The Structurist* 27/28 (1987/88): 4–11, and "László Moholy-

-Nagy, alchimiste de la transparence," in *Du Bauhaus à Chicago*, book I, 230-72.

> Where criticism explicates, opening out the folds of the writing in order to arrive at the meaning.
> . . . [*Key Notes*] is offered as a permanent interplication, a work of folding and unfolding in which
> every element becomes always the fold of another in a series that knows no point of rest.[15]

13. *Key Notes* took its inspiration from various sources. During the course of *Learning Modern*, the Sullivan Galleries, a teaching gallery, was concurrently temporary exhibition space, classroom, lecture hall, and project room. *Key Notes* needed to be an open text amid constant dialogue and flux—a work that embraced the possibilities of conversation with the shifting (neighboring) work and within the unique contingencies of the (host) building itself.

> Findeli note 6. See, for example, Mark Gelernter, "Reconciling Lectures and Studio," *Journal of
> Architectural Education* 41/2 (Winter 1988): 46-52.

> Findeli note 19. Kepes, *Language of Vision*.

14. *Key Notes* took its inspiration from various sources.

> In story cycles, narrative elements return, though changed slightly, and patterns recur so that
> memory is enhanced or stimulated and through this process culture passes from one nomad to
> another along paths of migration. We thought we were settled, but now all is movement again
> in the impermanence of things as virtual and real networks intersect each other like intricate
> weavings. Connections are made and broken, reestablished and dissolved.[16]

> Findeli note 28. For these questions, see for instance *Modernes et après: les immateriaux* (Paris:
> ed. Autrement, 1985) and also *Design Issues* IV, nos. 1 & 2 (Fall 1988), special issue: "Designing
> the Immaterial Society."

> Findeli note 29. Moholy-Nagy, *Vision in Motion*, 55.

> Findeli note 30. Ibid., 56.

> This walk shall be my book, and every step is a page.[17]

Notes

1. Michael Ondaatje, *In the Skin of a Lion* (Toronto: McClelland and Stewart, 1987), 146.
2. Joseph Siry, *Carson Pirie Scott: Louis Sullivan and the Chicago Department Store* (Chicago: University of Chicago Press, 1988), 230.
3. Italo Calvino, *Invisible Cities* (New York: Harcourt Brace and Company, 1974), 11.
4. Paul Auster, *The Invention of Solitude* (London: Faber & Faber, 1992), 82.

5. Helen Grace, "The Presence of Black," in *Narelle Jubelin: Ungrammatical Landscape* (Granada, Spain: Centro José Guerrero, 2006), 139.

6. Bernice Murphy, "Exhibition as Cultural Project: Theoretical Background," in *Localities of Desire: Contemporary Art in an International World* (Sydney: Museum of Contemporary Art, 1994), 40.

7. Harry Seidler, "Interactions between Art and Architecture," lecture at the University of New South Wales, 1980; see Ann Stephen, "Face-to-Face," in *Narelle Jubelin: Cannibal Tours* (Melbourne: Heide Museum of Modern Art, 2009), 18.

8. R. Murray Schafer, *The Soundscape: Our Sonic Environment and the Tuning of the World* (New York: Knopf, 1994), 9.

9. Niels Hutchison, "Colour Music: Painting by Numbers," http://home.vicnet.net.au/~colmusic/maistre.htm.

10. Schafer, *Soundscape*, 9.

11. Elizabeth Grosz, "Architecture from the Outside," in *Essays on Virtual and Real Space*, Writing Architecture Series (Cambridge, MA: MIT Press, 2001), 168–69.

12. Mies van der Rohe, quoted in Elaine S. Hochman, *Architects of Fortune: Mies van der Rohe and the Third Reich* (New York: Weidenfeld and Nicholson, 1989), 282.

13. Grace, "Presence of Black," 144.

14. Anthony Burgess, *A Clockwork Orange* (London: William Heinemann, 1962), 77.

15. Stephen Heath, "Ambiviolences: Notes for Reading Joyce," in *Post-Structuralist Joyce*, ed. Derek Attridge and Daniel Ferrer (Cambridge: Cambridge University Press, 1984), 32.

16. Grace, "Presence of Black," 139.

17. Tony White, "Gordana Stanisic," *London Palm* (London: Piece of Paper Press, no. 23, 2009), 23.

Modernity Retired

STAFFAN SCHMIDT

Modernity Retired begins with my grandmother: to remember the remembered. She told me about her childhood, things like switching on the light in the apartment for the first time, or walking through a town emptied out to watch for the first flying machine, or being trapped under a snowdrift in the cabin of an elderly couple who shared the space with hens, a cat, and a goat, and then sledding over it. My childhood was charter flights and parking lots with shopping carts. But the way she told stories stays. In 1919, when the Bauhaus was founded, she was seventeen and pregnant with her first child. Modernity built difference, not between us.

I started seeing the elderly as "the modern generation." In discussing politics with my parents I recognized proudly postponed fulfillment, waiting-in-line equality, consumption identified with wasting collective resources, dots on a modern map connected by a social imaginary. Was this the exceptional result of them being born in Sweden in the 1920s, emerging unscathed from World War II, and wandering out to build the Social Democratic modernity?

Interviews were already my method. The witnesses to the modern breakthrough, the second generation, are now pushing ninety. *Modernity Retired* backtracks, tracing vectorial changes of energy, space, and speed through the speakers' situated, competent objectivity. It is a discussion with architects and designers stuck in between conflicting hopes for a buildable naturalism: art *and* science, humanism *and* statistics. It starts from and stays with the open-ended question "What *was* modernity?" It stretches out beyond Sweden to four countries that conceive of themselves as modern: Germany, Israel, Turkey, and the United States. As it now stands, *Modernity Retired* as an artistic research project attracted

Staffan Schmidt, *Modernity Retired* (detail), 2009. Left: Narelle Jubelin and Carla Duarte, *Key Notes* (detail). Installation view in *Learning Modern*, Sullivan Galleries, School of the Art Institute of Chicago. Photo: Carla Duarte.

Modernity Retired was included in the exhibition *Learning Modern.*

funding and will be completed by a transdisciplinary analysis of the interviews, resulting questions, and follow-up sessions.

Modernity dislodged experience from expectations, claimed alienation and otherness to be meaningful, established institutions that destabilized social and aesthetic traditions—and went on to produce modern joys, privileges, aspirations, expectations, successes, and hopes.

• • •

Gertrude Kerbis says that she never interviewed her father about his journey from Germany to Illinois, where he was looking to become what he had been before: a farmer. The family was poor; they could not afford a car, and she learned to drive before her father. The November day is dark, and the windows and skylight of her Chicago house, rebuilt many decades ago, seem smaller than they really are. We sit in a one-room living space: at once private home and public reception area. Mies's Barcelona pavilion chairs are lovingly worn.

> Gertrude Kerbis: The challenges you have can make you tougher to survive. Looking back, I have no regrets having had it a little harder than some of my male associates. In fact when I did competitions, I would say my name was "Gert." I didn't want to be a woman. I was always trying to pretend to be … I had to be acting like a male. You sort of had to overcompensate. I was very much aware of myself as a woman in this man's field.

She was married long ago to a Bauhaus émigré, much her senior, Walter Peterhans. We find him in a coffee-table book. But before that time, she spent a night in Frank Lloyd Wright's Taliesin, in Wisconsin, and that sparked her desire to become a modern architect. As a woman and without funds, she was always a hard worker. When she got a house in Florida to escape the Chicago winters, it was reassuring to find out it had belonged to Betty Friedan.

The assumption that women know about food—that a female architect was first and foremost a woman and only second a professional—followed her throughout her early career. She was assigned to design a huge canteen for the US Air Force and the rotunda-style restaurant area at Chicago's O'Hare airport. She says her son can testify to her poor cooking. Later she formed her own office, successfully working with other women professionals. She is solidly independent.

• • •

Ken Isaacs is fascinated with models, a bricoleur, and an inventor with a distinct interest in simplicity. His DIY Microhouse and *Knowledge Box* can be remade, just as easy as assembling an Erector set, but the optimistic, lighthearted-modern atmosphere could not be reconstructed easily. Leaving utter devastation behind and cruising through a surplus economy, with the singular chance to do experimental things backed by Lyndon Johnson's Great Society, he wanted to make the world entirely fair, just, and American modern. But what kind of modern is that?

Ken Isaacs: I became a contributing editor to *Popular Science,* and they published a lot of my stuff. But those magazines were about building, and there is something about making. People overemphasize their various obsessions, but building is something that changes the individual who does it. That's what's really good about it, perhaps better than the finished product. And it's very important to experience that change. I think that's the real excitement. I built a lot of my things, and I found romance in the physical act of building. Romance has its place, even in modernism. Modernism may be the greatest romance of all. To even think that you can make improvements…

He used a gridded structure, modular steel-pipe frame, and drywall—or just about any other material that would secure or support a structure for basic, good-enough living. His interest in vernacular building grew, but what about the modern vernacular? Applying the grid to in-dus-tri-al-ism, but also in-di-vid-u-al-ism: building the world as an efficient encapsulation of values, but also finding the limits to what life demands and kicking excess out of the box. To distinguish excess from necessity. Finding out the limits of what a house can provide—just before you fold it up and move some other place—making space for less, perhaps Walden.

• • •

A modern-style office building was less expensive than a traditional one. Names and pedigree made a difference, yet still modern architecture became the home turf of developers. You understand from what Peter Roesch says that if there had not been people around who were willing to listen to what Mies meant, the cost-efficiency ratio between an aluminum, bronze-tinted glass curtain wall and a stone-and-glass wall would have been the only differential mark left. Buildings are works of art where functionality supplements aesthetics, understood as purposeless purpose. If we focus on the surface of a building, it inevitably becomes a mirror for society. Silence, and carefully listening to understand what quality means, was Mies's pedagogical vehicle at IIT: "That was the lecture. The silent lecture."

Peter Roesch: My office built thirty buildings in ten years. That was more than I was actually physically able to handle. I had to drive from one job to another. You needed to be there when they did things. In a strange way, it was Mies who gave me some of the strength. Some of my buildings also looked like his.

When I was to do my thesis I asked him, "What should I do?" And he said, "Do you have an idea?" I said, "Not really." And then Mies said, "If you don't mind to work on one of my ideas. I think you can learn more than if you're searching for an idea, because an idea may not come in the framework of a semester. It may come at the end of your life or tomorrow morning. You never know."

What can be learned from that which is perfectly modern? Is the IBM building at 330 North Wabash the ultimate standard. Up on North Lakeview Avenue, where Roesch lives, the façade remains of Mies's work, as well as the obligatory Barcelona pavilion furniture

on the ground floor, but the interior is the work of the developer: surprisingly small apartments, low ceilings, kitchenettes; no pets allowed. There is a vague sense of playfulness as Roesch sits back, aligning his comments while pointing to a source.

But it was never easy to begin with, and even when things worked out and houses were erected, a strange mixture of serendipity and unlimited-supply commercialism hovered over modern buildings as a social project. Seen as rationality, there was only one door to pass through; the work was about an impartial dealing with irrecusable needs. Engineering. Carrying on in the footsteps of the masters.

. . .

All we can do is tell a story. Natalie de Blois may not fit the description of a female chief designer. She was told to change her job because a man fell madly in love with her and she wanted nothing of it. But she says she was not angry at the time. It was just normal that a woman could not be presented as the responsible architect in a business meeting. It would make the investors worry that their job was not a top priority. Anyway, they were working as a team, with hardly any rest. Struggle and time changed the story.

After a few minutes she jumps up from the couch looking for Le Corbusier's book *Towards a New Architecture*. Modernity, starting with the Modulor; it was a top-down project, a claim for equality and a worthy life for every Western male. She was a part of the modern, working on it, opening the façade to the street for department stores and elevating the remaining pleasures up on top. Recognition came in retrospect. Do stories or injustice that survive become the endlessly repeated truth? In a volume that honors her boss at the time, her name is only mentioned in the back, among the assistants.

> Natalie de Blois: For Terrace Plaza in Cincinnati, I never went—never went and saw the site, never met the client. Today they ask me down to see it; they know that I was the designer on it. Somehow the credit is given to me—I did the design and the drawings for that building, you know. There's no doubt about it, but I was discriminated against. I couldn't go to meetings. I couldn't go to lunch with them. I was told I couldn't go to the clubs with them. That was just it.
>
> When Bunschaft came back from military service, I started working for him directly on all kinds of big buildings. I worked for him on Lever House. I was project designer for many buildings—many, many, many of his best buildings. He didn't seem to discriminate. In no way did he treat me differently that he did anybody else. When he introduced me to the clients, he would say, "This is my best designer, and she's going to work on the project." He wrote a book, Gordon Bunschaft. He didn't say a damn thing about me. I mean, I didn't exist. It's been recorded that I worked on it, but there are those who still try to make believe that someone else designed it.

The people are long gone, along with the leading characters, the inventories, and the art that embellished the floors. But most of the buildings are still standing, and the images of the houses remain. Why do they look different now? Natalie de Blois is still around to

change the answer to the question "Who is a subject?" Beginning in the mid-1970s the story began to change: women were no longer grouped with the minorities.

• • •

Alfonso Carrara lives in the townhouse of his parents, a far cry from the modern, on a quiet street. He says that his student peer group considered the Wrigley Building "the wedding cake," worthy of being demolished, as was more in the rest of the city. Was there not space enough for modernity? Did not modernity achieve a crushing win? Claiming rationality, modernity was moving without a script.

> Alfonso Carrara: If you go to the suburbs, the houses you see now are just as bad as the houses I used to see. We didn't really conquer the houses out there with modern architecture. You said something before about ecological things. We never even thought of that in those days. What we were against was the shapes: the typical house, the suburban house. We couldn't stand them. About the only thing that they had that was modern was a great big glass window—and it was covered with a drape—and the usual lamp.

Being held back by a system, a society that was once viewed from a back street, Carrara looked to understand its underpinnings and bring buildings into focus. If the basic module of life could be overturned, things would have a different starting point. Houses that hung their ancestry on their façade were despised, but could there not be traditional buildings that were "better than most"? What's the point of tearing down old functional houses just to build new ones whose selling point is that they put on the same face as the old ones? When the link between aesthetics and progressiveness was broken, the concept started turning toward brick-wall images of a safe past. Easy stuff, excellent readymade ideas. A past untorn. So the house skin made of brick came back, but what was worse was the returning illusion of a stable society, arguing its inevitability based on appearance.

Design with Conviction

CHARLES HARRISON

interviewed by Zoë Ryan

Zoë Ryan: Charles, throughout your career you have spoken about the importance of design education. You studied at the School of the Art Institute of Chicago (SAIC), graduating in 1954 with a BFA in industrial design, and then returned after having been drafted into the army for two years, where you worked as a cartographer. The second time around, however, your teachers Henry Glass and Joe Palma[1] had to create a master's program specifically for you in order to secure early leave from the army, am I correct?

Charles Harrison: Yes, at the time, there were only a few schools that had accredited master's programs, and SAIC wasn't one of them. However, at the end of 1955 I learned that I could gain early release from the army if I were to enroll in further education. Motivated by fear of having to stay in the army, I wrote a letter to Henry Glass and Joe Palma, and they created a program just for me!

ZR: Could you believe your luck when they wrote to you?

CH: No! I owe them a lot. Industrial design became very important after the war. It had a large role in helping pull the United States out of the Great Depression; it made products attractive so customers would buy them. And that's when industrial design came to be a force here, in my opinion—when it started making products appealing.

I have described industrial design as a synthesis of three disciplines: art, science, and business. When I began as a designer, it was not an equilateral triangle. Aesthetics was the long side. So if you were a designer, what they really wanted you to focus on was the appearance of an object. Over time, that triangle has changed, and now I think it's at a point where it's equilateral. When I teach, I tell students that I think

Charles Harrison, Kenmore sewing machine, Sears, Roebuck and Company, Chicago, ca. 1974. Installation view, in *Learning Modern*, Sullivan Galleries, School of the Art Institute of Chicago. Photo: Jill Frank.

This interview was conducted on February 15, 2011, in Chicago. Harrison's work was featured in the *Learning Modern* exhibition.

today you have to have equal strength on all three sides to really create a design that performs well.

ZR: When you were at school, who were the designers or professors that you looked up to for inspiration?

CH: Henry and Joe were two instructors that I remember the most at the School of the Art Institute. I felt very close to what they had to say. I came here as a young man. I was maybe nineteen years old when I first arrived, and I was ready to absorb anything. I knew nothing about design, so I saw these guys as giants in the industry. They were names in the industrial design world. For me, they were the ultimate, so I absorbed everything they told me. It was the gospel. And I used it, put it into who I am as a designer, into my toolbox, and have carried it with me for the entire distance of my travels as a designer.

Henry was also open to learning from other people. I know that he acquired a lot of his conviction about design—whether architecture or products, because he did both—from people he was inspired by, like Walter Gropius and Charles and Ray Eames or Buckminster Fuller.

ZR: Were you also encouraged to look at these people while at SAIC?

CH: Yes, absolutely. I remember that at the time, there was a strong emphasis on simplicity of form.

ZR: What did that mean specifically?

CH: No frou-frou, no frills, no elephants, no monkeys, no butterflies. Do what was appropriate.

ZR: You often talk about the importance of designing products that are intuitive, that are easy to use and not intimidating, but not cute. Can you explain this?

CH: Objects need their own identity and their own statement of what they are. We can be as philosophical as we like, but in spite of what we say, some people can still sell a product by making it take on the configuration of something cute. However, nature has long been a source of inspiration, and we do embellish the appearance of some products with surface applications of flowers or even animals.

ZR: One of the sewing machines that you designed has a case that is embossed with a floral motif.

CH: Yes.

ZR: To what extent did the work of architect Louis Sullivan and his intent to marry the organic and the industrial in projects such as the Carson Pirie Scott Building in Chicago influence your work and the use of ornamental or figurative qualities in design?

CH: I think my influences go back further than Sullivan even, to the Mayas, the Aztecs, and the Incas. The Egyptians would decorate their tombs with familiar images. Now, some of these were symbolic messages, hieroglyphics, and yet I think that humanity is drawn to images that we are accustomed to, that bring visual pleasure—like a flower. I've relied on things in nature; I've been attracted to them all through my life for inspiration. I look at seashells, inside bamboo plants, the egg. I think the egg is as beautiful a shape as you can find.

ZR: So for you, the inspiration for a design and its application should come from the functional capacity of the object?

CH: Yes, from the product or object. That should set the tone and then be closely followed by the material and process by which it was made. So, for instance, I would not consider taking a material and putting it in a shape or form that would be difficult to achieve or inappropriate, where it might break easily or where the material would weaken with use. There is a need for designers to have an in-depth understanding of the properties of the materials they were working with so that they don't misuse them.

ZR: In addition to furniture and product design, you worked early on in your career on interior designs, working for the office of Maurice Sternberg on custom furniture for apartments such as 1000 North Lakeshore Drive, and your designs were published in *Chicago* magazine? What are your memories of that time?

CH: Maurice was an interior designer, and I was too at that point in my career. I worked on some of the model apartments for high-rise buildings along Michigan Avenue. I also designed showrooms for furniture manufacturers and some exhibits and trade shows for the Merchandise Mart.

ZR: What was the climate like for design at that time? I have read about the influence of stores such as Baldwin Kingrey, which opened in 1947 and focused on midcentury modern design, as well as of course the Merchandise Mart?

CH: I think Chicago was proud of being a boomtown for design. Most of the manufacturing in this country was done in the Midwest, and the showrooms were centered here. Chicago was the furniture trade show hub for the nation. The customers came and marketers came here. And at least 50 percent of designers in the Midwest came out of the School of the Art Institute during the forties and fifties.

ZR: What types of design were being showcased at that time?

CH: We would go to trade shows and would be delighted to see things that were finally looking like what we would like to have. Design was still coming out of the era of sheer functional production. You could still find products in the forties that had control panels with big nuts on the front that you had to turn with a wrench. However, there was a movement to make products desirable in appearance, even desirable in usage, in the way they fostered human interaction. Of course, developments in technology helped us enormously to do a lot of things that wouldn't have been possible before. With the advancement of technology, both in terms of equipment to build things and of materials, we could achieve a far greater range of products. In the thirties and forties there were only one or two types of plastics available for use, and they hadn't been developed to the stages where you could use them except in a few applications. We had Bakelite and cellulose compression molding, a very slow and crude kind of molding process. Injection molding didn't come into its own until the late thirties, early forties; then it had a long growth period. And there were other processes for making products that started to blossom in the forties and fifties, like plastic extrusion. And it wasn't just because of the war it just hadn't been developed. But now there are so many more types of plastics for different applications that the possibilities for innovation are endless.

ZR: Although much of your inspiration seems to derive from a modernist bent, derived from the leanings of Bauhaus masters who were interested in creating work that favored industrial production, was fit-for-purpose, and made appropriate use of materials and production methods, in the 1920s and 1930s streamlining also came to mean modern in America. Designers were being challenged to determine a style of design that reflected contemporary interests and tastes and married historical or traditional methods with the new styles and approaches of the day, and they turned to streamlining as a reflection of technological and societal changes in modern life. What are your thoughts on streamlining at the time?

CH: There was a coexistence of these two directions, but streamlining was more popular. However, I don't think any designers were trying to make anything American. They might have been trying to appeal to a contemporary American market, if that characterizes modernism.

ZR: But I think this is all part of the modernist story—the reinterpretation of historical modes of practice to create work that speaks more readily to the time in which it was made. Would you agree?

CH: Well, during the Art Deco period, a lot of designers' products employed Art Deco motifs. Aesthetic movements impact how things are made, architecture and fashion included. The approach to design is directly informed by whatever movements are being exploited in the country at that time. And I think, yes, streamlining was probably an attempt to move beyond what I call a purely functional era, and it might have been the first styling effort toward aesthetics in American design.

ZR: What was the working process like when you went to work for Henry Glass or when you went in 1961 to Sears, Roebuck and Company? Were you still able to work on every aspect of the process of design development through concept development and realization, as you had been doing at SAIC? Or were you charged to develop the drawings and hand them off to the manufacturers to develop and determine an outcome? How hands-on could you remain in the process?

CH: In fact, I use this comparison when I'm teaching students about manufacturing: there's a distinction between a consultant design firm and an in-house, captive design firm. Consultant firms generally just conceptualize; they make a concept that should or might work and then deliver it to their client, leaving it for the client's manufacturing group, whomever they are—engineers or production engineers or development engineers, material specialists, and people like that—to take that design and put it into production, which means they are in control of making changes to the design in order to make it work.

Now, if you're an in-house designer with a firm, you stay with that project all the way through each phase. It has been much more gratifying for me during my lifetime to work in a corporate setting where I was friendly with the engineers. They knew me; they felt comfortable calling me when they had a problem or an issue. When working with consultants, if the engineers had questions and picked up the phone to call them, the clock started running. Instead, in those cases, they would just figure out themselves how to make a design, and typically what they ended up with might be

far from what the designer had in mind. The continuity of the designer's influence was dropped in those cases. However, if you're an in-house guy, you have lunch with the engineers or see them before or after work, and they'll say, "Come over here and look at this thing, we have a problem. Do you really mean this to go this way? What do you suggest we do?" They're very unlikely to do that with a consultant designer. So for that reason, I prefer that designers stay close to the development team until the product gets through production and into the customer's hands.

ZR: And at Sears, you always had that experience of taking a design through concept development to production?

CH: Yes. I actually had an increased benefit at Sears because I not only had engineers, but all types of engineers whom I was very comfortable with and they with me. So if I saw a problem as I was designing something and was uncertain, I could check with one of them and ask, "What do you think? Will this work? What are the problems? What are the issues here?"

ZR: So at Sears the engineers worked collaboratively with the designers?

CH: They did because they had to, because the business side of my triangle required us to sell those things. An engineer might make it work, build it strong enough so that it wouldn't break, and make it functional, but if you couldn't sell it, it was of no value. I also hasten to tell you that designers were not always responsible for a lot of things that we get accused of, because frequently production and manufacturing engineering would change things to fit their—I'd like to say "needs" but it's rather their desires or comfort level. If they found something that they weren't familiar with, they would be very resistant to go there, and sometimes they would reject making products with certain shapes or forms or structural properties. The point I'm trying to make is that while the designer had to wear the hat of the designer and frequently received the criticism when a product failed, the decisions in the making of those products were not always within the designer's control.

ZR: You trained in furniture design but throughout your career have worked on a wide range of products, even architecture. Did your approach change at all depending on what you were working on?

CH: My preference was to design a diversity of products. It was my passion, and I enjoyed the challenge. I just applied the Harrison toolkit to whatever project was in front of me.

ZR: What defines the Harrison toolkit?

CH: Well, first of all, make things well. Make them do what they propose to do, look like what they are, and convey this to the customer, the end user, so they serve their purpose well. This also includes making something attractive and appealing, so that people will feel comfortable with it and even like it.

ZR: When you were working for Sears, it seems to me that in the US there was something severely missing in terms of the diversity of the consumers you were making things for. For example, today, products, clothing, makeup, music is so much more advanced; companies are not trying to make things just for one type of white, middle-class, domestic housewife consumer.

CH: I'm on the same train with you on that, but in the United States there was no consideration of anybody but white, middle-class people. You could say the same for any of the so-called minority groups. There was no interest in appealing to Asians, Hispanics/Latinos, or Native Americans, for example. The rest of the people be damned, so to speak. There was no effort on the part of the managers or marketing people because they had enough business, so they didn't need to reach out to other people. But after the world became smaller, with television and marketers from other parts of the world, particularly in Asia, they started to have competition, and things started to change.

ZR: When you were thinking about the products you designed, did you have an audience in your mind, or was there an ideal customer?

CH: The Sears customer profile at the time was middle-class to lower-middle-class customers, not the upper class; they forfeited that market segment.

The American thrust at that time was to sell more products, and that is one of the distinctions, I think, that led the US to its position among other countries: its philosophy about selling goods. Europeans built products to last and were interested in new technologies. That was their kind of philosophy of life. In the 1950s, when you bought a car, you would consider it your car for life; if you bought a house, two or three generations were going to live there. In Asia, particularly when Japan became a world competitor, they used the lever of customer satisfaction: making a product easy to use and repair, with all kinds of little conveniences. The US thrust was cost. They figured that if they made it inexpensive, they could sell more. While at Sears, I worked all over the world—in Europe, Asia, and the US—developing products. I could see the philosophy of the place in operation at the manufacturing companies I worked with. That's how I came to this conviction.

ZR: What was it like working internationally at that time?

CH: There were few African American designers elsewhere in the world that I was aware of at that time, but I was in an enviable position as I was manager of the whole design department at Sears. Twenty-two designers reported to me then, and eight or ten model makers. During my last ten years there, I managed the entire industrial design area, and even before that, when I was working in consulting firms around Chicago, I had the position of lead or senior designer in the group.

ZR: Having traveled to Asia recently, I found it amazing to discover how spatial relationships and even the way certain products are used is quite different than in the United States. When you started to travel for Sears were there methods or approaches that you wanted to bring back?

CH: Well, the one thing that hit me very clearly in Asia was that the market strategy was directed toward customer satisfaction and convenience. I think that is essential to the philosophy of the Asian market. And I thought that this was a very good approach. I tried to emulate this and bring some of that kind of thinking into the product lines I designed. I teach this too—to explore materials and processes to their fullest extent. If there's an opportunity to go beyond what's basically required in the design, take it to its fullest capacity.

ZR: Many of your designs attempt to rethink conventional objects and how they are used.

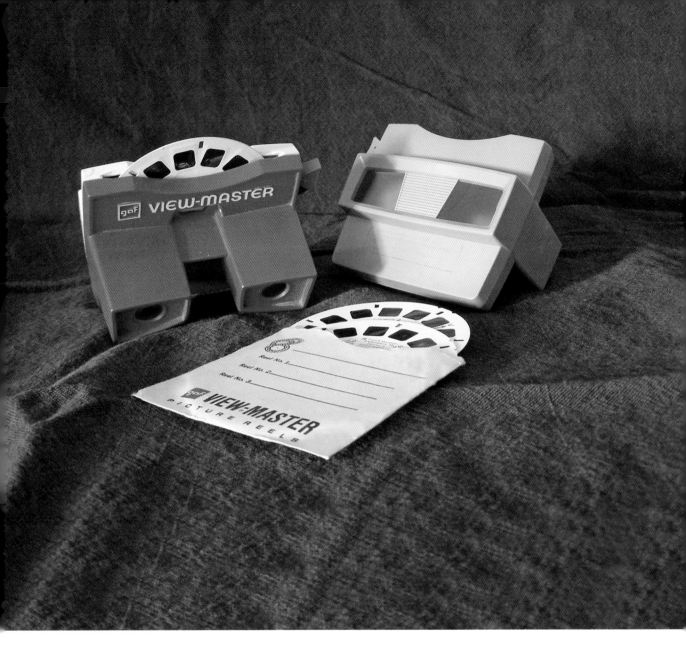

CH: Absolutely. Every day I look at objects that I use daily and wonder why they were made that way and could they be made differently.

ZR: Can you give an example of a design that you were charged to transform and how you approached it?

CH: The View-Master is a good example. We discovered we could make it easier to build, so that it could be molded faster, producing greater quantities in a shorter time, and consequently making the product considerably less expensive so that more people could afford it.

ZR: In effect, it became a different product?

CH: Yes, even the way it looked changed. The View-Master was initially a product for adults. It was large and heavy. The form we developed is similar, but the product is not the same. It's lighter in weight and more aesthetically appealing.

ZR: You made it more appropriate for everyday use, rather than such a precious object?

CH: That was the consequence. Because we made it less expensive, children were allowed to play with it. It became more accessible. It then developed from there.

ZR: Another important object that is ubiquitous today is your plastic trash bin, which was a very pivotal early work.

CH: This project came out of a collaboration with Richard Palase, a chemist in the Sears laboratory. We often talked about using technologies to radically alter designs. He came to me and said, "Chuck, if we could build a garbage can out of blow-molded polypropylene, it would be virtually indestructible." I said, "Well, that's wonderful. I'm happy to contribute my design expertise to this project, but you and I don't have the authority inside this corporation to make this product." But we knew the right guy—Alan Karch, a Sears buyer—because we had already done some other work for him designing garbage cans. So he let us sell him on this idea. He took a gamble, and that's how it happened. But it was because of Richard that the whole process started. I came up with the design, which has actually evolved to a couple other configurations.

ZR: It must have been such an exciting time to work in design. Did you feel like you were at the forefront of changing the American domestic landscape through your work?

CH: We were asked to be; they expected us to be on the forefront of that stuff. But we also knew there was a market segment that didn't want those things, so we had to design for those people too. Most of the products we worked on were developed with five or six products in a line so that they would appeal to a range of tastes, from the more traditional to the more contemporary. If we developed a range, they would have what the marketer called "price points," starting at a lower price point and going to the highest, with several steps between.

Now, the simplest of all those things would be at the lowest price point. As the features increased, so did the price, making the customer believe that those features were worth the value. Most of the time they weren't, in my opinion. If you wanted a lawn mower, then the good one had better cut grass or the customer will bring it back. A better one might cut grass at different heights, but the fact is, once you set that setting, you never changed it. The more expensive one had automatic adjustment settings, where you could adjust it with your foot or something. Who needs that? And it can get ridiculous. A lawnmower might even have a light on it to tell you that the grass was tall. Why would you cut the grass if it wasn't tall?

ZR: Sounds like you had fun making those designs! What seems great about working for Sears, however, was the enormous range of scales you got to work at—from tabletop items to heavy-duty equipment.

CH: Well, if you apply a certain kind of design thinking, you can design anything. There's nothing that I would shy away from taking on. But first you don't assume that you know anything about what you are doing; you learn as much as you can learn about the new challenge, and you learn whether there has been anything similar ever produced. And you find out if there's a market for it: are people other than you interested in it. That's part of the research—to learn.

Inventors dream up something and then go ahead and make it work; and only then do they go out and see if they can find someone interested enough to invest and produce it. But designers don't go that far until they have learned or are convinced, or know because of the history of that product, that it's something others want.

Inventors frequently have no market, even after they finish inventing. That's where I would say there's clearly a delineation between designers and inventors.

ZR: In addition to demanding well-made products that are easy to use, consumers today are also searching for designs that are meaningful, that stand out in the way they relate to their lives, that speak to them on multiple levels, beyond merely being functional or formally interesting. How do you communicate meaning?

CH: This is where the designer has to be able to walk the line between what is valid and what isn't. And no one else can make this decision but the designer. My answer is that we be straightforward and honest about what we are trying to do. Don't try to be cute or tricky, but make something do what it's supposed to do.

ZR: Did you ever think about establishing your own studio and working independently?

CH: Well, that might have been a fleeting idea, but that wasn't possible in this country, for me, because I was African American, and I knew that. There was no way for me to lead and design for myself, but that didn't bother me, because I enjoyed working at a company.

ZR: Why do you think there are still so few African American designers?

CH: Several reasons. One is that people in the African American sector, people in America generally, don't know what industrial design is. There's not a lot of general awareness of industrial design in many US communities, but in the African American community, there's probably even less. Any African American students who show an aptitude to draw, think, and create are directed by their teachers to architecture. To my knowledge, not one of the historically black colleges has a curriculum for industrial design.

ZR: Hopefully your National Design Award for Lifetime Achievement in 2008 [presented by the Smithsonian's Cooper-Hewitt National Design Museum] will make a difference in raising the profile of design.

CH: Let's hope so!

ZR: You worked at Sears at such an interesting moment. What do you think is the biggest challenge facing designers today?

CH: Since Sears, I've been immersed in education and have become involved with how design is taught. As to practicing designers today, I feel that they should maintain a high level of aesthetic quality and design, but I think it's difficult now, more difficult than before, with the use of the computer in design. A lot of the thinking in design is now done through the computer, but the digital process doesn't flow like the analog process does. There's a dependency on the computer that threatens the possibility of the best possible solution. If you send your ideas through the computer, you can only execute what the computer will allow you to execute. I think that there needs to be room for both digital tools and handmade processes in the development of a design.

ZR: So it should start with modeling, drawing...

CH: That's my position. I can look at a finished product, even graphics, and tell you whether it's been done on a computer or not. The Mercedes-Benz was one of the first automotive companies to do their cars totally on a computer, and it looked like it. I'm not trying to stand in judgment about whether it was good or not; it's just my sensitivity

that allows me to see what was done by a computer. There was some human interaction that I thought was missing.

I think it goes back to my fundamental convictions about the principles of design. I mentioned earlier that when I'm looking for input or motivation, I reflect on nature. Birds in flight, waves on the water, the reflection of the sun that create shadows, the form of trees, leaves—those things are where my heart is.

Note

1. Henry P. Glass (1911–2003) was born in Vienna and earned his master's degree at the Architectural College of Vienna in 1939. He gained early success designing interiors and furnishings for the city's bohemian elite and later immigrated to New York City, where he worked for Gilbert Rohde and Russel Wright. Settling in Chicago in 1942, Glass began his own design practice specializing in furniture. Over the course of his career, Glass was granted fifty-two patents; he may be best known for creating Swingline children's furniture in 1952 and the Cricket folding chair in 1978. Glass also spent twenty years as an instructor at the School of the Art Institute of Chicago. His work was featured in the exhibition *Design from the Heartland* at the Art Institute of Chicago in 1999. Joseph Palma Jr. (1909–2007) was one of the pioneer industrial designers in the Chicago area. After graduating as an architect from the Illinois Institute of Technology in 1932, he oversaw product design for Montgomery Ward for several years, then began his own design firm. Palma was also a professor of product design for more than twenty years at the School of the Art Institute of Chicago.

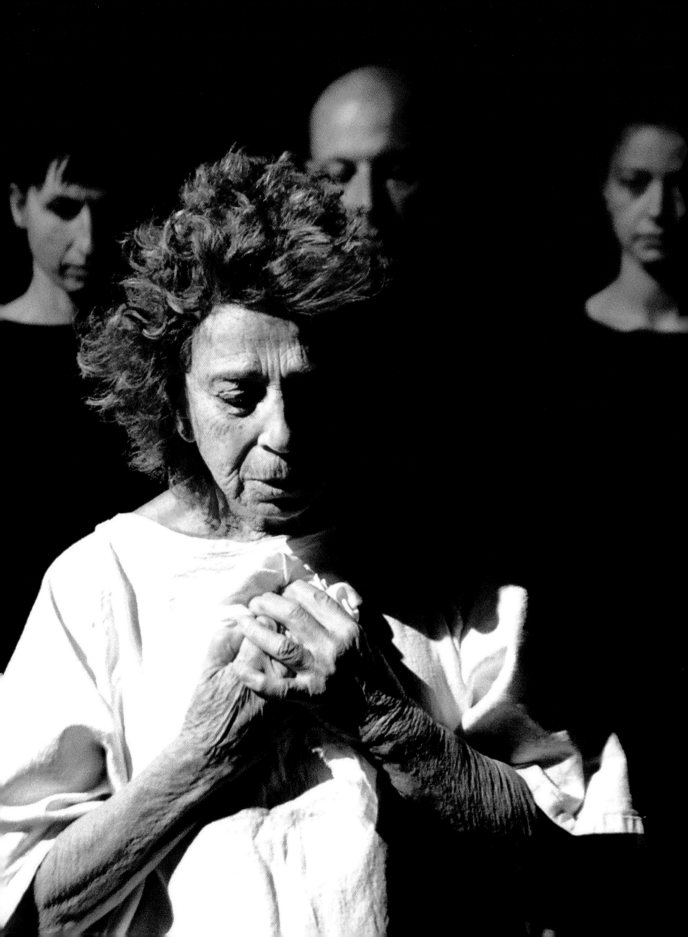

Life as Art

ANNA HALPRIN

interviewed by Jacquelynn Baas

Jacquelynn Baas: You'll be ninety years old this year, and you've been dancing pretty much your entire life. What *is* dance for you?

Anna Halprin: My recent film is called *Breath Made Visible* [Ruedi Gerber, 2010]. That title came from a quote of mine: "Dance is the breath made visible." What is unique about dance? For us, as artists, our instrument is our body. It's the only art form that has that particular—both limitation, in a sense, but also uniqueness. Everything in our body becomes our resource. It's the only thing we have to work with. And the only two elements in the body that limit us are the breath and the pulse.

When we are breathing, we are able to move. When we stop breathing, we can't move anymore. Movement is our only medium. Our instrument is part of the environment. It is not an object in the environment, which is another unique quality about dance. If you're a painter, you don't have to breathe in the planet, but *we* have to breathe in the planet—breathe in the trees that emanate into the air. There are absolutely no boundaries, therefore. So that is the unique thing about dance: it is the breath made visible.

Now the other element, the pulse, is universal, too. Every living thing has a pulse, whether or not you can hear it or are visibly aware of it. Everything exists in time, which is pulse. That tree has a pulse. It has a time when it is born, and it has a time when it dies. That's a pulse. Pulse is measurement of time and space. Everything that is alive, at some point, dies. Dance, for me, is connected to life force because of the uniqueness of our bodies as our instruments.

That means that dance is something available to every human being, no matter what age, no matter what the capacity of the person. For example, take the most

Anna Halprin, *Intensive Care* (detail), 2004. Performance documentation. Courtesy of the artist. Photo: Rick Chapman.

This interview was conducted on May 25, 2010, at the Sea Ranch, California.

interesting possible dance, the case of Jean-Dominique Bauby. Paralyzed and able only to blink, he wrote a book, *The Diving Bell and the Butterfly*; it was made into a movie [Julian Schnabel, 2007]. Just the movement of his blinking. People think of dance as being something for young, beautiful bodies. That's a *cultural* belief system, which isn't universal truth. So that's my definition.

JB: In 1945 you moved to California. What effect did California have on you?

AH: I didn't spend my entire career in California. I was dancing and performing on Broadway before I came here, and for four years before that at the University of Wisconsin. I was dancing and performing when I was a child, in 1934, at the Chicago World's Fair. What I *would* say is that, since 1945, following World War II, when I moved here, I've developed my particular, individual approach to dance. Up until that time, I was part of another kind of a movement: the "modern" dance movement. When I came to California there was very little dance activity. In my isolation, which I thought was the end of my career—actually it was the beginning, because I had to reassess dance from the beginning—I broke off from modern dance. I just didn't like it anymore because it was too idiosyncratic. You had to imitate Martha Graham or you imitated Doris Humphrey—imitated a *style*. I felt that dance was not based on somebody else's idiosyncratic style, that the creative process would lead us to find our own style.

So coming to California gave me an opportunity to reassess and redefine dance in the same way that my husband Larry [Halprin] redefined landscape architecture. It gave rise to a new definition of dance that I was left alone, on my own, to explore and experiment with. I even did human dissection for a year, so I could understand how the body actually worked. I had to really start from scratch.

The idea for the word "workshop" [as in her San Francisco Dancer's Workshop] was influenced by the Bauhaus, because of Larry's connection [at Harvard, 1942–1944], but also because it was a word that was just right to describe what was happening, *because* I was so isolated. All of the artists were isolated here [in the San Francisco Bay Area]. The painters eventually left and went to New York, because they couldn't sell paintings here. But because of the isolation—which I thought was a curse but turned out to be a blessing—I came to have this wonderful facility that Larry built for me, and so it became a gathering place.

JB: Your famous dance deck in the redwoods?

AH: Yes. It became a gathering place for artists who were painters, musicians, theater people, poets, filmmakers.... We gravitated into a group that experimented, each of us in our own way, but this was the place where we met, shared, and influenced each other.

JB: Surely the great beauty of the natural environment in California must have been important to this vision that you developed.

AH: Oh, absolutely. On the east coast they were developing conceptual art. We were getting away from that. We were developing a new approach to art, which was art and the environment, sensorial. They used to tease me on the east coast and call me "the

touchy-feely therapist." And I used to answer, "But is there something wrong with *feeling* something and *touching* something? Is that *wrong*?" Well, for the east coasters, who were so conceptual, I was not acceptable. But when I went back this last time [in April 2010], I was a hero; I had people lining up at the doors to take my workshop [at Judson Church]. But before that, I was just off the tree, the dance tree, completely.

JB: Yet your presence in New York was huge, thanks to the migration of your students there during the early 1960s, performers like Simone Forti, Trisha Brown, Yvonne Rainer, Meredith Monk. You've been called the "mother" of postmodern dance, referring to the incorporation of everyday activities into dance. Yet, I think of you as a quintessential modernist, due to the ways you radically challenged and retooled, for *social* ends, traditional cultural concepts and attitudes toward nature, including the body. Do you think of yourself as a modernist? as a postmodernist?

AH: I suppose something doesn't *exist* unless it has a label. Maybe "contemporary" means what's happening right now. But in my mind, I have really gone back to the origins of dance. I've gone back to the origins and roots. If you look at the origins of dance, it includes the totality of one's life. Look at the American Indians. As soon as they see that their dances are being lost because the elders are dying off, the first thing they do is get the kids to learn to speak the language, the dances, so they don't lose their tribal identity. As soon as the dances go—because dance for tribal people is the totality of their life and preserves their identification as a community—they've lost their identity.

So that's another label—"ritual" dance. But the ritual dances are also life-art dances. They're based on the community, maintaining the myths. Here is an example of a community life-art process: in the late 1970s we had the Trailside Killer, who killed five women on Mount Tamalpais. The trails there were closed for two years. We organized a dance to reclaim them, and one week later the killer was apprehended and the trails reopened. Thirty years later, we're still doing the dance that we did to reclaim the trails on that mountain. So that story became a myth and the dance a ritual. That mountain represents the spiritual icon of our community. We use the mountain to go on walks, on hikes, to meditate, to have weddings, to mourn our dead. It is our spiritual center. When the trails were closed, it was a matter of either maintaining our connection to our spiritual center or not. So we had to reclaim it. After two years, it was like, "That's enough. We've got to go back." Thirty years later, we're still going to the mountain in the springtime. Every year we've taken a different theme. This year we're calling it *Dancing with Life on the Line*.

I've developed, along with my daughters Daria and Rana, what we call the life-art process. Now, I would say that Picasso's *Guernica* is a life-art process work. He took a *reality* in his life and how it affected him, and he made a painting that said, "This is what the revolution is, and this is how it affected me." It was a lived experience. There were certain things I did that were very personal from my life experience, like *Intensive Care* (2000). It was an expression of a real-life situation.[1] In the movie [*Breath Made Visible*], I talk about where those movements came from, how it affected

me, how frightened I was, and how this dance became a catharsis for that fear. But the dance used *art* principles, so it was an art expression; it wasn't just a therapeutic release.

JB: But there is also a certain universalism to it, this strong expression that you rarely see in theater—a kind of honesty.

AH: Of course, there is a universalism to all of it. Larry had been influenced by the Bauhaus at Harvard, but at a certain point, as a result of going up to the Sierras every year with the children, his whole approach and definition of the art process shifted, at about the same time that mine did. It was *because* of the environment and beginning to look at the art process from the point of view of how nature operates. That's why I did human dissection. How does my body actually operate as part of nature? Everybody's body operates this way. It isn't an idiosyncratic pattern.

The everyday movement idea—everybody grasped that, because it was easy to grasp, but that was not where I was going. Everyday movement was used because I wanted to demonstrate that if you look at everyday movement as an art experience, anything can be art. I look at water all the time, and I get all kinds of ideas from it. You can look at people walking down the street and just shift your consciousness, and look at it as a dance. I send my students out, all the time . . .

JB: It's how you *see*.

AH: It's where you bring your awareness, and you can look at an everyday movement. But it isn't enough just to *do* an everyday movement. You have to *shape* that everyday movement with the elements of movement. All movement has three elements. One is the physical element. The other is the feedback process between the physical and the feeling state. So if I do this [*gestures*], it has one meaning; if I do this, just a flick of the wrist, it means something else. And so all movement is a feedback process between movement and feeling. Then imagery brings you into symbolism—the third aspect of movement. When I do this movement, I feel this particular feeling come up. I use drawing, and one of the first experiences that students have with me is to draw a self-portrait, and then throughout the time they're dancing, they keep drawing more and more and more. Images come up.

JB: When you were young, your family moved to Winnetka, Illinois, outside of Chicago. It's also the home of the Winnetka Plan—a progressive, experience-based curriculum in the public schools informed by the theories of John Dewey that linked pedagogy with individual development and social reform. What role did your primary and secondary school education play in your development as a dancer? Was there an emphasis on creative activity in the schools that you went to?

AH: Absolutely! It was unusual, but dance was being offered from the time I was in kindergarten. And in high school they had dance; dance was included in everything I did. I was placed in "slow" classes. According to their system, if you were a slow learner, you would do better with other slow learners. I was in all the slow classes. Now, they call it "motor learning"—I'm a motor learner, I learn through motor activities.

JB: Well, that's very Dewey: learning by doing.

AH: Yeah, so I was very happy in school, and it had a big influence on me. The Dewey

approach not only started in grammar school, but I ended up at the University of Wisconsin because they had the first dance major in the country, and Dewey was an influence there as well. I had wanted to get into Bennington, because they also had a dance major and all the New York dancers came and taught there. I didn't get in because Bennington had a Jewish quota. That wasn't allowed in a state school. I was devastated at the time, but I had the most wonderful teacher at Wisconsin—Margaret H'Doubler—who had been influenced by Dewey.[2] She was a biologist; she wasn't even a dancer. Blanche Trilling, the head of physical education for women, thought it was important to have dance in the department, and so she told Marge H'Doubler, "I want you to start a dance program." Marge said, "I don't know anything about dance. I'm a biologist." And Blanche said, "Well, go to New York and find out." So she did, but she didn't really like what she saw, so she started researching what dance might be as an educational tool rather than a performance tool.

JB: After graduating from Wisconsin, you moved to Cambridge with Larry Halprin, whom you'd married by that time, and you became acquainted with a number of Bauhaus artists, including Walter Gropius, Marcel Breuer, and László Moholy-Nagy. Larry was quoted as saying about the Bauhaus, "There's a great deal of misinterpretation of what the Bauhaus was. Everyone thinks of it as big square buildings, but that isn't it at all. The idea was that groups of people—artists, theater people, painters, sculptors, costume designers—would all work on ideas that went beyond the capacity of any one of them."[3] What impact, if any, did the thinking and practice of Bauhaus artists and architects have on your work?

AH: I was not personally involved with the Bauhaus artists in the way Larry was, but I *was* influenced by their parties, which were like no other party you've ever been to in your life! They would do costume parties, and people would show up in costumes. They would do free dancing, and it was just wide open. I gave classes in movement to students who wanted to do that—Bauhaus architects and artists were so open to the other arts.

But I actually think the main influence the Bauhaus had on me—somebody asked me to teach in his or her summer workshop, and I remember giving a course in space. That I had never studied at Wisconsin with H'Doubler, and so I analyzed movement in space—sparse space, dense space, planes in space, levels in space, open spaces, closed spaces. I did a whole analysis of space in movement, and taught that as a course one summer. That has affected me ever since. Most dancers think of themselves as objects in space, but I do not. In *Intensive Care,* for example, I used chairs that had wheels so that we could create more emphasis on the space, rather than just the movement. Sometimes there would be this huge speed in space that would take the space from in front and just wham it back, or we'd whirl it like the movement of the ocean. I would say that I developed a whole theory and approach around movement in space.

JB: In an interview in 1963, you described something that happened unexpectedly, in your garden. You said, "I was looking at sunlight on a tree for no reason at all, and without apparent preparation, I became intensely aware of a foghorn in the bay, a red berry at my side, and passing birds overhead. I saw each thing, first, as a separate

element, and then as independent elements related in unpredictable ways."[4] You said that this experience led to a new way of working. Can you say more about what you think may have generated this experience, and its impact on your way of working?

AH: Back in those days, Louis Horst was very important. He was Martha Graham's lover but also her musical artistic director. He was trying to get away from the romanticism of Isadora Duncan's choreography, dancing responsively to very emotional music. (She loved Tchaikovsky.) Horst was trying to get back to what he called "preclassic form," so he analyzed dances in terms of an A theme and a B theme. You could go back to the A theme, or you could do an A-B and then a C theme, and you could develop those and go back to the A theme. In other words, he taught choreography on the basis of form, in order to get away from interpreting music, and that became the basis of choreography for dancers.

So I was working out on the deck, and suddenly I began to become aware of how I was taking in and experiencing the *environment*. How do I look at it? How do I give it some form? And suddenly I said, "Oh, that's so interesting!" Like just now [as we're talking], I saw the stillness of the tree in relationship to the bird that just flew by.

JB: I saw the reflection of the bird in the window.

AH: Yeah, and that's *form*. That's organizing the way you experience things. Form is not necessarily cause and effect, because there was no cause or effect when I absorbed that bird moving. Perception is giving form to sensory experience. And that's where everyday movement comes in. For the piece I did in connection with Larry's 2005 redesign of Stern Grove Amphitheater, the container was huge, the size of two football fields, and there you have indeterminate movement happening all the time. Instead of closing off the park during the performance, Larry said, "Let the people walk their dogs here, walk their baby carriages, or sit down ..."

JB: ... sounding like John Cage.

AH: Yeah, exactly—let that be. Different forms became part of the total experience.

JB: So experience is made up of parts and the whole, as it assumes form within each person's mind. But this experience in your garden that you talked about in 1963?

AH: That was a turning point. That was one of those moments when you go "Aha!" I was looking for a way to think about choreography in a different way. I was on the lookout, and I didn't have a clue until that happened. It was part of what lay behind *Parades and Changes* (1965), which created a real revolution in dance when it was performed in New York. But it was also my demise, in a way. It was first performed in Europe, but I couldn't use nudity in this country.[5]

JB: So this new way of thinking about choreography came to you by way of your experiencing the world around you in a new way?

AH: Yes. I was looking for it. *Parades and Changes* was built on that premise, but then Larry developed something called the "RSVP cycles," which he used for workshops, that made it even more inclusive.[6] That gave me a *method* to use for creating dance.

JB: But wasn't it a little more reciprocal than that? Because Larry must have been influenced by your...

AH: He was influenced by my workshops.

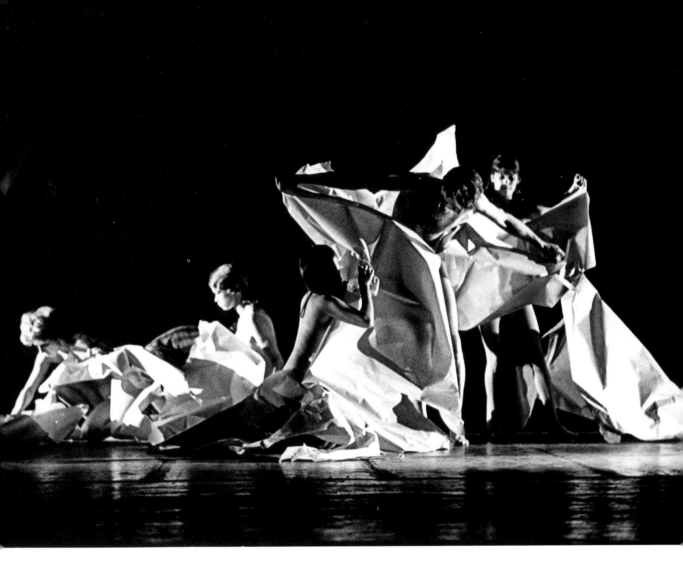

Anna Halprin, *Parades and Changes*, 1968. Performance documentation. Photo: Paul Fusco. Courtesy of the artist.

JB: I'm struck by the use of the term "score" in the RSVP cycles. Where did that term come from? It's interesting that Fluxus artists like George Brecht began using the term "event score" around 1960. You knew some of the Fluxus artists. "Event" came from science; George Brecht was a scientist. But "score," for the Fluxus artists, came from music, from Cage, because many of them studied music, too. So was music the origin of "score" for you and Larry?

AH: Actually, Larry came up with the word "score," and I immediately dropped "choreography" and starting using score. Now dancers are using it. I don't know if they use it in New York, but in San Francisco that has become the term.

JB: So it was Larry who came up with the process, and you who adapted it to dance?

AH: Right, but in order to utilize the RSVP cycle, you need to do it in a workshop setting, and Larry had never done workshops before. That he got from me.

JB: Around 1960 you began working with Terry Riley and La Monte Young, who was shortly to move to New York and become a founding member of Fluxus.

AH: I was too. We used to send scores back and forth, but at the time we weren't calling them scores, because we hadn't developed the RSVP cycle yet. *I* called them "events." On the east coast, they were calling them "happenings"—people like Kaprow—but I didn't know about it then. And Fluxus—George Maciunas would write to me and ask me to send him what I was doing, and I said, "Well, we do events, and we have a workshop." And so I would send him things. There is an event that Larry and I did, *Landscape Event*. You pull it out; it's a score of a city dance, all folded up. It was in a wooden box [*Fluxus I*, 1964], and as you opened it there were all these different things. Our contribution that year was this folded thing.[7] And I remember setting up correspondence with Yoko Ono. She would send me events. One of them was a falling event, and I remember doing it in San Francisco, where every five minutes people would just let loose in the city—every five minutes fall, wherever you are.

JB: One of the intermedia categories that has become ubiquitous is so-called performance art. What, for you, is the difference between dance and performance art?

AH: We do performance art too; it's just a matter of emphasis on multiple media. For example, I did an event called *Blank Placard Dance* (1968), where my San Francisco Dancers' Workshop marched down several streets in the Civic Center area carrying placards. The performance looked like a typical protest march, but there was no message on the placards that were being waved in the air. That was a performance art piece. It was done by dancers, but it could have been done by actors or anybody. I don't know that *Blank Placard* was even a dance. It was whatever it was. I love performance art…

JB: How would you describe your current practice?

AH: Well, I teach all the time, ever since I was twelve years old. I used to get all the kids in the neighborhood together in my backyard and I would teach them. I teach all kinds of people, not just dancers. Teaching, for me, is having a wonderful laboratory where I can develop ideas and experiment. I take very seriously whether what I'm experimenting with or exploring in my lab is useful to the people I'm working with, but it's also very important resource-gathering for me. I'm always finding something new that opens up new venues for me.

JB: You've been performing, as well as doing workshops, a lot recently. So you're not slowing down at all?

AH: It's just my subject matter, which is more appropriate for my age and for my life experiences.

JB: You turn ninety this year. What advice do you have for young artists today?

AH: As your life experience deepens, your art skills expand; as your art skills expand, your life experiences deepen. Build on that. Don't ever get discouraged. Every single thing in your life, even things you think are a curse at the moment, will turn out to be a blessing, because everything that happens to you in your life is a resource for your personal development. If you look at your life as art, there is nothing in your life that can ever pull you down.

Notes

1. Halprin says *Intensive Care* grew out of her experience of being a cancer survivor: "It took me years to be able to deal with the fear I experienced and the emotional upheaval that I went through as I confronted my mortality. It was like instant enlightenment at gunpoint. Years later Larry went through a similar situation when he was in intensive care for a month—that's where the title came from. As I was dealing with his facing his mortality, it stirred up things in me. It started as a solo, but I wanted to expand the idea of the dance so it wasn't so personal and to explore our differences around these themes and to find our commonalities."

2. Margaret H'Doubler wrote an influential book, *Dance: A Creative Art Experience* (New York: F. S. Crofts, 1940), whose title, Halprin points out, was based on John Dewey's *Art as Experience* (1934).

3. Peggy Northrop, "Man In Space," *San Francisco Examiner Image Magazine* (August 3, 1986), 25.

4. Janice Ross, "Anna Halprin and the 1960s: Acting in the Gap between the Personal, the Public, and the Political," in *Reinventing Dance in the 1960s: Everything Was Possible*, ed. Sally Banes (Madison: University of Wisconsin Press, 2003), 29.

5. When Halprin's company performed the work in New York, she was issued a subpoena and could not return to New York for a year.

6. Landscape architect Lawrence Halprin's workshop approach to collective creativity, which he called "Taking Part," was designed to foster collective creativity through a process Halprin dubbed "RSVP." The initials stand for Resources, physical and human (including motivation and aims); Scores, or instructions; Valuation, meaning analysis and decision-making; and Performance—not just the end result, but the entire process, including its implications. Lawrence Halprin and Jim Burns, *Taking Part: A Workshop Approach to Collective Creativity* (Cambridge, MA: MIT Press, 1974).

7. According to Jon Hendricks, it was announced in a prospectus for Fluxus Yearboxes that Ann Halprin (she would later change her first name), "with her workshop … would contribute 'Landscape score for a 45 Minute Environment' to *Fluxus No. 1 U.S. Yearbox*." *Fluxus Codex* (New York: Abrams, 1988), 260. The score for the Halprins' *Landscape Event* was printed in 1963 or 1964.

City of Art

MICHELANGELO PISTOLETTO

interviewed by Mary Jane Jacob

Mary Jane Jacob: You founded Cittadellarte–Fondazione Pistoletto in 1998 in your hometown of Biella in the Piedmont region of Italy, and converted a textile factory complex into a center for the development of innovative projects in diverse fields. In recent decades we have seen others renovate abandoned nineteenth-century industrial sites into spaces for private contemporary art collections, museums, or artist's studios, but you opened this space to others to come and work.

Michelangelo Pistoletto: I conceived Cittadellarte as a great laboratory, a generator of creative energy with the basic objective of making artistic interventions in every sector of civil society. The name incorporates two meanings: that of the citadel, an area where art is defended, and that of the city, which corresponds to the idea of openness and interrelational complexities with the world.

MJ: So how does art fit in?

MP: Here art, as a primary expression of creativity, assumes a social responsibility, playing an active part in the construction of a new civilization on a worldwide scale. We aim to inspire and produce a responsible change in society through ideas and creative projects.

MJ: With such an ambition there needs not only to be a commitment to change the mindset of people, but also to invent and introduce new practices.

MP: To contribute responsibly and profitably in addressing the profound need to make changes in our age, we set up a structure of offices, or *uffizi*, each of which carries out its own activity in a specific area of the social system. But I also believe that personal initiative can play a part, based on individual responsibility rather than on ideological creed. Each person is, in him- or herself, society, and has to be aware of and participate in every function that concerns society. In my view this could

This interview was conducted on May 21, 2010, at Fondazione Pistoletto, Biella, Italy.

be taken as a formula for democracy. So we start small and, like cells, grow bigger to inspire others too. Our logo represents the cellular structure of Cittadellarte, and Cittadellarte reflects this in the way it organically functions.

MJ: Was this strong, bold step a shift away from the art world for you? Is it a change of course, or is it the same course?

MP: Cittadellarte is the evolution of my work. At the beginning of my research in the 1950s, painting had become an expression of the autonomy of the artist. At the same time, it caused a strong existential crisis. Because artists at that time created individual signs, not the sign of religion or politics or the economy, but an individual sign. The responsibility of artists to their signature started in the Renaissance, as the artist became more and more individual and autonomous, less representative of social systems. The last point of this journey, for me, was the abstract expressionist artist. This was the extreme moment in the 1950s when the artist felt responsible only for his own sign in the world. It was his right. Subjectivity became the basis of the work.

MJ: And did you see an inherent problem in art being identified only with the artist unto him- or herself?

MP: I realized it was not possible to repeat this same reconsideration of the self as the final point. Meanwhile I was suffering from a kind of aloneness of the artist as a human being. The exclusive subjectivity of the artist generated an unsustainable existential crisis. For me the autonomy of the artist had to be extended to the wider community.

I felt art needed to deal with the loss of civil balance in the twentieth century. This had troubled me deeply since the 1950s, and I have steered my work in the direction of individual conscience and interpersonal responsibility. And all the problems that I felt existed around me—fascism, communism, religion, war—were the perverse result of institutions saying one thing and doing the opposite.

MJ: And you saw that being an artist was a way to confront these problems in society?

MP: I understood that modern and contemporary art were the only free space where one could take responsibility for society, where one could understand the world.

MJ: What kind of work were you making in the 1950s?

MP: At that time I wanted to bring back the human image. The artistic tradition of Italy is figurative because it comes from the history of Christian religion. Religious images take us into the Renaissance and the artist's vision that created perspective. Perspective was the scientific description of the world, carrying us to modernity. I used an element that was basic in my culture, the Christian icon: an image on a gold background. I had grown up with icons; my father was a painter and restorer, and I learned painting from him. In keeping with this tradition, I wanted to put the person together with the background—the essence of the world. But I had to discover my own path to give meaning, not only to the person at the center of the icon, but also to what is around the figure and in the world.

First, I transformed the icon into a self-portrait, looking at myself not in an abstract but a figurative way. I felt a necessity to understand who I was and what I was. It started from the self-portrait, looking at myself in the mirror, but the problem was to transfer the reality of the mirrored image onto the conceptual frame of the canvas. At that moment I

was using different mediums to make monochromatic backgrounds (gold, silver, copper, and other pigments). Then when I finally painted a very shiny black monochrome, for the first time I saw my own image when I looked into the canvas.

By 1962 the mirror as the picture plane (eventually, I used mirror-finished stainless steel) became the medium in which I recognized myself. And at that moment, I also saw others passing in the same room. They were inside my painting! The viewers had entered my work and became part of it. So I started to look into the work in order to discover the phenomenology of existence. Finally, I couldn't paint my image with a brush anymore, because the brush produced an individual mark. Even if you make it very realistic, it's always a specific sign of you. I had to eliminate the individual mark. So I used photography to fix the image on the mirror. Photography—in a way similar to the reflection in the mirror—is automatic and more objective. I put together the memory, caught by photography, with the present, which is changing in the mirror, and will always change. Even somebody who is not born yet can be present in it in the future.

MJ: So they will become part of the work.

MP: It is the reality of the universe that is represented.

MJ: And at the same time dynamic.

MP: Time and space are joined in the mirror paintings: static and dynamic, absolute and relative, chaos and order. Opposites are joined but without drama. Such a work peacefully reflects society, and I am in the picture with the viewer, not an artist alone but part of the same world. In the mirror paintings the self-portrait of the artist becomes the self-portrait of the world.

Later, in the sixties, I felt the necessity to start to move away from the virtual representation provided by the mirror and to bring its meaning into the physicality of the world. In 1967 I opened up my studio in Turin to poets, musicians, theater people, and filmmakers. We put our different artistic languages together and started to do creative collaborations.

MJ: Was this a move against the object and the system of galleries and museums?

MP: I wasn't against art institutions; I respect museums. I respect everything that protects art. But institutional protection can become economic and political protectionism. My studio was an institution, as is the gallery, the museum, or the theater. With these other artists I formed the group "the Zoo," which meant coming out of the cage and into the street. This happened at a time when everyone went into the street looking for freedom, looking for other dimensions, trying to gain expression and space. In the early seventies this dream turned into a political nightmare. But I never stopped trying to work in that direction.

MJ: How did you find a way to continue?

MP: A chance came in 1978–1979 when I was invited to Atlanta to do a citywide project. I organized "Creative Collaboration" and invited the American composer Morton Feldman to join me, along with two Italians—jazz musician Enrico Rava and theater director Lionello Gennero. Together we developed works with local artists from different disciplines, creating artistic activities all over the city. It was an exciting time to be there; we were guests of the first black mayor of a major city in the American

south, Maynard H. Jackson Jr. Something had changed in that city. Now in the United States, "we" have a black president.

Another opportunity, in 1991, was when I started to teach at the Fine Arts Academy of Vienna. This was just after the Berlin Wall came down and the world of communism dissolved. Vienna was the arrival point of a kind of exodus of artists from the east; they were discovering a new world through art. It was a fantastic experience for all of us, and we started to work around the concept of interdisciplinary activity.

MJ: Did that moment teaching lead to making a school at Cittadellarte?

MP: The first thing I made here in Biella was the University of Ideas—UNIDEE—a residence program based on interaction between different artistic languages and connected to other social sectors. I would say that it developed from the Viennese experience.

MJ: And so that was the start of Cittadellarte?

MP: Even before that, in 1994, I published the manifesto "Progetto Arte" saying that it was time for art to connect all the sectors of social life and become the basic energy for the responsible transformation of society. I made a list of the sectors that comprise the civil community: architecture, art, communication, ecology, economics, education, fashion, labor, nutrition, politics, production, and spirituality. Then I started to imagine a project for each one of these areas. For example, for politics, there is "love difference, an Artistic Movement for an InterMediterranean Politic." Later these areas led to the offices, or *uffizi*—each activity that makes up Cittadellarte. The roots were already in the "Progetto Arte" manifesto.

MJ: So by 1994, with this manifesto, you had proposed a new role for the artist, placing art in direct interaction with the areas of human activity that form society. How was your manifesto received at the time?

MP: When I presented it publicly in Italy and Germany, everyone said, "Wow, good, fantastic. But this is utopia." I said, "Yeah, it's utopia, but at the same time, maybe not, because it's a project."

MJ: I suppose people thought it was a utopian vision because it did not exist. But I also suspect they thought this because it was the proposition of an artist. They see art as a world of illusion and fantasy, not reality.

MP: Absolutely. Fantasy is the moment of the first projection. Utopia is the basic energy, but just the beginning. Then when you make projects, it is no longer utopia. When you have a project, you start to move into reality. And whereas the word "utopia" means no place, I had had a place in mind since 1991, when I purchased a former textile mill in Biella in order to realize the project. You transform no place into a place. Here it's not utopia anymore because we have this place—Cittadellarte—a place where we work.

MJ: And it starts to become real.

MP: Here we work together, because I can't make a social transformation alone. I need others. Yet in the future, I think that Cittadellarte can go on without me, going ahead with the others.

MJ: And with this program you dedicated yourself to the responsible transformation of society.

MP: Now is the time we have to reexamine the past in order to move into the future. We

Michelangelo Pistoletto, *New Sign of Infinity*. Courtesy of Citladellarte-Fondazione Pistaletto.

have to transform. This is why I call this project a social transformation, not a social break or revolution. Transformation means to change what exists. I respect the past, even if I criticize it. Because it exists, I have to take it into consideration. It has value. It is where we are from. We have to look to our past in order to understand when we have been right and when we have been wrong. If we don't analyze our past, we can't reorganize our future. Then you understand, too, how the mirror changes our perspective, making us not only look ahead but also back.

MJ: And are you also still making art on your own, solo?

MP: While with the mirror, I sought to eliminate symbols, now I am starting to make new symbols. The most inclusive is the Third Paradise, made by adding a third circle between the two circles of the mathematical infinity sign. This circle represents the womb of a new civilization.

MJ: What is the Third Paradise?

MP: The first paradise is primordial nature. The second is the artificial paradise of humans, who broke away from nature to shape a world that eventually became totally artificial and in conflict with nature, creating global processes of degradation. The Third Paradise consists of uniting artifice and nature to restore life to the earth and ensure the survival of humankind. Paradise means "protected garden." Our garden is planet earth. This planetary garden is the Third Paradise, and all human beings have to become increasingly conscious of their responsibility as gardeners, as makers of their own environment.

The Third Paradise is not a prophesy of a future imbued with metaphysical hopes but a real commitment to carry out transformation that affects every area of human life and to channel everyone's mental and practical energies into attaining a balance between nature and artifice, reason and emotion, the individual and society, public and private, the global and the local.

MJ: And how does art fit in? What can art do?

MP: With its independence in the last century, art gained enormous freedom, which today carries enormous responsibility. This places the artist at the center of any prospect of responsible change of society. Art also takes on the spiritual values humanity needs.

MJ: So art makes the state of things greater, stronger.

MP: Art, as I said before, is the first expression of the mind. This is why it comes before religion, and religion is the basic component of the social construct. Thus, the place of art is at the center of the social system.

MJ: So art has always had a primary role.

MP: Artists have a role of responsibility not only because they are creative but also because they are free. Now art must re-view the film of past history and develop new scripts for the future.

An Outbreak of Peace

JITISH KALLAT

interviewed by Madhuvanti Ghose

Madhuvanti Ghose: Jitish, what brought you to your site-specific installation at the Art Institute of Chicago, *Public Notice 3*?

Jitish Kallat: In the beginning, it was a feeling that going back into the past might help us understand the present. It was really the moment of the Gujarat riots in 2002, which was the culmination of a decade of progressive breeding of intolerance and fanaticism in India, that made me question the very notion of a secular India with which we were raised.[1] I felt that perhaps one might find answers if one went back to the moment of India's independence and looked at the foundational texts of the nation. This is how the first *Public Notice* piece came about in 2003. In *Public Notice* the words of India's first prime minister, Jawaharlal Nehru, spoken on the midnight of Indian independence against the riots and bloodshed of partition, were evoked by hand-rendering them on a mirror using rubber adhesive. The speech was full of hope for the newly formed nation-state, speaking of secularism, tolerance, and peace, which was very much in contradiction with the violence and sectarianism we were witnessing. I would write the text and then set it aflame, as if cremating the speech; the burning of each letter felt like a small riot during the act of making the piece. This burning melts the acrylic mirror, thus distorting the body of the viewer in and around the text. The reading of the text is at all times intersected by a warped reflection of the viewer.

 A sequence of developments in the work around the time that I was making the first *Public Notice* steered me toward the moment of September 11. I made an online project called *Under Destruction* that was shown within the context of a contemporary pan-Asian art exhibition by the Japan Foundation in Tokyo titled

This interview was conducted on February 19, 2011, in Mumbai, India.

Under Construction (2002–2003), which looked at the Asian continent as a work in progress. So my title actually came from an inversion of the exhibition title. On the *Under Construction* web page, there was a link that led you to the *Under Destruction* project, where you find a screen full of peculiar symbols: fingers pointing at each other, blood drops, bomb blasts, skull-and-bones, etc.[2] As you change the font, you will see the Indian National Pledge emerge from these sort of sinister, ominous signs. This piece was linked to the viral perpetuation of fear and paranoia that followed September 11, when e-mails went around the world asking people to change the flight numbers to the font Wingdings, and if you did, you would find a plane crashing into the Twin Towers, and the letters NYC would change to become a Star of David, skull-and-bones, etc. These kinds of e-mails found many recipients who were actively perpetuating the paranoia, as if there were a premonition enshrined within all of this. Similarly there were numerous signs of forewarning ascribed to the numbers 9 and 11.

So in a sense, through the making of *Under Destruction*, I traveled from a very critical moment in India's secular history to another world-changing event, the moment of September 11. I wanted to journey with those numbers 9 and 11 away from all these online myths surrounding the attacks on the Twin Towers to [another] moment in history. That is how I arrived at the moment of September 11, 1893, when Swami Vivekananda spoke at the World Parliament of Religions; held on the site that is now the Art Institute of Chicago. Just as within the first *Public Notice* I was overlaying the moment of the Gujarat riots with the moment of the Indian partition, *Public Notice 3* was essentially a superimposition of the same dates, separated by 108 years, and their varying contexts.

MG: What was your reaction when you discovered that this date had another significance?

JK: I wanted to acknowledge it as pure coincidence, which it is. But at an artistic level, I wanted to view it as a palimpsest with potential, as something that you could overlay to understand the world. The two dates are separated by 108 years. Interestingly, the figure 108 is regarded as sacred in Hindu numerology; it is the number of beads on the Hindu rosary used for chanting that marks a full circle; and it also recurs in ceremonies and rituals across several other religions.

In addition, while one kind of paranoia and one set of myths that followed September 11 emanated from active users of the Web, others were put out by nations, either as acts of self-defense or as a way of manufacturing fear to create consent for military action. This is how I became fascinated by the multicolored terror alert system of US Homeland Security, which was constituted immediately after September 11. In *Public Notice 3* Swami Vivekananda's speech is illuminated, conceptually and actually, in the threat coding system of the US Department of Homeland Security. I find it interesting how the advisory system co-opts five colors from the visual artist's toolbox into the rhetoric of terror, by framing them as devices to meter and broadcast threat (much like its predecessors, the British "bikini alert state" and the French "vigipirate").

SAGO WE MADE A TRYST
AT TIME COMES WHEN
E NOT WHOLLY OR IN
SUBSTANTIALLY AT
GHT HOUR, WHEN THE W
WAKE TO LIFE AND FR

Jitish Kallat, *Public Notice* (detail), 2003. Burned adhesive on acrylic mirror, wood, stainless steel; five panels. Shumita and Arani Bose Collection, New York. Courtesy of the artist.

MG: Yet the Homeland Security alert system had such a global impact.

JK: It did have a global impact. It had a purpose to begin with; one would probably not deny that. But when its purpose is examined a decade later, one wonders what message it gives out if, in that entire time, the threat level would be revised every day and would move between the states of "severe," "high," and "elevated" risk. It would be raised and lowered only within this register, never to be relaxed; it's like a bad weather forecast every day. Interestingly and coincidently, a few months after *Public Notice 3* opened, Homeland Security put out its plans to revise the use of the codes.

MG: Janet Napolitano, the secretary of the Department of Homeland Security, is considering releasing the colors back to your artist's palette.

JK: Yes, released from being an apparatus to meter threat to becoming what they are—an artistic tool, a thing of beauty. *Public Notice 3*, like any artwork, was purely an act of

257 AN OUTBREAK OF PEACE

pointing to a few existing symptoms, signs, signals, symbols to signpost a story about the world with hyperlinks that lead to other stories.

MG: Well, not all artworks.

JK: No, I don't think all artworks do the same thing, but the gesture . . .

MG: But many artworks are not political. To me, *Public Notice 3* was a real gesture, unlike a lot of other art pieces that might be about vital ingredients such as posture, stance, scale, and its physical response to an individual coming from different sites and locations in the world.

That got magnified many times over when it was realized at the Art Institute. I wish there was a way to read or hear how people reacted to the work there and then see how, over time, it may have had an impact and took on a different relevance. When Public Notice 3, the idea, became *Public Notice 3*, the work, and took its tenancy in the architecture of that building, all previous gestures made with reference to this speech in other contexts, such as at the Walsh Gallery in Chicago in 2004 or at the Guangzhou Museum in 2008, seemed like notations.[3]

JK: That's how it looks to me as well. It feels as though these earlier iterations were all preliminary steps leading up to the making of *Public Notice 3*. I was interested in how it began to appear in the blog-space and the virtual discussions that emerged from the piece, several of which were written by people who hadn't seen the piece but were discussing the idea by superimposing the dates and revisiting Vivekananda's words.

MG: In a way this replicates the 9/11 experience, which in fact most people were not witnesses to, and yet there was this viral effect that we were all transfixed by. Similarly, people reacted to *Public Notice 3* regardless of whether they had seen it or not. It had its own life, which is not something you or I envisaged or engineered. I find that there are several interesting themes discussed in the blogosphere conversations as well. How do you feel about the kind of comments that *Public Notice 3* has generated?

JK: The dialogue that *Public Notice 3* has generated is indeed gratifying, and recent collaborations such as the one with the School of the Art Institute and spoken-word collectives such as Young Chicago Authors and Louder Than a Bomb have been invaluable.[4] But if I go back to the very beginning of *Public Notice* in 2003, the reference to history and the need to stay within the framework of a historical speech was really a result of questions directed toward the self rather than to the public.

Of course all three *Public Notice* works take their form and scale with an awareness of the architectural context and audience. For instance, *Public Notice 2*, which was made in 2007, four years after the first *Public Notice*, was also shown earlier this year at the Kennedy Center's Hall of Nations in Washington, DC. The juxtaposition of the work with every possible flag in the world hanging above the piece created an interesting contextual canopy for it. In *Public Notice 2*, Gandhi's speech calling for complete nonviolence in the face of complete civil disobedience is rendered in the form of approximately four thousand five hundred re-creations of bones shaped like

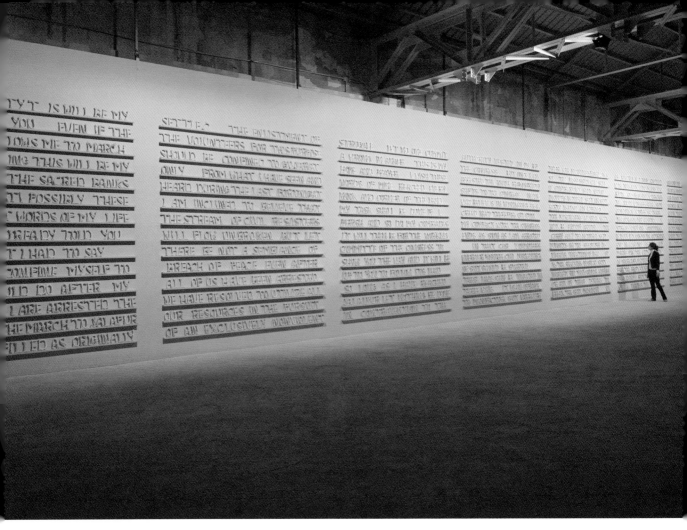

Jitish Kallat, *Public Notice 2*, 2007. Resin; 4,479 sculptural units. Installation view, Saatchi Gallery, London. Courtesy of the artist.

an alphabet. On the 11th of March, 1930, prior to setting out to break the brutal Salt Act instituted by the British, Mahatma Gandhi laid out the codes of conduct for his fellow revolutionaries, the only fierce restriction being that of maintaining "total peace" and "absolute nonviolence." The speech has within it several themes that may aid our ailing world, plagued as it is with aggression.

Shaped as they are like bones, these are words that are not only to be read but also seen, as they collectively evoke imagery; the viewing of forty-five hundred bonelike letters evokes other memories of death and violence.

MG: Which is terribly pessimistic. Underlying all the *Public Notices*, there's a tremendous discordant note of being confronted by the reality of our present, and then trying to find meaning and answers.

JK: One could say that. *Public Notice* was made of charred words, *Public Notice 2* (2007) of words fashioned like fossils and placed like relics on shelves, while *Public Notice 3* (2010) is made of 68,700 light bulbs collectively holding up the chorus of threat.

The warped image of the self in *Public Notice* that appears in between Nehru's words intercepts the reading of the piece, just as the act of confronting Vivekananda's words in the interstitial space of a staircase as one ascends and stepping on threat levels as one descends is integral to the reading of *Public Notice 3*.

MG: If one really thinks about what Code Red means on an individual basis, you're supposed to seal your window, have your provisions for three weeks, not go out. If you look at what that means, you're bunkering yourself away from the world, because everything outside your window can potentially destroy your being.

JK: Yes.

MG: Because when we view something, we bring our history with us, so it always has that very personal element. At the same time, there is a kind of group psychosis about a general impression that a work creates. But in some ways, I guess we don't want to confront the true horror of what a Code Red would be, because we don't want to face that. Which is why all the colors were so problematic for us to even think about. How often do we think about the blues and greens?

JK: In other words, the "occasional outbreaks of peace."

MG: Yes. But in our perception, it's been one of heightened orange. I can't think of any other color that so dominates our popular imagination.

JK: That's right.

MG: I found the physicality of the experience really fascinating. People who view the work as pictures on their computer screens might lose that: the experience of actually confronting it or actually walking in that space, enveloped by the lights. Sometimes when I had time, I would just go and watch people's reaction to the work as they climbed up and down the stairs, peering and bending down to look at specific words or phrases, or considering their reflections on that glass behind the big Tang period Buddha cloaked in the Homeland Security terror-alert colors. And also the fact that certain words pop out more. It's almost like a sense of awe with which they confront the installation. I remember particularly a senior government minister from India coming and seeing it on a Sunday night; it was dark and just the lights on the staircase were on. And the sense of awe he had, as he walked up and down the stairs, viewing the letters and words. I'll never forget his sense of awe as he first saw it, and he said, "Oh, my god."

JK: I've enjoyed the experience of the piece once it becomes dark outside and the illuminated words get an amplified presence within the museum.

MG: Events that took place in the United States on 9/11 were global events. They had such an impact on all of us, it parallels the initial moment of the speech by Swami Vivekananda. Could you talk about the 1893 World Parliament of Religions, where his speech first took place, and the reaction it had?

JK: What intrigued me the most about the moment of the parliament was that this was prior to the world wars; it was prior to those active colonial annexations of one nation by another. For those organizers in 1893 to locate the potential site of human conflict within the space of religion, and to create a global space to

converse about these things and link the world on the basis of faith, seems full of foresight. As we see today, it's no longer nations at war, but faith and ideology.

MG: The World Parliament was all about trying to understand each other. The local leaders, with their desire to reshape modern Chicago in the aftermath of the Great Fire, took this international approach to it.

JK: An "interfaith" approach.

MG: Yes. They brought religion into it with an understanding of other faiths, particularly Asian faiths, as part of this exercise, at a time when we were so immersed in our colonial experience—that is such a fascinating thing for us to contemplate.

JK: In some ways, being the first parliament of this nature on a world scale, one can think of it as a foundational moment in the formation of the faith landscape of the world, just as the moment of Indian independence becomes a foundational moment in

the history of the subcontinent. To me as an artist, it was really about finding these heightened moments, and revisiting them to understand another moment.

MG: But also the juxtaposition between the hopefulness of these people who are trying to put an open dialogue together on faith, versus the reality of this other event that happened on that day 108 years later.

JK: And we see the same inversion with Nehru's words—the moment of independence and the aspirations for a secular state—and the reality that has emerged, which is almost a complete inversion.

MG: It's like a cycle of hope, and the reality of what actually happens. Then you have to reassert hope, because otherwise it would be too difficult to carry on. The modernism we have experienced in India is built upon Nehru's dream of a modern India. It is based on both optimism and the reality of an India that was, at the time of independence in 1947, poverty-stricken, uneducated, ill prepared for independence—and his attempts to reshape a secular nation out of a nation of believers. In a way, that underlies your *Public Notice* work. How do you view that period of Nehruvian optimism that shapes our looking, as Indians, at our postcolonial experience?

JK: Nehru's speech, delivered with optimism at a moment of the euphoria of independence, is likewise marked by a great sense of pain, at a time when a part of the body of this big nation had been amputated and separated.

MG: And in the midst of such terrible riots.

JK: Absolutely. So in a sense, all notions of nation formation and hope—those are part of that speech, are equally drenched in a certain kind of fear and blood, and another kind of pain that the partition brought with it. And in a sense, as we see the reinscription of mistrust by the divisive politics of today, we almost see a replaying of the moment of partition, in the way wounds are constantly being reopened.

MG: It's like a scab that's never had a chance to heal, because you're always picking at it.

JK: That's right.

MG: In the optimism of India's future, we tend to stop and say, "Where did it all go wrong post-1947?" In a way, I see it as a kind of historical progression, where the start-off point was so difficult that these were natural steps—faltering steps—that a young nation took to come to this point from the tremendously religious- and caste-based society that we were trying to get ourselves out of. I think when you have a population that is this diverse living so close together, it is natural that there will be moments when it flares up, and then you go back to the status quo.

JK: An outbreak of peace happens.

Notes

1. In Godhra in the western Indian state of Gujarat in 2002, Muslims were killed by Hindu mobs on a rampage, purportedly in collusion with the state administration and police, in retaliation for their having torched a train carrying Hindu activists. These were probably the worst communal riots since the partition of the Indian subcontinent in 1947.

2. The site, http://www.operacity.jp/en/ag/exh37.php, is currently inactive.

3. In 2004 Kallat exhibited his previous work *Public Notice* (2003) at the Walsh Gallery, Chicago, and *Detergent* (2004) in 2008 at Guangzhou Museum, China. These earlier works now feel like earlier renditions of *Public Notice 3*.

4. This collaboration culminated in the performance *Ekphrasis*, held on the tenth anniversary of 9/11, a program of spoken-word poetry and hip-hop dance by Chicago youth. Created in response to Kallat's *Public Notice 3*, it was organized by the School of the Art Institute of Chicago's Departments of Exhibitions and Exhibition Studies, and Art Education; the Art Institute of Chicago's Department of Asian Art; Louder Than the Bomb; and Young Chicago Authors.

Raising the Roof

AI WEIWEI

interviewed by Jacquelynn Baas

Jacquelynn Baas: What is art for you? What is it that you practice?

Ai Weiwei: Art is possibility. It's not what has been done, but what hasn't been done. It is a practice of our mind, and the questioning of this practice for humanity and the whole civilization. Art is a continuous attitude toward our life, in every aspect.

JB: Your father was an important modern poet. Your own vocabulary of forms, especially your architecture, is modernist as well. Do you consider yourself a modernist, and if so, what does modern mean, in the context of contemporary China?

AW: I'm modernist in the sense that we have to give a new definition to everything. In our times, we need to be ready to face changes. Being in a continuous process of change is a way to admit to your own conditions, to renew yourself, and to be self-critical.

JB: So does this relate as well to the context of contemporary China? Is it different to be a modernist in contemporary China?

AW: Contemporary China has its origins less than a hundred years ago. The first generation opened the door to democracy and science. Before that, China was a completely closed-off society. The Chinese thought of themselves as the center.

JB: No consciousness of the world beyond.

AW: Yes. Then came an opening of the wall. However, all the big nations—the French, the British—invaded with gunpowder, so the dream was shattered. The modernists then started, but we were far behind in the industrial struggle, scientific development, and a democratic society. From the very beginning, the modernists thought that China was ill. When the Kremlin Palace was attacked during the Russian Revolution in 1917, to China it signaled the possibility to destroy the old world and build a new world. It was the starting point.

Ai Weiwei, *Fountain of Light*,
2007. Courtesy of the artist.
Photo courtesy Tate Liverpool.

This interview was conducted on May 18, 2010, at Ai Weiwei's studio in Caochangdi, Beijing, China.

Ai Weiwei, *Fairytale*, 2007.

Courtesy of the artist.

JB: The modernist impulse.

AW: Yes. In Russia, in China, and in many countries, communists struggled. The ideology is Karl Marx's *Communist Manifesto*. His first point was: we want to destroy this world. There was no hesitation, no negotiation. It openly declared that this world has to die, and we have to build a new one.

After fifty years of ideological and political struggles—sixty years for the Russians—we became different societies. China has become a capitalized society, but still under a *tough* communist regime, while the Eastern bloc has become a free world. The Cultural Revolution of the sixties influenced Western countries with the red guards and anti-American sentiments. Liberal intellectuals in the West— poets, writers—wanted to make social and political change. The world has now become globalized. Through Internet technology, it is well connected. China has become more culturalized and materialistic, but under this communist dictatorship, still an authoritarian society.

JB: And they seem very technologically adept.

AW: It became a postmodern society with mixed ideologies. It's communist and capital-

ist at the same time—it's a very interesting society. The struggle still continues and anything can happen, and it moves very fast.

JB: So things are still evolving, and you believe new things are possible that would . . .

AW: You can feel the sense of *new*, the sense of "change is in the air" every morning. It isn't so in many societies—not in old Europe, where you don't have a sense of change, because change is not possible.

JB: So even though there's still a great deal of repression here, there's an equally strong possibility of change, or almost equally strong possibility of change?

AW: Yes, because the repression—the old structure—obviously cannot work; despite that, it's still working. The new generation from the eighties and nineties are quickly becoming the people who will take charge. This generation learns from the Internet. They are much more open, and their structure is different from the old society.

The pre-Internet society was based on structure and power. Its ethics came from a long history of human struggle. I think the individual has now become a true individual. You can freely select information, build your own knowledge, and express yourself. Humanity has never had such an opportunity. Previously we were limited by our family, location, economic power, and associations. That structure is deteriorating because of the Internet.

JB: I went on the Internet this morning to try and do some research and got a big message saying, "FORBIDDEN." So the government does try to keep people from getting information.

AW: The communist government has spent a *lot* of money on censorship since the beginning. Chairman Mao openly said, "We can control this world. Our Communists will come into power because of two barrels: the gun barrel, and the pen barrel. The gun barrel will take over the power, and the pen barrel will control people's minds."

It's brutal and it's violent, but it's the most efficient way to control *anything*. That's why we don't have free press; that's why we don't have free information and we cannot allow people to express their minds. My name cannot be typed on many Internet sites in China. What will appear is the phrase "illegal words being used." Now, the question is why such a strong nation, with sixty million Communist Party members, *all* the resources, military, police, undercover agents, and so on—wouldn't let this name appear.

Last year, they spent over forty billion Chinese yuan on maintaining stability, which is just a little bit higher than maintaining the military.

JB: So the pen barrel is costing more than the gun barrel.

AW: Much more. If you saw how they did the Olympics, or the Shanghai Expo, then you'd see how much they're paying for what they understand as a necessity. They're so *frightened*, because they think if one day they don't do it, it's going to be the end of the world.

JB: And that's a sign of weakness to you.

Ai Weiwei, *Fairytale
(accommodation)*, 2007.
Courtesy of the artist.

AW: Yes.

JB: So going back a few years, I was struck while reading your biography by how you solved the problem of your father hitting his head on the ceiling of the bunker-type dwelling where your family lived in exile by lowering the floor.[1] Your solution was simple, though hardly obvious, and the process must have been quite labor intensive. Might this be considered your first artwork?

AW: Yes. I was ten. As a punishment during the Cultural Revolution, they said: "You have to live underground." We walked into an abandoned excavation with just a roof; you could barely walk in there. It was completely dark; there was no window, just a small hole. I remember it vividly.

When I followed my father in, immediately his head hit something. He knelt down because the blow was very strong. Because we could not raise the ceiling, the only thing we could do is to dig deeper, one step deeper, one shovel deeper.

Throughout the history of China, people have been trying to dig a little bit deeper rather than to raise the ceiling. I'm tired of it. I have to raise the ceiling as *much* as I can.

JB: And make architecture with high ceilings and straight lines. You seem to be something of a modern renaissance artist, with art productions that encompass architecture, objects and installations, photography and media, books and archives, and now social media. What is the thread that runs through your production? What's the through-line?

AW: First, I don't believe in "professionals." Second, life starts as a miracle, it bears meaning that you can never really understand, and it will *end* as a miracle. It is a pity to categorize it. We came to experience, and to share our experiences. We came to be influenced by, and to be an influence to others as part of a society. We do this by any possible means, and we adjust ourselves to different conditions, which can mean that you end up in jail, or you become some kind of public celebrity or artist or writer or . . .

JB: Or *both*.

AW: Or both. But that is just the surface. What does it mean? It's to *celebrate* life. We have to explore. We cannot accept whatever knowledge and "answers" we are given. We are not just another generation. We have to make an announcement, to shine our light over humanity, and to surprise ourselves. It doesn't matter what you *do*, but to limit the *way* you do it is not going to achieve anything.

JB: My next question carries on from this. You have said, "All creative acts are ultimately the same. Everything is part of the same thing and it is that thing that should really fascinate us the most. Art is just a means to exploring that."[2] These statements strike me as very Taoist. I know you are not religious, but to what extent has ancient Chinese philosophy been a resource for your thinking about art and what art is?

AW: That's very difficult to analyze, it's like asking me to isolate to what degree gravity relates to my job. Hmm?

JB: So it's a very Western question.

AW: Oh it is. We all know gravity's there, but we never "know" it. Yet all movements somehow relate to it. I grew up in a society that destroys the old. But any true destruction needs an understanding of the nature of what you're destroying—otherwise you cannot really destroy it. So I can't *know*; I *don't* know.

JB: In 1981 you moved to the United States for twelve years—first to Philadelphia and then to Berkeley before settling in New York. Was it in Philadelphia in 1981 that you first saw the work of Marcel Duchamp?

AW: Yes.

JB: What was the effect? When you saw Duchamp's work, you must have seen *Étant Donnés*, because you've referred to that work, and that was on view at the Philadelphia Museum at that time. And, of course, all the other work they have there. What was the effect on you?

AW: It's a funny story. I grew up in Xinjiang, which is northwest. If you look at the United States map, it's Washington State. And New York is . . .

JB: Opposite.

AW: Yeah. So my father was exiled, and afterward I went to a film university. During that time, a famous translator gave me three or four small books, catalogs, about Western art. I remember three of them were about impressionists: Gauguin, Van Gogh, and Manet. I loved Manet a lot. But there was another book; it's square, and it's about Jasper Johns. I tried to show people this American artist, but nobody understood. *"Yellow, Blue, and Red*—what is this?" It was because of the classic training we had. Nobody cared about ale cans, or whatever.

Then I went to the United States. And in Philadelphia, of course, we saw the museum, but there were more interesting things to me at that time in Philadelphia, like Rodin's sculpture garden. I could not associate Jasper Johns with the museum. If we went there to see anything, it was Rembrandt, the Old Masters. I could not understand Johns's American flag. But after I moved from Berkeley to New York and attended Parsons, I started to find Jasper Johns a charming American artist. I was in love with what he did, and I forgot about the impressionists; I had no interest anymore. I was fascinated with the language, the kind of play, and the interpretation in what Jasper Johns did. I think he is a hero. And I realized that he was very much influenced by Duchamp.

JB: Johns certainly went to Philadelphia!

AW: Yes! So I realized—I read a book called *Off the Wall*,[3] about him and Rauschenberg, and Rauschenberg trying to steal the sugar cubes from that birdcage.

JB: From Duchamp's birdcage [*With Hidden Noise*, 1916] in Philadelphia.

AW: That drew me back to Duchamp. For *years*, I often went to the Philadelphia Museum but I didn't peek into that hole to the interior of *Étant Donnés*.

JB: It's not very tempting. You look in the room, and it's down there, and you think, "What is that old door?"

AW: Yes, I even purposely decided not to look at it as an artwork, not to *see* what's inside of Duchamp. Because the hole, in the arse, is the only point you can see in that work.

JB: So when you went to Philadelphia first, you did see Duchamp, but you never really looked at him. That was only later, after you...

AW: That's very interesting. You're the first person asking this question. I went to the museum several times and never really paid attention to those things. I saw it as a *stranger*. Then, I saw it through Jasper Johns.

I think he's my teacher, Duchamp, even though I'm not a good student, but still...

JB: Like you, Duchamp held strong individualist, antigovernment convictions. He first came to the United States because he didn't like the wartime atmosphere in France, and then, when the United States entered the war, he left and he went to Buenos Aires. He was very pacifist, very antiwar.

AW: I've never heard about this.

JB: Well, it's not stressed, because the party line on Marcel Duchamp, and you know there is one...

AW: Yes.

JB: ...that he's...

AW: So—anti-action.

JB: Disconnected, above it all, aloof. In fact, if you read accounts of people who knew him, he felt things very deeply.

AW: It *must* be.

JB: And I believe it was for that reason he developed this almost Buddhist attitude of "indifference," taking things as they come. But he was antigovernment, just in general. He was very individualist, like you.

AW: Well, this is all so wonderful to hear, because nobody clearly talks about this, and they always think he's frivolous, insincere. But I'm sure he had his strong attitudes and opinions on this.

JB: So, what do you think Duchamp's intentions were regarding his art practice, and how does your practice differ from his?

AW: Jasper Johns or Duchamp reminded me of the wise men of East Asia, their art is a mental practice. The product is the attitude and the way of understanding life, which is precious and beautiful. The wisdom comes naturally with humor, and it can be so strong and influential. I think that is truly amazing.

I really appreciate how much Duchamp had an influence on me. I can't think without him, or be what I'm going to be. I'm very lucky to know his work and also to know that such an artist can exist in such a time. Of course, there's no *answer* for art; there's no fixed position. We all have to find our own way, our own approach, and our own "game" to play. He said, "There is no solution because there is no problem."

JB: We still have to find a few solutions to these nonproblems.

AW: Even to *that* problem—the problem of no problem.

JB: You have spoken of making "another possibility of a social system which will create a greater space for a different way of looking."[4] Would you say more about perception and perspective?

AW: Even if we think the world is an illusion of our mind (and it *could* be), we have to adjust ourselves to see and to interpret differently. We can make our world rich and different. What you see and what I see in the world is completely different.

JB: Your large illuminated work, *Fountain of Light (Working Progress)* (2007), was a realization of Tatlin's 1919 project *The Monument to the Third Communist International* in the form of a gigantic floating chandelier. Like so many other early Soviet utopian projects, Tatlin's tower never went past the planning stages. *Fountain of Light* would seem to allude to failed utopias. Can you say more about this?

AW: It refers to that, and also to a period of history when humans deluded themselves. They thought everything was possible, that they were really changing the world according to their will, or their dreams. This practice often failed. Even today, with problems of the economy or the environment and energy, we can notice that they are trying to build something that may finally collapse.

As human beings, as a society, this utopian notion is still there, although we have almost come to a point of no return. Technology and our own self-delusion, and *desire*

as a driving force, are all constantly putting society into an embarrassing situation. All that comes from the early thinking of this utopian society. Of course, we always imagine our dream as a particular, nice, sweet thing. But the consequence, the reality, is not exactly like that.

JB: So utopias—just because of our human nature—are always oversimplified?

AW: Purified, simplified.

JB: And so this is what you're pointing out with this piece—with a little humor.

AW: Yeah, floating—the lighting, lighting nothing, floating on water.

JB: You said once that you like the spiral shape, and the devolving spiral of Tatlin's tower strikes you as "a good model of the human mind" in the way that it goes nowhere and ends up collapsing in on itself.[5] But what about the light? I am thinking also of your first piece in this vein, the gigantic *Chandelier* of 2002, which was surrounded by steel scaffolding that the viewer had to enter in order to encounter its brilliant light at close range. Was this a model of the human mind as well?

AW: I think light is an interesting physical phenomenon because it's hard to describe its shape and size, and how it relates to shadows. And Duchamp had illumination in the last work, yes?

JB: Yes, in *Étant Donnés* the nude is actually holding a light, like the Statue of Liberty.

AW: So everything comes back to Duchamp [*laughs*]. It's interesting, because most artworks *are* about light on or light off. Do we see it, or do we not see it? When we see something, what happens to us? And if we don't see it, if we close our eyes, is it still there? It's much like how we look at ourselves—our present, past, and future situations. It is fascinating to look at this aspect.

JB: So again, light, for you, has to do with seeing clearly. How would you describe your current practice?

AW: I more and more take myself, the society, and the current political conditions as a readymade.

JB: All right, Duchamp again. A continuous attitude, like you said at the beginning. And finally, what advice do you have for the young artists of today? What would you say to them?

AW: I think, for students, you're either an artist or you're not an artist. Learning happens not through school but through life. It started before you were conscious of it, and it ends after.

JB: So you came to art school already an artist?

AW: Of course, with education, from the first class to the last class, you're learning. But learning is a long process. Jasper Johns once said that when people asked him what he wanted to be, he would say, "I want to be an artist." And then he thought, "I can't say that all the time." So then he would just say, "I'm an *artist*. I *am* an artist."

JB: It's a state of mind.

AW: Yes, it is a state of mind and it's an announcement. It's about language and how that works with reality.

JB: With the reality of yourself as a readymade.

Notes

1. Chin-Chin Yap, "Introduction: A Handful of Dust," in *Ai Weiwei, Works: Beijing 1993–2003* (Beijing: Timezone 8, 2003), 16.

2. Karen Smith, "Portrait of the Revolutionary as an Artist," in *Ai Weiwei/Illumination* (New York: Mary Boone Gallery, 2008), 28.

3. Calvin Tomkins, *Off the Wall: Robert Rauschenberg and the Art World of Our Time* (New York: Penguin, 1981).

4. Charles Merewether, interview, in *Ai Weiwei, Works: Beijing 1993–2003*, 29.

5. *Ai Weiwei/Illumination*, 82.

Integrating Art and Life

ARTWAY OF THINKING

interviewed by Mary Jane Jacob

Mary Jane Jacob: So just what is artway of thinking?

artway of thinking: artway of thinking is the name we gave to our research on making art in the public context. We started at the beginning of the 1990s, when a new and different interpretation of "public art" was being developed. We wanted to take the US practice of "community-based" or "new genre" public art and see if we could make the processes ergonomic, more sustainable. Creativity, multidisciplinarity, and reading complexity were our main experimental paradigms. Our vision was of a more harmonious relationship between the individual and the environment. This research became for us a metaproject for the optimization of creative collective processes aimed toward a common good. [1]

Then we realized this was more than a two-person project; we were always working with others. So by the mid-1990s we founded the artway of thinking cultural association (*artway of thinking associazione culturale*)—a multidisciplinary organization that activates collaborations among administrative institutions and other enterprises.

MJ: Where did you situate your role as artists?

AT: We imagine an artist as one who operates, together with other professionals, in the development of contemporary society; a professional who is an asset, whose added value is to bring creative thought into planning, who has the courage to imagine outside the norm and bring innovation into production in many realms. With this image of the artist, the question that we have addressed in our research has been How? How can an artist bring creativity into socially responsible transformation?

artway of thinking, *Co-Creation Circle*, 2009. Courtesy of the artists.

This interview with Stefania Mantovani and Federica Thiene began on May 24, 2010, at Fondazione Pistoletto, Biella, Italy, and continued online.

Today, after living through such experiences, we can affirm that making art for us is, in principle, the way in which we create relationships in the world and through which we build life experiences. Being an artist is an expression of the soul that takes form in work and in daily life. We firmly believe that the responsibility of the artist is to act with awareness in order to produce and inspire responsible changes in oneself, in personal relationships, and in society. We have seen that we cannot bring to the world that which we have not already digested ourselves. We have recognized the value of operating in groups, creating together and in an interdisciplinary way. We have made this value our foundation, and from this we seek to activate collective creative processes in social and public environments. And always to bring attention to social dynamics, with an intention to bring these into harmony, while furthering processes of personal and collective growth and positive change.

MJ: How do you guide that development? Can you discuss the structure or your methodology?

AT: The methodological model that we identified for the good governance of collective creative processes is based on phases, dimensions, and tools; it acts on the "creative fluxus," on functions and dynamics, as in game theory. For this we developed a diagram beginning in 2000. It is the image of the methodology that we apply—a methodology that remodulates itself every time to address the given circumstances, yet without losing its essence. It is the vision of the interconnection between human beings and the environment. It is this vision that generates a creative act, responsible and therefore, free. We call it the Co-Creation Circle.

MJ: This is an unusual term: co-creation.

AT: Co-creation is intended as an alternative to the creation of individual artists, authors, or creators. To create together is the goal we set for ourselves. It is an essential theme of our artistic research.

The diagram serves as a map or reference for this collective creative process. It is also a checklist, an evaluation system. By following the diagram, the process can be opened, allowing the process to function as an incubator for one's personal and collective growth, and ultimately, as a generator for innovation that is sustainable and integrated into the environment—that is the totality of the human being, the society, or the ecosystem.

The result of each successful passage around the circle, each completion of a creative process, becomes a seed for the future—a responsible and collective act toward transformation—in which egocentricity and narcissism, as well as interpersonal confrontations, are contained and also transformed.

But it is important to say that all the parts of the diagram were drawn from our own experiments with them. We tested each aspect many times. When we started artway of thinking, we did not have a diagram. But we came to understand that the work was very important, and so we wanted to find a way to share how to do it. We had the will to integrate with reality, and not just overlay our processes onto reality. We had the will to work together. But this was not enough. So we decided to make a diagram. This diagram is the product of our evolution with others.

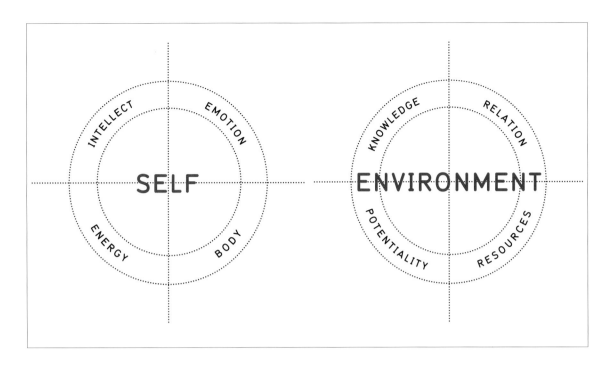

MJ: Did you have certain influences as you synthesized and tested approaches to arrive at a creative understanding of individual and group dynamics and the potential for collaboration, co-creation?

AT: Many. We drew from Georges Ivanovich Gurdjieff's vision of a human being; the transformative value of the self-reintegration of our multiple dimensions, as expressed in the Hoffman Quadrinity Process; Bruno Munari's ideas on creativity; Claudio Naranjo's vision of personalities; the concept of space-time in Einstein's theory of relativity; the idea of unity proposed by quantum physics; the interaction between organism and the environment in biology, as well as Fritjof Capra's research found in *The Tao of Physics*; the metaphor of the butterfly in chaos theory; Ken Wilber's integral theory; the action of the artist as conceived by Marcel Duchamp; Joseph Beuys's idea of social sculpture; and Michelangelo Pistoletto's ideas on the role of the artist in bringing about socially responsible transformation.

MJ: The chart functions on two levels: the individual and the group. The individual level is the baseline; it always is at work because a group is made up of individuals. So the individual, the self, is at the center. Can you explain that core aspect?

AT: The idea and the experience, as we state it, is that "each creation reflects its creator, both individual and group." This means that every creation reflects the human being who thinks, feels, acts. Harmony in the created work mirrors the balance of the individual being. Each one of us has four dimensions: intellectual, emotional, physical, and energetic. We have to harmonize and align these four languages every day, each time, because each one is telling us something. The diagram acknowledges these four aspects in each one of us and collectively as a group. They combine to make up our point of view of reality.

MJ: Moving on to the next ring of the circle, we come in contact with the environment.

AT: The reality around us is telling us something: the diagram acknowledges its four aspects that influence and come into play in the creative process. So if in the first ring we see the Dimension of the Self, then the second one is the Dimension of the Environment, which also needs to be taken in consideration. In the environmental dimension we use the intellect to gather knowledge, that is, all the information we can find in the real world—data, written material, research studies, all the information you can find there. With the emotions we come into relation with others: making connections to other people and to the environment. The physical state of the environment relates to its available material and economic resources. Finally, the energetic state is related to its potentiality for growth and change, allowing for the generation of new points of view.

The four dimensions of the self and the four dimensions of the environment are the two platforms that need to be considered to generate a collective creative process or any conscious action in life. In the diagram, you see that the "self" or the "environment" is at the center of the collective creative process; it represents the reality observed by the individual or the group that comes in contact with it and on which we act with awareness.

MJ: Then how does the creative process begin?

AT: The diagram functions like a map for co-creation processes, a tool to prevent getting lost while working. We divided the process into four phases: Observation, Relation, Action, and Integration. In our research, as we came to understand that creation is the result of the reflection of a creator, and for the group to engage in co-creation it needs to become, for a time, a collective body and take on the identity of "creator," like an individual self, so we use the word "self" at the center.

Observation is when we collect information to produce a systemic vision of the situation on which we will act. And as we observe, we collect information in the four dimensions: knowledge, human relations, resources, and potentiality. During this phase, as in all four phases, the persons in the group need also to remain aware of their own dimensions, as required for inner balance and harmony. For example, if in being excited about all the information you have found, you've become very tired by the end of the day, forgetting to take care of yourself, this diagram can serve as a wellness checklist. But it is almost impossible to be always aware of what we are doing, because we are inside the process. And by nature, as human beings, we are sleepers, so we can't be fully aware of what we are doing. We also introduced the external observer who takes the position of observing the observers—ideally not emotionally involved, as far as possible from the conditions of the environment being addressed, and with an awareness of his or her own state of being. This person can tell you more objectively what is going on. If you do all of this without having someone observing from the outside, you're not being critical. In the collective creative process the external observer has a temporary role, and ideally each participant in the process also has this state of awareness.

And *we* practice all this. We look at the environment, observing the reality of the

situation or problem or set of circumstances. We observe in different ways and with different filters to acquire different types of information from which to understand the reality of the situation. We use also our sensitivity and feeling to connect to other people and establish new relations. We consider the physical condition in terms of resources and limitations, strengths and weaknesses, while staying open and readying ourselves to feel what is the potentiality for growth and the need for positive change. And when we are doing this, we observe ourselves, being conscious and aware of our own state—intellectually, emotionally, physically, and energetically—and we use this diagram to remember those parts of ourselves.

MJ: From the diagram, it appears that once you have completed the observation phase, you gain intuition about the situation.

AT: From our experience, intuition comes during these moments of intense observation. Then in the co-generation phase, we share points of views, perceptions, feelings. A kind of creative chaos ensues as we make new connections, so we must arrive at some consensus, a feeling of unity, to go forward. This comes together in the form of a gesture. Its substantive results are forms of communication and participation in the creative processes by which the group becomes a network that can work toward the common good.

MJ: You have used the word "sustainability" in the third quadrant of the circle. We usually see it used in ecological terms—it's very popular in terms of design today. How do you mean it in regard to the action phase of the circle?

AT: In the collective creative process, sustainability is the harmonic relation between resources and limitations, between the group and the natural and social ecosystem. To have a sustainable process, the group needs to remain open, reconfiguring functions flexibly to take action. Whatever is sustainable can be more easily integrated into the reality of a situation; a nonsustainable action cannot generate wellness and collective growth. So it is necessary to consider the process's sustainability, otherwise what takes place next as an innovation will not be of use, productive, and integrated. We don't want to build new "cathedrals in the desert."[2] Sometimes innovation becomes an obsession for the creator, a fulfillment of the ego. In the world there are many innovations that we actually do not need. Our use of the term is indebted to the 1987 Brundtland Report to the United Nations.[3] When we look at sustainability we take into consideration its four pillars: economic development, social development, environmental protection, and culture. The problem with many artists' projects is that they just do an action without considering the three other parts, sometimes even leaving off the observation part![4] So then their work can never become integrated into reality.

MJ: Then this all comes together in the integration phase?

AT: Any change in a person or society, as well as any innovation, requires time to be absorbed. We need space and time to fully develop a personal or collective process to the point of integration. And we need time to activate the other parts of ourselves. The integration phase assumes this time lag for the "new" to become part of the collective consciousness. When an innovation answers dreams and real needs, it is

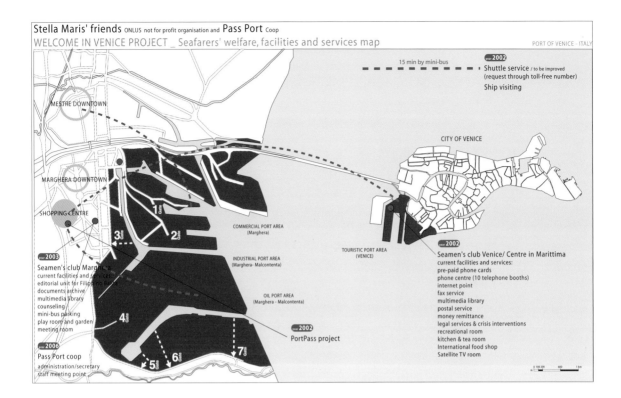

artway of thinking, *The Mestre Project*, 2002. Services map. Courtesy of the artists.

more easily integrated into a living situation; it can create a feeling of collective trust. Trust innately boosts our well-being, which is also essential energy for co-creation. So integration is very important—it is the only way transformation happens in society. Moving from observation to integration, we grow together. And then another need presents itself, and we start the cycle again.

MJ: As we internalize the first three phases in the fourth, we integrate this change into our way of living and our point of view, so that the next time we go around the circle, we start with a transformed point of view, because we have responded to the previous action. László Moholy-Nagy said the artist is the integrator for society.[5]

AT: Yes. This is when the artist has a systemic vision and the feeling of unity inside and outside him- or herself, acting in a sustainable and responsible way toward the common good, and attending to the growth and wellness that includes beauty, poetry (*po-ethic*), and freedom.

MJ: Give me an example of when, as artists, you have been integrators for society—a project in which you think, as artists, you have made an action that became integrated into the larger realm as well as into yourselves, so that innovation was integrated.

AT: In 2001 we were invited to participate to the exhibition *TerraFerma*, curated by Riccardo Caldura, a program of the Cultural Office of the city of Venice and the Venice Biennale, on the occasion of the opening of the Cultural Center Candiani in Mestre-Venice. It was to reflect on the city of Mestre. Our intervention, *MS3*, became a five-year project.

The city also requested that we involve young people in the process. So the first thing we did was to create a group, bringing in young architects and artists, along with sociologists. We did a workshop, learning how we could work together as a group, looking at individuals and group dynamics, exploring the talents and capabilities of each person. Then we went out and observed the context of Mestre. And we did it as a performance called *MS3 H24*: twenty-four hours of observation, from six in the morning until six in the morning the next day, looking at what Mestre was producing. We went around asking simple questions about this place that could create a changed point of view: If Mestre was a person, what would be its personality? Which diseases would it have? Would it be a man or a woman? What job would it have? and so on. We asked these questions to many people—from those in the streets to major urban developers, priests, teachers, vendors, students.... We were followed by journalists who reported on the experience, inviting their readers to come to our headquarters in the Candiani to express their views on Mestre.

During this observation phase, with the ideas, data, and information we collected, we had already started to relate with people by sharing and listening, and to locate possible collaborators. Because when you observe, you start to flow into the cogeneration phase that helps you understand which of the people you meet can be part of the process in the action phase. Intuitions develop. It's like reading; it's a fluid action. The lines in the diagram are an indication but in the process everything is dynamic. So, while we are working to produce a creative collective process, observation and cogeneration are connected. But it's very important to analyze them separately, because otherwise you do an action that is just an emotional reaction to people's needs, instead of a sustainable process that will continue to develop in the future.

MJ: Which is why the diagram becomes a checklist as we move through the process. So what did you learn from the first two phases, looking at Mestre with the people there?

AT: We came to understand that Mestre is a city of water where the water is invisible. Most people who live in the mainland of Venice come from the surrounding islands, and water is part of their heritage. However, in Mestre, the people are separated from the water by an industrial area. Here, water means all the reality of life that is going on in the port. We understood that the port and the people who were coming and going in the port were invisible. We are talking about an area in which three hundred thousand people live, and a port with another three hundred thousand seafarers from 120 countries coming in and out every year. So there are two cities, in fact, and one is invisible. In this we found potential. The goal became to create a relation between the two cities. We intensified relations with the people in the port—authorities and others—and from that, developed an action. The action phase was the result of the observation and the cogeneration.

MJ: What action did you take?

MJ: The action was the creation of a not-for-profit organization with the young people in the group, and also with other elements that we found during the observation and cogeneration phases: the port authority, the city of Venice, port entrepreneurs, and a

artway of thinking, *The Mestre Project*, 2002. Courtesy of the artists.

Franciscan friar who was already helping seafarers. This organization helps seafarers enter the city, because before they didn't have any relation with the city and had no services. Reciprocally, it also opens the port to the city, so that citizens could regain a connection with that lost part of their history. Venetians have always been seafarers.

MJ: This is a volunteer organization?

AT: Yes. It is the Stella Maris Friends' Association/Seafarers' Welfare Venice, and the people working there are part of the original group—artists—along with other volunteers who have joined the mission. At first we led the organization, but after less than two years others were integrated into the system and they went on by themselves. But during this action we found that we couldn't just have a volunteer organization because there were three hundred thousand people.

MJ: There was such a big demand?

AT: Yes, so we needed to find another structure. During the observation phase we got to know a social service organization in Mestre, Centro Don Milani; we had talked with them about the social disease of this city. In the action phase we had asked them if they were interested in integrating seafarers into their social services. So instead of creating something new, we went back to them, and they offered a co-op that they had already formed but was dormant. We said, "You give us the structure, and we will

artway of thinking, *The Mestre Project*, 2002. Courtesy of the artists.

activate it through our process of learning in order to make it an action that functions in the port."

We created Passport, a cooperative in which Federica became vice president for the first year. Passport began with five paid workers coming from Stella Maris, serving seafarers with free bus service from the port to the different areas of the city and giving other services in two Seamen's Clubs. Meanwhile the people from Stella Maris continued with cultural and social actions, promoting the idea of relating the life of the port to the city through events, international and local partnerships, conferences, fund-raising, and memberships. The two organizations are financed by unions, ship-owners, the city of Venice, the port authority, seafarers, and self-generated income.

And now there are two buildings, the Seamen's Club at the tourist port in Venice and another in Mestre's commercial port, where they can find Internet, newspapers, a small bank that allows them to send home their salary, shops with their local community foods, counseling, lawyers, doctors, unions, a lounge, a kitchen area, book and video sharing, and a play room where they can relax. They can receive a "portpass" card to go to shops friendly to them in the city. This was one of the first actions that we made. At the beginning, when we did not have a building structure to provide

the services, we asked the shop owners in Mestre to become friends of the seafarers, welcoming them in with discounts and a good attitude. The shops that take part in the initiative have a sticker on the door, and seafarers receive a map that shows where they are located. There is also a service, so that when seamen are close to Venice they call a toll-free number and say, "We are arriving. I need to go to a doctor. I need to go to a church. I need to go shopping." And there is a little bus that goes and picks them up and takes them around.

MJ: So the integrated innovation is that now there are a host of services for three hundred thousand seafarers that didn't exist before.

AT: The innovation was that these two concrete actions made the seafarers visible. The goal was to integrate the two societies—the residents and the seafarers—into one. A collective process is integrated when the idea that was generated becomes part of the collective consciousness. And now this integration has led to more political and social integration. In Venice a portion of the port that was closed is now open, so Venetians can walk in the port. There are also some departments of the University of Venice IUAV working inside there. Every year there is an event when the port is open to everyone: Seafarers International Day is today a city event. In the past in Italy, seafarers were not considered a category within the society. People would say, "They are workers, so they don't need anything." The offices for social needs are there to help minorities, but there was no category for seafarers. In reality they have many problems because they travel on the sea and things happen there. Maybe they're not paid, maybe the owner of the ship abandons the ship, so they are . . .

MJ: Left at sea—the reality of the phrase.

AT: It's really an amazing situation. But for us, to not even see those people as human beings was absurd.

MJ: The general population may have imagined that the companies took care of everything for the workers aboard their ships, but they also didn't hold them accountable because the workers were invisible.

AT: Let's say that, for instance, one person is sick onboard. When they arrive at the port, if they're not perceived as a human being, they don't have access to care. So our innovation was to put that label on them as part of the society.

Ninety percent of the goods we use daily arrives by sea. Ports are designed to make goods arrive on land as quickly as possible. Very little is done for the workers, who spend six to eight months on a boat without stepping on land. There is also the problem of flags of convenience; the owners of a boat can change the flag according to their needs, and this determines the laws they follow. A ship is like a piece of floating land. So if in Liberia workers are paid five dollars per hour and they do not have human or workers' rights, then that is the way they are treated under a Liberian flag. If in Indonesia there is the death penalty for a person who smokes marijuana, the captain can change the flag of the boat in twenty minutes by Internet, temporarily placing it under the laws of another state based on convenience. So these people that are providing us with what we need, need to be integrated and respected as human beings.

MJ: Seafarers are actually making everybody else's—our—reality possible.

AT: Yet they were not "real." To be very concrete, when we needed funds to do activities for them—if this part of the population doesn't exist—every department we went to said it was not their issue because seafarers didn't exist on their list. So the innovation was to say, "Hello. They exist." And the integration is that after four years of fighting in the courts, now they are on the list of minority groups in our society.

Then innovation on the resource dimension of the environment is that now we have a new reality. Seafarers have places to go to get services. On the knowledge dimension, there is a new law that became possible once it was acknowledged that seafarers exist.

MJ: And on the relation dimension?

AT: Here the partnership with the public administration, local authority, the union, and all the nonprofit organizations and businesses have changed how they feel about the situation, and these people have taken responsibility to act. This innovation produces a new energetic field of experience, a new collective growth.

MJ: And this all began with an invitation from the Cultural Office of the city of Venice and the Venice Biennale. Did they stay in the process, or were they just there for the youth action and performance? Did they know what they were starting?

AT: They stayed only for the first part. From there we immediately shifted into the social and urban issues and began talking to people working in those realms, and the money for the project shifted. This was our work of art. Today we are not part of the two organizations; others are doing the job and pursuing the mission. But as artists we stimulated a new vision for the city and made it possible. From a cultural point of view we also stimulated a new idea of space in which artists can act. From this experience many of the young artists and architects in the group applied this practice in other realms, generating new groups and processes. The curator transformed the city contemporary art galley into "an open space gallery" where artists are invited to work in the city and in participatory projects; the gallery is used as a space to document the process. And processes, if they are integrated into reality, create space to restart the circle.

Notes

1. The public projects and processes of artway of thinking will be documented in a forthcoming book.

2. See Jeffrey P. Stahley, "Building Cathedrals in the Desert: The Spanish American Short Story of the Neo-Absurd" (PhD diss., Boston College, 1997), and J. Hardy, J. "Cathedrals in the desert? Transnationals, corporate strategy and locality in Wroclaw," *Regional Studies* 32 (1998): 639-52.

3. The Brundtland Report looks to sustainable development as that which meets the needs of the present without compromising the ability of future generations to meet their own needs. See "Our Common Future," Report of the United Nations World Commission on Environment and Development (1987), http://daccess-dds-ny.un.org/doc/ UNDOC/GEN/N87/184/67/IMG/N8718467.pdf.

4. In 1998 the French art critic Nicolas Bourriaud pointed to a contemporary art tendency characterized by "a set of artistic practices which take as their theoretical and practical point of departure the whole of human relations and their social context, rather than an independent and private space." Cited in Claire Bishop, "Antagonism and Relational Aesthetics," *October*, no. 110 (Fall 2004), 51–79. See also Nicolas Bourriaud, *Relational Aesthetics* (Paris: La Presses du Réel, 2002). This term has entered art language, seized as a handy moniker for a wide range of art-

ists' projects. Artway of thinking's creative process diagram goes beyond these relational practices. Yet it also clarifies them. By situating the "relational" in the second co-generation quadrant of the circle, artway of thinking shows where relational art lies (usually ending with the gesture in an art institutional space, not always concerned with an action and certainly not with integration), in contrast to their model of artistic practice, which, as the diagram indicates, is completed only when integration into life takes place. So "relational art" is, in fact, an apt label, according to artway of thinking's Co-Creation Circle.

5. "Our time is one of transition striving toward a synthesis of all knowledge. A person with imagination can function now as an integrator." László Moholy-Nagy, *The New Vision: Fundamentals of Design, Painting, Sculpture, Architecture* (New York: W. W. Norton, 1938), 17.

CONTRIBUTORS

Ai Weiwei's artistic practice questions tradition and provokes the Chinese state while forging a position that allows him to influence cultural policy and identity. He speaks of individual experience as "the foundation for social change," a modern conception of art as experience that in turn creates conditions for social change. Born in Beijing in 1957, the son of well-known modernist poet Ai Qing, Ai's personal and radicalized trajectory led him in 1982 to relocate to New York, where he was drawn to the work of Andy Warhol and Marcel Duchamp. Returning to Beijing in 1994, he challenged received notions of modernity, Western influence, and the hegemony of the Chinese system. Since then, he has become something of a modern renaissance artist: his art production encompasses objects and installation, photography and video, books and archives, architecture, and, more recently, social media. His art and architecture references the history of modernism, such as the large, illuminated work *Fountain of Light (Working Progress)* (2007), a realization of Vladimir Tatlin's *Monument to the Third International* (1919–1920) in the form of a gigantic, floating chandelier.

artway of thinking is the name given by Stefania Mantovani and Federica Thiene to their collaborative practice of making art in the public context, which they initiated in 1992 and formalized as a cultural organization in 1996, establishing working relationships with dozens of others from diverse fields on project-based initiatives. Based in Venice, Italy, they are dedicated to experimentation and the development of the practice of community-based public art as a form of dialogue, cooperation, and social development. Their primary research has led to a methodology of collective creative processes. The artway of thinking associazione culturale, founded by the mid-1990s, has engaged in over thirty projects of social change and undertaken methodological models of workshops in Buenos Aires, Chicago, and Panama, as well as many urban centers in Italy. Artway of thinking is also the recipient of various awards, including the CEREC (European Committee for Business, Arts, and Culture) Award (2000), Pistoletto Foundation Prize (2003), and the Regione Toscana, Premio ex/Equo (2005).

Jacquelynn Baas is director emeritus of the University of California Berkeley Art Museum and Pacific Film Archive and an independent scholar. Previously, she served as chief curator and then director of the Hood Museum of Art at Dartmouth College. She has organized some thirty exhibitions, including a

2011–2012 traveling exhibition for Dartmouth entitled *Fluxus and the Essential Questions of Life*. Her recent publications include the book accompanying that exhibition, as well as *Smile of the Buddha: Eastern Philosophy and Western Art from Monet to Today* and, with coeditor Mary Jane Jacob, *Buddha Mind in Contemporary Art* and *Learning Mind: Experience into Art*, all published by the University of California Press. Baas has taught and conducted numerous workshops, including, with Jacob, a 2007 "mobile workshop" for *Documenta 12* and Sculpture Projects Muenster involving groups of graduate students from Bauhaus University-Weimar and the School of the Art Institute of Chicago. In September 2008 she facilitated the second international workshop on "The Modern" at Göteborg University, Sweden. Baas received her PhD in art history from the University of Michigan.

Amy Beste is director of public programming for the Department of Film, Video, New Media, and Animation at the School of the Art Institute of Chicago, where she curates the visiting artist and screening series "Conversations at the Edge" at the Gene Siskel Film Center. As part of the exhibition *Learning Modern*, she coordinated "Vision in Motion," a program of rare archival films from László Moholy-Nagy's Institute of Design, also shown at the Siskel Film Center. From 2000 to 2003 she served as director of programming for the Chicago Underground Film Festival. Beste has also organized moving-image exhibitions for a variety of institutions and organizations, including the Museum of Contemporary Art, Chicago; WTTW Channel 11, Chicago; and Anthology Film Archives, New York. Her research includes studies of the relation between independent filmmakers in Chicago and the city's industrial, educational, and advertising moving-image industry.

Marcos Corrales is an architect based in Madrid. While undertaking commercial, civic, private, and social housing projects, he also often works as exhibition designer for major contemporary shows. In Madrid, these include *Cocido y Crudo/Cooked and Raw* (1994), *Julião Sarmento* (1999), and *David Hammons and Vito Acconci* (2000–2001), all at the Museum National Reina Sofia; *Sol Lewitt* (1996) at La Caja; and Jorge Pardo's *Apartment in Gran Via* (2007) at Galeria Elba Benitez. Corrales undertook the design of the Spanish pavilion, São Paulo Biennale (2002); *Poetic Justice* at the Istanbul Biennale (2003); the Portuguese pavilion, Venice Biennale (2007); and *Prospect* at the New Orleans Biennial (2008). He has also designed exhibitions for the National Aerospace Museum, Madrid, and in 2001–2002 was director of design for the permanent collection at Robben Island, Capetown, South Africa.

Carla Duarte is a visual and performance artist living in Chicago. She works individually as well as collaboratively, performing integrated experiences that look at the relation of the self to others. Her work has been exhibited in Chicago at *Here nor there,* Museum of Contemporary Art (2009); *Learning Modern*, Sullivan Galleries (2009); and *Systems of Inefficiency*, Mveseum Gallery (2010). She performed in *Dreaming Kansas* (2010) under Ernesto Pujol through the Salina Art Center and undertook three summer residencies as a visiting artist at Mildred's Lane, Pennsylvania.

Ângela Ferreira was born in Maputo, Mozambique, lived in South Africa, and since 1992 has resided in Lisbon, Portugal. Over the last twenty years Ferreira has created an extensive body of work in which she interrogates geopolitical, art historical, and gender issues related to given cultural contexts using a range of media. Her installations frequently include sculptures that evoke modernist vocabularies, combined with text, semidocumentary photographs, and videos. In 2007 she represented Portugal in the Venice Biennale with her work *Maison Tropicales*, a critique of Jean Prouve's flat-pack houses, originally built in the 1940s in Niger and the Congo. She has also participated in biennials in Istanbul, Johannesburg, and Melbourne. Her solo shows have included one at Donald Judd's Chinati Foundation, Marfa, Texas, where she was in residence.

Madhuvanti Ghose is the first Alsdorf Associate Curator of Indian, Southeast Asian, Himalayan and Islamic Art at the Art Institute of Chicago. Previously she was a lecturer in South Asian art and archaeology

at the School of Oriental and African Studies, University of London (2004–2006), and a research fellow at the Department of Eastern Art, Ashmolean Museum, Oxford University. At the Art Institute, Ghose opened the Alsdorf Galleries of Indian, Southeast Asian, Himalayan and Islamic Art in 2008 and curated the first Indian contemporary exhibition—the site-specific light installation *Public Notice 3*, by artist Jitish Kallat. Ghose is developing a major exhibition on the arts of Jaipur for spring 2015.

Michael Golec is associate professor of design history at the School of the Art Institute of Chicago. His writing and research focuses on theoretical and historical issues that arise from the intersections of art, design, and technology. He is the author of *Brillo Box Archive: Aesthetics, Design, and Art* (Dartmouth University Press, 2008) and the coeditor of *Relearning from Las Vegas* (University of Minnesota Press, 2009).

Anna Halprin's diverse career has spanned the field of dance since the late 1930s, creating revolutionary directions for the art form. In 1955 Halprin founded the groundbreaking San Francisco Dancer's Workshop and, in 1978, the Tamalpa Institute. Her students have included Trisha Brown, Ruth Emmerson, and Meredith Monk. Among the many artists she has worked with are John Cage, Merce Cunningham, Robert Morris, Morton Subotnick, and Robert Whiteman. Halprin has also investigated various social issues through dance and through theatrical innovations. Her *Planetary Dance: A Prayer for Peace*, staged in Berlin at an event commemorating the fiftieth anniversary of the signing of the Potsdam Treaty, which ended World War II, involved over four hundred participants. Halprin's work has been acknowledged with a lifetime achievement award in choreography from the American Dance Festival and numerous honors from the National Endowment for the Arts, the Guggenheim Foundation, the American Dance Guild, and many others. In 2010 she traveled to Israel as a Fulbright Senior Specialist Program Fellow. Halprin is the author of a number of books and videos about her work and is the subject of Ruedi Gerber's 2009 documentary film *Breath Made Visible*.

Charles Harrison is a designer, educator, and speaker specializing in industrial design across multiple consumer products areas. The primary portion of his career was spent working for Sears Roebuck & Company, first as a freelancer, then as a staff designer, and later as head of the company's design department. Harrison's designs not only reflected our changing lives but often drove the transformations that took place in the American home and workplace in the era following World War II through the mid-1980s. Harrison executed more than seven hundred designs, of which the most iconic include the redesign of the View-Master (1958) and the first-of-its-kind plastic refuse can (1963). Harrison received the 2008 National Design Award for Lifetime Achievement from the Smithsonian Institution's Cooper-Hewitt National Design Museum. He also has received awards from the Industrial Designers Society of America, Executive Leadership Council, and HistoryMakers, a national institution based in Chicago and dedicated to archiving the stories of accomplished African Americans. In 2009 he received an honorary doctorate from the School of the Art Institute of Chicago. Harrison has been profiled in numerous publications, including the *Washington Post*, *Chicago Tribune*, *Chicago Sun-Times*, and *Ebony Magazine*, and on the Tavis Smiley radio show.

Walter Hood is a professor in the Landscape Architecture and Environmental Design Department at the University of California, Berkeley. His Oakland-based studio, Hood Design, has been engaged in architectural commissions, urban design, art installations, and research since 1992. His early projects in Oakland, such as the Lafayette Square and Splash Pad Park, are regarded as transformative designs for the field of landscape architecture. He has also designed gardens and landscapes for the De Young Museum, San Francisco; California African American Museum, Los Angeles; and Jackson Museum of Wildlife Art in Wyoming. He won design competitions for the Center for Civil & Human Rights in Atlanta and Garden Passage, a public artwork in Pittsburgh. Hood received the Smithsonian's Cooper-Hewitt National Design Museum Award for Landscape Design in 2009. He is a fellow at the American Academy in Rome in landscape architecture.

Mary Jane Jacob is a curator and professor in the Department of Sculpture and executive director of exhibitions and exhibition studies at the School of the Art Institute of Chicago. As chief curator of the Museums of Contemporary Art in Chicago and Los Angeles, she staged seminal shows of American and European artists, then shifted her focus to critically engage the discourse around public space through the site- and community-based programs "Places with a Past" in Charleston, "Culture in Action" in Chicago, and "Conversations at the Castle" in Atlanta. In addition to many exhibition catlogs, she has published the anthologies *Buddha Mind in Contemporary Art* and *Learning Mind: Experience into Art* (coedited with Jacquelynn Baas; University of California Press), and *The Studio Reader: On the Space of Artists* (coedited with Michelle Grabner; University of Chicago Press, 2010). She has received lifetime achievement awards from the Women's Caucus for Art and Public Art Dialogue (2010) and ArtTable (2011).

Kathleen James-Chakraborty is professor and director of the School of Art History and Cultural Policy at University College, Dublin. She was previously professor of architecture at the University of California, Berkeley, and Mercator Visiting Professor for the Art History Institute at the Ruhr University Bochum, Germany. She has published widely on German and American architecture. Her books include *Erich Mendelsohn and the Architecture of German Modernism* (Cambridge University Press, 1997), *German Architecture for a Mass Audience* (Routledge, 2000), and *Bauhaus Culture from Weimar to the Cold War* (University of Minnesota Press, 2006). She is currently writing a book about Louis Kahn.

Justine Jentes is the director of the Mies van der Rohe Society at the Illinois Institute of Technology, an organization she launched in 2002 to preserve Mies's legacy, restore his masterpiece buildings on the historic IIT campus, and reinforce Chicago's international reputation for architectural distinction. At the Mies Society she curates public programs and exhibitions. The educational offerings Jentes organizes also address the IIT campus, which also includes buildings by Rem Koolhaas and Helmut Jahn, while contextualizing the institution within the vibrant Bronzeville neighborhood and core district where Mies and his followers pioneered urban design solutions. Previously, Jentes ran insideART, a business venture comprising both a contemporary art gallery in Chicago's Wicker Park and tours exploring the city's creative community. She coordinated tour programs in Chicago for the Around the Coyote arts festival, the Department of Cultural Affairs' Chicago Artists' Month, and collectors series of Art Chicago exposition at Navy Pier.

Ronald Jones is professor of interdisciplinary studies at Konstfack, University College of Arts, Crafts and Design, Stockholm, Sweden, where he leads the Experience Design Group and codirects WIRE, the MA program in curatorial practice and critical writing. He is a guest professor in experience design at the National Institute of Design, Ahmedabad, India. A practicing artist, Jones has exhibited internationally and has work in the collections of the Guggenheim Museum, Museum of Modern Art, Metropolitan Museum of Art, and the Whitney Museum of American Art, all in New York; the Museum of Contemporary Art, Los Angeles; and Moderna Museet, Stockholm. Jones is a regular contributor to *Artforum* and *Frieze* and writes frequently on contemporary art and design for other publications, including *Art in America*, *Flash Art*, *ID Magazine*, *Parkett*, and *Zone*.

Narelle Jubelin was born in Australia and has worked in Spain since 1997. She is an artist who marks the journeys that objects make through the world and the history that accrues to them. Her practice acknowledges that any notion of modernism has been fraught with dislocations, constantly changing and reinterpreting how the work comes to be received in one place or another. *Key Notes*, the site-specific installation Jubelin created for *Learning Modern* in collaboration with Carla Duarte, has been reconfigured for *Vision in Motion*, an exhibition at the University of Sydney (2012) that will subsequently travel to Melbourne and South Australia. Jubelin's work has also been presented in group and solo exhibitions at spaces including the Centre for Contemporary Art, Glasgow (1992); Renaissance Society at the University of Chicago (traveling to the Grey Art Gallery, New York, and Monash University Gallery, Melbourne); Art Gallery, Ontario and

York University Gallery, Toronto (1997); Pavilhao Branco—Museu da Cidade, Lisbon (1998); John Curtin University Gallery, Perth (2002); and Centro Jose Guerrero, Granada (2006). She and Marcos Corrales have collaborated on several projects: *And Hence Re-written* (1996); *Case Number: T961301*, Tate Gallery, Liverpool (1998); *Unwritten*, Galeria Luís Serpa, Lisbon (1999); *On Writing. Writing On*, John Curtin University Gallery, Perth (2002); *Shumakom* (with Andrew Renton), Artists Space, Jerusalem (2002); and *Duration Houses* (2003) and *Superimpositions* (with Luke Parker), both in Mori Gallery, Sydney (2008).

Jitish Kallat's work derives much of its thematic and visual vocabulary from the immediate urban environment of Mumbai, where he lives. His work has been featured in the Havana Biennale, Asia Pacific Triennale, and Fukuoka Asian Art Triennale, as well as at Tate Modern, London; Martin Gropius Bau, Berlin; Kunst Museum, Bern; Mori Art Museum, Tokyo; and Museum of Moderne Kunst, Copenhagen. Kallat's recent solo exhibitions include shows at Chemould Prescott Road, Mumbai; Arario Gallery, Beijing and Seoul; Arndt, Berlin; and the Bhau Daji Lad Museum, Mumbai. His major site-specific installation *Public Notice 3* was on view at the Art Institute of Chicago from September 11, 2010, through September 11, 2011.

Walter E. Massey is president of the School of the Art Institute of Chicago, a post he assumed in 2010. He is president emeritus of Morehouse College and has served as provost and senior vice president for academic affairs of the University of California system, professor of physics and vice president of research at the University of Chicago, director of the Argonne National Laboratory, and director of the National Science Foundation. Massey is also past chairman of the board of the Salzburg Global Seminar, a former trustee of the Andrew W. Mellon Foundation, and a trustee emeritus of the University of Chicago.

Ben Nicholson is associate professor in the Department of Architecture, Interior Architecture, and Designed Objects at the School of the Art Institute of Chicago. He taught at the Illinois Institute of Technology for sixteen years before joining the faculty of SAIC in 2006. He has been a visiting professor at the Southern California Institute of Architecture, the Royal Danish Academy, the University of Edinburgh, and the University of Houston. He was a fellow at the Chicago Institute for Architecture and Urbanism and has received grants from the Graham Foundation and others. His work alternates between designing homes and urban projects, digging into vernacular culture, and studying geometry and pattern. Nicholson's earlier work focused on issues of domestic architecture, resulting in the publications *Appliance House* (MIT Press, 1989) and *Thinking the Unthinkable House* (Renaissance Society, University of Chicago, 1997). He is currently coediting a book about Frederick Kiesler and Paul Tillich titled *Forms of Spirituality: Modern Architecture and Landscape in New Harmony*. Nicholson is also creating micro-infrastructural projects in the utopian town of New Harmony, Indiana, where he lives.

Helen Maria Nugent has taught since 1997 at the School of the Art Institute of Chicago, where she is associate professor in the Department of Architecture, Interior Architecture and Designed Objects. She currently directs the graduate and undergraduate programs in designed objects and teaches studio courses focusing on the design process, thematic object design, lighting, and materiality. She has lectured at the Emily Carr Institute of Art and Design, Vancouver; Northwestern University; and Syracuse University, and has produced exhibitions such as *Deceptive Design* and *Beyond Function: The Art of Furniture* for the Chicago Cultural Center and "ThickDesign" for SAIC's Betty Rymer Gallery. In collaboration with artist Jan Tichy, she designed the exhibition *Moholy: An Education of the Senses* at the Loyola University Museum of Art, Chicago. She serves on the board of the Chicago Furniture Designers Association and is a cofounder of HAELO Design.

Michelangelo Pistoletto was born in Biella, Italy, in 1933. An inquiry into self-portraiture characterizes his early work; his first *Mirror Paintings* (1961) brought him international acclaim, leading to one-man shows in important galleries and museums in Europe and the United States. In 1965 and 1966 he produced a

set of works entitled *Minus Objects*, considered fundamental to the birth of Arte Povera. In 1967 he began working outside traditional exhibition spaces and in 1968 published his *Manifesto of Collaboration*; in the decades since, his projects have brought together artists from different disciplines and diverse sectors of society. In the early 1980s he made a series of sculptures in rigid polyurethane, translated into marble for his solo show in 1984 at Forte di Belvedere, Florence. During the 1990s, with Project Art and with the creation in Biella of Cittadellarte—Fondazione Pistoletto and the University of Ideas—he brought art into active relation with diverse spheres of society with the aim of inspiring and producing responsible social change. In 2003 he won the Venice Biennale's Golden Lion for Lifelong Achievement. In 2004 the University of Turin awarded him an honorary degree in political science. On that occasion the artist announced what has become the most recent phase of his work, Third Paradise, the symbol of which is the *New Infinity Sign*. In 2007 he received the Wolf Foundation Prize in the Arts "for his constantly inventive career as an artist, educator and activist whose restless intelligence has created prescient forms of art that contribute to fresh understanding of the world."

J. Morgan Puett's work focuses on clothing design, textiles, and costume history as well as the re-creation of milieus that recollect her well-worn southern rural heritage. This was the subject of her stores on East Fifth Street, Broome Street, and Wooster Street in New York City as Puett launched her career with the creation of her own designer label and accompanying retail fashion house. She has been featured in *Artforum*, *Art in America*, *Harper's Bazaar*, *New York Magazine*, the *New York Times*, and *W*, among others. Puett is the recipient of a Pew Fellowship in the Arts and is a United States Artists (USA) Fellow. Her work has been exhibited at the Fabric Workshop and Museum of Philadelphia; Wave Hill, New York; Spoleto Festival USA, Charleston; Victoria and Albert Museum, London; and the Massachusetts Museum of Contemporary Art.

Zoë Ryan is the chair and John H. Bryan Curator of Architecture and Design at the Art Institute of Chicago. Her exhibitions include *Fashioning the Object: Bless, Boudicca, and Sandra Backlund* (2012), *Bertrand Goldberg: Architecture of Invention* (2011), *Hyperlinks: Architecture and Design* (2010), *Konstantin Grcic: Decisive Design* (2009), and *Graphic Thought Facility: Resourceful Design* (2008). Previously, she was senior curator at the Van Alen Institute in New York, where she organized numerous exhibitions including *The Good Life: New Public Spaces for Recreation* (2006). She regularly serves as a lecturer, critic, and juror, and her writing on architecture and design has been published internationally. She is the author of numerous publications including *Building with Water: Concepts, Typology, Design* (Birkhäuser, 2010). Ryan is an adjunct assistant professor at the School of Art and Design at the University of Illinois at Chicago, where she teaches an interdisciplinary design seminar.

Staffan Schmidt undertakes visual and theoretical examinations of the built environment, exploring implications on social space and social consequences. As discursive and visual art studies, his work investigates conflicts that evolve in the public and private spaces of the everyday. With *Off the Grid* (2006–2008), he connected communities in New England and a suburb of Stockholm to provide their own power as an act of sustainability and resistance. Other research-based exhibitions have included *Cortile Japonica*, Landskrona, Sweden (2001); *Minsk Dérive*, European Humanities University, Belarus (2002); *Kanebo Factory Housing*, Japan (2002); *Spaces of Conflict*, Helsinki, Berlin, Vilinus, Portland, and Vienna (2004); *Point of Origin*, Malmö, Sweden, and Hiroshima (2006); and *Networks of Nitroglycerine*, Nobel Museum, Stockholm (2008).

Elizabeth A. T. Smith is the executive director of curatorial affairs at the Art Gallery of Ontario. Previously, Smith was chief curator and deputy director for programs at the Museum of Contemporary Art, Chicago, where she curated major exhibitions of the work of such artists as Lee Bontecou, Jenny Holzer, Kerry James Marshall, Donald Moffett, and Catherine Opie, as well as exhibitions on architecture and installations of the collection. As curator at the Museum of Contemporary Art, Los Angeles, she organized numerous exhibitions on architecture, including *Blueprints for Modern Living: History and Legacy of the Case Study*

Houses, *Urban Revisions: Current Projects for the Public Realm*, and *Paradise Cage: Kiki Smith and Coop Himmelblau*; co-curated *The Architecture of R. M. Schindler, At the End of the Century: 100 Years of Architecture*; and presented the work of artists Uta Barth, Margaret Honda, Toba Khedoori, Catherine Opie, and Jennifer Steinkamp for the first time in a museum context. In 2011 Smith coorganized the exhibition *Bertrand Goldberg: Architecture of Invention* at the Art Institute of Chicago. Her publications include *Case Study Houses: The Complete Case Study House Program 1945–66* (Taschen Verlag, 2002) and *TechnoArchitecture* (Thames and Hudson, 2000).

Maggie Taft's work on twentieth-century art and design has investigated the fabrication, distribution, and use of Danish design in Scandinavia and abroad during the first decade of the Cold War. Her research on László Moholy-Nagy and the New Bauhaus in Chicago has been presented in lectures at the School of Visual Arts in New York, the Art Institute of Chicago, and the Illinois Institute of Technology. She has collaborated with DoVA Temporary gallery in Chicago, organizing the 2008 exhibition *Looks Like Freedom*, which examined activist art initiatives in the Chicago area during the 1960s, and curating the 2009 University of Chicago MFA student thesis show *[Re]-View*. She is co-editor in chief of the *Chicago Art Journal* and an art advisor for the Chicago-based journal *The Point*.

Jan Tichy works at the intersection of video, sculpture, architecture, and photography. Born in Prague, Tichy moved to Israel in the mid-1990s and to Chicago in 2007. He has had solo exhibitions at the Herzliya Museum of Contemporary Art, Israel; the Museum of Contemporary Art, Chicago; Richard Gray Gallery, Chicago; and the Center for Contemporary Art, Tel Aviv. His work has been included in exhibitions in Barcelona, Berlin, Frankfurt, Jerusalem, Paris, Prague, Stockholm, Tel Aviv, Venice, and Washington, DC, and is included in the collection of the Museum of Modern Art, New York. In spring 2011, Tichy created his largest installation to date, *Project Cabrini Green*, which illuminated the last pubic high-rise building at this Chicago site.

Tricia Van Eck is artistic director of 6018NORTH, a sustainable space for installation, sound, performative art, and experimental culture in Chicago. She was formerly associate curator at the Museum of Contemporary Art, Chicago, where she oversaw the museum's extensive artists' book collection. At the MCA she curated "Interactions," a four-month series of artist and audience activations, as a companion to the exhibition *Without You I Am Nothing: Art and Its Audience*, which she co-curated, as well as other performative series. Van Eck also co-curated *Kerry James Marshall: One True Thing, Meditations on Black Aesthetics*, which traveled extensively throughout the United States; curated the Chicago presentation of *Buckminster Fuller: Starting with the Universe*; and coordinated the MCA showings of *Andy Warhol/Supernova: Stars, Deaths, and Disasters, 1962–1964* and the 2008 Jeff Koons retrospective. She edited the catalog *Universal Experience: Art, Life, and the Tourist's Eye* (DAP/MCA Chicago, 2005). In addition to curating numerous artists' books shows, she has staged exhibitions showcasing the work of emerging Chicago artists since 2001.

Arturo Vittori, an Italian architect and designer, is cofounder, with Andreas Vogler, of the research and design studio Architecture and Vision (AV). AV's projects have been exhibited at venues including the Centre Pompidou, Paris, and are included in the collections of the Museum of Modern Art, New York and the Museum of Science and Industry, Chicago. From 2002 to 2004 he was manager of cabin design at Airbus, taking part in the design for the first A380 aircraft. AV's project *Atlas Coelesits*, created for *Learning Modern*, traveled to space in 2011 in the form of *Atlas Coelestis Zero G*—a smaller version of the original that orbited inside the Japanese Experimental Module of the International Space Station. From 2004 to 2006 Vittori worked with Future Systems, collaborating with Anish Kapoor on the design of the Monte Sant'Angelo subway station in Naples. Vittori has also collaborated with architects such as Santiago Calatrava and Jean Nouvel. He practiced yacht design in 2006 at the London-based studio Francis Design. He has led workshops and spoken at international conferences on the topics of aerospace architecture, technology transfer, and sustainability. Vittori teaches industrial design at the First Faculty of Architecture Ludovico

Quaroni, Sapienza University of Rome. He was a research professor at the Illinois Institute of Technology, Chicago, and a member of the Order of Architects of Viterbo Province and the American Institute of Aeronautics and Astronautics.

Andreas Vogler, a Swiss architect and designer, is cofounder, with Arturo Vittori, of the research and design studio Architecture and Vision (AV). Early in his career, he collaborated with Richard Horden in London, later becoming Horden's teaching and research assistant at the Technical University of Munich, where he taught semester courses in aerospace architecture and micro architecture. In 1998 Vogler started his own architectural practice in Munich, working on several architectural competitions. In 2003–2005 he was a guest professor at the Royal Academy of Fine Arts, Copenhagen, where he did research in prefabricated buildings; in 2005–2006 he participated in the Concept House research group at the Delft University of Technology. He has written conference papers on space architecture and technology transfer to architecture for international conferences, and organized the space architecture session at the International Conference for Environmental Systems ICES, Rome, in 2005. Vogler has taught and lectured on industrial design and architecture at international universities, including Hong Kong University, Sapienza University of Rome, ETH Zurich, University of Venice IUAV. He is a member of the Bavarian Chamber of Architects (ByAK), the Deutscher Werkbund, and the American Institute of Aeronautics and Astronautics.

Kate Zeller is assistant curator in the Department of Exhibitions and Exhibition Studies at the School of the Art Institute of Chicago and has worked to mount the exhibitions *Touch and Go: Ray Yoshida and His Spheres of Influence, Picturing the Studio*, and *Learning Modern*, as well as site-specific installations with artists including Wolfgang Laib and Kimsooja. Zeller curated the exhibition *A Sense of Place* at the Italian Cultural Institute of Chicago, which was represented via film in the Italian Pavillon at the 2011 Venice Biennale. She edited the commemorative book *Ray Yoshida* (SAIC, 2010), and has served as assistant editor for the books *Learning Mind: Experience into Art* (University of California Press, 2009) and *The Studio Reader: On the Space of Artists* (University of Chicago Press, 2010), as well as the present volume. Zeller is an adjunct lecturer at the Art Institute of Chicago and the Museum of Contemporary Art, Chicago.

INDEX